GUSTAVE COURBET

GERSTLE MACK

§

GUSTAVE COURBET

A DA CAPO PAPERBACK

Library of Congress Cataloging in Publication Data

Mack, Gerstle, 1894–
 Gustave Courbet.

(A Da Capo paperback)
 Reprint. Originally published: New York: Knopf, 1951.
 Bibliography: p.
 Includes index.
 1. Courbet, Gustave, 1819-1877. 2. Painters — France — Biography. I. Title.
ND553.C9M3 1989 759.4 [B] 89-11817
ISBN 0-306-80375-5

Published by Da Capo Press, Inc.
A Subsidiary of Plenum Publishing Corporation
233 Spring Street, New York, New York 10013

PREFACE

FOR several reasons Gustave Courbet was one of the most important painters of the nineteenth century. He destroyed, almost single-handed, the dominance of the classical and romantic schools, which had become, by 1850, stagnant and decadent. He founded a new movement, realism, which replaced the obsolescent portrayals of gods and nymphs, knights and damsels, with honest, earthy pictures of contemporary French peasants and townsfolk and with forthright landscapes and seascapes, uncontaminated by literary idealization. He exerted a profound influence upon his successors, the impressionists, and through them upon the artists of the twentieth century. Although this enduring influence has been to some extent obscured in recent years by a trend, set in motion by Paul Cézanne, away from realism towards abstraction and symbolism, the beauty of Courbet's pictures has earned for him a secure place among the greatest masters of French painting.

To the biographer, Courbet's failures are as interesting as his many positive accomplishments. In his own day Courbet was enormously successful as an artist, childishly inept as a social philosopher. He was in truth nothing but a painter, and

his inability to recognize his own limitations led inevitably to disaster. He became involved in politics, for which he had no talent whatever. His sincere but muddled socialism brought him into conflict with the reactionary officials of the second empire. He was elected a member of the Commune of 1871, and after the downfall of that short-lived revolutionary régime he was accused, on scanty evidence, of responsibility for the demolition of the Vendôme Column. For this he was tried, convicted, and imprisoned. When the French Government attempted, after his release, to force him to pay the entire cost of reconstruction of the monument, he took refuge in Switzerland, where he remained in self-imposed exile until the end of his life.

Courbet's character was a curious combination of obvious faults and simple virtues. His most conspicuous defect was his outrageous conceit; but this vanity, so exasperating to his contemporaries, appears in retrospect merely naïve and slightly comic. Neither in life nor in art was he intellectual, spiritual, or notably imaginative; he painted instinctively, and when he tried to communicate his ideas he was rarely able to express them clearly without the aid of a more erudite collaborator. Courbet had an affectionate nature but little or no capacity for love on a higher plane; his relations with women were casual, primarily physical, and often cynical. On the credit side he had great courage; he fought valiantly for the principles in which he believed; he had immense vitality and a keen sense of humour; he was generous, though by no means unaware of the value of money; he was kind and helpful to the younger painters with whom he was acquainted; he was a jovial companion, a loyal friend, a devoted son and brother.

Many kind friends have contributed in various ways to the preparation of this biography. I gratefully acknowledge the invaluable assistance of M. Robert Fernier, president of Les Amis de Gustave Courbet, an association dedicated to the col-

lection and preservation of documents and relics pertaining to Courbet, to the maintenance of the Musée Courbet at Ornans, and to the publication in a semi-annual *Bulletin* of articles concerning the master. In April 1950 M. Fernier, himself a painter and, like Courbet, a native of the Franche-Comté, patiently piloted me for several days, in his ancient but sturdy little Peugeot (affectionately nicknamed *la princesse*), to Ornans, Flagey, Salins, La Vrine, Besançon, Pontarlier, and other towns and villages associated with Courbet; to many of the sites represented in Courbet's landscapes; and across the Swiss frontier to La Tour-de-Peilz, where Courbet spent the last four years of his life. My thanks are also due to M. Fernier for several photographs, both from his own collection and from that of the Musée Courbet at Ornans, and for much information derived from local records.

To M. Alfred Daber of Paris I am indebted for a number of photographs, for permission to reproduce paintings in his collection, for several useful introductions, and for valuable information concerning the dates and present locations of various pictures. To M. Jean Adhémar, *conservateur adjoint* of the Cabinet des Estampes in the Bibliothèque Nationale in Paris, for placing at my disposal the Courbet manuscripts and other documents in his charge, and for helpful advice in connection with my researches. To M. Jean Claparède, *conservateur* of the Musée Fabre at Montpellier, for information about Alfred Bruyas and the Bruyas collection of paintings. To M. Henry, *syndic* of La Tour-de-Peilz, and to M. Henri Edouard Bercher of Vevey, for information relating to Courbet's last years in Switzerland. To Mme Marguerite Carrez, cousin of Robert Fernier and present owner of the Hôtel des Voyageurs at La Vrine, for her charming hospitality and for a description of the inn as it was when Courbet rested there during his flight to Switzerland in 1873. To Mlle Suzanne Canoz of Saint-Sulpice-de-Favières (Seine-et-Oise) for personal recollections of Juliette Courbet. To Mr John Rewald

PREFACE

of New York for helpful suggestions and for permission to reproduce an original letter written by Courbet at Trouville in 1865. To Wildenstein and Company, Inc., of New York for a large number of excellent photographs of Courbet's works. To Blanche W. Knopf and Mr Herbert Weinstock for valuable suggestions and criticisms. To Mr John Foster White, Jr. for many courtesies during my months of research in Paris in the spring of 1950. For permission to reproduce paintings by Courbet in their respective collections, my thanks are due to the Metropolitan Museum of Art, New York; the Art Institute of Chicago; the William Rockhill Nelson Gallery of Art, Kansas City; the Toledo Museum of Art, Toledo, Ohio; the Springfield Museum of Fine Arts, Springfield, Massachusetts; the Phillips Gallery, Washington, D.C.; and the National Gallery, London

G. M.

CONTENTS

CONTENTS

ILLUSTRATIONS

xiv

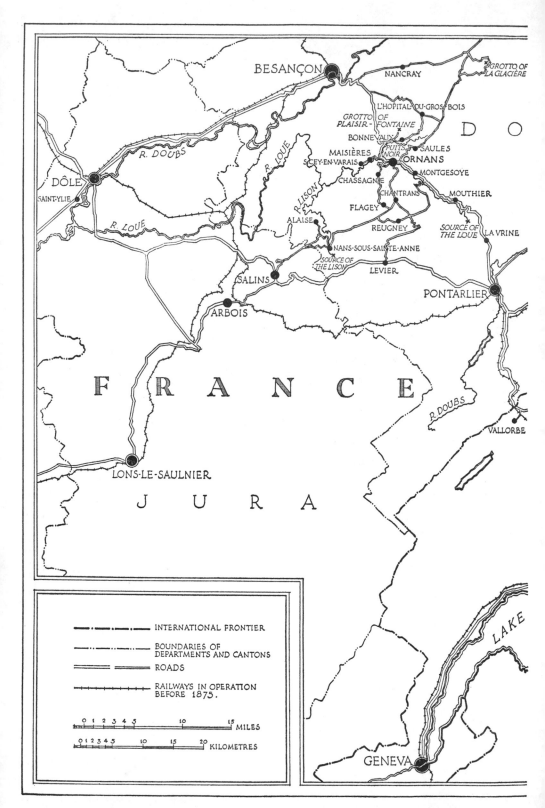

MAP OF THE FRANCHE-COMTE

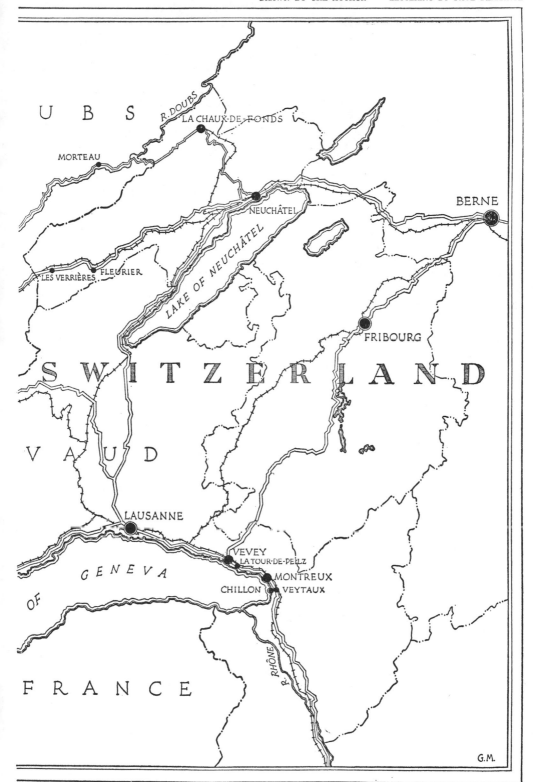

J U B S

R. DOUBS
LA CHAUX-DE-FONDS

MORTEAU

BERNE

NEUCHÂTEL

LES VERRIÈRES FLEURIER

LAKE OF NEUCHÂTEL

S W I T Z E R L A N D

FRIBOURG

V A U D

LAUSANNE

VEVEY
LA TOUR-DE-PEILZ

G E N E V A

MONTREUX
CHILLON VEYTAUX

OF

RHÔNE R.

F R A N C E

G.M.

AND WESTERN SWITZERLAND

GUSTAVE COURBET

ORNANS

THE LITTLE town of Ornans is situated in the heart of the ancient province of the Franche-Comté near the Swiss frontier, a mountainous region criss-crossed in every direction by the Alpine foothills. Above the heavily forested slopes rise perpendicular cliffs of bare grey stone honeycombed with caves and grottoes out of which turbulent streams, flowing underground for long distances, emerge abruptly into the sunlight to cascade swiftly down steep rocky channels. Spring comes late to this rugged upland country and the winter snows often remain on the sparsely populated heights through April and into May, but lower down the broad open valleys, gently rolling and dotted with villages, have been intensively cultivated for centuries. The architecture is in general unpretentious, part French, part Swiss, with a suggestion of German influence from nearby Alsace. The people have the sturdy independence of mountaineers, clannish, filled with pride in the beauty of their homeland, clinging stubbornly to their provincial customs, and speaking with a thick guttural accent quite unlike that of any other area in France. Ornans itself, in the department of Doubs on the main highway between Besançon and Pontarlier, is approximately the same size today as it was in

Courbet's time: a community of about three thousand inhabitants. Through the town flows the Loue river, far enough here from its source to have acquired breadth and placidity. It is a pretty town but not too obviously picturesque, solidly built of local stone with the steep roofs appropriate to a snowy region.

Here on June 10, 1819 Gustave Courbet was born, and here he returned year after year to paint landscapes, hunting scenes, and portraits. His father, Régis Courbet, was a prosperous landowner whose fields and vineyards extended over a considerable area in the vicinity of Flagey, a village some eight miles south of Ornans, where he occupied a simple but comfortable farmhouse. When at Ornans the family lived in the somewhat larger house (Plate 2) in the rue de la Froidière, overlooking the river, belonging to Gustave's maternal grandfather Jean-Antoine Oudot. This house is now the property of a retired concert singer, M. de Casteras, a resident of Nancy. Some slight doubt exists as to Courbet's actual birthplace. According to a persistent local tradition his mother left Flagey in a carriage for Ornans, where the delivery was to have taken place; but on the way she was overtaken by labour pains, and the child was born under an oak tree by the roadside near the spot known as La Combe-au-Rau. This version, which is not corroborated by documentary evidence, may be truth or merely legend; it is much more likely that he was born in the Oudot house at Ornans. The official record of the painter's birth reads as follows:

In the year 1819, on June 11, at two o'clock in the afternoon, before us, Jean-Antoine Tournier, mayor and state officer of the town of Ornans, appeared the *sieur* Eléonor-Régis-Jean-Joseph-Stanislas Courbet, landowner residing at Flagey, who presented to us an infant of the male sex, born the previous day at three o'clock in the morning,

4

son of the deponent and of Suzanne-Silvie Oudot his wife, and stated that he wished to name the child Jean-Désiré-Gustave. Which presentations and declarations were made in the presence of the *sieurs* Louis-Roger Hébert, secretary of the Town Hall, and Anatole-Georges Saulnier, former director of the Post Office, both adult residents of Ornans. And the said father and witnesses and ourselves have read and signed the present record.

<div style="text-align:center">

COURBET HÉBERT

SAULNIER TOURNIER [1]

</div>

Courbet's ancestors had been natives of the Franche-Comté for many generations. His paternal grandfather, Claude-Louis Courbet, was born in 1751 and died at Flagey on April 12, 1814; his paternal grandmother, *née* Jeanne-Marguerite Cuinet, died at Flagey on June 23, 1806. Both had been dead some years when the painter was born, but his grandparents on his mother's side, Jean-Antoine Oudot, born at Ornans in 1767, and his wife Thérèse-Josèphe *née* Saulnier, also a native of Ornans, lived throughout Gustave's childhood and young manhood and formed an integral part of the boy's affectionate, closely-knit family background. Gustave was devoted to these old people. His grandmother was "a good housekeeper, industrious, economical," [2] somewhat overshadowed by her more colourful husband, "a man without pretentiousness but extremely enlightened, who had read the works of Voltaire and other philosophers, assertive, brusque, even coarse in argument, whose integrity and goodness were acknowledged by everyone." [3] It was from Jean-Antoine Oudot, an ardent liberal who had fought on the republican side during the French Revolution, that his grandson first acquired the radical political and anti-clerical opinions from which he never deviated and which, many years later, were to lead to disaster. "My grandfather," Courbet wrote in 1861, "who was a republican

of '93, had invented a maxim which he repeated to me again and again: 'Shout loudly and march straight ahead!' My father always followed this advice, and I have done the same!" [4]

Régis Courbet, Gustave's father, was a well-to-do farmer but in no sense a country gentleman. Untroubled by social ambitions, he contentedly accepted his position in the community, half bourgeois, half peasant. From time to time he held office in the municipal government of Flagey, no great burden in that tiny village where he had lived all his life and where he was known and respected by all the neighbours. His lands, scattered in small parcels, were in the aggregate sufficiently extensive to qualify him as a voter during the reign of Louis-Philippe long before the days of universal suffrage. He did not till the soil with his own hands, for he could well afford to hire labourers to cultivate his farms and vineyards, but he took a keen interest in certain aspects of farming; not always the most profitable aspects, so that his lands usually yielded less than they might have produced under more practical supervision. "He was intensely interested in agricultural improvements," wrote Courbet's friend Castagnary. "He made several attempts at large-scale cultivation without success; he tried to install a drainage system, he invented a harrow, improved other farm equipment. But he grew bored quickly. I have seen a storehouse at Flagey filled with his inventions; all sorts of implements, unused and unusable, lay there in the dust. . . . Tall, thin, tireless, he was constantly on the move, on foot, on horseback, in a carriage. . . . He frequented fairs and markets where he could be seen from afar in the crowd, boisterous, jovial, shaking hands, haranguing the bystanders, shouting, laughing, gesticulating. . . . As a young man he possessed unusual strength and beauty. He retained both for many years. . . . His education was better than one would have expected to find in a peasant born towards the end of the Revolution. . . . Endowed with a merry disposition and a caustic tongue, he was always ready to jest. . . . He was certainly the most

6

unconscionable chatterbox I ever met in my life." [5] His passion for unpractical invention earned Régis Courbet the nickname of *cudot*, meaning in the Franc-Comtois dialect a visionary or dreamer. Gustave inherited from his father this inventive streak as well as his virile beauty, his boisterous humour, his back-slapping good-fellowship, and his love for his native soil.

Régis Courbet was born in Flagey on August 10, 1798. On September 4, 1816, at the age of eighteen, he married Sylvie Oudot, born at Ornans on July 11, 1794 and thus four years older than himself. She was a handsome woman, modest and tactful, a devoted wife and an affectionate, understanding mother. Endowed with more common sense than her unbusinesslike husband, Mme Courbet actually managed the farms and vineyards in addition to the household, supervised the planting and harvesting, kept the acccounts, sold the produce, and gently but firmly curbed her husband's extravagance.

Gustave, the eldest child and the only son, was followed by four sisters, all born at Ornans. Clarice (christened Bernardine-Julie-Clarice) was born on September 9, 1821 and died at Ornans on December 29, 1834, so young that her brother's memories of her as a childhood companion seem to have faded quickly, and he rarely referred to her in later years. Zoé (Jeanne-Thérèse-Zoé), born on August 26, 1824, was an excitable impetuous child who, as she grew older, developed into a tactless, sharp-tongued, quarrelsome woman, a thorn in the flesh of her family and especially of her brother. She was to cause him infinite trouble, and her eccentric conduct, inexplicable at the time to him and to the other members of her family, opened a breach that never healed. The third sister, Zélie (Jeanne-Zélie-Mélaïde), was born on August 1, 1828: gentle, placid, affectionate, sentimental, and pious, she was— probably because her health was always delicate—something of an anomaly in this energetic, boisterous family. The youngest, Juliette (Bernardine-Juliette), born December 14, 1831, ran truer to the Courbet type: robust, assertive, self-satisfied

to the point of conceit, rather dry and spinsterish. Although farthest from her brother in age she was closest to him in spirit. Their mutual devotion never diminished; they invariably understood, depended upon, and confided in each other.

In 1864 Courbet's friend Champfleury transformed the members of this family into characters in a novel, *Les Demoiselles Tourangeau*. Michel, the son, a law student, was more or less drawn from Courbet himself. The father's occupation was "to buy houses, demolish them, and have them rebuilt. . . . He is constantly darting through the streets of the town, harrying joiners, locksmiths, masons, and carpenters. He is as active as a stag at bay. . . . M. Tourangeau is a man of ideas who alarms his wife with the schemes that continually float through his mind, schemes that for forty years have inspired him to cry: 'I have made my fortune!' without having actually succeeded in doing anything but squander his patrimony." [6] Mme Tourangeau, "an excellent woman who adores her son," was "the counterweight needed by such a husband." [7] She and one of her daughters, Julienne (Juliette), attended to the cooking and the household chores; they were always busy and always smiling. The other sisters, with fewer duties, were not so contented: "The eldest, Mademoiselle Christine [Zélie], is a woman with languorous dark eyes which sometimes light up a sickly countenance. It is an effort for her to smile. . . . Mademoiselle Christine seems to envy the activity of her sister Julienne. . . . The poor girl suffers from her inability to display the treasures of goodness that are in her. . . . Her gentle sad voice veils all the delicacy of a melancholy soul turned inward upon itself. . . ." [8] But the strangest of the sisters in the novel (as in real life) was Emelina (Zoé) : "A mind thrown into chaos by outlandish reading. I had not crossed the threshold of the house before Mademoiselle Emelina began to pester me with a thousand questions about Paris, where nothing exists for her but drama and romance. What interests her most of all is the private lives of famous men and

women. . . . In spite of her romantic notions Mademoiselle Emelina is really an amiable person." [9]

Evenings in the Courbet farmhouse at Flagey or the town house at Ornans were often devoted to music, a form of entertainment in which most members of the family participated. Each played a different instrument: Mme Courbet the flute, Zélie the guitar, Juliette the piano at Ornans and the harmonium (now preserved in the village church) at Flagey; while Gustave composed little songs in blank verse, usually adapted from or based on local folk-songs of the Franche-Comté, and bellowed them at the top of his voice. He fancied himself as a musician and with characteristic vanity regarded himself as a first-rate composer and accomplished performer. His family and a few of the friends and neighbours who were privileged to attend these recitals accepted him at his own valuation, but in the opinion of more sophisticated auditors his verses were amateurishly clumsy and his rendition more remarkable for noise than quality. Occasionally some of the neighbours took part in the family concerts; among them Alphonse Promayet, son of the organist at Ornans, who grew up with Gustave and remained his devoted friend for forty years.

As a very young child Gustave seems to have been a promising student. His mother's cousin François-Julien Oudot, who taught at the Faculté de Droit (law school) in Paris, complimented him in a letter to the boy's parents dated January 7, 1830, when Gustave was ten years old: "You must kiss your little writer for me on both cheeks; his little letter was a nice surprise, better than a New Year sweetmeat; his handwriting is firm; his words are well formed; I wish that I, his schoolmaster cousin, could write as well as he does. . . ." [10] And the professor's wife added: "I thank you, my dear Gustave, for being thoughtful enough to tell me about your progress; I congratulate you; you could already qualify as a secretary at the Town Hall; have courage, forge ahead, don't waste your time;

when you are older you will have nothing to regret." [11] This youthful promise was never realized. The following year, 1831, he was sent to the "little" seminary at Ornans, a subordinate diocesan institution administered by the archbishopric of Besançon but intended for the education of laymen as well as theologians. The school still exists, though the building in which it was housed in Courbet's time has been replaced by a larger and exceedingly ugly modern structure. Gustave attended the seminary for six years, largely wasted years from a scholastic standpoint; he obstinately refused to study, and his marks were uniformly poor. Long afterwards his friend and schoolmate Max Buchon, who entered the seminary in 1830, wrote: "We were in the same class, both stammerers, I a boarder, he a day pupil; I sedate, quiet, and retiring; he lively and boisterous. I received prizes at the close of each year; he got nothing of the kind. I left the school at the end of 1833. Courbet remained. . . . Impervious to all other branches of learning, Courbet distinguished himself at that time by his French essays, invariably so comical that the professor always postponed the reading of them to the last as a crowning treat. On Thursdays it was he whose dominant influence set the course of our promenades. . . ." [12] Gustave loved the countryside as much as he detested the schoolroom. From earliest childhood he had rambled over every path, climbed every hill, explored every field and grove and watercourse in the vicinity, and his leadership on these outdoor excursions was accepted without question. His proficiency in original composition—the one exception to his deplorable academic record—was a natural gift which demanded little effort; all his life he loved to tell exaggerated fanciful stories, punctuated by uproarious laughter at his own wit. As to the stammering, both boys soon outgrew all traces of it.

The childish penmanship admired by his cousin Professor Oudot degenerated into a careless scrawl, difficult to decipher; a difficulty vastly increased by Courbet's inability (or unwill-

ingness) to spell even simple words correctly. Mistakes in orthography occurred frequently, especially in connection with the use or non-use of doubled consonants. Thus we find such eccentricities as *atellier, toille, pitoresque, accadémie, embarassé* and many others sprinkled throughout his letters. Were these errors caused by ignorance, carelessness, or sheer perversity? Courbet's own views on the subject of spelling were illustrated by an incident that took place in 1873 when the painter became involved in a controversy with a picture dealer named Hollander, of Brussels. Courbet wrote an intemperate letter to the dealer, who retaliated by publishing it verbatim in the *Salon,* a German periodical edited in Leipzig, together with a commentary pointing out and ridiculing the orthographical mistakes. Courbet's friend Dr Edouard Ordinaire wrote to Castagnary that the painter "feels no shame whatever for the mistakes in his letter; in the first place he says that one does not need to take the trouble to conform to rules of spelling when writing to such a shady character, and furthermore he refers to great men who made similar errors and prides himself on his resemblance to them in this respect. When I remarked that a painter should at least spell the word *toile* [canvas] correctly, he maintained that there are no rules for the middle of a word but only for its two ends, and that he has a perfect right to spell *toile* with a double 'l'." [13]

Religious instruction naturally formed part of the curriculum at the seminary. For this Gustave showed even less aptitude than for most of his other courses; he was utterly unable to memorize the catechism, and for some time it seemed unlikely that he would ever be prepared for first Communion. Perhaps the seeds of his future anti-clericalism were already beginning to sprout. "No matter how often he appeared with the other students before the ecclesiastical examiners," wrote Castagnary, "he was invariably deferred. The sins he revealed to his confessor so monstrously exceeded, in number and in kind, the iniquities appropriate to his tender age that nobody

was willing to give him absolution. . . . These successive rejections began to affect his reputation. The housewives of Ornans gossiped about him and wondered what would happen to him. Then Cardinal de Rohan, archbishop of Besançon, came to Ornans and was informed of the situation. The cardinal, being a sensible man, decided to clear up the matter himself. 'Come to see me,' he told Courbet, 'we shall have a chat.' The boy asked nothing better. He presented himself to the cardinal, who received him kindly . . . and persuaded him to confess. Courbet fell on his knees and began to recount his sins. Suddenly the cardinal, who had been looking in another direction, heard the confession of some outrageous wickedness, turned his head quickly, and saw that the boy was reading from a huge notebook. In order to be sure that he would forget nothing, Courbet had compiled a list of all the sins it would have been possible for anyone to commit, from the most trifling peccadillo to the blackest of crimes. It was this litany he had read to his other confessors, who had failed to perceive the fraud in the darkness of the confessional. The archbishop understood at once and burst into a roar of laughter. So Courbet had the honour of receiving his first Communion from the hands of the cardinal who, wishing to make the most of an almost miraculous occurrence, delivered a sermon to the amazed housewives on the text: '*Quomodo fiat istud?*'—'How was this wrought?' " [14] In later years Courbet often told this story, probably with embellishments of his own invention.

Courbet's youthful distaste for all intellectual activities became even more pronounced as he grew older. Reading gave him no pleasure; he was "so lazy that he read nothing but the newspapers in which he was mentioned, while he mocked and poked fun at culture. . . ." [15] "The sight of a book threw him into a rage," wrote another biographer with a certain amount of picturesque exaggeration. "The appearance of an inkstand made him shudder." [16]

Of all the courses offered at the Ornans seminary, only one

profoundly interested Courbet: the study of art. This subject was not taught there until 1833 or 1834, after the headmaster Abbé Gousset (who later became archbishop of Reims and a cardinal) had been superseded by the former professor of rhetoric Abbé Oudot, another cousin of Mme Courbet's. Under Oudot's administration elementary lessons in drawing and painting were given by a teacher named Baud—affectionately called *le père* Baud—who had been a pupil of Antoine-Jean Gros. Baud "had no great talent, but he did employ excellent methods of instruction. He would take his pupils out of doors to some picturesque site and encourage them to reproduce, some with pencil, some with the brush, what they could see with their own eyes. He himself would set to work like a student, an older student." [17] Baud left an interesting if somewhat naïve and awkward record of these outdoor excursions in a picture of his pupils industriously painting a landscape, with Courbet in the front row. Courbet, then about sixteen, also served as a model for a representation of St. Vernier, patron of vine-growers, which now hangs in the church at Ornans and which may have been painted by Baud. Having at last discovered an absorbing and fascinating outlet for his youthful energy, Courbet neglected his books more completely than ever and devoted himself wholeheartedly to his brush and pencil, rapidly filling sketchbooks with studies of flowers, portraits, and scraps of landscape. With boyish enthusiasm he attempted to copy in a single impetuous session a religious picture on the wall of a chapel, using a porcelain palette belonging to one of his sisters and colours begged or borrowed from a house-painter. His ambition even led him to try his hand at a portrait of a schoolmate named Bastide, afterwards chaplain of the French army in Rome, who remembered many years later that he still preserved at Ornans "a horrible portrait of myself painted by my friend Courbet at the age of fifteen." [18]

BESANÇON

RÉGIS COURBET was by no means a tyrannical parent, but he had little sympathy with what he considered his son's perverse enthusiasm for painting and drawing. Such frivolities might be tolerated as amusements for an idle hour, certainly not as a career for the child of a prosperous agriculturist with a respected position in the community. Gustave was to be prepared for some reputable profession such as the law. Accordingly he was sent in October 1837, when he was eighteen, to the Collège Royal at Besançon, a dignified ancient city, capital of the department of Doubs, some fifteen miles from Ornans. Here he was enrolled as an *interne* or boarder for the study of philosophy. But book-learning was as unpalatable to Courbet at the college as it had been at the seminary, and he immediately began to bombard his parents with woeful complaints about practically everything. The working day was far too long and too full, he protested: he was obliged to rise at five-thirty and study for two hours; then half an hour for recreation, followed by two hours of philosophy lectures on which he was expected "to take notes as fast as the professor talked"; [1] another hour of study; from eleven to noon a drawing lesson, the only pleasant interlude in the tedious routine; fifteen min-

14

utes for lunch during which conversation was forbidden; recreation until one o'clock, study until two, then two hours of mathematics which he found so incomprehensible that he had to pay twelve francs a month for private lessons in order to attain even the lowest marks; from four to five more recreation; and finally two and a half hours of study, then supper, and bed at eight-thirty. Twice a week there was in addition a class in physics.

To a youth of Courbet's temperament, to whom all erudition was anathema, such a curriculum meant sheer misery, and the living conditions at the college only made matters worse. Accustomed to hearty well-cooked meals at home, he grumbled bitterly about the food: a piece of bread for breakfast; at noon a bowl of soup and a plate of fried potatoes or cabbage or some other vegetable, "always watery," [2] plus an apple or a pear and a small glass of thin wine, "the whole unappetizingly served and often tainted by a strange taste or smell"; [3] for supper a slice of meat with a salad and an apple, which had to be eaten so hurriedly that he was often obliged to stuff half the meal into his pocket for future consumption. The beds were narrow and hard, and the nights so cold that he could not sleep even with his entire wardrobe piled on top of him; he begged his family to send an extra blanket. The same wintry chill penetrated the classrooms, forcing the students to pool their pocket-money to rent little stoves and buy firewood. The instructors, habitually sour-faced, "never spoke a word to the pupils during the whole year"; [4] the students "were much more spiteful than at Ornans; they thought of nothing but teasing, making mischief, and playing practical jokes." [5] On top of all this he was homesick: "I long to see Ornans and all of you; that should be forgivable the first time I have been away from home!" [6]

A few days later he wrote again, complaining of a colic caused by the repulsive "cold mutton they give us every evening"; [7] he was denied the solace of his pipe, for whenever he

attempted to smoke he was caught, and if he did not smoke he felt "dizzy and faint" [8]—which must have sounded oddly unconvincing to his parents. Even the one hour he might have enjoyed, the drawing lesson, was ruined because "there are a hundred of us in a large room which is so cold one cannot hold a pencil; and moreover . . . everybody shouts and talks and makes such a noise one cannot hear oneself; if I could only go somewhere else I could copy some bits of painting." [9]

The flood of letters continued in the same melancholy mood. If his parents would not permit him to leave the hated college he begged to be allowed at least to change his status from *interne* to *externe,* to live and board in lodgings in the town instead of at the school. When this too was refused he lost his temper: "Perhaps you think I wrote to you as I did for my own amusement; not at all. . . . Since in everything and every place I must always be an exception to the general rule, I shall take steps to follow my own destiny." [10] Again on December 4, 1837 he threatened to run away: "If you will not let me be an *externe* I shall leave, for I am accomplishing nothing at the college; this is ridiculous, it's impossible." [11]

Apparently his harassed family urged him to be patient for another month or two, to which he replied on December 9 with what amounted to an ultimatum: "I must tell you that I have come to a decision and I shall not need two more months in my present situation to make up my mind. Since you have set yourselves so obstinately against me I am thoroughly disgusted. You have tried to force me and in all my life I have never done anything under compulsion, that is not my nature. You sent me to college against my will, and now I have become too antagonistic to be able to do any work here. I shall give up my classes with regret, especially since I have only one more year to go and I know very well that I shall be sorry for this later on; but no matter, I cannot finish my studies here, and all I have done so far is absolutely wasted because in these classes one must do all the required work or none, and now, for what-

ever employment I may decide to take up, my studies will be of no more value than if I had never started them; for all these courses are directed towards the award of a bachelor's degree, without which they are useless, and now any occupation I may choose will require a fresh start from the beginning. Had I been able to foresee this kind of opposition I should have given up my classes long ago. They have been dragged out too long, since by this time there are already many occupations and many schools into which I can no longer enter because I am too old. I shall do the best I can. But to remain two more months at this college is absurd, impossible. I already have too little time ahead of me to waste two months in a barracks like this. I beg you to try to come next Sunday, you two and my grandfather, if the weather permits, because I refuse to stay here much longer; I shall run away. You have already made me waste enough time by your procrastination. . . . I am longing to see Ornans again. . . . Be sure to tell my grandmother not to worry. I hope you are all well. As to myself, I vomit only once in a while when hunger forces me to eat their mutton." [12]

But Régis Courbet refused to yield, and his son continued to plead, bluster, and protest without quite daring to carry out his threats. He wrote that his trunk had been packed for a week and that he would return to Ornans on New Year's Day, but he did not go. On January 5, 1838 he announced that the headmaster approved of his departure and that he would come home the following Sunday "whether you write to me or not. . . . I was determined to leave the other day, but when the headmaster heard of it he sent word that it would be better to wait for a letter from you. I am no longer attending classes; I have stopped that altogether." [13] His father remained unmoved, and Courbet still hesitated to flout parental authority by a flagrant act of disobedience; he merely sulked and for a month or two ceased to correspond at all with his family. Then on March 19 he wrote more violently than ever: he was doing

no work, his teachers paid no attention to him any more and no longer even spoke to him; the physics professor punished the twenty most backward pupils by obliging them to copy ten extra pages after each session, so that Courbet had twenty pages to copy every week; another instructor made his life unendurable by sneering and cursing; the headmaster had caught him smoking again and hoped to be rid of him in a few days. Once more he begged his father to relent and not force him to run away.

With this letter the tide turned. Régis Courbet gave up the struggle, at least so far as to allow his son to become an *externe*. Before Easter the young man was installed in a small room in the house of a certain Arthaud at 140 rue du Rondot-Saint-Quentin (subsequently renamed Grande Rue), the house in which Victor Hugo was born in 1802. For the moment this compromise satisfied Courbet. His complaints ceased abruptly, he resumed his studies dutifully if not enthusiastically, again took lessons in mathematics from a coach named Meusy, and made a determined effort to atone for his previous recalcitrance by playing the part of an obedient son. But the prospect of examinations terrified him, and he was soon writing home that the number and difficulty of his courses had been greatly increased; he was expected to pass tests in "Greek translation, geography, and astronomy, subjects we have not studied in our classes, as well as chemistry, algebra, Latin, all the well-known writers; also a composition to begin with, and if that is not well done one is not allowed to proceed. All that, added to the prodigious number of subjects we were already studying, throws me into a frightful panic." [14] When Courbet finally left the college in 1840 he had never presented himself for these examinations, and he departed without his bachelor's degree.

Nevertheless he was much happier as an *externe*, largely because he was freed from the constant surveillance of prying schoolmasters and able to devote more time to drawing and

painting. If his other studies suffered increasingly from neg-
lect, so much the worse for them. Moreover he soon found a
number of allies among the local artists and art students. A
painter named Jourdain lived in the same house—a mediocre
painter long since forgotten, but his mere presence under the
same roof, the jumble of pigments and canvases in his studio,
the smell of linseed oil and turpentine, the opportunities to
talk about art with a sympathetic older colleague, were enough
to stimulate Courbet and strengthen his determination to
make a career of painting. Still more dominant was the influ-
ence of two friends of about his own age: the son of the land-
lord, Arthaud, and Edouard Baille, who afterwards became a
moderately distinguished painter of religious subjects. Both
of these young men were students at the Ecole des Beaux-Arts
of Besançon, and Courbet needed little encouragement to ac-
company them to the classes in painting and drawing con-
ducted by the director of the school, Charles Flajoulot.

Flajoulot, a disciple of Louis David, was then about sixty
years old. He was an eccentric but engaging character, "good
as bread, naïve as a child . . . adored by his pupils. . . ." [15]
An ardent admirer of Greek and Roman art as well as of
Raphael, he had painted a series of thirty-seven pictures rep-
resenting the amours of Eros and Psyche. "My compositions
are not as good as those of the divine Sanzio," he admitted,
"but I have produced two more than he did." [16] Steeped in
classical literature, Flajoulot "wrote verses, sang to his own
accompaniment on the lyre, and when he was pleased with his
pupils he would promote them to the rank of gods. There was
a god of colour, a god of drawing, a god of harmony, a complete
Olympus." [17] He himself assumed the dignity of "god of draw-
ing" and bestowed that of "god of colour" on Courbet, his fa-
vourite pupil. Lacking the skill to carry out the grandiose con-
ceptions that crowded his imagination, Flajoulot "sketched out
on his canvases, which soon became smudged with confused
scrawls in charcoal, vast compositions which he visualized in

his mind and displayed with enthusiasm, believing them to be already executed. A strange teacher, this slightly crazy fellow. . . ." [18] Crazy or not, he proved of enormous value to Courbet, who learned under his guidance to draw from life, filling his sketchbooks with precise, sensitive pencil drawings of eyes and ears, legs and arms, hands and feet, male and female torsos, as well as street scenes of Besançon and Ornans and tentative portraits of his young friends Adolphe Marlet and Urbain Cuénot. He also produced a number of small paintings, somewhat crude in colour and composition and on the whole less successful than his studies in black and white: *Ruins by a Lake* (1839), a *Monk in a Cloister* (1840), and several landscapes painted in the vicinity of Ornans, including the *Roche du Mont, House of Grandfather Oudot, Approach to Ornans, Valley of the Loue,* and *Islands of Montgesoye* representing himself, with a gun under his arm, against a hilly background of poplars and willows. In addition he began to experiment with lithography, a medium to which he reverted from time to time in later years without notable success.

Courbet made no attempt to conceal his preoccupation with art from his parents, to whom he wrote from Besançon, probably in 1839: "I have recently taken up a kind of drawing which would suit me perfectly if my financial resources would permit me to practise it a little more often. It is lithography. I am sending you some examples with which I am well pleased. Give one to Adolphe Marlet . . . you may give the others, which are not as good, to whomever you wish, telling them that these samples are provisional and that I shall exchange them when I print other copies. . . . Tell *père* Beau [Baud] these are merely proofs." [19] He did not forget to ask his father for ten francs to cover the cost of printing.

Max Buchon, who had left the Ornans seminary in 1833 to study at a Jesuit seminary at Fribourg, Switzerland, returned to France in the autumn of 1838 and entered the college at

Besançon. As schoolmates at Ornans Buchon and Courbet had known each other only casually, but at Besançon their friendship ripened quickly, a friendship which was to endure without interruption until Buchon's death some thirty years later. Maximilien Buchon was born at Salins, about twenty-five miles from Ornans, on May 8, 1818. His father, Jean-Baptiste Buchon, had served in Napoleon's army and had retired with the grade of captain; his mother, *née* Jeanne-Louise Pasteur, died when Max was very young. Buchon and Courbet were distantly related and often referred to each other as cousins: in the late seventeenth century one of Buchon's ancestors, François Buchon, a resident of Flagey, had married a certain Catherine Courbet of the same village. His family was wealthy enough to enable Max to follow his chosen career, writing, without having to worry about the financial returns from his books. He was, according to Castagnary, "an unusual character in literature. . . . The son of a former soldier, he had a military appearance and bearing. A scar that furrowed one cheek and that had a purely civilian origin heightened this impression, but this ugly disfigurement masked a great fundamental goodness, and in him energy was combined with gentleness." [20] "Max Buchon was not much of a talker," wrote Charles Léger. "He lent a willing ear to the endless chatter of the Courbet family. . . . When they did ask him to speak he would come to life, and they would listen attentively to his narration, with a grave expression, of droll stories delivered with a clever aptitude for imitation. . . . Enraptured by new ideas and inspired by a vision of happiness for all hitherto oppressed human beings, this apostle preached by setting an example and assembled in groups, in the country at a place called Les Engoulirons between Arbois and Salins, all the republican-socialist partisans in the vicinity. . . . Completely honest, he had a bold and fearless mind, an unfaltering conviction. His upright character and his kind heart attracted to him all the wretched people who toiled on the land. He used to wander,

with a knapsack on his back and a staff in his hand, in search of old songs in the Doubs and the Jura. . . . His prose as well as his poetry, without flamboyance, were paintings in small brush-strokes of the men, habits, and customs of his corner of the Jura. . . . A realist, a collector of popular songs, a French forerunner of naturalism, Max Buchon wielded an influence superior to his written works. There was so little of the typical man of letters about him." [21]

Friendship between Courbet, obstreperous, aggressive, conceited, a loud and inveterate talker who hated books and took no interest in intellectual pursuits, and Buchon, gentle, spiritual, erudite, might have seemed so incongruous as to be practically inconceivable. Nevertheless there were few men for whom Courbet felt so warm an affection, so deep a sympathy; and Buchon fully reciprocated these sentiments. Moreover the painter held the poet's opinions in great respect, and Buchon's humanitarian principles, his championship of unvarnished realism, quietly but profoundly influenced Courbet.

Buchon's first book, *Essais poétiques, par Max B———, vignettes par Gust. C———,* was published at Besançon in 1839. It was a small volume to which Courbet contributed four lithographed illustrations. There was no great merit in the immature verses, still less in the lithographs; outside the limited circle of family and friends the book attracted almost no attention, but to the collaborators themselves the appearance in print of their first work seemed an event of vast importance. Courbet's illustrations represented a conscript bidding a tearful farewell to his fiancée at a wayside shrine; two Negroes ministering to an injured white man at the seashore; a pair of lovers, for whom Courbet himself and one of Buchon's cousins served as models, seated in a large room; and a wayfarer at the edge of a lake.

During the summer of 1840 Courbet spent his holidays at Ornans and Flagey, painting and sketching in the neighbourhood and pestering his father for permission to go to Paris. For

some months Régis Courbet, reluctant to abandon all hope of a college degree and a respectable legal career for his son, hesitated; but the young man's persistence finally triumphed. In November 1840 Courbet set out for Paris on top of the diligence, accompanied by an assortment of luggage, several letters of introduction to Parisian acquaintances of the family, and the good wishes of innumerable relatives and friends. His departure was saddened by the loss of his beloved teacher Flajoulot, who had died on September 15.

Some time during that year Edouard Baille, who preceded him to Paris, executed a pencil portrait of Courbet, but whether this was drawn at Besançon before Baille left or in Paris after Courbet's arrival is uncertain. Courbet was depicted as " a tall young man with a slim and graceful figure; a faint down covered his chin and cheeks; the broad arch of the brow surmounted eyes of great beauty. He had the tranquil look of a lion aware of his own strength. The mouth was humorous and firm; the prominent cheek-bones and the compact shape of the skull indicated energy and determination. He wore his hair long, curling over his collar. Seated with his legs crossed, he was dressed in the fashion of the day: tail-coat, trousers with flaps; and he already held in his hand the pipe which was never afterwards to leave his lips and which was to accompany him through life." [22]

PARIS

DURING all his years in Paris Courbet lived on the left bank of the Seine, generally in the sixth *arrondissement,* and always close to the present site of the Boulevard Saint-Germain which at that time had not yet been extended through the labyrinth of narrow old streets that separated its eastern and western extremities. His first lodging was in the rue Pierre-Sarrazin, a very short street connecting the rue Hautefeuille with the Boulevard Saint-Michel. Soon after his arrival he moved to a small hotel at 28 rue de Buci, where for about two years he occupied an attic room which cost twenty francs a month and could be reached by climbing "only 104 steps." [1] It had a high ceiling with a horizontal skylight so thickly covered with snow in winter that he could not see to paint in the dim light and was obliged to climb onto the roof to melt the snow with pails of hot water. The room was cold and the furniture scanty; Courbet asked his parents to send him an extra mattress, blankets, and sheets. His next move, which occurred on January 8, 1843, took him to 89 rue de la Harpe. Here his habitation was "formerly the chapel of the Collège de Narbonne, remodelled into a studio for M. Gati de Gramont, a well-known painter, and later used as a music room by M. Habeneck, conductor

of the orchestra at the Opéra." [2] The studio, amply propor-
tioned, had a vaulted ceiling; it was on the first floor and had
a window opening onto the courtyard in addition to a skylight;
it would be warm in winter; in short, he was delighted with
his new quarters, where he expected to be "splendidly installed
for work, for this is a fine large house, very quiet." [3] The rent
amounted to 280 francs a year.

The date of Courbet's next—and last—change of address in
Paris is uncertain, but it was probably about 1848 that he
moved to 32 rue Hautefeuille, where he was to remain until
1871. The house (Plate 4) occupied the corner formed by the
rue Hautefeuille and the rue de l'Ecole-de-Médecine, and the
painter's studio was equipped with a small window facing
the latter street, as well as a large skylight. It was "an old house
of austere aspect, a remnant of the former college of the Pre-
monstratensians [an order of Augustinian canons]. After the
suppression of the monasteries in 1790 the priory had become
secular property and the chapel had been converted into a
private house. The Café de la Rotonde on the ground floor
and Courbet's studio on the first floor occupied the site of the
apse of the chapel. . . . It [the studio] was a large lofty room
with the roof for a ceiling. Beams similar to those used in the
construction of the former church roof spanned its upper por-
tion and gave it an appearance of great antiquity. The furni-
ture seemed extremely inadequate: a divan covered with worn-
out rep, half a dozen dilapidated chairs, an old dresser with a
curved front, a small table littered with pipes, beer glasses, and
newspapers. All this was half buried beneath an avalanche of
paintings of all kinds and all dimensions, some framed and
hung on the walls, others merely standing on the floor with
their backs to the room. In the middle an empty space and
an easel holding an unfinished portrait. In the corners huge
rolls of canvas resembling carefully reefed sails. No luxury
whatever, not even ordinary comfort." [4] In one corner a
wooden partition enclosed a small bedroom. By way of con-

trast with all this austere simplicity, the studio was approached by a handsome Louis XIII staircase. The house was torn down about 1878 and replaced by a corner of the present Ecole de Médecine.

Courbet arrived in Paris well provided with letters to friends and relations whose cordial hospitality did much to make him feel at home in the strange and, to a country lad, bewildering city. One of these letters was addressed to a firm of colour merchants named Panier at 75 rue Vieille-du-Temple, who became his bankers and doled out the allowance remitted by his father. Although Régis Courbet's credit was good the Paniers took no chances. "It will always be a pleasure to us," they wrote, "to hand over to your son such sums as he may require; but we shall call upon you regularly for repayment within a month or a month and a half on each such occasion, it being impossible for us to maintain unproductive resources because we need them constantly for our own purchases, which are all on a cash basis." [5]

One of the first doors thrown open to Courbet was that of his mother's cousin François-Julien Oudot, the law professor who had praised his handwriting ten years earlier. But Courbet found his academic relation far from congenial; he resented the surveillance and interference, real or imaginary, of his older cousin. He was soon complaining to his parents that Oudot treated him discourteously, and announcing that he would visit that house no more often than was strictly necessary. The professor, more tolerant of his rebellious young kinsman, wrote to Courbet's parents on December 18, 1842 after one of the painter's periodical journeys to the Franche-Comté: "We have had a chat . . . with your big sturdy boy, who has brought back to us a lungful of Ornans air. May he have great success! May he become an artist, the glory of his native town! Is he following the best path towards achievement? Is he right to insist upon attaining success through his talent alone, with-

out lessons from a master? I have some doubts about it; but in any event it is courageous of him." [6]

Oudot urged Courbet to register as a pupil in the art school conducted by Baron von Steuben, an academic institution which the young man found insufferable and which he attended not more than four or five times. More to his taste was the informal Atelier Suisse on the Ile de la Cité at the corner of the Quai des Orfèvres and the Boulevard du Palais, a site now occupied by the Prefecture of Police. Suisse, a former model, offered neither instruction nor criticism; he simply provided, for a modest fee, nude models which his clients could draw or paint in any way they pleased. The casual atmosphere was well suited to the encouragement of unorthodox talents and the uninhibited development of potential leaders of revolutionary movements in art. The Atelier Suisse spanned a long and extremely important period in the history of French painting: Delacroix had worked there some twenty years earlier, while about twenty years after Courbet several of the forerunners of impressionism, including Camille Pissarro, Armand Guillaumin, and Paul Cézanne, were drawing a new generation of models at the same studio. During his first years in Paris Courbet spent many evenings at the Atelier Suisse and produced a large number of rapid sketches which he afterwards put to good use in his paintings of nudes. In 1861 he painted a portrait of old Suisse himself, with his flowing mane of white hair silhouetted against a dark background.

Occasionally Courbet sketched at another atelier run in the same free-and-easy manner by a certain Desprez, nicknamed *le père Lapin*—Papa Rabbit. According to Alexandre Schanne, who also worked there, Courbet "was never seen, at *père* Lapin's, to draw an entire figure; he merely made studies of details." [7] More important was Courbet's association with Auguste Hesse, a teacher of excellent repute who, like Steuben, directed an academic school of painting. One of Hesse's students was Adolphe Marlet, Courbet's boyhood friend from

Ornans; and through Marlet Hesse met Courbet and became deeply interested in his work. This friendly interest afterwards gave rise to the misconception that Courbet had actually taken lessons from Hesse. In the catalogue of the Salon of 1853 Courbet was listed as a pupil of Auguste Hesse, an identification which Courbet indignantly repudiated in a letter dated May 18, 1853 and published in *La Presse* two days later. He was not a pupil of any teacher, he protested; but when he had first exhibited in 1844 he had been obliged, like all new applicants for admission to the official Salon, to register as a pupil of some well-known painter, and he had merely requested Hesse to lend his name to this formality. The truth appears to be that Courbet never attended Hesse's academy, nor did the older man venture to offer specific criticisms of his work; but Hesse's generous praise did much to encourage Courbet at the beginning of his career. "The people round me," he told his family in February 1844, "who are in a position to comprehend what I am doing, for example M. Hesse, Marlet's teacher, to whose house I often go to show him what I have done, and who has visited me, for he takes a great interest in me . . . and many other people agree in the prediction that if I keep on working as I am doing, I shall ruin my health. . . ." [8]

Soon after Courbet's arrival in Paris tension developed between him and his father. For some reason—possibly because the boy, obstinately refusing to follow the advice of his cousin Oudot to enrol in a conventional academy, insisted upon his right and his ability to teach himself—Régis Courbet convinced himself that his son's life in the wicked city was one of wild extravagant dissipation, that he was doing no productive work, that he was wasting his own time and his family's substance. This was so far from the truth that Courbet, who was in fact living austerely and working very hard indeed, bitterly resented his father's incessant complaints. Still he managed to keep his temper most of the time. "I always like to receive your letters," he wrote, "even with the inevitable little sermon

which I have known by heart ever since I have been old enough to think, because I seem to have heard it even before that. You see I am not behaving like the young people of today who will listen to nothing that is said to them; unless you take me for a madman, I do not see what good these lectures can do me any longer; because you must understand that I am thinking seriously, a hundred times more seriously than yourself, about all these matters. Moreover this [scolding] discourages more than it encourages, for it is just like the jab of a spur to an animal that is already pulling too hard. You are the opposite of my acquaintances here who try to distract me from my work from time to time for fear that I shall injure my health. . . ." [9] Again: "I have received your letter in which, as usual, you heap reproaches on me. I do not understand how you can always say the same things when you have no evidence to support them. Some people marvel at the amazing frugality of my life; others cling to their doubts. If I did not know this old habit [of yours] it would be discouraging." [10] Still later, in February 1844, he protested once more: "If you think I am trying to deceive you, I am deeply offended; I certainly cannot work any harder; and yet my father has the effrontery to write me letters which . . . are extremely discouraging, and they always arrive at the most inopportune times just when I am busiest. I thank him for his remonstrances, but he should not always say the same thing. I believe that I am thinking more about my own future than anyone else, and I am proving it. I am living in so economical a fashion that it might soon be considered ridiculous. My father should have a son who squanders money as young people usually do in Paris." [11]

Perhaps in his repeated attempts to convince his mulish parent Courbet somewhat exaggerated his own virtue. Yet his grievance was legitimate; he was devoting himself wholeheartedly to his painting and he was certainly not a spendthrift. After his rent and his bills for canvas and pigments had been paid, little of his allowance was left for food and practically

none for entertainment. At this time his breakfast consisted of dry bread eaten in his studio, and his only other meal was consumed at a nearby restaurant, for a fixed price, at five in the afternoon. Slim rations for a young man with a healthy appetite, but he never complained on that score. What he did object to was his father's failure to recognize and appreciate his abstemiousness.

Although Courbet firmly rejected all academic instruction in painting he did not carry his rebellion so far as to refuse to learn from the works of old masters. He made frequent excursions to the Louvre, generally accompanied by François Bonvin, whom he had met at the Atelier Suisse and whose enthusiastic admiration for some of the great artists of the past helped to educate his less sophisticated companion's taste. At that time Bonvin, like Courbet, was just beginning to paint, and to support himself during his apprenticeship he had obtained ill-paid employment as a minor functionary in the Assistance Publique, a charitable agency of the state. The two young men, though basically congenial, often disagreed; in Courbet's opinion Bonvin's pictures were too small, whereas Bonvin maintained that Courbet painted on too large a scale. On at least one occasion the bickering developed into an open quarrel, eventually patched up through the tactful intervention of their friend Francis Wey. In 1846 Courbet painted a portrait of Bonvin.

Studying the works of the Renaissance masters, Courbet found himself indifferent to the paintings of the great Italians with the exception of a few representatives of the Venetian school, notably Veronese and Canaletto. For Titian, Raphael, and Leonardo da Vinci he expressed nothing but contempt, though this may have been due at least in part to a perverse desire to outrage the conventional standards of taste he professed to despise. On the other hand he paid homage to the Spanish painters Velázquez, Ribera, and Zurbarán as well as

to the Dutch and Flemish masters Hals, Van Dyck, Van Ostade, and especially Rembrandt, who "charms the intelligent but confounds and annihilates imbeciles." [12] These likes and dislikes remained unchanged throughout his life; it is significant that Courbet frequently travelled in Holland and Belgium but never visited Italy or apparently felt the slightest desire to go there. At the Louvre he copied pictures by Rembrandt, Hals, Van Dyck, and Velázquez, and he also tried his hand, not very successfully, at a few pastiches or free imitations "in the manner of" Flemish and Venetian classics.

At the same time he was assiduously painting original pictures in his studio, and he even managed to obtain an occasional order for a portrait, which provided a welcome addition to his scanty income. But at first his earnings from this source were small and sometimes difficult to collect. "The other day," he informed his parents, "I received some money from———. Those people are indifferently honest. They tried to reduce the price of the portrait, although we had definitely agreed on it; they offered me one hundred francs, to which I replied that I would rather give it to them as a present. I think that shamed them a little. Finally, with the air of people who were unable to pay, they asked if I would be satisfied with 150; not wanting to quarrel with them on that score, I replied coldly enough that I was well satisfied; they paid me 150 francs altogether, in two instalments. There is no need to put on such airs or make such a fuss in order to behave like that." [13]

THE SALON

COURBET's work during his first four or five years in Paris, considerable in quantity, varied greatly in quality as he struggled simultaneously with technical problems and conflicting theories of art. This was a period of immaturity, of transition and indecision. He devoted far too much of his time to the painting of romantic and literary subjects, sometimes sentimental, always stiff and wooden. Among these early pictures was an *Odalisque* inspired by Victor Hugo's poem beginning:

> *Si je n'étais captive,*
> *J'aimerais ce pays. . . .*

Others were *Lélia*, suggested by George Sand's novel of that name published in 1833, and *Walpurgis Night* derived from Goethe's *Faust*. More startling though no more admirable as a work of art was *Lot and his Daughters*, erotic to the point of obscenity, representing one daughter in the act of opening her robe and exposing her nakedness to her father's view while the other, reclining on the ground at the entrance to a grotto, pours wine into the drunken old man's cup. An allegorical composition pompously entitled *A Man Delivered from Love by Death,* in which Courbet himself posed for the figure of the

32

bereaved lover contending unsuccessfully with Death for his beloved, was afterwards light-heartedly referred to by the painter as the sequel to an episode of amorous folly—which suggests that the young man's life in Paris may not have been quite as austere as he wished his family to believe.

Such works were a concession to the prevailing artistic tastes and conventions of the day rather than an expression of Courbet's own personality, non-intellectual to the core. Fortunately he soon realized that literary subjects meant nothing to him and abandoned them forever. Much more successful, because more spontaneous and instinctive, were his early landscapes and especially his portraits.

The landscapes were still few in number and tentative in execution. One, *Views in the Forest of Fontainebleau,* was painted in 1841 during a brief sojourn in that artists' paradise. That same year he made an excursion to Le Havre with Urbain Cuénot. "I was delighted with this trip," he told his parents, "which has greatly developed my ideas about many things I needed for my art. We have at last seen the sea, the horizonless sea (how strange it seems to the dweller in a valley!). We saw the fine buildings on its shores. It is too tempting; one feels carried away, one would like to sail away to see the whole world." [1]

In the autumn of 1842 Courbet returned to Ornans for a visit, the first of a long series of such pilgrimages, spanning sometimes a few weeks, sometimes several months, which were to be repeated at varying intervals until a few years before his death. For Courbet's devotion to his family, his boyhood friends, and his native countryside never diminished; wherever he might be, his roots remained firmly planted in the soil of the Franche-Comté. Even the conflict with his father generated more noise than heat and left no permanent scar. At Ornans in 1842 he painted a portrait of his father (Plate 1) and one of his eleven-year-old sister Juliette, dressed in brown, leaning against a wall. During the same visit he produced at

33

least two landscapes: *Founèche Rock,* showing the town of Ornans and the road leading to Salins, and *Winter Woods,* probably the first of his innumerable snow scenes. In 1844, again at Ornans, he painted another portrait of Juliette (Plate 7) , in a striped blue and yellow dress, seated in an armchair by a window against a background of figured drapery. He also executed at least one portrait of his grandfather Oudot, probably in the same year. Possibly in 1844 but more probably about 1846 he painted his sister Zélie in a blue dress with white collar and cuffs, her cheek resting on her right hand, her dark hair parted in the middle and bound smoothly over her ears.

Many of Courbet's portraits, not only at this period but for years to come, were of himself—so many that he was often accused of being in love, like Narcissus, with his own image. There may well be some truth in the charge; Courbet's vanity was quite comprehensive enough to include admiration for his own handsome features. Probably the first of these self-portraits, a tiny picture measuring less than four inches by three, was painted late in 1840 very soon after his arrival in Paris. It was followed in 1841 by *Despair,* a sentimental composition representing the artist with his hands covering his bowed head in an attitude of romantic (and quite insincere) grief.

In 1842 he produced his first truly successful picture, *Self-portrait with the Black Dog.* Although painted in Paris this small portrait shows Courbet seated on the ground in front of the entrance to the grotto of Plaisir-Fontaine near Ornans. His boyhood rambles had so deeply impressed the topography of that region upon his consciousness that he could easily draw any feature of it from memory. His dark curly hair, worn very long, is covered by a broad-brimmed hat; he wears a loose pink-lined painting jacket of some dark stuff and grey trousers with green stripes. Behind him on the left are his cane and

sketchbook; on his other side, silhouetted against the distant sunlit landscape, is a black droopy-eared spaniel. In the sky and background are a few experimental touches with the palette knife, an implement which Courbet was later to use frequently and with superb skill.

The dog was a new acquisition, as he wrote to his parents in May 1842: "Now I have a wonderful little English dog, a pure-blooded spaniel, given me by one of my friends; it is admired by everyone and it is welcomed by my cousin [Oudot] much more enthusiastically than I am." [2] Two years later this self-portrait won for Courbet his first admission to the Salon, an honour eagerly sought by all beginners. He had intended to submit only a newer and larger canvas (which has not been identified), but Hesse persuaded him to send the self-portrait as well. Of the new work Courbet wrote to his family in February 1844: "I have just painted a picture which is rather large and which has involved so much work that I have almost lost my mind during the past month. And even so I have not done it as well as I could, because I was in such a rush I did not know what to do and I could think of nothing else. If you think I am amusing myself [a dig at his father] you are wrong; for more than a month I have really not had a quarter of an hour to myself. This is why: I have models who are very expensive, from whom I paint from the earliest morning light until five in the afternoon, my dinner hour. In the evenings I have to buy what I need for my work, hunt for models from one end of Paris to the other, and then call on people who might be useful to me and go to certain obligatory parties in order to avoid being considered a churlish bear. . . . I have just sent my picture to the Salon. . . . M. Hesse praised it highly and predicted the most flattering things for me; he paid me so many compliments on what I was doing and on the pictures in my studio that I did not know how to reply; he also urged me to send a portrait . . . that I painted two years ago. If I am not accepted it will be a misfortune. . . ." [3]

It is refreshing to find Courbet, at the age of twenty-five, flustered by compliments. His conceit more commonly demanded praise, and when that was not forthcoming in sufficient quantity he was more than willing to supply it himself. In March he was able to announce that the jury had accepted the *Self-portrait with the Black Dog* but rejected the newer painting: "At last I have been accepted at the exhibition, which makes me extremely happy. The accepted picture is not the one I most desired to show, but that doesn't matter; I can ask for nothing better because the painting they refused was not really finished. . . . They have done me the honour to give me an excellent place in the exhibition, which is some compensation. . . ." [4] To his grandfather he wrote that the portrait had been hung in the gallery of honour reserved for the best works in the Salon, and that if it had been larger it would have been awarded a medal, "which would have been a magnificent début." [5] Obviously Courbet was well pleased with himself, though he had no illusions concerning any immediate financial returns; he expected to earn no money that year because he intended to devote himself "to more important work; nothing is so prejudicial to that as a compulsion to earn money too soon." [6]

Thereafter, for the next twenty-five years, Courbet was represented at almost every annual Salon by at least one picture, usually by several. In February 1845 he informed his family that he had been working every day, Sundays and holidays included, without an hour's rest; he was physically and mentally exhausted, having just sent five paintings to the Salon: a *Young Girl's Dream* (better known as the *Hammock*), the *Guitar Player,* the *Chess Players,* a portrait of a man, and the portrait of Juliette executed at Ornans in 1844, "which I have entitled, as a joke, *Baroness de M———*. The frames cost me a great deal of money, but that cannot be helped. . . . I do not expect they will all be accepted; if two are accepted I shall be satisfied. . . ." [7]

The *Hammock* depicts a young girl in a striped dress asleep in a hammock slung between two trees in a dark forest glade, with a brook in the foreground. The *Guitar Player* is a self-portrait of Courbet seated at the foot of a tree against a background of rocks and woods, holding a guitar. The *Chess Players* cannot be identified. The portrait of a man may have been a portrait of Paul Ansout painted in 1844, or one of the youthful Paul Blavet painted in 1845; or it may have been the *Wounded Man,* another self-portrait, this time representing the artist dying of wounds received in a duel; with closed eyes and ashen face he lies helpless on the ground, his head against the trunk of a large tree.

Of these five offerings the jury rejected four, accepting only the *Guitar Player*. With unusual modesty Courbet wrote to his parents in March 1845: "I have no right to complain, because they also rejected a great many famous men who certainly had better claims than I." [8] He was happy to report that the *Guitar Player* had attracted two potential purchasers, a banker and a picture dealer; Hesse had advised him to ask five hundred francs, but Courbet considered that too high a price for a small canvas painted in a fortnight. In the end both the banker and the dealer changed their minds, and the picture remained on Courbet's hands.

Although still very short of cash Courbet somehow managed to procure a few more amenities than he had been able to afford when he first came to Paris. In December 1844, after his return from a visit to Ornans, he wrote that he had bought a better stove, costing ten francs, to heat his studio, and that he had added to his breakfast of dry bread a bowl of milk delivered daily by a suburban dairyman, and a pot of coffee made by his humpbacked concierge and brought upstairs by her similarly deformed husband—"an incredible pair," [9] Courbet called them, certainly no overstatement. But when he heated the milk and coffee together on his stove he would often be-

come so engrossed in his work that he would forget to take them off before they boiled over. In the same letter he vigorously denied a rumour, current at Ornans, that he was about to marry a certain Mademoiselle C——; he had no more idea of marrying than of being hanged. The question of Courbet's marriage was to crop up again and again in later years, each time to a different woman, but he remained a bachelor.

Nearly all of Courbet's early canvases had been fairly small, but he was already planning more ambitious works. "During the next year," he wrote home in March 1845, "I must paint a large picture which will enable the public to appraise me at my true value, for I demand all or nothing. All these little pictures are not the only things I can do. . . . I want to paint on a bigger scale. What I am saying is not . . . presumptuous, because everybody I meet who knows anything about art predicts this for me. The other day I made a study of a head, and when I showed it to M. Hesse he told me in front of all the people in his studio that there were very few masters in Paris who could equal it. Then . . . he told me that if I could produce a picture painted like that during the next year, it would win me a high rank among painters. I admit there is some exaggeration in his statement. But one thing is certain, I must make a name for myself in Paris within the next five years. There can be no middle course. . . . I know it will be difficult to attain; there are few, sometimes only one in thousands, who succeed. . . . To make more rapid progress I need but one thing, money, in order to carry out my ideas boldly." [10] But money was a serious problem: "I shall not earn a penny this year; one cannot work and make money at the same time; that is the worst possible assumption. The little I might earn would retard my progress enormously, especially during those years which are most vital to my advancement; you should understand that." [11]

If Courbet intended this as a hint that an increase in his allowance would be welcome, it seems to have fallen on deaf

ears. Fortunately he received an unexpected windfall at this crucial time. H. J. Van Wisselingh, a young picture dealer from Amsterdam, visited Paris on a buying expedition, met Courbet, admired his work, purchased two pictures for 420 francs, and commissioned a portrait of himself. The amiable Dutchman also promised to create a market for Courbet's paintings in Holland, where, he predicted, Courbet would achieve remarkable success. Van Wisselingh kept his word; when he moved to The Hague a few years later he induced a wealthy collector, Mesdag, to buy seven pictures by Courbet. This marked the beginning of Courbet's long and happy association with Dutch dealers, artists, and collectors. His popularity in both Holland and Belgium never waned, and his exhibitions in those countries were invariably successful.

He started work on his large picture, ten feet wide by eight feet high, but soon ran into difficulties. The task sapped his strength to the point of complete exhaustion, especially as he was planning another summer at Ornans and wanted to finish the painting before he left Paris, or at least carry it so far that it would be dry enough to complete after his return. He warned his father that this time he would spend most of the summer at Ornans itself, where he would be with friends and his beloved grandparents, rather than with his parents and sisters at dull little Flagey. The sojourn at Ornans was a real vacation; accompanied by Promayet, Cuénot, and other cronies, Courbet hunted, fished, roamed the hills, consumed vast quantities of wine and beer, and organized evening concerts for which he composed sentimental ballads that he sang with great gusto. One of these songs lamented the faithlessness of a certain Jeannette, a village lass with whom Courbet had apparently had a brief, rough-and-tumble love affair but who (at least in these verses) jilted him to marry the wealthy mayor.

There were a great many women in Courbet's life, but his relations with almost all were purely physical. His emotions were seldom involved at all, never for long. No deep or per-

manent attachments resulted from these casual relationships; he demanded nothing more from them than simple, uncomplicated sexual satisfaction. Very often his mistresses were his models, who served for longer or shorter periods in both capacities until they were dismissed without apparent regret on either side. One of the first of these mistress-models was Justine —surname unknown—whom Courbet painted in *Lovers in the Country,* probably in 1844 or 1845. In the foreground stands Courbet himself clasping the hand of his mistress; both figures are in profile with their heads, one dark, one fair, outlined against vague shrubbery and a darkening evening sky. The whole conception is romantic and poetic but not cloyingly sentimental.

After his return to Paris he abandoned, temporarily, his project for an immense picture, giving as excuse the lack of sufficient light in his studio during the short dark days of winter. He would not admit even to himself the real reason: that he had bitten off more than he could chew at that stage, that he would not be ready to paint such huge canvases for at least three more years. A letter of January 1846 revealed his discouragement because "there is nothing in the world more difficult than the practice of art, especially when nobody understands it. Women want portraits with all shadows eliminated; men want to be painted in their Sunday clothes; there is no way to combat these notions. It would be better to turn a crank mechanically than to earn a living by such daubs; at least one would not have to compromise with one's principles." [12] Nevertheless he produced enough that winter to send eight canvases to the Salon, of which only one, an unidentified self-portrait, was accepted; and that was hung so near the ceiling that it could scarcely be seen. He poured out his indignation to his family, accusing the jury, "a set of old imbeciles," [13] of malicious ill will; in his opinion the verdicts were necessarily superficial because four hundred pictures were judged per

day, or two a minute, so rejection by such a crew was actually an honour.

One of Courbet's best self-portraits, the *Man with the Pipe* (Plate 9), was painted in 1846 or early in 1847. The contrast between this and the dandified *Self-portrait with the Black Dog,* sleek and scrubbed and with every curl in place, is striking: the *Man with the Pipe* is a dishevelled bohemian with a straggly beard and a shaggy mop of matted unkempt hair. Yet the head is unmistakably that of an artist, not a ruffian; the sensuous mouth, delicately modelled nose, and dreamy expression combine to produce an effect of extreme sensitivity.

In 1846 Courbet again spent several months at Ornans. Immediately after his return to Paris in December he began a portrait of Urbain Cuénot which, he wrote, was greatly admired by Hesse and other friends but would probably not be approved by the Salon judges because it did not conform to conventional standards. His fears were more than justified; not only the portrait of Cuénot but also his two other offerings were rejected by the jury of 1847—one of the few years in which Courbet was not represented at the Salon. For the reactionary officials he felt only contempt, "but one must exhibit in order to become known, and unfortunately there is no other exhibition. In former years, when my own style was less fully developed and I still painted a little like themselves, they accepted me; but now that I have become myself I must henceforth give up hope." [14] Nevertheless he had some reason for optimism. The stodgy jurors had in fact overreached themselves and had offended so many prominent artists that several members of the rejected group, supported by some of the more liberal-minded of those who had been accepted, formed an association of protest to organize an independent exhibition in some private gallery. The rebels, including Ary Scheffer, Delacroix, Daumier, Alexandre-Gabriel Decamps, Théodore Rousseau, and the sculptor Antoine-Louis Barye, held a meet-

ing at Barye's residence on April 15, 1847 and drew up a resolution in legal form in favour of annual independent exhibitions. But the revolution of the following year brought in its train a much less conservative Salon, which made the realization of the project unnecessary at that time.

During the summer of 1847 Courbet went to Holland, his first excursion beyond the frontiers of France. He already knew and liked Van Wisselingh, who had promised him a warm welcome, and he was also furnished with letters of introduction to "a certain Van den Bogaert, chief cup-bearer to the king of Holland, a very influential person and one of the leading figures in Amsterdam." [15] His early admiration for Rembrandt and other Dutch masters, acquired at the Louvre, turned to rapturous enthusiasm as he viewed their works in the museums and galleries of Holland. "I have been in Amsterdam for two days," he wrote to his family. "I have already made the acquaintance of two or three artists on whom I shall call today. I shall also visit the museum, which will be open. I am already enchanted with everything I have seen in Holland, and this [tour] is really indispensable to an artist. A voyage like this teaches one more than three years of work. At The Hague, a charming city, I saw the finest collections. . . . I do not yet know the day of my departure, for I might be commissioned to do a portrait here. People assure me that if I were to remain two or three months, long enough to become known, I could make some money. My style pleases them. I brought with me only one small landscape, which they like very much from the standpoint of craftsmanship. Nobody here paints in that manner. . . ." [16] Apparently nothing came of the proposed portrait, and the rate of exchange made the cost of living so high that Courbet was obliged to leave Amsterdam a week later.

Almost immediately after his return to France early in September he proceeded to Ornans, where his homecoming was

saddened by the recent death of his grandmother on August 16. Stimulated by his sojourn in Holland, he went eagerly to work and produced a number of landscapes, including *Evening Shadows,* the *Valley of Scey,* and a pencil drawing, *Within the Forest,* all executed in a more realistic manner than he had ever adopted before, a manner which foreshadowed the full-blown realism of his maturity. While at Ornans he also made a portrait of his friend Promayet, a group painting of his three *Sisters at Flagey,* and a pencil drawing called *Girl in a Reverie* —also known by the same title as one of his self-portraits, the *Guitar Player*—depicting his sister Zélie in a sentimental mood, dreamily plucking at the instrument. But the most curious product of that autumn was a large religious picture, approximately ten feet high by five feet wide, which Courbet painted for the parish church at Saules, an upland village about four miles from Ornans. It represented *St. Nicholas Raising the Children from the Dead,* Nicholas being the patron saint of Saules. The model for the figure of the saint, richly clad in the vestments of a bishop, was Urbain Cuénot. Although painted in 1847 it was not purchased by the village authorities until January of the following year, and the artist did not receive the agreed sum—900 francs—until 1850. Subsequently the canvas was permitted to fall into a sorry state of disrepair, from which it was rescued by careful restoration in 1948. Although far from being one of his finest works it is unique in one respect: it is the only picture even remotely associated with religion that Courbet, fiercely and consistently anti-clerical all his life, ever painted except in a spirit of mockery.

Another picture painted probably in this same year, in Paris, was the portrait of *Marc Trapadoux Examining an Album of Prints.* The bearded eccentric, seated on a stool and wearing the coarse blouse of a labourer, is absorbed in attentive contemplation of the open volume on his lap. Trapadoux

was the author of two books: a biography of St. John of God, the Portuguese founder of the Brothers of Charity in the sixteenth century; and a study, published in 1861, of the great Italian actress Adelaide Ristori. In 1876 Courbet described Trapadoux as "a very studious man with a distinguished mind, learned in philosophy. . . . He came from Lyon, where he was born. . . . He believed that asceticism was a form of inebriation, helpful to the creative impulse. He wrote several remarkable articles on painting, based on trips he made to Belgium. He wrote letters to the newspapers, and returned to Paris where he died in poverty eight or nine years ago. He was an original, even eccentric, character who indulged in extraordinary physical exercises in the belief that he could thereby increase the strength of his body and of his intellect; all in all, a sincere and devout man. He was known in all the artistic circles of Paris. . . ." [17] Trapadoux frequented the famous Café Momus and was a close friend of Henry Murger, who combined in the fictional character of the philosopher Colline in *Scènes de la vie de Bohême,* published in 1848, the idiosyncrasies of Trapadoux and of another member of the group, Jean Wallon, a wealthy young provincial from Laon. According to Alexandre Schanne, himself the prototype of the musician Schaunard in the same book, Trapadoux was "tall and nervous, with unkempt hair and a bushy beard; his nose was perceptibly inclined towards the left as if disdainful of conventional symmetry. His skin was dark, the skin of an Arab. He wore a high hat with a narrow wavy brim. As to his overcoat, it had certainly once been green. . . . From that came his nickname the 'Green Giant.' Nobody ever knew whether he had a private income or some salaried employment. . . . Charles Baudelaire alone could lift a corner of the veil that shrouded his life." [18] Even Baudelaire knew little enough about the private life of the mysterious Trapadoux, though he was one of the few to be admitted to the philosopher's shabby lodging in the Boulevard du Montparnasse, a single

room containing nothing but an iron bed and heaps of dusty books. One evening Baudelaire, finding himself without enough money to hire a carriage for the long drive to his mistress's residence in surburban Neuilly, was invited by Trapadoux to share his quarters. The poet spent a restless night, during the course of which he was amazed and somewhat alarmed to see his host going through a series of violent contortions, using as dumb-bells a pair of bottles filled with buckshot.

Preparations for the next Salon kept Courbet busy during the winter. In January 1848 he wrote to his parents: "My picture is progressing rapidly, I hope to finish it for the exhibition, if it is accepted it will be most helpful and will secure me a great reputation. In any event I am on the threshold of success, for I am surrounded by people, very influential in the press and the arts, who are enthusiastic about my work. At last we are about to found a new school, of which I shall be the representative in painting." [19] Which picture Courbet referred to is not clear. He submitted seven pictures to the Salon of 1848: *Walpurgis Night,* the *Cellist* (a self-portrait), the *Sleeping Girl,* a portrait of Cuénot, and three landscapes entitled respectively *Morning, Midday,* and *Evening.* In addition he sent three drawings, the *Girl in a Reverie* and two portraits. To his astonishment all ten offerings were accepted by the judges who, influenced by the vehement protests against the wholesale rejections of the preceding year, had adopted a much more liberal standard of admission. Too liberal, in Courbet's opinion; he complained that the jury had accepted the unprecedented number of 5500 pictures, among which his own, which were not even well placed, would pass unnoticed. His fears proved unfounded; for the first time several critics reviewed his works favourably, even enthusiastically. His name was becoming known to a wider public than his own small circle of friends.

One exceptionally exuberant member of this new public

was an Englishman, Pierre (or Peter) Hawke, who over-whelmed the painter with compliments, promised to make him famous through a series of newspaper articles, and commissioned a portrait of himself. In May 1849 Hawke wrote to Courbet: "I must write to express all the affection I have for you as a loyal and good man, and all the admiration your great genius inspires in me. I need not tell you that my heart is compelled to attach itself to everything that is fine and noble, and in those respects you hold one of the first places in my esteem. . . . My portrait is considered marvellous. I have made many people jealous." [20] But Courbet could not exist on flattery alone. Many praised but few purchased; he sold none of his exhibits at the Salon, and he was forced to humiliate himself by borrowing money from his father in order to pay his debts.

REVOLUTION

BEGINNING with a local revolt in Sicily, the revolution of 1848 spread quickly throughout much of Europe. In most countries it was speedily repressed, generally with a good deal of violence and bloodshed, but in France it attained, for some months, the proportions of a minor civil war. Insurrection broke out in Paris on February 24, 1848 when a mob stormed the Chamber of Deputies and forced the proclamation of a republic. Louis-Philippe, who had started his reign eighteen years earlier as a liberal and democratic king but who had gradually degenerated into a reactionary Bourbon of the old school, promptly abdicated and fled to England. But the new republican Government that replaced the monarchy were taken over almost at once by a conservative group of politicians; the socialists and other radical elements were excluded from participation therein; and in June another violent clash resulted in the defeat of the radicals by the armed forces of the Government. This was succeeded by a period of ruthless repression; thousands of the Government's opponents were imprisoned, hundreds deported or executed. On December 10 Louis Napoleon Bonaparte, nephew of Napoleon I, was elected president of the French republic for a term of four years, re-election being

forbidden by law. Louis Napoleon's ambitions went much farther than that, but he shrewdly bided his time until December 2, 1851, when without warning he launched his famous *coup d'état*, dissolved the Assembly, and extended his own term of office ten years, thus becoming a dictator in fact if not in name. Exactly one year later, on December 2, 1852, he completed the process by assuming the title of Napoleon III, Emperor of the French.

The commencement of the revolution disturbed Courbet very slightly. Although his boyhood had been vaguely influenced by his grandfather's republican views, and although his own nature instinctively rebelled against all forms of authority imposed from above, he had not yet really been aroused to political consciousness. Shortly after the fall of the monarchy in February he informed his parents that he took very little interest in politics, which he considered futile; he was above all a painter, hence he had resumed his painting "in spite of the republic, which is not the most favourable form of government for artists, at least according to history." [1] But by June 26, just after the brutal massacre of the insurgent radicals by the Government troops, his indifference had vanished. He was sickened and horrified by the slaughter; his sympathies were now with the victims of repression, though he assured his anxious family that he had not abandoned his pacifist principles and did not intend to plunge into active combat: "This is the most distressing spectacle one could possibly imagine. I don't think anything like it has ever happened in France, not even the massacre of St. Bartholomew. . . . I shall not fight for two reasons: first, because I have no faith in war with guns and cannon, it is not consistent with my principles. For ten years I have been waging a war of the intellect. Therefore I should be untrue to myself if I acted otherwise. The second reason is that I have no arms, so cannot be tempted. Hence you have nothing to fear on my account. . . ." [2]

Courbet did in fact play a slightly more active part in the

uprising than these letters indicated. He had recently become acquainted with Charles Baudelaire, who had fought behind the barricades during the first days of the February insurrection and who, in collaboration with Champfleury and Charles Toubin, had founded a four-page radical newspaper, *Le Salut Public*. The first number appeared on February 27, 1848, only three days after the proclamation of the republic. According to Toubin, the three editors "started the paper with one hundred francs. . . . We wrote our articles at a table in the Café de la Rotonde [directly below Courbet's studio in the rue Hautefeuille] . . . and in less than an hour the paper was patched together." [3] It was then discovered that another journal with the same name had already been published, so the second issue was delayed while Courbet, at Baudelaire's request, hastily drew a vignette to be printed on the title-page in order to distinguish the Baudelaire-Champfleury-Toubin *Salut Public* from its rival. The vignette depicts a scene at the barricades: a young revolutionary in blouse and top hat stands on a heap of stones, brandishing a musket in one hand and holding in the other a tricolour flag inscribed: *"Voix de Dieu, voix du peuple."* He is haranguing a crowd armed with muskets and bayonets, but these background figures were added to Courbet's sketch by the engraver, Fauchery. This second issue of *Le Salut Public* was also the last: "The two numbers sold well, but the vendors forgot to bring back to us the proceeds of their sales." [4]

Courbet's friendship with Baudelaire was something of an anomaly, since the painter's distaste for literature included poetry and, by extension, poets. "To write verse is dishonest," he is reported to have said, "to speak differently from ordinary people is to pose as an aristocrat." [5] Baudelaire, two years younger than Courbet, was often penniless and temporarily homeless; at such times he gladly accepted the artist's offer of a makeshift pallet on the studio floor. The poet proved to be a temperamental guest, especially when under the influence of

alcohol or opium. One night Courbet was persuaded, reluctantly, to note down Baudelaire's dreams, a series of incoherent ravings and horrifying nightmare images that made the less emotional painter's flesh creep. Many references have been made to a quarrel, or at least a coolness, between the two, and it is possible that some estrangement did take place. If so, reconciliation followed in the course of time. When they met by accident at Le Havre in 1859 they were obviously on the best of terms; later that year Baudelaire was among the guests at a large party given by Courbet, who gave the poet a still-life painting, *Bouquet of Asters,* inscribed: "To my friend Baudelaire."

One reason for the quarrel, if it did indeed occur, may have been a portrait of Baudelaire (Plate 10) by Courbet, often dated 1853, but more probably painted in 1848 soon after their first meeting. The poet, wearing a brown suit, blue shirt, and yellow cravat, is reading a book propped against a table on which is an ink bottle holding a quill pen. Behind him is a pile of red cushions. The portrait is an admirable study of rapt concentration as well as, according to many of the poet's contemporaries, an excellent likeness; but for some reason Baudelaire disliked it. Courbet himself was not altogether satisfied. He found the young writer a difficult subject and complained: "I don't know how to finish Baudelaire's portrait; his face changes every day." [6] "It is true," commented Champfleury, "that Baudelaire had the ability to alter his appearance like an escaped convict seeking to evade recapture. Sometimes his hair would hang over his collar in graceful perfumed ringlets; the next day his bare scalp would have a bluish tint owing to the barber's razor. One morning he would appear smiling with a large bouquet in his hand . . . two days later, with hanging head and bent shoulders, he might have been taken for a Carthusian friar digging his own grave." [7]

In addition to his contribution to the *Salut Public,* Courbet proposed to enter a competition for a projected allegorical

painting of the *Republic* which was to supersede a portrait of the dethroned Louis-Philippe, but he soon abandoned the idea. Instead he called on Daumier and urged him to compete, and in due course Daumier submitted his sketch but was not awarded the prize. Courbet wrote: "I have not competed for the picture of the *Republic* . . . but on the other hand I shall enter the competition for popular songs which is open to musicians." [8] It is most unlikely that he carried out this naïve intention, though he continued to cling stubbornly to the illusion that he had in him the makings of a great musician.

The reaction following the sanguinary revolt of June 1848 placed Max Buchon, who had made no secret of his democratic and humanitarian principles, in a very dangerous position. He retired to his home at Salins, where for a short time he was left in peace; but he was soon tracked down and arrested by the local police. According to Courbet's account in a letter to Castagnary, written immediately after Buchon's death in 1869, Buchon spent a year in prison awaiting trial and was then "conducted, with a chain round his neck, between two gendarmes on horseback, from Besançon to Lons-le-Saulnier to be tried. He travelled twenty leagues [about fifty miles] on foot under these conditions. . . . After December 2 [1851] Napoleon III went after him again. A warrant for his arrest was issued, he was hunted like a wild beast. During this time he hid in a secret place under the floor, where he remained a long time; then he escaped disguised as a plasterer. He hid in the house of a poor old man, a bachelor, in the neighbourhood; then one fine night he took refuge with me [at Flagey or Ornans]; he spent two days concealed in our house. My mother had had trapdoors cut to provide hiding-places for us. In his attempt to run away Buchon had fallen into the jaws of the wolf, since a warrant for my arrest had also been issued. . . . We decided to escape, he to Switzerland, I to Paris under a false name. His father died while all this was happening. . . .

Buchon spent eight or nine years in exile at Berne. . . . His small fortune diminished day by day after his father's death, and [eventually] his friends had him brought back to France, where he remained under police surveillance until his death." [9]

The accuracy of this somewhat incoherent recital is questionable. Even in his calmest moments Courbet never allowed factual precision to hamper his inclination to overstate and dramatize, and this letter was dashed off in a mood of intense emotional distraction caused by the death of his beloved friend. Moreover he was writing almost twenty years after these events had taken place, when he no longer remembered details clearly. There is no good reason, for example, to believe that a warrant for Courbet's arrest had been issued after the *coup d'état* or that he had returned to Paris under an assumed name. Nevertheless he appears to have had some cause for uneasiness. In January 1852 he wrote to Francis Wey from Ornans that his letters were being intercepted and opened, that one of the police officers at Ornans kept him under close surveillance and had denounced him at the prefecture; and he asked Wey if he could safely re-enter Paris, "for I am not anxious to be deported to Guiana at the moment; I can't say how I might feel about it later on." [10]

Much as he may have exaggerated, in retrospect, his revolutionary activities and the perilous situations in which he found himself, it is undeniable that Courbet's interest in politics and sociology developed rapidly during the troubled years between 1848 and 1852. In February 1848 he had been politically apathetic, suspicious of the republic; by June he had definitely, though still passively, become a partisan of the persecuted rebels; in 1851 he was clearly identified, by himself as well as by some of his friends and almost all of his enemies, with the socialist movement. In February 1851 Cuénot wrote to Juliette Courbet that in various Parisian salons the gossips were saying that her brother "is a terrible socialist, that he is the leader of

a band of conspirators. This, they add, is obvious in his painting. The man is a savage. . . . And every day some fresh nonsense is babbled concerning your brother." [11] In November of the same year Courbet himself announced defiantly that he was "not only a socialist, but also a democrat and a republican, in short a partisan of the entire revolution, and above all a realist, that is a sincere friend of the real truth." [12]

It is reasonably certain that Courbet would never have wandered by himself into the political and sociological arena. He was a painter and only a painter, not a thinker or philosopher or dialectician; and even as a painter his work was almost wholly instinctive. "M. Courbet," commented Théodore Duret, "produces pictures in almost the same manner as a tree bears fruit." [13] Some outside influence was needed to draw this naïve untutored artist into an intellectual struggle he was never able to understand, a foreign field which ultimately became a bog in which he floundered, hopelessly out of his depth.

A little of this influence may have been contributed by Buchon, but the chief impetus came from a much more aggressive friend, Pierre-Joseph Proudhon. Born at Besançon on January 15, 1809, the son of poor parents, Proudhon attended the college in his native town until, at the age of nineteen, he was obliged to interrupt his academic education in order to earn a living as typesetter and proofreader for a local printing house. This employment gave him opportunities for the study of theology and classical languages, and in 1838 the award of a scholarship enabled him to obtain a bachelor's degree. He then went to Paris, where in 1840 he published a brochure entitled *Qu'est-ce que la propriété?* in which he answered his own question with the emphatic declaration: *"La propriété, c'est le vol"* (property is theft). This was followed in 1842 by *Avertissement aux propriétaires,* which was considered so subversive that its author was arrested and tried before the court of assizes at Besançon, but acquitted. In June 1848 he was elected

a deputy under the republican Government, in which he took an active part although none of the measures he proposed for the reform of taxation and banking was adopted.

Victor Hugo described Proudhon in the act of addressing the Assembly on July 31, 1848 as "a man of about forty-five [he was actually thirty-nine], blond, with scanty hair and abundant whiskers. He wore a black tail-coat and waistcoat. . . . His voice had a vulgar intonation, his enunciation was common and guttural, and he wore spectacles." [14] In March 1849, after the conservative wing of the Government had firmly established itself in power, Proudhon was incarcerated, first in the prison of Sainte-Pélagie and later in the Conciergerie; but he continued to write brochures and to edit radical journals until he was released in June 1852.

Proudhon's socialism was based on the highest ideals of universal equality, justice, and liberty, a humanitarian doctrine designed to put an end to the oppression and exploitation of the poor. He was not in agreement with most of the theories expounded in the *Communist Manifesto* of Karl Marx. He expected that a long period of transition would elapse before his utopian society could be established and he hoped that the evolution would take place through compromise and education rather than by violence. He was a superb dialectician but, like most zealots, somewhat narrow-minded and self-righteous. His moral code was rigid, his personal life irreproachable. A devoted husband and an affectionate father, Proudhon was at the same time a strict disciplinarian in his own household. In 1855 he gently scolded Nicolle, one of his fellow prisoners in Sainte-Pélagie in 1849, for sending gifts to his young children: "No more presents, if you please. They create bad habits, and I want to teach my daughters that they, like their father, must owe everything to themselves and nothing to the generosity and courtesy of others. . . . Take this warning literally, or we shall quarrel." [15]

Proudhon and Courbet probably met for the first time in

1848, and the older man's influence began to exert itself almost at once. They had in common, to begin with, the same Franc-Comtois background, and Courbet was always predisposed in favour of natives of his own province. But there was more to their friendship than a mere accident of geography. "The talents of Courbet and of Proudhon," wrote the critic Théophile Thoré in 1866, "are not unlike; both exhibit unusually forceful characters and audacious sincerity to such an extent that they appear to seek out deliberately anything that will offend sensitive tastes. Through their horror of banality they seem to plunge wantonly into coarse uncouthnesses. Yet both . . . have exquisite delicacy. There are pages by Proudhon which are airy, flowing, witty, with that silvery flame one finds only in Voltaire and Diderot. There are paintings by Courbet with a quality of tone that recalls Velázquez, Metsu, Watteau, Reynolds, and the most refined colourists." [16]

Although Proudhon influenced Courbet profoundly, introduced him to members of dissident political groups, and supplied many of his sociological ideas, it is not true, as some of Courbet's apologists have maintained, that the painter was a mere dupe of Proudhon and his socialist colleagues who made use of his prestige, already considerable in the field of art, to further their own political aims. There is no evidence to indicate that the motives of these radicals with respect to Courbet's participation were deliberately selfish or sinister. Moreover there was no need for trickery; his reaction to the initial impulse from outside was immediate and, in his own confused way, consistent. Fundamentally Courbet was led astray, not by the cajoleries of his associates, but by his own spectacular conceit. Just as he had claimed, with little warrant though harmlessly enough, to be an expert in music, so did he assume the rôles of politician and social philosopher with even less justification and far greater risk of disaster. It is obvious to anyone today, as it was to many of his contemporaries, that Courbet would have been infinitely better off had he understood his

55

own limitations, had he realized that he possessed but a single talent, had he done nothing but paint, had he never meddled in politics at all. But it is also obvious that if he had been prudent and logical, modest and wise, he would not have been Gustave Courbet.

BRASSERIE ANDLER

COURBET began to frequent the Brasserie Andler about 1848, and for more than fifteen years this unpretentious establishment served him as restaurant, bar, club, and forum. When in Paris he lunched or dined there, almost daily at first, afterwards less often. Its location at 28 rue Hautefeuille, only two doors from his studio, made it a most convenient rendezvous for the painter and his friends, many of whom lived in the same quarter. Schanne remembered the brasserie as "very modest in appearance, a real village tavern. . . . The proprietor was Swiss by birth [according to other sources Mme Andler was Swiss and her husband Bavarian], and the pronunciation of our language always remained a mystery to him. Moreover he was slow-witted, and if he understood our jokes it was only after a week of meditation." [1] The food was simple, hearty, Teutonic, and conspicuously displayed. "Hams hanging from the ceiling," wrote Champfleury, "garlands of sausages, cheeses as big as mill-wheels, barrels of savoury sauerkraut seemed to belong in a monastic refectory. . . ." [2]

Castagnary described his first appearance at the brasserie about 1860: "A room shaped like a tunnel, long and dark, with no furniture except wooden tables and benches on which the

patrons sat back to back. It was run in the German fashion: beer, sauerkraut, ham. A centre aisle was kept open for service, which was adequately attended to by M. Andler . . . Mme Andler, whose rotund figure was ill adapted to walking, and [their niece] Mlle Louise, a young woman blonde and mild as beer. . . . At the back a billiard table which was shared amicably. On one side a bright cheerful room lighted by a skylight like a studio. It was completely filled by an immense table of unpainted wood. There meals were served to the habitués, there took place the philosophical, æsthetic, and literary discussions, intermingled with paradoxes, laughter, and epigrams. The repast took a long time. Courbet ate slowly in the manner of peasants and cattle. We talked of a thousand things. As soon as he realized that I did not expect him to speak of nothing but painting, he relaxed, became gay and charming. After the meal pipes were lighted, coffee was drunk. . . . Realism may have been born in Courbet's mind in his studio . . . but the brasserie held it over the baptismal font. It was at the brasserie that he established contact with the outside world. From six to eleven in the evening we ate, argued, coined witticisms, laughed, and played billiards. Courbet held court. The brasserie was merely an extension of his studio. People who were eager to see him came there. . . . Courbet held forth on all the arts, all the sciences, even those he knew nothing about. . . . Great was the number of Parisians who were attracted to this manger where, they were told, a new god had been born. . . . The fame of the brasserie spread, its praises were sung in prose and poetry." [3]

Conversation at Courbet's table was rarely serious and never solemn. Courbet's sense of humour was keen, his hearty laughter explosive and contagious. His laugh, Castagnary reported, "started like a rising rocket. Hearing wheezes mingled with popping noises, one would look at Courbet who seemed to be having convulsions; he wriggled, stamped on the floor, lowered and raised his head while his stomach heaved and shook vio-

lently. As soon as he had quieted down and appeared to have stopped laughing, off it would go again as if he were gurgling into his beard. Certain fireworks throw off similar showers of sparks. Finally after several alternations of silence and noise he would subside, and calm would return. The fit would have lasted two or three minutes." [4]

Thursday was the most popular day at Andler's, though the tables were well filled all through the week. The élite group that assembled more or less regularly round the large table presided over by Courbet included a few men already well known, many more who were to become so. Among them were the painters François Bonvin, who had piloted Courbet on so many sightseeing tours through the Louvre; Camille Corot, older than most of the habitués and already famous; Honoré Daumier; Alexandre-Gabriel Decamps; François-Louis Français; Amand Gautier; Jean Gigoux, a native of Besançon. There were also the sculptor Barye and the musicians Promayet and Schanne, as well as a number of writers: Baudelaire; Max Buchon during the year or two preceding his flight and self-imposed exile; Champfleury; Fernand Desnoyers, future author of the pantomime *Le Bras noir;* Duranty, afterwards editor of the periodical *Réalisme:* Emile Montégut, who translated Shakespeare into French; the art critics Gustave Planche and Théophile Silvestre; Proudhon; Jules Vallès, socialist author and journalist, and, after 1860, Jules-Antoine Castagnary, art critic and journalist, author of many articles on Courbet and of an unfinished biography of the painter.

A sketch by Courbet of the interior of the Brasserie Andler served to illustrate the *Histoire anecdotique des cafés et cabarets de Paris* by Alfred Delvau, published in 1862. Much more important was Courbet's portrait of Mme Andler, known as *La Mère Grégoire* (Plate 28), painted about 1855. The plump proprietress, dressed in black with white embroidered collar and cuffs, is seated behind the brasserie's marble-topped counter, on which are a vase of flowers, a few coins, and a large

flat book, presumably the ledger containing the accounts of her patrons. One hand rests on the ledger, the other holds a single flower. It is a rich, ripe portrait of a preposterously fat but strong and vigorous woman. Although Silvestre protested that the sitter's "hideousness makes one forget the witches and the dwarfs which the most brutal painters have sometimes introduced into their compositions for the sake of contrast," [5] the majority of critics found the portrait admirable, and some considered the triple-chinned *Mère Grégoire* worthy of comparison with the buxom figures painted by Rubens.

After a dozen or so years of prosperity the vogue of the Brasserie Andler gradually declined. Several causes contributed to its loss of prestige: Andler obstinately refused to follow the lead of more progressive establishments by installing a pump for beer, and a puritanical streak in Mme Andler offended the younger clients who, when they brought their mistresses to the brasserie, "had to endure the blaze of the wrathful glares of the proprietress." [6] Many of the habitués were lured away by Mme Andler's popular niece, Louise—"Luisse" in her aunt's Swiss accent—who, after her marriage to a man named Schaller, opened a rival restaurant round the corner in the rue de l'Ecole-de-Médecine. Others, including Courbet, drifted to a nearby brasserie run by *père* Laveur at 6 rue des Poitevins. The Brasserie Andler received its *coup de grâce* about 1866, when the Boulevard Saint-Germain was extended through that ancient quarter and the building that housed the restaurant was demolished.

Occasionally Courbet joined a group of friends for a convivial evening at the Brasserie des Martyrs in the rue des Martyrs on the lower slopes of Montmartre. Unlike the unadorned and simply furnished taverns on the left bank, the Brasserie des Martyrs was ornately decorated with mirrors, painted panels, gilt mouldings, and garish chandeliers. The clientele was different too, comprising not only the disciples

of realism but followers of all the other current Parisian "isms" as well. Whereas Courbet had been the unchallenged monarch at Andler's and Laveur's, at the Martyrs he was only one of a number of conspicuous figures. Among the least conspicuous was young, shy Claude Monet, who had come to Paris from Le Havre in 1859 and who gaped at Courbet in the crowded brasserie without daring to speak to him at that time.

The ledger introduced so incidentally into the portrait of *Mère Grégoire* caused Courbet a great deal of trouble some years later. About 1864 a vigorous disagreement with Andler over unpaid bills put an end to sixteen years of mutual good will. Courbet was often generous but never extravagant; there was in him enough of the peasant to give him a keen sense of the value of a penny, and even after he had outlived the lean years of his youth and was earning a substantial income from the sale of his pictures he did not throw money away. But he was also enough of a bohemian to be careless about daily expenditures, especially if they did not involve immediate payments in cash; he was quite willing to let an account run for years without troubling to check the individual items or to ascertain the total amount.

Just when Andler began to press Courbet for settlement of an unpaid account covering some eight years is uncertain, but evidently some correspondence on the subject must have been exchanged prior to Andler's letter to Courbet dated January 17, 1865: "In your letter you accuse me of appearing before you in the guise of a dangerous and formidable man. I do not believe I deserve such a reproach. . . . I feel no resentment whatever towards you, not even an account of certain people you have brought to my brasserie. . . . Still I am giving you one more proof of my good will by asking you now to settle only your own account. I shall wait until the next exhibition [at the Salon, which was to open in May], which will, I hope,

furnish a favourable opportunity for the pleasure of seeing you. In any event, if you find it possible to send me some money before then, do not fail to do so. . . ." [7]

This was a conciliatory, almost an obsequious letter, the letter of a humble publican to his most distinguished patron. Andler had no desire to offend the principal magnet that had formerly drawn clients to his brasserie. Courbet's reply, if he condescended to write one, has disappeared. In September 1865 Andler wrote another polite note: "Having already called on you several times without having . . . found you in, I hope that before you leave [Paris] you will kindly favour me with a welcome visit and that you will meet me at either lunch or dinner. . . ." [8]

We do not know whether Courbet accepted or refused this invitation, whether he put Andler off with promises or simply chose to ignore the whole matter. From time to time, over the years, he handed over small sums on account; but a considerable balance remained unpaid, and after another long wait Andler brought suit. Courbet turned the case over to his friend and legal representative, Gustave Chaudey, who had been closely associated with Proudhon for many years and who, as an outspoken liberal, had been imprisoned and temporarily exiled after the revolution of 1848. In July 1868 Courbet wrote to Chaudey: 'I have a number of remarks to make about this bill, which fixes the total of my account at Andler's from 1855 to October 1863. . . . The total . . . comes to 7153 francs 35 centimes, from which Andler has deducted for payments on account the sum of 3500 francs, which leaves me in his debt for the amount of 3553 [*sic*] francs 35 centimes. I knew I owed Andler something but I had no idea it was such a large sum; I am really justified in questioning his figures. . . . I went to Andler's for a long time; in a way it was my home. I can even claim to have contributed not a little to the vogue of this establishment; I . . . allowed everything to be charged . . . without ever verifying anything, and when I paid him something

I never thought of asking for a receipt. I am in no position to-day to contest the amount of the bill and I do not intend to do so. Let us admit that I have paid only 3500, but am I not justified in demanding information concerning my total expenditure? Several of my good friends have told me that whenever I sat at one of the tables . . . it was known at the cashier's counter as M. Courbet's table, and everything ordered there . . . was put on my bill. . . . Very often, I admit, I had friends lunching or dining with me, but while it is quite fair that I should pay for my guests, I do not see why I should be expected to buy free meals for everybody or to be held responsible now for the bills of all the unidentified clients in my vicinity. . . . I must insist upon the production of his books so that I may examine my account in some detail. I shall be greatly surprised if, after this examination, I do not reach the conclusion that I do not owe Andler more than 1500 or 1800 francs." [9]

In December 1868 Chaudey wrote to Courbet, who was then at Ornans: "As to the Andler case, I have been able to have it postponed until now. I have been handed a ledger containing an itemized list, day by day, detail by detail, of all the refreshments for which payment is demanded from you. . . . Being incompetent to question it in detail without you, I shall be unable to do more than challenge the total. . . . The case will not come up again until January." [10] On April 16, 1869 Chaudey announced the final decision: "The verdict takes into consideration all of the arguments I presented. . . . It recognizes that . . . you might sometimes have been charged for refreshments consumed by others, for which you were not responsible. But taking into account the great length of time the debt has been due and the non-payment of interest for eight or ten years, the verdict has reduced Andler's bill only from 3553 francs to 3000. . . . I think we shall have to be satisfied with that." [11]

ACHIEVEMENT

THE YEAR 1849 marked the beginning of Courbet's mature period. The preparatory stage was over; now he knew precisely the kind of pictures he wanted to paint and had acquired the technical ability to execute them. Almost overnight he found himself famous, or at least notorious. Thenceforth his work held the attention of the critics, who wrote innumerable articles, some praising him to the skies, more condemning him to the nethermost reaches of the artistic inferno, but for the most part striking some note of modified commendation or disparagement between the two extremes. The rest of his life was passed in a glare of publicity which, even when unfavourable, gratified his vanity. In the press an extraordinary amount of space was devoted to him and to his work; the most celebrated caricaturists of the day— Cham, Nadar, André Gill, Daumier, and many others—were kept busy drawing clever and often malicious travesties of his pictures, his physiognomy, and his more conspicuous mannerisms; he was gossiped about in Parisian salons, quarrelled over on café terraces, burlesqued on the stage.

Between the end of 1848 and the middle of 1850 Courbet produced, in addition to a number of minor paintings, four

64

of his largest, finest, and most memorable pictures: *After Dinner at Ornans* (Plate 11); the *Stone Breakers* (Plate 12); *Burial at Ornans* (Plate 13); and *Peasants of Flagey Returning from the Fair,* more commonly entitled *Return from the Fair* (Plate 14).

After Dinner at Ornans was almost certainly sketched in and partially completed during one of Courbet's sojourns at Ornans prior to 1849, but apparently the final touches were added in Paris. Francis Wey remembered having seen it, unfinished, when he first visited Courbet's studio late in 1848. Wey was a novelist and philologist, born at Besançon in 1812. His friend Champfleury, having recently discovered Courbet and wishing to share his enthusiasm for the young painter, brought Wey to the rue Hautefeuille, where he was received by "a tall young man with superb eyes, but very thin, pale, yellow, bony . . . who greeted me with a nod without uttering a word. He resumed his place at his easel which supported a canvas [*After Dinner at Ornans*]. . . . 'With such a rare and wonderful talent,' I said . . . 'why are you not yet famous? Nobody has ever painted that way!' 'That's right,' he replied with a provincial Franc-Comtois accent, 'I paint like *le bon Dieu.'* " [1]

The picture represents a group in front of the immense fireplace in the kitchen of the Courbet house at Ornans. The table has been cleared of all remnants of the repast except a dish of fruit, three bottles of wine, and four partly filled tumblers. At the left the painter's father dozes in his chair; across the table sits Courbet himself; next comes Adolphe Marlet, seen from the back, lighting his pipe with a brand from the glowing hearth; on the right sits Alphonse Promayet playing the violin. Under Marlet's chair a large bulldog sleeps peacefully. The room is filled with the shadows of evening, and the relaxed attitudes of the listeners, replete after a hearty meal, indicate placid enjoyment of the music.

Courbet used his father, Marlet, and Promayet as models in

other group pictures, and he also painted a second portrait of the musician alone, probably in 1851 (Plate 16). Promayet had come to Paris from Ornans about the same time as Courbet, and like the painter he frequently revisited his home town. In Paris he earned a meagre living as a violinist in the orchestras of the Cirque de l'Impératrice, the Jardin d'Hiver, and the Hippodrome. He remained poverty-stricken and obscure in spite of all the efforts made by Courbet, who "tried to find employment for him and exerted himself to persuade the Parisians to share his own enthusiasm for him, without success. The excessive touchiness of the musician was one of the causes of his failure to achieve recognition." [2] Whenever he was unemployed and consequently destitute, Promayet took refuge in Courbet's studio in the rue Hautefeuille, sleeping in a hammock behind a screen. He repaid the painter's hospitality with "all the devotion one could demand from a member of the canine family. . . . Would one believe that Courbet gave him music lessons? . . . Every morning he forced Promayet to practise as he swayed in his hammock, insisting that this training would enable him to play with greater facility when he was quietly and comfortably seated." [3]

The Salon of 1849, which opened on June 15, differed refreshingly from most of its predecessors. By way of experiment the jury was chosen, not by the tradition-bound Académie des Beaux-Arts, but by the exhibiting artists themselves. Among the twelve jurors selected were Paul Delaroche, Alexandre-Gabriel Decamps, Eugène Delacroix, Horace Vernet, Jean-Auguste-Dominique Ingres, Robert-Fleury, Eugène Isabey, Ernest Meissonier, and Camille Corot. Courbet sent seven pictures, all of which were accepted. Four were landscapes: *Grape-picking at Ornans, Valley of the Loue from the Roche du Mont,* the *Château of Saint-Denis* near the village of Scey-en-Varais, and *Communal Pasture at Chassagne.* The other canvases were *Marc Trapadoux Examining an Album of Prints;* a self-portrait which may have been the *Portrait of the*

Painter, a Study from the Venetians—better known as the *Man with the Leather Belt*—depicting Courbet in a slightly affected pose, his cheek resting on his hand, and wearing a belted smock; and *After Dinner at Ornans.*

After Dinner at Ornans created something of a sensation. Practically every critic mentioned it, and while a few objected to the unprecedented dimensions of what was after all a genre painting—the figures were almost life-sized, whereas traditionally such interior scenes were executed on small canvases—the majority found much to praise and little to denounce. The judges awarded it a second gold medal—a prize of great utility, since it placed the recipient *hors concours* and ensured the obligatory acceptance of his offerings at all future Salons; obligatory, that is, in theory, though the rule was occasionally violated in practice. Official recognition promptly followed. The director of the Beaux-Arts, Charles Blanc, purchased *After Dinner at Ornans* on behalf of the French Government for 1500 francs, intending to hang it in the Luxembourg; but after reconsideration it was presented to the museum at Lille.

During the spring of 1849 Courbet often made brief excursions into the lovely countryside near Paris: to the forest of Marnes west of Sèvres, to an inn near Aulnay-sous-Bois northeast of the capital, to other simple inexpensive resorts. Among those who accompanied him at various times were Bonvin, Champfleury, Baudelaire, Promayet, Murger, and Schanne. Most if not all of these young men brought along their mistresses of the moment, who "were so frequently superseded that they have become anonymous." [4]

Early in the summer Courbet visited Francis Wey at Louveciennes near Marly-le-Roi. Although he had originally been invited to dinner only, he remained as a guest of the Wey family for about two months, returning to Paris once a week for fresh clothing. The change of scene and air were beneficial, for he had been suffering from one of those digestive ailments

which were to recur at intervals throughout his life. "He was just recovering from an attack of cholera [European cholera or enteritis] and he needed . . . to put on flesh," his host recorded. "Leaner and paler than ever, he who later grew so fat was then a pitiful object, though he had already become the most vigorous of wraiths and had acquired a good appetite. His conversation, inexhaustibly inventive and incisively earthy . . . was essentially lacking in wit, but it was spiced with such unexpected and original quips that our neighbours and friends came to dine with us out of curiosity, well aware that each time they would be treated, most affably, as if they were idiots. He redeemed everything with his good nature, he healed every wound with his explosions of merriment. He never thanked us for the hospitality he had himself solicited, and nothing seemed to us more natural. One day, when he had gone to his studio in Paris for some paraphernalia and a little linen, he told us that he had found the place full of vagabonds, his friends, who had improvised sleeping accommodations for themselves, using his own bed and all the other furniture, and were spending the nights there to avoid paying rent elsewhere. But he cut short all our indignant comments with the words: 'I left them the key for that purpose.' " [5]

At Louveciennes Courbet painted a few small landscapes as well as a portrait of Mme Wey. One afternoon he set out with Corot, who had come to lunch, to sketch in the forest of Marly. Corot had difficulty in locating a suitable spot and shifted his position several times before he settled upon a satisfactory composition. But Courbet planted himself wherever he happened to be standing: "Where I place myself," he said, "is all the same to me; any location is good as long as I have nature before my eyes." [6]

In October Courbet returned to Ornans, preceded by the news of the medal and of the acquisition of his picture by the state. He was welcomed like a conquering hero. From Besan-

çon he made the last stage of the journey on foot, escorted by a delegation of friends who had come to meet him on the road. That night, after a dinner at the Courbets' house, Promayet organized an impromptu serenade outside the windows, playing music he had composed as a setting for lyrics written by Courbet. The painter delivered a speech of acknowledgement and invited the musicians into the house, where the company drank, sang, and danced until five in the morning. "I leave you to imagine," he wrote to Wey, "how many people I had to embrace and how many compliments I had to accept all over town; it seems I have brought great honour to the town of Ornans." [7]

Courbet was eager to undertake more large pictures, but he required a more spacious studio than the family dwelling could supply. His mother had inherited from her father, who had died the year before, two houses at Ornans: the one in which Courbet was born, and another in the quarter called the Iles-Basses. This second house contained a large two-storey room in which laundry had formerly been hung to dry. The painter persuaded his father to convert this into an atelier. A big window was cut in the north side, and Courbet painted the walls greenish yellow and dark red, the window embrasures white, and the ceiling and upper fourth of the walls sky blue. On this blue background he painted swallows, traces of which are still visible, in various attitudes of flight.

The first picture painted in the new studio was the *Stone Breakers,* ten feet wide by more than seven feet high. In a letter to Wey, Courbet described the picture and recounted the circumstances that had led to its conception: "As I was driving in our carriage on the way to the château of Saint-Denis [at Scey-en-Varais] near Maisières, to paint a landscape, I stopped to watch two men breaking stones on the road, the most complete personifications of poverty. An idea for a picture came to me at once. I made an appointment with them at my studio for the next day, and since then I have been working at my

picture. . . . On one side is an old man of seventy, bent over his task, sledge-hammer poised in the air, his skin tanned by the sun, his head shaded by a straw hat; his trousers of coarse material are all patched; inside the cracked sabots, torn socks which had once been blue show his bare heels. On the other side is a young man with a dusty head and swarthy complexion; his back and arms show through the holes in his filthy tattered shirt; one leather brace holds up the remnants of his trousers, and his leather boots, covered with mud, gape dismally in several places. The old man is kneeling, the young one stands behind him holding a basket of crushed rock. Alas! In labour such as this, one's life begins that way, it ends the same way." [8] In a novel written shortly afterwards, *Biez de Serine*, Francis Wey used the phrases in Courbet's letter almost word for word to describe a pair of labourers breaking stones by a roadside.

Courbet posed his two models separately. The old man, named Gagey, had spent his entire life working on the roads near Ornans. The painting was greatly admired by the inhabitants of Ornans, some of whom, according to Proudhon, proposed to buy it and hang it over the altar in the parish church because it pointed a moral. It was Proudhon who in 1864 called Courbet the first true socialist painter and the *Stone Breakers* the first socialist picture: "Others before Courbet have attempted socialist painting and have not succeeded. That is because the desire is not enough; one must be an artist. . . . The *Stone Breakers* is a satire on our industrial civilization, which constantly invents wonderful machines to . . . perform . . . all kinds of labour . . . and yet is unable to liberate man from the most backbreaking toil. . . ." [9] But Proudhon could never see anything in a picture except a sociological tract, and there is no reason to believe that Courbet, when he conceived and executed the *Stone Breakers,* was concerned more than incidentally with the social significance of the subject. The letter to Wey indicates that, although he pitied the wretched labourers and was not unaware of the

tragedy of their hopeless, toilsome, and poverty-stricken lives, he was interested primarily in the pictorial qualities of the scene. Later, as Proudhon's influence grew stronger, Courbet adopted his friend's moralistic interpretation and in time even managed to convince himself that this conception had been his own from the beginning. In 1866, when Courbet was asked by his friend and future biographer Ideville: "Did you intend to make a social protest out of these two men bent under the inexorable compulsion of toil? I see in them, on the contrary, a poem of gentle resignation, and they inspire in me a feeling of pity," the painter replied: "But that pity . . . springs from injustice, and that is how I stirred up, not deliberately but simply by painting what I saw, what *they* [the reactionaries] call the social question." [10]

As soon as he had finished the *Stone Breakers* Courbet commenced an even more ambitious project, *Burial at Ornans,* which deserves a chapter to itself. The remainder of his sojourn at Ornans was devoted to *Return from the Fair.* At sundown the peasants wend their way home from the fair at Salins. Leading the procession are a pair of half-starved oxen purchased that day by the farmer to be fattened for the market. Next come two riders: one, Régis Courbet wearing a tall hat and holding a whip, the other a young farmhand. They are followed by two young women on foot, one leading a cow by the horns, the other carrying a basket on her head. In the distance other figures can be dimly seen. On the right, by the roadside, a countryman carrying a huge umbrella in one hand and a small keg of oil on his back is leading, or more accurately being led by, a pig tied by one leg to a cord.

"I am still working like a slave," Courbet wrote to Wey in March 1850, ". . . I have worked with perseverance and tenacity, and now I am feeling more fatigued than I should have thought possible; what tires me most is that the last fortnight has been like summer, and after such a fine winter you can

imagine how delightful it is to ramble amid the beauties of nature, especially in one's own country when one has not seen the spring for twelve years." [11]

On May 7 he opened an exhibition of his new works, *Burial at Ornans,* the *Stone Breakers,* and two landscapes—one of which may have been *Rocks at Ornan* (Plate 15) , a vigorous representation of the massive cliffs characteristic of the Franche-Comté, painted about 1850—in the concert room of the Market Hall at Besançon, placed at his disposal by the mayor without charge. Courbet placarded the hoardings with colourful announcements, and the venture (a daring one at the time, when one-man shows were almost unheard of even in Paris) proved successful in spite of the admission fee of fifty centimes. He had decided to charge admission, he told Wey, because the townsfolk of Ornans had considered him an imbecile when, earlier that spring, he had admitted them free of charge to a similar exhibition in the seminary chapel at Ornans, "which proves that it is silly to have a kind heart, for it merely deprives one of funds without enriching others in either spirit or purse. In order to be free, people want to pay, so that their judgements will not be warped by gratitude; they are right. I wish to learn, and therefore I shall be so grasping that I shall give everyone the right to tell me the most cruel truths." [12] This was not altogether sincere; when, as often happened, he did hear or read "cruel truths" he resented them bitterly.

In connection with the show at Besançon Courbet wrote to Max Buchon: "There is no retouching to be done; I must admit I do not go in much for retouching. . . ." [13] Yet he did alter a number of his pictures, sometimes painting out figures and adjuncts, sometimes adding new ones. "I have repainted my *Return from the Fair,*" he informed Alfred Bruyas during the winter of 1853–1854, "which lacked many things and in which there was an error in perspective; I have also enlarged it by one fourth." [14] The new strip was added on the right side,

and on this Courbet painted the countryman with the umbrella, not a part of the original composition. The picture measured, after enlargement, seven feet in height by nine in breadth.

An exhibition of the same pictures at Dijon in July failed to duplicate the success at Besançon. By midsummer of 1850 the political situation throughout France, unsettled since 1848, had reached another crisis. Government troops were billeted in the public buildings so that Courbet was unable to obtain a suitable hall and was obliged to rent, for ten francs a day, a room in a building occupied on the ground floor by a café. Dijon was divided into two factions, and because the café belonged to a member of the radical group no Government partisan would enter the building; whereas the insurgents were apparently too busy, too indifferent, or too poor to attend in sufficient numbers to pay Courbet's expenses. Pocketing his losses, he closed the exhibition and went to Paris early in August.

Because of the political turmoil the Salon did not open until December 30, 1850, and was then made to serve for 1851 as well. Notwithstanding his fatigue, Courbet went to work as soon as he arrived in Paris on a portrait of the "apostle" Jean Journet, a personage even more eccentric than Marc Trapadoux. Born at Carcassonne in 1799, Journet fled to Spain in 1819 to escape punishment for his revolutionary activities, but soon returned to set up a pharmacy in the town of Limoux near his birthplace. After his marriage he adopted the social philosophy of Charles Fourier and for the rest of his life assiduously spread throughout France and Belgium the gospel of the brotherhood of man, preaching with fanatical fervour and encountering all sorts of fantastic adventures. In March 1841 he startled the fashionable audience during a performance of Meyerbeer's *Robert le Diable* at the Paris Opéra by showering the auditorium with Fourierist leaflets, for which

he was imprisoned for a brief term. His moral code was puritanical, his chastity unassailable. One night at the Café Momus, Murger and Champfleury, to amuse themselves, persuaded one of the more seductive sirens to test Journet's powers of resistance by sitting on his lap; but virtue triumphed, for the evangelist unceremoniously dumped the temptress onto the floor and fled headlong from the den of iniquity.

A lithograph by Courbet of the same subject, probably executed in the same year, is better known than the original painting. The bearded "apostle," clad like a pilgrim in a heavy coat tied with a cord, carrying over one shoulder a small pouch containing clothing and over the other a huge sack crammed with pamphlets, and holding in one hand a staff and a broad-brimmed hat, strides majestically along a country road on his evangelical mission. Surrounding the lithograph are verses lamenting various evils, to the eradication of which Journet had dedicated his life. The first verse begins:

> Ah! In this age of ignorance,
> Of madness,
> If there exists a kindly soul,
> Let him behold, let him turn pale,
> Let him tremble,
> Let him share my sadness.[15]

Courbet had painted, probably in 1848, a small portrait of Frédéric Chopin, who died in Paris on October 17, 1849. The painter and musician had been at most casual acquaintances; they may have met at the house of the sculptor Jean-Baptiste Clésinger, a native of Besançon, whom Courbet knew well and who had married Solange Dudevant, daughter of Chopin's former mistress, the novelist best known by her pseudonym George Sand. In the autumn of 1850 Courbet painted a more important picture of another composer, Hector Berlioz, who had been induced by Francis Wey to sit for the portrait (Plate 17). The lines of the face are stern, almost

harsh; the lips are thin, the cheeks sunken; the nose is sharp, the eyes are cavernous under heavy brows; the severity of expression is accentuated by the high collar and black stock. The sittings were painful ordeals to Berlioz, for in the presence of a musician Courbet's naïve musical pretensions burgeoned, with disastrous results. Wey recorded that Courbet "had fallen into the habit of singing songs in such a way that the words did not rhyme and the lines . . . had no rhythm. It was the vilest and most incoherent prose that a shepherd could have invented. He took it into his head, as he painted, to squawk these formless melodies to Hector Berlioz. At first the latter thought he was being deliberately made a fool of; perceiving that such was not the case . . . he decided that the painter was an idiot; and as he understood absolutely nothing about painting he allowed himself to be persuaded by his second wife [actually at that time his mistress; Berlioz did not marry the singer Marie Recio until after the death of his first wife in 1854] that the portrait was worthless, that she knew more about such things than I [Wey] because she had drawn little landscapes in pencil and miniature portraits, so finically dainty, so painstakingly slick! . . . In the end these foolish people refused the picture which had been presented to them as a gift." [16]

Courbet offered the portrait to Wey, whose admiration was sincere but whose scruples forbade him to accept the valuable present, and it was finally given to the painter Paul-Joseph Chenavard. The portrait so disdainfully rejected by Berlioz, one of the finest Courbet ever produced, now hangs in the Louvre. As a token of appreciation for Wey's many kindnesses and to console him for the Berlioz fiasco, for which Wey felt in a measure responsible, Courbet painted the writer's portrait to match the one he had already executed of Mme Wey.

The deferred Salon of 1850–1851 had two juries: one for admissions, elected by the exhibiting artists; the other to distribute the awards, composed of thirteen elected members and

seventeen appointed by the minister of the Interior. Courbet, now *hors concours,* sent nine pictures which were all accepted: two landscapes, *Ruins of the Château at Scey-en-Varais* and *Banks of the Loue on the Maisières Road;* the portraits of Journet, Berlioz, and Wey, as well as the *Man with the Pipe;* and the three large new pictures, *Return from the Fair,* the *Stone Breakers,* and *Burial at Ornans.*

BURIAL AT ORNANS

GRANDFATHER OUDOT, to whom Courbet had been especially devoted, died at Ornans at the age of eighty-one in 1848, one year after his wife's death. His grandfather's funeral may have suggested to Courbet the painting of *Burial at Ornans,* though he did not begin actual work on it until late in 1849.

This immense canvas, now in the Louvre, contains more than forty life-sized figures, all faithful portraits of Courbet's fellow townsfolk. The old man at the extreme left is the painter's deceased grandfather, adapted from the portrait painted about 1844. Next come the four bearers of the pall-covered coffin, turning their faces (a gruesome touch of realism) from the decomposing corpse; from left to right they are *père* Crevot, Alphonse Promayet, Etienne Nodier, and Alphonse Bon. Just above Bon's wide-brimmed black hat can be seen the profile of Max Buchon, and in front of him the sacristan Cauchi, whose head almost conceals the face of an unidentified spectator. Behind the two choir-boys stands the vine-grower Colart bearing the cross. The curé, Bonnet, clad in black and silver funeral vestments, reads the prayers for the dead, and directly above the book is the surpliced figure of Alphonse Promayet's father, the organist. The two beadles in red robes

77

trimmed with black velvet, wearing curious flaring hats, also red, are the shoemaker Pierre Clément, adorned with a nose as grotesque as the famed proboscis of Cyrano de Bergerac, and the vine-grower Muselier. In front of them Cassard the grave-digger, in shirt-sleeves, kneels by the open grave, on the far side of which lies a skull disinterred from some previous burial.

The models for the central group of mourners were Sage, wearing a tall hat, just to the right of the beadles; the mayor's deputy Tony Marlet, standing in front of his older brother Adolphe whom Courbet had painted in *After Dinner at Ornans;* Bertin, weeping into his handkerchief, and behind him Régis Courbet in a high hat. In the foreground are the notary and deputy justice of the peace Proudhon, Pierre-Joseph's cousin, his formal attire and his prominent position in the centre of the picture suggesting that he is the chief mourner; the corpulent mayor of Ornans, Prosper Teste de Sagey; and two aged veterans of the revolution of 1793, Cardet and Secrétan, in their outmoded eighteenth-century costumes.

The right side of the picture is occupied by the mourning women, standing apart from the men as was the custom but slightly overlapping the central group. In the back row to the right of the mayor is Joséphine Bocquin, wearing a dark hood and using a handkerchief to dry her tears; one of the women in the large white bonnets is the mother of Alphonse Promayet; at the extreme right in the second row is Courbet's mother, holding by the hand the little daughter of the mayor. To the right of the old veterans and just back of the hound are the painter's three sisters: Juliette on the left, holding a handkerchief to her mouth, Zoé in the middle, with her face entirely hidden by her handkerchief, and Zélie in profile on the right. The other women are not specifically identified, but they are known to include Célestine Garmont, Félicité Bon, and the wife of the old stone breaker Gagey. In the background are the cliffs, so characteristic of the region, of the Roche du

78

Château and the Roche du Mont, silhouetted against a threatening grey sky. The prevailing tone of the entire picture is dark and sombre; the areas of white in the foreground and the deep red of the beadles' robes stand out in sharp contrast to the unrelieved black of the garments of all the women and most of the men.

The practical difficulties involved in the execution of so huge a painting almost drove Courbet frantic. The picture measured more than eleven feet in height by twenty-three in length; his new studio was only sixteen inches longer than the canvas and about fourteen feet wide, so that while working he was never able to view the picture as a whole from a suitable distance. This handicap may account for a certain lack of depth in the composition, which has a two-dimensional flatness, a friezelike quality that prompted the American painter Mary Cassatt to exclaim, when she first saw the long rows of grieving women: "Why, it's Greek!" [1] In this cramped room no space was available for group sittings, and Courbet was obliged to summon his models one by one to pose for what became in effect a series of individual portraits. It was not difficult to persuade the townsfolk to pose, as Courbet wrote to Champfleury: "Here models are to be had for the asking, everyone wants to appear in the *Burial*; I shall never be able to satisfy them all, I shall make plenty of enemies. Those who have already posed are the mayor who weighs 400, the curé, the justice of the peace, the cross-bearer, the notary, Marlet the deputy, my friends, my father, the choir-boys, the grave-digger, two veterans . . . a hound, the corpse and the coffin-bearers, the beadles (one of the beadles has a nose like a cherry, but five inches long and thick in proportion) , my sisters, other women, etc. I had hoped to omit the two precentors of the parish, but it was impossible; I was informed that they felt slighted because they were the only ecclesiastical functionaries I had not 'taken.' They complained bitterly, saying they had never done me any harm and did not deserve such an affront,

etc. Only a madman could work under the conditions I must put up with, I am groping *blindly,* I have no room to step back [from the canvas]. Shall I never be installed as I should be? At present I am just about to finish fifty life-sized figures with a background of landscape and sky. . . . It is enough to kill one. . . ." [2]

Courbet's offerings at the Salon of 1850–1851 were accorded a mixed reception by the critics. Of the nine works exhibited, only the *Man with the Pipe* met with general approval. The landscapes were for the most part ignored; the portraits of Wey, Berlioz, and Journet were condemned by most of the journalists, acclaimed by a few; the three large paintings were attacked from every conceivable angle. To most of the critics the peasants in *Return from the Fair,* the grimy labourers in the *Stone Breakers,* the bourgeois functionaries, citizens, and wrinkled old women in *Burial at Ornans* seemed unpardonably mean and ugly, an insult to the lofty traditions of art. The *Burial,* the largest picture and hence the most conspicuous, became the target for the most savage onslaughts: the composition was deemed faulty, the perspective distorted, the colour murky, the figure-drawing poor; the beadles were no better than irreverent caricatures; the representation of common people, especially in such numbers and on so large a scale, was undignified, subversive, and socialistic.

A few courageous defenders attempted to stem the tide of recrimination, but their efforts had little effect. Champfleury protested indignantly: "There is not a trace of socialism in *Burial at Ornans.* . . . Woe to artists who try to teach by their works. . . . They may appeal to the passions of the mob for five minutes; but they express matters of but momentary interest. . . . Fortunately M. Courbet has not tried to prove anything by his *Burial.* It represents the death of a citizen who is escorted to his last resting-place by other citizens. . . . It has pleased the painter to show us the domestic life of a small

town. . . . As to the alleged ugliness of the Ornans towns-
people, there is nothing exaggerated about it; it is the ugliness
of the provinces, which must be differentiated from the ugli-
ness of Paris." [3]

Early in September 1851 Courbet accepted an invitation
from Clément Laurier, a young barrister, to spend a week or
two at his country house near Le Blanc in the department of
Indre. Several other guests, including Courbet's friend the poet
Pierre Dupont, joined the party. During this sojourn, accord-
ing to the biographer Ideville, occurred an amusing incident
which, if true, throws some light on the curious combination
of peasant miserliness and bohemian generosity in Courbet's
character. Laurier had recently inherited this estate from his
wealthy and eccentric father, who habitually secreted coins
and banknotes in various parts of the house, whence, after the
old gentleman's death, they were unearthed from time to time
by the old housekeeper, Brigitte, and handed over to her em-
ployer. One day Dupont asked Courbet for a loan of fifteen
francs, which the painter, declaring that he had brought no
money with him, refused. Shortly afterwards Courbet showed
signs of extreme agitation and, without explanation, suddenly
announced his intention to return to Paris at once. The mys-
tery was cleared up when Laurier, examining a hoard of gold
coins, wrapped in a sock, which Brigitte had ferreted out and
brought to him, found among the coins the gold medal
awarded to Courbet at the Salon of 1849, and realized that this
particular sock and its contents had been hidden, not by his
deceased father, but by his present guest. The painter had just
discovered his loss but had been ashamed to mention it be-
cause he had told Dupont that he had no money; but when
Laurier, with only a slight twinkle in his eye, handed him his
sock, Courbet was so delighted that he cancelled his departure,
forgave Brigitte's prying fingers, made Dupont a present of

the fifteen francs he had previously declined to lend, and in a genial mood invited the poet to accompany him to Le Blanc for a celebration.

Soon afterwards Courbet proceeded to Brussels, stopping on the way to inspect his *After Dinner at Ornans* which had just been hung in the museum at Lille. The *Stone Breakers* and the self-portrait known as the *Cellist* were on exhibition in Brussels, where they were praised by the Belgian critics and studied attentively by some of the younger Belgian painters, upon whom they exerted a considerable influence. From Brussels he may have gone to Munich, where some of his other works were being shown. By November 1851 he was back at Ornans.

This time there was no triumphal procession, no welcoming serenade. The Parisian diatribes against *Burial at Ornans* had ruffled the feelings of the townspeople, and many of those who had so eagerly flocked to Courbet's studio to have their portraits "taken" now accused the painter of having deliberately and maliciously made them grotesque, and thus exposed them to the ridicule and insults of the critics. The ecclesiastics complained of irreverence to the church, the municipal authorities of disrespect for the dignity of their offices, the women of aspersions upon their comeliness. To the general resentment was added a certain amount of disapproval of Courbet's well-known republican principles; it must have been during this winter, after the *coup d'état* of December 2, that Courbet aided Buchon to escape to Switzerland and may have believed himself in danger of arrest.

None of this prevented him from beginning another large picture, but this time he prudently chose all but one of his models from within his own family. The setting of *Young Women of the Village* (Plate 20) is an upland pasture near Ornans, watered by a winding brook and encircled by an irregular wall of cliffs. In the centre are the painter's three sisters: Zoé on the right, wearing a large beribboned hat; Juliette

in the middle, shading her fair complexion with a parasol;
Zélie on the left, extracting from the basket she is carrying a
sweetmeat which she is offering to a bashful, barefooted little
girl. The child is in charge of two cows grazing placidly in the
pasture, while behind Zoé a shaggy, bushy-tailed dog stands on
the alert to keep the cattle from straying. Although this pic-
ture, intended for exhibition at the Salon of 1852, must have
been painted in midwinter between November 1851 and the
following February, the bright sunlight, green grass, full-
grown foliage of the bushes and stunted trees, cloudless blue
sky, and light frocks of the women are all obvious indications
of a warm summer day. There was nothing incongruous in
this transposition of the seasons, for while Courbet often
painted at least parts of his pictures out of doors he evidently
did not do so in this instance. He simply copied the cows from
one of his earlier canvases, probably adapted the landscape
from a sketch or combination of sketches, and posed the hu-
man models in his studio. Light in tone, cheerful in concep-
tion, this pastoral scene presents a striking contrast to the dark
and mournful *Burial*. That this contrast was intentional is
proved by a letter to Champfleury: "It is difficult for me to
describe to you what I have done this year for the Salon. . . .
You will judge better than I when you see my picture; I have
put my critics off the track, I have shifted them to new ground;
I have done something charming; all they have said about me
heretofore will have no bearing on this. . . ." [4]

The Salon opened on April 1, 1852. That year only one
jury, composed of seven members elected by the artists and
seven appointed by the director general of Museums, passed
on both admissions and awards. Courbet exhibited *Young
Women of the Village, Banks of the Loue,* and the portrait of
Urbain Cuénot which had been rejected at the Salon of 1847.
If he had really expected to disarm his critics with his sunny
pastoral he was soon undeceived. The chorus of disapproval,
though neither as strident nor as nearly unanimous as the out-

cry that had greeted the *Burial,* was loud and exuberant. The young women were frowned upon as vulgar, the cattle as wooden, and even the painting of the rocks, which in fact was almost photographic in its fidelity to nature, was labelled preposterous by Gustave Planche, who had never visited the Franche-Comté.

During the summer of 1851, before his journey to Belgium, Courbet had started to work on a large painting for which the idea is said to have been suggested by Proudhon: *Departure of the Fire Brigade,* depicting a detachment of Parisian firemen setting out at night to extinguish a conflagration. It is a lively scene: curious householders wakened by the din lean out of windows while in the street the uniformed firemen with their engines, followed by a crowd of excited spectators, race towards the distant flames. The picture was painted or at least begun in a building occupied by the fire department, placed at Courbet's disposal by the obliging officer in charge who, to provide the painter with realistic documentation, once went so far as to turn in a false alarm for his benefit. But the *coup d'état* put an end to all such favours, and the picture was never finished.

On September 6, 1852 Champfleury wrote to Max Buchon, then in exile at Berne: "I have been to see Courbet, who was about to go to Dieppe for a few days. . . ." [5] This journey to Dieppe may possibly have been connected with what appears to have been the only serious love affair in Courbet's life, an attachment which, while it may not in itself have been notably romantic, was much more significant in its consequences than any of his casual relationships with his models. Unfortunately little is known about the life and death of Courbet's illegitimate son, and even the few reports that have been published, long after the event, are vague and contradictory. In some instances there seems to have been a deliberate attempt to suppress the details. In 1886 Champfleury refused to permit one of the painter's biographers, Estignard, to consult the letters

written to him by Courbet, on the ground that they "contain nothing that would be useful in a history of the painter and his works; they might cause pain to worthy people." [6] Although numerous extracts from Courbet's correspondence with Champfleury were published in 1906 by Georges Riat, there is only a brief reference to this episode. All of the available information, contradictory as it is, may be summed up as follows:

Dr Paul Collin, who attended Courbet during the last week of his fatal illness, wrote a long letter to Camille Lemonnier a few hours after the painter's death in 1877. The source of the physician's statement concerning Courbet's son was Cherubino Pata, who had known Courbet only a few years and who may or may not have heard the story from Courbet himself: "A lady came to sit for her portrait at the young painter's studio. He was then twenty-eight years old [which would have been in 1847]. Love soon followed, and one day the lady fell on her knees before Courbet and begged to be allowed to remain with him, saying: 'I have left my husband and now I want to belong only to you.' They lived together, and a child was born of the union. After the husband died, I am told, Courbet acknowledged the child. . . . He loved the boy with overflowing tenderness, and when he lost him, eight months after the death of the woman who had given him birth, he was overcome with grief. . . . The young man had chosen literature as a profession; he had published several articles that were well thought of. Oddly enough, Courbet apparently never painted a portrait of this beloved son." [7]

Gros-Kost, least trustworthy of Courbet's biographers, published in 1880 a somewhat different version ridiculing the notion that the unintellectual painter could have sired an author: "He [Courbet] had a son who died at the age of twenty. This illegitimate son could not be made legitimate by law. . . . Since he could not give the boy his name he tried to transmit his talent to him. He taught him to paint. The young

man worked so hard that one day his proud father told some friends: 'There is nothing more that I can teach him.' According to Dr Colin [sic] . . . this son was a distinguished writer. That is an error. A writer! His father would almost have disowned him. He might have had to read the boy's works! " [8]

Much more reliable is the testimony of Castagnary, who actually saw the lad: "The truth is that this son, whom I have seen and who bore little resemblance to his father, was a carver of ivory at Dieppe and had never followed any other profession. He died there before he was twenty years old." [9] Castagnary did not meet Courbet until about 1860, so this indicates that the painter must have kept in touch with his son throughout at least a major portion of the boy's short life. It also provides a basis for the suggestion that Courbet's visit to Dieppe in September 1852 may have been inspired by a desire to see his ex-mistress and the baby. Another tenuous link between Courbet, Dieppe, and ivory was Paul Ansout, the son of a cloth merchant at Dieppe, whose portrait Courbet had painted in Paris in 1844. Ansout's uncle, Louis Belletete, who died in 1832, had been an ivory-worker at Dieppe, and it may have been through Ansout's family connection with this highly specialized craft that Courbet's son was accepted as an apprentice by one of Belletete's successors.

Riat states that while Courbet was at Ornans during the winter of 1851–1852 he received a letter from Champfleury informing him that his (Courbet's) mistress had left Paris and had taken the child with her, to which the painter replied philosophically: "May life be kind to her, since she thinks she is making the right decision. I shall miss my little boy very much, but art gives me enough to do without burdening myself with a household; moreover, to my mind a married man is a reactionary." [10]

One more scrap of documentary evidence is contained in a letter written in 1883 to an unnamed correspondent by Lydie Jolicler, whom Courbet had known well for many years and to

whom he had always confided his most intimate secrets. In November 1872, during one of his not infrequent sojourns at the Jolicler house at Pontarlier, he painted a portrait of his host. As he worked he chatted with Mme Jolicler, who recorded that "when we were alone he talked to me about his son, whom he had loved so dearly and whom he had just lost, at the age of twenty; a fine lad." [11]

All of this boils down to very little that can be accepted as indisputable fact, but the century-old mystery may have been solved by researches undertaken in the spring of 1951 by M. Guillouet, conservator of the Dieppe museum, at the suggestion of Robert Fernier, president of Les Amis de Gustave Courbet. In the municipal registers of Dieppe, M. Guillouet discovered one entry—and one only—that may apply to Courbet's son: the record of the death at Dieppe on July 5, 1872, of a certain Désiré-Alfred-Emile Binet, a carver of ivory, born on September 15, 1847. He was the son of Thérèse-Adelaïde-Virginie Binet, *unmarried,* who was born at Dieppe on April 18, 1808 and who died there on May 7, 1865. The name of the boy's father is not mentioned. Désiré Binet was married on August 17, 1868 to Juliette-Léonie Blard, born at Dieppe, the daughter of Joseph-Noël Blard, a rope-maker of that city.

There is only one discrepancy between this official record and Castagnary's account: Désiré Binet was almost twenty-five when he died, whereas Courbet's son is said to have died before he was twenty. All other circumstances of Binet's life— his residence in Dieppe, his profession, his illegitimacy, and the date of his death—correspond so closely to Castagnary's brief outline of the career of Courbet's son that the identity of the two young men must be considered highly probable, though not absolutely certain.

REALISM

In the history of art almost all of the important "movements" seem to have followed much the same pattern or sequence of development. The first of these progressive stages is revolt against some aspect of the immediately preceding tradition which has become in the course of time obsolete or degenerate; next a period of struggle against the opposition and ridicule of the adherents of the expiring school; then acceptance by the critics and the general public; and finally, to complete the cycle, decadence and once more supersession by some newer and more vigorous movement. There are no sharp lines between these successive stages; each merges imperceptibly into the next with much overlapping, and the duration of the entire cycle as well as of each phase thereof varies greatly according to circumstances; but the basic pattern is repeated century after century.

The movement known as realism, of which Courbet was the acknowledged leader in the field of painting, is difficult to define; its precise meaning was never agreed upon even by its creators. It was in fact not a single idea but a combination of several diverse though related concepts: rebellion against classicism on one hand and romanticism on the other; a de-

termination to express contemporary life, the realities of existence, with particular emphasis on the common everyday activities of the proletariat and the petty bourgeoisie which had previously been considered unworthy of representation; a reaction against pomposity, elegance, sentimentality, and mere prettiness. Courbet himself attempted to define realism in 1861: "The basis of realism is negation of the ideal, a negation towards which my studies have led me for fifteen years and which no artist has dared to affirm categorically until now. . . . *Burial at Ornans* was in reality the burial of romanticism and left nothing of that school of painting except what was an expression of the human spirit and therefore had a right to live; that is, the works of Delacroix and [Théodore] Rousseau. . . . Romantic art, like that of the classical school, was art for art's sake. Today, in accordance with the most recent developments in philosophy, one is obliged to reason even in art, and never to permit sentiment to overthrow logic. Reason should be man's ruling principle in everything. My form of art is the final one because it is the only one which, so far, has combined all of these elements. Through my affirmation of the negation of the ideal and all that springs from the ideal I have arrived at the emancipation of the individual and finally at democracy. Realism is essentially the democratic art." [1] As was to have been expected from Courbet, this was a confused and confusing analysis; in spite of his insistence on the merits of logic, rationalization was not one of his strong points; and the smug assertion that realism was the "final" form of art was typical of Courbet but none the less absurd.

By 1850 the two dominant schools of painting, classical and romantic, had begun to degenerate: the first into rigid pedantic formalism, the second into exotic flamboyance. Although the partisans of the two schools opposed each other violently they had one characteristic in common: both habitually selected subjects remote in time or distance from contemporary life in France. The classicists specialized in incidents

drawn from mythology or in heroic occurrences in Greek and Roman history, the romanticists in scenes of mediæval chivalry or Oriental splendour replete with armoured knights, ferocious Moors, and seductive odalisques. In 1838 Thackeray noted that at the Ecole des Beaux-Arts the subjects "are almost all what are called classical: Orestes pursued by every variety of Furies; numbers of little wolf-sucking Romuluses; Hectors and Andromaches in a complication of parting embraces. . . ." [2]

It is true that realism was not invented in France in the middle of the nineteenth century. It had a long line of eminent forerunners: in sixteenth-century Italy Caravaggio, rebelling against the current tradition of ideal beauty, had founded a school of naturalism; in Spain Ribera, Velázquez, and Goya had painted scenes of everyday life; Dutch and Flemish masters had produced innumerable genre pictures of homely interiors and middle-class family groups; and in France certain pictures often classified as romantic, such as the *Plague Victims of Jaffa* by Gros, painted in 1804, and Géricault's *Raft of the Medusa,* exhibited in 1819, were in a sense realistic compositions.

The term "naturalism" has sometimes been used in place of "realism," and many attempts have been made to differentiate between them. "Naturalism," wrote Lemonnier in 1878, "is realism broadened by the profound study of society and keen observation of character. Naturalism presumes a philosophy that is lacking in realism. . . . Naturalism in art is the examination of character through style, of social position through character, of life as a whole through social position; it proceeds from the individual to the type and from unity to collectivity. . . . Millet was a perfect naturalist . . . emancipated from the realism from which Courbet failed to emerge." [3] Today few critics trouble to split hairs over such distinctions, and the terms have become practically synonymous.

. . .

Courbet was one of the most important painters of the nineteenth century for three reasons: firstly because he destroyed, almost single-handed, the domination of the decadent classical and romantic schools and proclaimed, loudly and insistently, the merits, as subjects for painting, of the toilworn workers of the fields and villages, the poor but sturdy mountaineers among whom he had lived and whom he understood; secondly because he transmitted to his successors, the impressionists, a vital influence without which they could not have developed as they did develop; thirdly because he was, without reference to subject, a truly creative artist who has enriched the world with a tangible and permanent legacy of beauty. The social content of his pictures, so important to himself, is of little consequence today; the beauty remains. In fact most of the works he considered his masterpieces — the *Stone Breakers, Burial at Ornans,* the *Atelier,* and similar "significant" paintings of enormous size—appear after the lapse of a century to be inferior in some respects to many of his more modest, less controversial productions: landscapes, seascapes, hunting scenes, portraits, still lifes, nudes.

Within the relatively limited range of Courbet's palette his colours, even when darkened by age, grime, and the deteriorating effects of bituminous pigment, still glow with a subdued brilliance. His composition, except in a few of his most ambitious and crowded pictures, is almost invariably successful. His drawing, though undistinguished in black and white, is generally faultless when overlaid with paint. He was a passionate lover of natural beauty in all its forms, and his representations of trees and cliffs, ocean waves and mountain streams, have never been surpassed. Courbet was neither a spiritual nor a highly imaginative painter because he was neither a spiritual nor a highly imaginative man; but his shortcomings in these respects were at least partially redeemed, until degeneration set in a few years before he died, by his in-

corruptible honesty, both in art and in life. His painting, like his character, overflowed with vitality. His failures as a man and as an artist stemmed chiefly from his inability to recognize his own limitations. Not content with the work in which he excelled, he persistently (and sometimes disastrously) reached for more than his temperament permitted him to grasp.

The movement headed by Courbet consisted almost wholly in a substitution of commonplace contemporary subjects for the grandiose artificialities of the established schools. It was not a technical revolution; Courbet invented no new methods of applying pigment, no novel theories of colour and light. The only technical innovation he introduced, an unprecedentedly lavish use of the palette knife, was not sufficiently radical or conspicuous to be noted by the general public. He painted in a relatively low key, using traditional colours in a traditional way. Courbet was an exceptionally adroit craftsman, a true virtuoso, but except on rare occasions his integrity as an artist prevented him from sacrificing solidity and depth to mere facility. He would often ponder for months over the idea for a picture before tracing the first outline on canvas, but once he began to paint he worked swiftly and without hesitation. This rapidity enabled him to produce an enormous number of pictures; in thirty-five years he painted almost two thousand canvases.

Gregarious by nature, Courbet was never disturbed by the presence of spectators. Indeed he rather enjoyed "showing off" in public, and when he had an audience he would talk, laugh, and sing without interrupting his work for a moment. He painted in broad strokes, using any implement that suited his purpose: a brush, a palette knife, a rag, even his own thumb.

Courbet's revolution was a one-man revolution; what he accomplished, he accomplished alone. Whereas the impressionists, at least during the early years of their struggle for recog-

nition, worked together, held joint exhibitions, and knew each other intimately, Courbet painted as an individual, never as a member of a group. He was not only the founder and leader of the realist movement; he was quite literally *the* realist, the sole first-rate realist painter of his time. Few artists of Courbet's own era adopted his theories, and none of those who did follow his lead could compare with him in stature; they were imitators, not equal partners. Although Courbet was casually acquainted with most of his distinguished contemporaries in the world of art, he had no really close friends among them. For this his overweening conceit may have been partly responsible; he could not tolerate or even admit the existence of a living rival in his own field. Many of his colleagues who sincerely admired him as an artist disagreed with him politically; others were repelled by what they considered his blatant exhibitionism.

The only contemporary group in France with which Courbet had anything in common was that of the Barbizon painters: Camille Corot, François Millet, Théodore Rousseau, Narcisse Diaz, Charles-François Daubigny, and half a dozen others. These were, or believed themselves to be, realists; like Courbet, they abandoned history and mythology to paint trees and fields, farm animals and humble peasants. But the differences between their treatment of proletarian scenes and Courbet's approach to similar subjects were as great as the differences between the placid meadows and groves of the forest of Fontainebleau and the rugged cliffs of the Franche-Comté. Although Millet, for example, was born a peasant several degrees below Courbet in the social scale, he developed into a studious, contemplative man, an attentive reader of Virgil and the Bible, who observed his reapers and gleaners through literary spectacles and idealized them in his paintings. Millet's proletarian figures were pious, resigned, and spiritual; Courbet's were earthy, independent, and uncouth.

. . .

Courbet's influence on the painters of the next generation was much more powerful than on his own contemporaries. By replacing the pretentious litter of gods and goddesses, swaggering knights and simpering damsels, haughty sheikhs and indolent houris with sturdy townsfolk and flesh-and-blood peasants; by painting trees and meadows, rocks and villages just as he saw them, without idealistic or romantic trimmings; by perceiving and insisting upon the beauty of common objects and ordinary people, he paved the way for the impressionists, who like himself painted simple contemporary subjects uncontaminated by literary or historical allusions. It is not too much to say that without Courbet impressionism would never have come into existence. In a way impressionism did not supplant realism; it merely carried realism a step farther. For the impressionists sought and found a more precise realism in the representation of light than the so-called realists themselves had ever thought of looking for, and in that direction at least the impressionists succeeded in imitating nature much more closely and scientifically than their predecessors.

Unlike Courbet, the impressionists did actually produce a technical revolution in painting. Preceded by Edouard Manet, who daringly violated the accepted conventions by juxtaposing areas of light colour without any intervening expanses of darker tones and semitones, and who furthermore attempted to reproduce the effects of reflected sunlight by painting shadows blue or green instead of a conventional brown or black, the impressionists flouted one tradition after another in their efforts to portray on canvas the brilliance of sunlight and the intensity of natural colour. Abandoning their dusky studios, they ventured out of doors, set up their easels in fields and woods, and painted the surface effects of summer sun and winter mist on foliage, flowers, haystacks, ponds, villages, and cathedrals, as well as peasants at work, young people on picnics, and bustling traffic in grey city streets. To obtain the desired

intensity the impressionists evolved a new technique: instead of mixing the pigments on their palettes they brushed onto their canvases tiny dots and strokes of pure color which, when viewed from a certain distance, became blended by the eye of the observer to produce on the retina an effect of extraordinary intensity.

Thus the works of the impressionists were distinguishable at a glance from those of other painters; they looked like nothing that had ever been painted before, whereas Courbet's pictures differed only in subject from the productions of his more conservative colleagues. For this reason the critical denunciations and sneers directed at Courbet, violent and prejudiced as they were, never approached in virulence the abuse flung at the young impressionists. Although Courbet had many enemies and detractors he also had able and articulate defenders; during a period of twenty-five years his pictures were exhibited at almost every Salon; and after about 1850 he was able to sell much of his output at reasonably high prices. But the unfortunate impressionists, once they had begun in earnest to develop their characteristic method of painting, could count on very few influential friends, were consistently rejected at the Salon, and were rarely able to find purchasers who would pay as much as two or three hundred francs for one of their pictures.

Even in a technical sense some of Courbet's landscapes, and especially his marines, did foreshadow, if only to a limited extent, the experiments of the younger school. Like the impressionists, Courbet painted out of doors; but whereas the impressionists painted their landscapes in the open air from start to finish, Courbet usually completed his in the dimmer light of his studio. His juxtaposition of semitonal areas contained the germ from which sprang Manet's bolder use of the same device, which in turn led to the impressionist treatment of reflected light and surface colour. The early works of Manet, Pissarro, Monet, Renoir, and Cézanne exhibit numerous unmistakable traces of Courbet's influence, and all of these paint-

ers freely acknowledged their debt to the realist leader. "People forget," Pissarro wrote to his son in 1895, "that Cézanne was first influenced by Delacroix, Courbet, Manet and even [Alphonse] Legros, like all of us. . . ." [4] Until Cézanne was thirty years old, when he adopted the impressionist techniques, his paintings, dark in tone and trowelled with the palette knife, bore a striking resemblance to Courbet's works; and in his later years, after he broke away from the impressionists, Cézanne reverted in some measure to the three-dimensional solidity characteristic of Courbet.

Courbet himself failed to recognize his affiliation with the embryonic impressionists, and his appreciation of the work of the younger men was far from enthusiastic. He is reported, perhaps apocryphally, to have urged his sister Juliette to visit an exhibition of Manet's paintings but to have refused to go himself: "I prefer not to meet that young man, who has a sympathetic personality, works hard, and is striving to succeed. I should be obliged to tell him that I do not understand his pictures at all, and I don't want to hurt his feelings." [5]

It must be remembered that Courbet probably saw few of the early productions of the impressionists and could have seen none of their maturer works. He left Paris for the last time in 1872, two years before the first impressionist exhibition. His only personal acquaintance among the future leaders of the new school was Claude Monet, whom he liked as a man and approved of, with faintly amused condescension, as an artist; but at that time Monet had scarcely begun to experiment with unconventional techniques. What Courbet would have thought of the impressionists had he lived longer and had more opportunities to become familiar with their fully developed works can only be surmised, but it is unlikely that he would have found to his taste these light and airy pictures, so radically different from his own darker and more solid compositions.

• • •

Courbet's description of realism as "essentially the democratic art" was literally true, for in the middle of the nineteenth century the connection between French art and French politics was exceptionally close. The social upheaval that followed the revolution of 1848 split the nation into factions; almost all of the artists and writers who joined the revolt against the traditional schools were also in more or less open rebellion against the reactionary Government, while most of their severest critics supported the conservative régime. "It was the *coup d'état*," wrote Castagnary, "that forced realism into opposition. Prior to the *coup d'état* it had been merely an artistic doctrine, afterwards it became a social doctrine, the protest of republican art." [6] An extremely articulate group of liberal and radical social philosophers, led by Proudhon, proclaimed the dignity of labour and insisted that peasants and workmen were entitled to serious representation in print and on canvas. Scientific research and discoveries, especially in biology, also contributed to the destruction of outmoded standards; even before the publication of Darwin's *Origin of Species* in 1859 the concept of man as a creature of earth rather than of heaven had gained considerable headway and tended to sweep away artificial class distinctions.

The realistic movement in painting had its counterpart in the other arts: sculptors, composers, poets, dramatists, and especially novelists adapted the general principles of realism to their respective uses. The founder of the realist school of novel-writing was Champfleury, a prolific and intelligent but uninspired writer whose works are seldom read today and whose authority soon passed into the more talented hands of Gustave Flaubert, Edmond and Jules de Goncourt, and Emile Zola. Champfleury, whose real name was Jules-François-Félix Husson, was born on September 17, 1821 at Laon, where his father earned a modest living as secretary to the municipality. Champfleury came to Paris in 1838 and, after working for a year without pay as errand boy for a bookshop, went back to

Laon and found employment in a printing shop. In 1843 he returned to Paris, determined to become a writer, and supported himself as an art critic for various periodicals. His first volumes of short stories were published in 1847; thereafter he turned out novels, essays, stories, and articles in rapid succession. In middle age he married Marie Pierret, god-daughter of Delacroix, and from 1872 until his death on December 6, 1889 he held the post of conservator in the national porcelain factory at Sèvres.

Courbet and Champfleury probably met at least as early as February 1848, when Courbet drew the vignette for the *Salut Public* of which Champfleury was co-editor. It was at the Salon of 1848 that the critic first saw Courbet's pictures; he immediately became one of the painter's most ardent admirers and devoted champions. "Not enough attention has been paid this year at the Salon," he wrote, "to a great and powerful picture, the *Classic Walpurgis Night.* . . . I say here, take note of it! The unknown who painted this *Night* will become a great artist." [7] During the succeeding years Champfleury wrote a number of articles in praise of Courbet's work, though after 1855 his enthusiasm began to wane. In 1853 Courbet painted a portrait of Champfleury in profile (Plate 18) which the sitter considered far from flattering.

The realist painter and the realist writer possessed complementary talents which in combination were of great service to the cause: Courbet, the unlettered but creative artist, contributed the raw material, the tangible specimens upon which his more erudite colleague based his formulation of realist theory. Yet Champfleury, "the Courbet of literature," [8] repeatedly and earnestly disclaimed any intent or desire to proclaim a doctrine. "All those who express any new ideas are called *realists*," he wrote in 1855. ". . . M. Courbet is a realist, I am a realist; since the critics say so, I let them say it. . . . The word repels me because of its pedantic termination; I fear schools as I fear cholera, and my greatest joy is to meet strongly

individual personalities. That is why M. Courbet is, in my opinion, a modern man." [9] And in a letter to Buchon written probably in the same year: "As to *realism,* I consider the word one of the best jokes of our era. Courbet alone has made use of it with the robust faith he is fortunate enough to possess and which makes it impossible for him to doubt. For a long time my sincerity made me hesitate to use the label, for I do not believe in it. Realism is as old as the world, and there have been realists in all ages. . . ." [10]

Champfleury's distaste for labels did not prevent him from publishing a book entitled *Le Réalisme* in 1857. Max Buchon, still a refugee in Switzerland, wrote a shorter brochure, *Recueil de dissertations sur le réalisme,* published at Neuchâtel in 1856. For a year the movement received valuable support from a journal of its own, *Réalisme,* edited by Duranty and dedicated to the spread of the new gospel. The first number of the little periodical appeared on July 10, 1856, and succeeding issues were announced for publication on the fifteenth of each month; but official opposition combined with financial difficulties to cause the postponement of the second number to December 15, and the paper went out of existence after the publication of its sixth issue in April-May 1857. Realism was furthermore blessed with what would be called today a theme song, *La Soupe au fromage,* sometimes called the "*Marseillaise* of realism." Max Buchon contributed the lyrics, which were set to music by Alexandre Schanne in 1855 and sung with vast enjoyment by Courbet and his companions at the Brasserie Andler. The lines, simple and unaffected as a cookbook, extolled the virtues of a regional delicacy of the Franche-Comté, cheese soup, a variety of onion soup. The first verse follows:

> The pot is on the fire,
> Put the butter in
> With a generous hand;
> And when the butter melts

Add onions and some flour,
And tend with loving care
The cheese soup!
The cheese soup! [11]

Realism and its partisans offered tempting targets to the comic dramatists, and Courbet, with his conspicuous appearance and swaggering conceit, was lampooned as mercilessly on the stage as he was caricatured in the press. In December 1852 a revue by Théodore de Banville and Philoxène Boyer, *Le Feuilleton d'Aristophane,* was presented at the Odéon. In one scene a character named Réaliste, made up to resemble Courbet, recited his creed to Aristophanes:

To paint the truth is not enough to make a realist;
One must paint ugliness! And so, sir, if you please,
Everything I draw is ugly to excess!
My painting is loathsome, and to make it quite true
I tear out all beauty as one pulls up weeds!
I love muddy colours and noses of cardboard,
I love dainty maidens with beards on their chins,
The features of scarecrows and horrible monsters,
And bunions and corns and plenty of warts!
Such is the truth![12]

Whereupon Aristophanes, scandalized, summoned a Muse whose verses in praise of beauty in art so shamed Réaliste that he fled in confusion.

Another jest at Courbet's expense appeared in *Le Royaume du calembour,* a revue by Théodore Cogniard and Louis-François Clairville which opened at the Théâtre des Variétés in December 1855. On December 10 Champfleury wrote to Buchon: "Yesterday we went to the Variétés to see a play about Courbet; there is nothing duller or sillier than these revues of the end of the year; but just the same it made us laugh." [13] Courbet, who was in Paris at the time, probably accompanied

Champfleury to the theatre. In this skit Courbet was presented in the guise of a painter named Dutoupet (*toupet* means presumption or effrontery) who had been commissioned to paint a portrait; but when the sitter arrived at his studio the realist was horrified to find that she was a beautiful young woman. Unwilling to contaminate his brushes, thitherto used only for the muddiest pigments, with the clear fresh colours appropriate to such a subject, Dutoupet dismissed her and summoned instead a sooty charcoal-burner; but when this model, thinking to please the painter, washed himself thoroughly before posing, the exasperated realist turned him away too.

Almost twenty years later this burlesque scene was paralleled in fact, according to the biographer Gros-Kost, who often preferred anecdotes to accuracy. At Ornans in 1873 Courbet proposed to paint a neighbour's calf which was covered with mud and dung; but when he prepared to start work next morning he found, to his intense disgust, that the calf had been scrubbed all over and that the farmer's wife had even ornamented its ears with pink rosettes. The tale is probably fictitious, for in the actual painting of the *Calf* the little animal is quite clean and tidy, whereas nothing would have been easier than to splash it with mud if Courbet had really wanted to portray it in a dirty condition. Courbet detested prettiness and consistently refused to idealize his subjects, but he did not carry realism to such a point of absurdity as to insist on filth.

Courbet maintained that "painting is essentially a *concrete* art which can exist only in the representation of *real* and *actual* things. . . . An *abstract* object, invisible, non-existent, does not lie within the domain of painting." [14] This narrow view was wholly consistent with his concept of realism. He dismissed as nonsense all mythological and religious subjects and ridiculed anything that suggested the supernatural. The following dialogue is said to have taken place between Courbet and one of the waiters at a brasserie during a conversation with

his drinking companions concerning religious painting. Courbet interrupted impatiently:

"Angels! Madonnas! Who has seen them? Auguste, come here. Have you ever seen an angel?"

"No, Monsieur Courbet."

"There you are! Neither have I. The first time one comes in here, don't forget to let me know." [15]

Courbet could not foresee that within less than a quarter of a century after his own death an entirely new trend in painting would appear; that, beginning with Cézanne, the pendulum would swing away from realism in the direction of symbolism and abstraction. Courbet was not sufficiently broad-minded or imaginative to realize that there could be no such thing as a definitive achievement in any art, that each movement must lead inevitably to the next, cycle after cycle. The new trend towards abstraction, combined with the intensity and brilliance of colour inherited from the impressionists, made Courbet's forthright, subdued pictures seem, for a time, curiously out of date. Fortunately the eclipse was only temporary. Realism has recovered its rightful place as a wholesome and indeed an indispensable phase in the development of art; and Courbet, after some years of relative disfavour, is now re-established in a secure position as one of the great masters of French painting. The furore over his controversial subjects has long since subsided, and today his paintings hang in the Louvre and other public galleries all over the world, as well as in many private collections, side by side and in perfect harmony with the works of his most illustrious predecessors and successors.

ALFRED BRUYAS

COURBET contributed three pictures to the Salon of 1853, which opened on May 15: the *Wrestlers,* the *Sleeping Spinner* (Plate 21), and the *Bathers* (Plate 22). The first was painted over an earlier picture, the *Walpurgis Night* which had so deeply impressed Champfleury in 1848 but which the painter himself evidently considered unworthy of preservation. The *Wrestlers* is one of Courbet's least successful works. The muscular contestants, massive and solid, are entirely out of key with the thinly painted background representing the Hippodrome des Champs-Elysées. The models were obviously posed in the dim light of a studio, whereas the outdoor scene was apparently adapted from a sketch made in bright sunshine, with little attempt to blend or harmonize the discrepant tones. The *Sleeping Spinner* must have been painted or at least sketched at Ornans, for the model was Courbet's sister Zélie wearing a flowered dress and a shawl striped in blue and white. At the left the idle spinning-wheel is still attached by a thread to the distaff which has fallen from the sleeper's hands.

The *Bathers,* one of Courbet's most celebrated pictures, was the subject of an immense amount of controversy, a target for ribald comment and hilarious caricature. It represents an

enormously heavy, solidly built woman, nude except for a
towel held loosely round her fleshy buttocks, stepping out of
a shallow pool. Her right arm is raised in greeting to another
woman, fully dressed, seated by the edge of the water. The
colours of the bather's glistening skin, her companion's gar-
ments, and the trees and shrubs in the background are fresh
and brilliant. Courbet liked full-blown women with voluptu-
ous contours, and Joséphine, the model for this nude and his
mistress of the moment, was a perfect example of his favourite
type. Joséphine was a native of the Franche-Comté, and appar-
ently the picture was commenced at Ornans; a boastful letter
from Courbet to his parents, written from Paris two days be-
fore the Salon opened, indicated that his family had already
seen the painting in an unfinished state: "My life here is a
constant turmoil, goings and comings, visits; my head is in a
whirl. My pictures were accepted by the jury a little while ago
without any opposition whatever; I was considered to be rec-
ognized by the public and beyond [the reach of] judges. At last
they have left to me the responsibility for my own works. . . .
All Paris is eager to see them and hear the sensation they will
make. I have just heard from Français that they are very well
placed. It is the *Spinner* that is most generally admired. As to
the *Bathers,* it upsets people a little, though since I left you I
have added a cloth round the haunches. The landscape in this
picture is approved of by all. About the *Wrestlers* nothing
either good or bad has been said so far. . . . I have been of-
fered 2000 francs for the *Spinner;* I did not sell it because I
hope to get at least 3000. . . . We have been very busy re-
cently having photographs made of the *Wrestlers,* the *Spinner,*
the *Bathers,* and myself. Nothing is so difficult as these proce-
dures. We had three or four photographers try to take them but
they could do nothing. My own picture is superb; when I get
the prints I shall send you some, as well as those of my paint-
ings." [1] This was Courbet's first mention of photography, then
a cumbersome, slow, and still uncertain process.

Champfleury wrote to Buchon: "I think he [Courbet] will have great success this year; in particular he has a *Spinner* which I consider a masterpiece. The *Wrestlers* will not be questioned; I shall not say the same about a certain nude woman coming out of the water. You may expect a great uproar if the picture is accepted, for opinions are heated already."[2] They became more heated as time went on. Delacroix, who saw the canvases in Courbet's studio a month before the opening of the Salon, noted in his journal: "I was amazed by the vigour and depth of his principal picture [the *Bathers*]; but what a picture! What a subject! The vulgarity of the figures would not matter; what is abominable is the vulgarity and uselessness of the idea; and moreover, if only that idea, such as it is, was clear! What do these two figures mean? . . . The landscape is extraordinarily vigorous, but Courbet has done nothing more than enlarge a sketch which was standing near the canvas; the result is that the figures were introduced later without connection with what surrounds them. This brings up the question of harmony between the accessories and the principal subject, in which most great painters are deficient. That is not Courbet's worst fault. There is also a sleeping *Spinner* which displays the same qualities of vigour as well as of imitation. The wheel, the distaff, admirable; the dress, the armchair, heavy and graceless. The two *Wrestlers* show insufficient movement and confirm his poverty of invention. The background overpowers the figures, and more than three feet of it should be lopped off all round."[3]

Most critics were even more severe: the *Wrestlers* were wooden (which was true enough), the *Spinner* needed a bath, and the nude *Bather* was disgustingly fat, a repulsive mountain of pink flesh. But Edmond About, habitually more inclined to condemn Courbet's works than to praise them, was perceptive enough to commend the sheer animal health and vigour of the huge body: "She is not so much a woman as a column of flesh, a rough-hewn tree-trunk, a solid. The artist

has handled a human figure like a still life. He has constructed this brawny mass with a power worthy of Giorgione or Tintoretto. The most surprising thing about it is that this ponderous woman of bronze, articulated in layers like a rhinoceros, has faultlessly delicate knees, ankles, and all joints in general." [4]

The day before the public opening of the Salon a private view was held for the imperial family. The elephantine proportions of the nude *Bather* so shocked Napoleon III that he struck the picture with his riding-crop. When Courbet, who detested the imperial régime, heard of the incident he is said to have commented: "If I had only foreseen this spanking I should have used a thin canvas; he would have torn a hole in it, and we should have had a splendid political lawsuit. . . ." [5] And the empress Eugénie, who had just been admiring the massive Percheron horses in Rosa Bonheur's *Horse Fair,* expressed her opinion of Courbet's nude by asking: "Is she a Percheron too?" [6]

By far the most significant event of this year in its effect on Courbet's life was his meeting with Alfred Bruyas, who became one of his closest friends and most loyal champions. Jacques-Louis-Alfred Bruyas was born on August 16, 1821 at Montpellier, the son of a wealthy and indulgent banker. As a youth he had studied painting under Matet, at that time conservator of the Musée Fabre in Montpellier, but had soon abandoned the practice of art for the more congenial occupation of collecting pictures, drawings, and bronzes. In 1846 he visited Rome, where he acquired a cultivated taste in painting. Bruyas was "slim and distinguished in appearance; there was nothing especially remarkable about his looks, but one was immediately attracted by his eyes . . . of an unusual colour . . . in which a mysterious fire seemed to glow and which caught and held one like a magnet. When he spoke . . . his voice was charming. . . ." [7] His health had always been delicate, and as he grew older the symptoms of tuberculosis

became apparent, though he lived a fairly active life and did not begin to treat himself like an invalid until he was almost fifty. Sensitive and introspective, Bruyas was inclined to visualize himself as a being not altogether of this world: a mystic, a saint, a brooding Hamlet. Yet in other moods he could be jovial enough; by no means a recluse, he was a generous host who liked to dispense lavish hospitality, and he thoroughly enjoyed and appreciated Courbet's boisterous humour and overflowing vitality; nor did his ascetic pose prevent him from keeping a mistress and begetting an illegitimate daughter.

Bruyas could well afford to spend money freely on his favourite hobby, the acquisition of portraits of himself by the most celebrated contemporary painters. During the course of several years he commissioned no fewer than sixteen of these likenesses: one each by Alexandre Cabanel, Gustave Ricard, Narcisse Diaz (subsequently destroyed), and Eugène Delacroix; two by Thomas Couture; three by Auguste Glaize; three by Courbet; and four by Octave Tassaërt. Nearly all of these show Bruyas in a pensive mood, with a long thin face, prominent bony nose, melancholy eyes, and reddish brown hair and beard. The most curious item in the collection is a small canvas representing Bruyas wearing a crown of thorns—a startling identification, verging on the neurotic, of the art collector with Christ. In 1868 Bruyas donated his entire collection of paintings, including the portraits, to the Musée Fabre, and in 1872 he presented his magnificent library of books on art to the same museum.

Bruyas first saw Courbet's pictures at the Salon of 1853 and immediately took such a fancy to them that he hastened to make the painter's acquaintance. He promptly purchased the *Bathers,* the *Sleeping Spinner,* and the earlier *Man with the Pipe,* and ordered a portrait of himself (Plate 24) which Courbet executed at once. During the next few years Bruyas bought eight more pictures by Courbet. The two friends were united by mutual trust and affection, although they saw each other

but seldom. Montpellier was a long distance from Paris; Cour-
bet went there only twice or possibly three times, while as the
collector's health slowly but steadily deteriorated his journeys
to the capital grew more and more infrequent. The gaps were
filled by a voluminous though intermittent correspondence
covering more than twenty years.

Before Bruyas left Paris he invited Courbet to visit him at
Montpellier, but the painter was unable to accept until the
following summer. After the Salon closed in the autumn of
1853 Courbet went to Ornans, whence he wrote to his new
friend a long letter demonstrating his sturdy and aggressive,
if sometimes boastful and boorish, contempt for all officialdom:

> I have neglected you shamefully, my dear friend, but
> you will forgive me when you learn that I have been work-
> ing like a slave. . . . When I arrived at Ornans I was
> obliged to go to Switzerland, to Berne and Fribourg, on
> business, which was inconvenient and forced me to delay
> work on the pictures I wanted to undertake. It annoyed
> me all the more because if I had gone to see you it would
> have taken me no longer and would have been more bene-
> ficial and pleasanter for me. I received with the greatest
> joy your letter full of affection and courage. One must
> have courage. I have burnt my boats. I have declared war
> on society. I have insulted everyone who treated me scur-
> vily. And now I am alone against society. One must con-
> quer or die. If I am beaten it will have cost them dear, I
> promise you. But I am growing more and more certain
> that I shall triumph, for there are two of us [himself and
> Bruyas] and at the present time perhaps only six or eight
> [others] that I know of, all young, all energetic workers,
> all arrived at the same conclusion by different paths. My
> friend . . . I am as certain as I am of my own existence
> that within a year we shall number a million.

I want to tell you about an incident. Before I left Paris

M. Nieuwerkerke [Alfred-Emilien, Comte de Nieuwer-kerke], director of the Beaux-Arts, invited me to luncheon in the name of the Government, and fearing that I might refuse the invitation he sent as his emissaries Chenavard and Français, both *won over* [by the Government], both *decorated*. I must say to their discredit that they played the Government's game against me. They talked me into a receptive mood and supported the director's wishes. In fact they would have been happy to see me become like themselves.

After they had earnestly begged me to be what they called a *good fellow,* we went to lunch at the Restaurant Douix in the Palais-Royal where M. de Nieuwerkerke was waiting for us. As soon as he saw me he came towards me, shook my hand and said that he was delighted I had accepted, that he wanted to be frank with me, and that he would not deny that he had come to convert me. The two others exchanged glances as if to say: 'What tactlessness! He has ruined everything.' I replied that I was already converted but that if he could make me change my view-point I asked nothing better than to be taught. He went on to say that the Government regretted I was so isolated, that I must change my ideas, put water in my wine, that everyone wished me well, that I must not be quarrelsome, and all kinds of similar nonsense. Then he concluded by telling me that the Government would like me to paint a picture in my most vigorous manner for the exposition of 1855, that I could rely on his word, and that he would require by way of conditions that I should present a sketch, and that when the picture was finished it would be submitted to a group of artists chosen by me and to a com-mittee selected by himself.

You can imagine the rage into which such a proposal threw me. I replied at once that I did not understand a word he had said, since he claimed to represent a Govern-

ment and I did not consider myself in any way a part of that Government, that I was a Government too and that I challenged his to do anything whatever for mine that I could accept. I went on to say that to me his Government seemed just like any private citizen, that if they found my pictures pleasing they were at liberty to purchase them, and that I asked only one thing, that they should grant freedom to art in their exposition and not use their budget of 300,000 francs to favour three thousand artists opposed to me. I added that I was the only judge of my own work, that I was not only a painter but also a man, that I painted not to produce art for art's sake but rather to establish my intellectual freedom, that through the study of traditional art I had finally broken away from it, and that I alone, of all contemporary French artists, had the ability to express and represent in an original manner both my personality and my social environment, etc, etc.

To this he replied: 'M. Courbet, you are very haughty!' 'I am surprised,' I told him, 'that you have only just come to realize that. Sir, I am the proudest and haughtiest man in France!' This fellow, who is perhaps the most inept I ever met in my life, looked at me in amazement. He was all the more confounded because he must have promised his masters and the Court ladies that he was going to show them how to buy a man for twenty or thirty thousand francs. He asked me again if I intended to send nothing to the exposition. I answered that I never entered competitions because I did not recognize judges, but that nevertheless I might, in a cynical spirit, send my *Burial* which was my beginning and my declaration of principles . . . but that I hoped (perhaps) to organize an exhibition of my own, as a rival to theirs, which would bring in 40,000 francs in cash which I should certainly not earn at theirs. I also reminded him that he owed me 15,000 francs for the entrance fees they [the Government] had collected

on my pictures at previous Salons, that the attendants had informed me that they had personally conducted two hundred people a day to look at my *Bathers*. To which he replied idiotically that these people had not sought out that picture in order to admire it. It was easy for me to retort by questioning the value of his personal opinion and by saying that that was not the point; that whether visitors had come to criticize or to admire, the fact remained that they [the Government] had pocketed the entrance fees and that half of the reviews in the press were devoted to my works. He went on to say that it was very unfortunate that there were people like myself in the world who were born to destroy the greatest institutions, and that I was a striking example. I laughed until I cried and assured him that the only victims would be himself and the academies. . . .

To conclude, he finally went away from the table, leaving us stranded in the middle of the restaurant. As he was going out the door I grasped his hand and said: 'Sir, I ask you to believe that we are still as friendly as ever.' Then I returned to Chenavard and Français and begged *them* to believe that they were a couple of imbeciles. After that we went out to drink beer.

Here is another remark by M. de Nieuwerkerke that I remember: 'I hope, M. Courbet,' he said, 'that you have nothing to complain of, the Government are paying enough court to you. Nobody can claim to have received as much attention as you have! Take note that it is the Government and not I who invited you to lunch today.' So I am indebted to the Government for a lunch. I wanted to pay him for it, but that suggestion made Chenavard and Français angry. . . .

I have begun five or six pictures which will probably be finished by spring. . . . I am delighted that you rely on me. I shall not fail you, be sure! Do me that honour, for

I offer as a pledge my hatred of men and of our society, a hatred which will be extinguished only when I am. It is not a question of time, therefore you are more important than I am, you possess the means I have always lacked and shall always lack. With your background, your intelligence, your courage, and your financial resources you can rescue us while we are alive and enable us to save a century of time. . . . I shall finish what I have undertaken as soon as possible and on my way back to Paris I shall visit you at Montpellier if you are still there, and if you are in Paris we shall look for a gallery together, if we decide to hold an exhibition.[8]

Obviously Courbet had enjoyed baiting the director of the Beaux-Arts. Nieuwerkerke was in fact a conscientious but narrow-minded functionary, a stubborn traditionalist, the sworn enemy of unorthodoxy in art. This letter contains the earliest known reference to Courbet's project for an exhibition of his own works to be held simultaneously with but entirely separate from the huge Exposition Universelle of 1855. He expected Bruyas to collaborate by lending pictures from his collection as well as by advancing 40,000 francs for expenses.

During the winter of 1853–1854 at Ornans Courbet produced four pictures. Three were landscapes: *Château of Ornans,* a cluster of houses on the site of a demolished mediæval castle high above the town; *Roche de Dix Heures,* a conspicuous landmark; and *Rivulet of the Puits Noir,* a shaded well-spring of which he painted numerous versions at various times. The fourth was the *Winnowers* (Plate 23), representing his sister Zoé, wearing a dress of some heavy reddish-brown material, kneeling on a white cloth and sifting grain from a large winnowing basket. At the left another young woman, dressed in grey and wearing a small cap, leans comfortably against sacks of grain as she sorts the kernels on a platter; on

the right a small boy peers inquisitively into a wooden grain bin. Bowls and baskets are scattered about the yard, which is enclosed by a wall upon which the sun throws the shadow of a vine-covered trellis.

Courbet was in no hurry to finish these canvases, for the Salon of 1854 had been cancelled to allow ample time for the preparation of an exceptionally comprehensive art exhibit at the Exposition Universelle. The painter thus had leisure for his favourite sport, hunting, and spent long days rambling with a few companions over the wintry hills in search of game. One of these excursions ended disastrously, for he had forgotten that hunting in the snow was forbidden by law. "I had gone hunting," he wrote to Bruyas, "my head was buzzing, I needed fresh air and exercise. The snow was superb. But it happened to be illegal. When I returned to our town I received a summons which caused me the loss of three days, as I had to go to Besançon to hear the indictment and avoid imprisonment. Long live Liberty! . . . I have begun two pictures which I shall finish soon: the first is the *Winnowers,* the second . . . will form part of my roadside series, a sequel to the *Stone Breakers;* it will represent a gypsy and her children." [9]

The picture of the gypsy was never completed, but fifteen years later Courbet introduced a similar group into his painting of the *Beggar's Alms.* The three days in Besançon turned out to be not entirely wasted after all, for although his out-of-season hunting cost him one hundred francs in fines, he sold a picture to a Besançon collector for four hundred. In the same letter Courbet referred again to his contemplated one-man exhibition, but now the project called for the erection of a large tent to house the paintings: "So we shall set up our artillery and proceed to the great burial [of traditional art]. You must admit the rôle of grave-digger is a congenial one, and that clearing away the dirt from all that litter of bric-à-brac will not be unpleasant! The sum of 40,000 francs is something to dream about. We shall have to lease a plot of ground from

the city of Paris opposite their big exposition. I can already see my huge tent with a single column in the centre, frame walls covered with painted canvas, the whole thing mounted on a platform; also hired guards, a man dressed in black for the ticket office, a cloakroom for canes and umbrellas on the opposite side, and two or three attendants in the gallery. I believe we shall get back our 40,000 francs (even though we are counting on nothing but hate and jealousy). Subject to change, this will be the title: EXHIBITION OF PAINTINGS BY THE ARTIST COURBET AND FROM THE BRUYAS GALLERY. This will really be something to turn Paris upside-down. It will undoubtedly be the greatest joke ever played in our time. It will cause some people to fall ill, I am sure." [10]

That winter several pictures by Courbet were exhibited in Frankfort. Courbet received reports, which he gleefully communicated to his friend Adolphe Marlet, that the paintings had created such a sensation and had given rise to such violent arguments that "at the Casino they were forced to put up a notice to this effect: 'In this club it is forbidden to mention M. Courbet's pictures.' At the house of a very rich banker who had invited a large party to dinner, each guest found tucked into his napkin a little note in which was written: 'Tonight nobody will talk about M. Courbet.' " [11]

Gorchakov, the Russian minister in Frankfort, offered to buy the *Man with the Pipe,* which Courbet was unwilling to sell since he had already promised it to Bruyas. In May, a few days before his departure for Montpellier, he wrote to Bruyas: "Yesterday my portrait [the *Man with the Pipe*] arrived from Frankfort. . . . It is not only my portrait, it is yours. I was impressed when I saw it; it is a crucial element in our solution [a term often used by Courbet, apparently meaning the triumph of realism]. It is the portrait of a fanatic, an ascetic [or æsthete; both versions appear in the published sources], a man without illusions concerning the nonsense that composed his education, one who is trying to establish himself in harmony

with his principles. I have painted many portraits of myself in my life, corresponding to the changes in my state of mind; in short I have written my autobiography. The third most recent [self-portrait] was that of a gasping and dying man [the *Wounded Man*], the second [possibly the *Man with the Leather Belt*] was the portrait of a man filled with ideals and love in the manner of Goethe, George Sand, etc. And now this one. One more remains to be done, that of the man firm in his beliefs, the free man. . . . Yes, my dear friend, I hope to achieve a unique miracle in my life, I hope to live by my art all my life without ever having deviated by a hair's breadth from my principles, without ever having lied to my conscience for a single moment, without ever having painted a picture even as big as my hand to please anybody . . . or to attract a buyer. I have always told my friends (who were amazed by my fortitude and afraid of what might happen to me) : 'Have no fear. Though I might have to search all over the world I am sure to find men who will understand me; if I find only five or six they will keep me alive, they will save me.' I am right, I am right! I have found you. It was inevitable, for it was not ourselves who met each other, it was our solutions. I am delighted that you will own my portrait. At last it has escaped from the barbarians. It is a miracle, for during a period of extreme poverty I had the courage to refuse an offer of 2000 francs for it from Napoleon, and later one from insistent dealers acting for Gorchakov." [12]

The last sentence illustrates Courbet's inveterate habit of self-glorification. In 1850 the future emperor had in fact proposed to buy the *Man with the Pipe,* but a reduction in his revenues from the state obliged him to abandon the idea. There can be little doubt that at that time Courbet would have been only too happy to sell the picture to Louis-Napoleon or any other purchaser with cash in hand. The letter continued: "Dear friend, how much trouble one has in life to keep faith with oneself! In this charming country of France, when

a man who has something to contribute finally reaches his goal, he arrives, like the Greek soldier [the runner from Marathon], *dead*. But as there is always something new under the sun . . . we shall show them [the reactionaries] an example of two individuals who do not intend to die. I beg you, dear friend, not to fret yourself any longer over such people. . . . For my part, I confess that I regard a man with curiosity as I regard a horse, a tree, any natural object, and that is all. And for a long time I have ceased to feel anger, I assure you I have recovered my tranquillity in that direction. I go a step further: they have even become of value to me, because when I study men attentively, the more I see the more different aspects I encounter, which fills me with joy, and that is what demonstrates to me the superiority of men over horses. . . . Yes, I have understood you, and you have a living proof of that in your possession: your portrait. I am ready to depart for Montpellier; I shall leave Ornans next Monday, I shall spend a day or two at Besançon, and after that I don't know how many days it will take me to reach you; when I arrive I shall do anything you wish and all that is necessary. I am impatient to go, for I am eagerly looking forward to this journey, to the meeting with you, and to the work we shall do together." [13]

This long rambling letter is an excellent example of Courbet's ineffectual struggles to express even the simplest philosophical ideas on paper. He lacked both the temperament and the vocabulary for lucid, logical exposition. His clumsy phrases probably conveyed his meaning adequately to his intimates, but whenever he found himself called upon to issue statements to the press or to communicate with the public through any printed medium he was forced to rely upon Champfleury, Castagnary, or some other professional penman to edit his slipshod compositions and in most instances to rewrite them from beginning to end.

MONTPELLIER

COURBET remained at Montpellier as Bruyas's guest from about the end of May until September of 1854. He had never before travelled so far south, and the blazing sunshine, clear atmosphere, deep blue sky, and sharply defined shadows of the Midi opened his eyes to a new appreciation of both form and colour. His palette grew lighter in key and acquired a more luminous intensity. Equally novel was the social background. The Bruyas family—Alfred, his parents, and his sister—lived in a fashion far more luxurious than any previously experienced by Courbet, whose socialist principles apparently had no perceptible effect on his naïve enjoyment of the unaccustomed amenities. His joviality made him popular with the friends of the Bruyas family, especially with those of more or less bohemian tastes who shared the painter's fondness for long evenings of talk and laughter round a café table laden with tankards of beer and carafes of local wine. In the late afternoons he would often play at *mail,* a game resembling croquet at which he soon became proficient.

The most congenial of these new friends, with the exception of Bruyas himself, was Pierre-Auguste Fajon, born in 1820. Shortly before Courbet's arrival Fajon had returned to Mont-

pellier from Paris, where he had gone with high hopes of success and fortune; but after a few weeks he found himself reduced to peddling in the streets. Garbed in the burnous and turban of an Arab, he hawked his wares, consisting chiefly of a sticky jam made of grapes and other fruits, in a hoarse monotone. Fajon's misfortunes never affected his irrepressible spirits for long, and Courbet found him a merry comrade always ready to participate in the clownish pranks and escapades invented by the painter for the amusement of himself and his friends. In Paris in 1862 Courbet painted Fajon's portrait and presented it to him. Some years later Fajon, in desperate need of money, appealed to Bruyas to help him by purchasing his only valuable possession, the treasured portrait: "It is only after I have exhausted every other available resource that I am turning to you. For the past twelve days I have been in a hopeless position. A visitor from Bordeaux informs me that my daughter is absolutely destitute. Although she and I have been on bad terms for four years, in the circumstances I cannot refuse her the assistance she asks for. So I have thought of you; this is what I propose. I shall send you my portrait painted by Courbet. You know it was always destined to be included in your collection. I think I can give it up without offending Courbet. My excuse is honourable, and moreover it will pass into your hands. I am without money, without friends, I have no winter clothes, and no restaurant will feed me on credit. You see, dear friend, my situation is critical. Only you can rescue me from this predicament. The portrait and this letter will be delivered to you at noon. I shall await your reply between two and four o'clock at the Café du Lion d'Or. Alfred, in the name of your own daughter, I beg you not to abandon me!" [1] Of course Bruyas bought the portrait and added it to his collection.

During the summer Courbet painted two more portraits of Bruyas, both somewhat smaller than the one executed in Paris the year before, as well as a self-portrait in profile known as

118

Courbet in a Striped Collar (Plate 25), and a much larger and more important picture, the *Meeting* (Plate 26), all of which were purchased by Bruyas. The *Meeting* represents Courbet's arrival at Montpellier. The painter, wearing a white shirt, blue duck trousers, and buttoned gaiters, holding in one hand a hat and in the other a long staff, and carrying on his back a heavy box of painting materials wrapped in his coat, stands in the middle of a hot dusty road. His head in profile is poised so that the dark pointed beard tilts at an impudent, even aggressive, angle. A few paces to the left is Bruyas, come to meet his guest on the road. The art patron is dressed in blue trousers and a short green jacket with striped collar and piping; he carries a cane in one hand and with the other, holding a black hat, he makes a sweeping gesture of welcome. Next to Bruyas his servant, Calas, wearing a russet tail-coat and carrying a red shawl, bows respectfully. Bruyas's dog Breton completes the group. At the far right the diligence by which Courbet has travelled is already disappearing round a turn in the road. In the background the heat has shrivelled the sparse and dusty vegetation, and the plain bakes in the torrid sunshine under an intensely blue cloudless sky.

The somewhat obsequious attitudes of Bruyas and the valet in contrast to the haughty stance of the artist, as well as the differentiation between the strong, clearly outlined shadow cast by Courbet and the indistinct shadows, almost obliterated by the shade from an unseen tree, of the other figures, gave the critics yet another opportunity to jeer at Courbet's notorious conceit. "M. Courbet has carefully emphasized all the perfections of his own person," commented Edmond About, "even his shadow is graceful and full of vigour; it displays a pair of calves such as are seldom met with in the world of shades. M. Bruyas is not so flattered; he is a bourgeois. The poor servant is humble and self-effacing as if he were helping to celebrate a mass. Neither master nor valet casts a shadow on the ground; there is no shadow except for M. Courbet; he alone

can stop the rays of the sun." [2] At the exhibition of 1855 the *Meeting* acquired two nicknames: *Bonjour, Monsieur Courbet!* and *Fortune Bowing before Genius.*

The influence of the southern climate on Courbet's palette was already apparent in the *Meeting,* painted in a higher key and a more sparkling tonality than any of his preceding works. He used the same light fresh tones for his first seascape, *Seashore at Palavas,* executed on the flat Mediterranean coast about seven miles from Montpellier. With the exception of a rock or two in the foreground and a few distant sailboats silhouetted against the horizon, this serene and sunny canvas depicts nothing but sea and sky.

Among the friends to whom Bruyas presented Courbet was François Sabatier, the wealthy proprietor of the Tour de Farges, a large château near the town of Lunel halfway between Montpellier and Nîmes. Sabatier was a poet, the translator of Lessing, Schiller, and other German writers, a disciple of Fourier, and like Bruyas a patron of the arts and benefactor to impecunious artists. His wife had been a well-known opera singer. Courbet apparently spent several days as the guest of this cultivated family, for he produced three pictures at the Tour de Farges: a view of the *Bridge of Ambrussum,* a Roman ruin spanning the river Vidourle; the *Tour de Farges,* showing vineyards and spreading pines with the long low château in the distance; and a small oval pencil drawing of Sabatier reading a newspaper which has often been erroneously identified as a portrait of Proudhon, presumably because both men wore spectacles and full beards.

Between work and play Courbet's time was so fully occupied that he neglected to write to his family, though he was habitually a most dutiful correspondent. Zoé complained to Bruyas, whom she had never met: "Forgive me for addressing myself to you. . . . There are people who regard with distaste those who are absent, my brother is one of them. Since he departed for . . . Montpellier six weeks ago we have had no news of

him. If you have seen him, be kind enough to let me know.
. . . My brother will think me very presumptuous, but I am
addressing this not to him, but to you, M. Bruyas, with my
apologies. . . ." [3]

A severe epidemic of cholera broke out at Montpellier in
the summer of 1854. Courbet was stricken suddenly during a
dinner party and suffered acutely for some time. "I stayed in
bed four or five days," he informed Buchon, "I took all sorts
of remedies and I am cured. After all, nobody dies except
those who fail to take care of themselves, and the very poor.
By this time the malady has lost a great deal of its potency and
virulence. In Montpellier about fifteen hundred people died;
now it is over, and my health is all the better because I have
lost a little weight. I had grown disgustingly fat. And my diges-
tion is better as a result of the purging. When the colic pains
begin one takes twelve drops of laudanum in a linseed enema;
that stops them almost immediately." [4] Possibly on account of
this drastic treatment a distressing after-effect remained in the
form of hæmorrhoids, which persisted intermittently for the
next twenty years.

In the same letter, written shortly before his departure from
Montpellier, Courbet announced his intention to visit Buchon
on his way back to Ornans. He also gave his friend a condensed,
cynical, and slightly bewildering account of his recent amorous
adventures, notable chiefly for their kaleidoscopic variety: "I
expect to be in Berne the 15th, the 18th, the 20th [presumably
of September] at the latest. But above all don't wait for me,
don't hold me to a definite hour. Don't worry, I shall come to
see you. Sleep on your feet, on your behind, on your head, on
both ears, but above all don't wait for me. . . . I should have
been with you already if Bruyas had not ordered another por-
trait from me. You must understand that when opportunity
knocks one must take advantage of it. . . . My love affairs
here have grown complicated. Jealousy on the part of Camélia,

a young girl from Noucy; disclosure of our relations. Rose in prison. Blanche succeeds her. The commissioner annoyed by Blanche. Blanche exiled to Cette [now called Sète]. Tears, visit to the prison, vows of love, I go to Cette. Camélia in prison, *mère* Cadet in a frenzy. *Mère* Cadet and I make love. Mina, in anguish, takes a new lover. I still have Rose. Rose wants to go to Switzerland with me, saying that I may abandon her wherever I please. My love will not stretch far enough to include a journey with a woman. Knowing there are women all over the world, I see no reason to carry one with me. Moreover there is one at Lyon who has waited for me fifteen months. As soon as I finish the portrait I shall go to Marseille. . . . Thence to Lyon, Geneva, and Berne." [5] Little is known about the patient mistress who had waited fifteen months except that Courbet painted her portrait at Lyon that autumn and entitled it the *Spanish Lady*. His casual reference to her in a letter to Bruyas was anything but romantic: " When I left you I was still suffering from the cholera. Fortunately at Lyon I met a Spanish lady of my acquaintance. She suggested a remedy that cured me completely." [6]

During the years of his self-imposed exile Buchon translated works by the German-Swiss poet Johan Peter Hebel, the Swiss novelist Jeremias Gotthelf (pseudonym of Albrecht Bitzius), and the German novelist Berthold Auerbach. He also wrote poems and a few stories and short novels, two of which, *Le Matachin* and *Le Gouffre gourmand,* were published in the *Revue des Deux Mondes* in 1854. Despite these activities Buchon was restless and unhappy; he wanted to return to France, but his applications for amnesty and a safe-conduct were repeatedly rejected. In desperation he begged Champfleury to use his influence. Champfleury replied in May 1854: "I have had some difficulty in finding anyone in a sufficiently important position to support your petition . . . but yesterday I hit upon the right man. It is Francis Wey . . . he is our president [of the Société des Gens de Lettres], and in that capacity

he is always in close contact with the ministries. He received my request cordially, and there is nothing more for you to do but write to him. Be polite to him. . . . Just explain your position, the reason for your exile, your literary works, etc. . . . He will certainly accomplish what you ask." [7]

But it was not to be as easy as that. Gentle Max Buchon could be stubborn as a mule when his integrity and principles were involved; much as he wanted to come home, he refused to ingratiate himself with the authorities or even to express himself tactfully. A few weeks later Champfleury wrote again: "Wey is displeased with you; he claims he has written to you several times . . . and that he has gone to a great deal of trouble for you, all wasted because of a rude letter from you which he turned over to M. Collet-Meygret [a functionary of the political police] and which makes it impossible for your petition to be granted. You did wrong, my friend, not to conform to diplomatic usage. . . . Urged by Wey to explain his refusal, M. Collet-Meygret said: 'Do you wish to know why we cannot grant M. Buchon what he asks? It is because we should have to send his letter to the prefect of his department, and we cannot with propriety recommend to our subordinates a letter couched in such impolite language.' " [8] Champfleury made another attempt in July: "Write to me once more the reasons for your exile, the applications you have made and to whom you made them, the character of the rejections and from whom they came, etc., etc. I may have found a way to obtain approval of what you ask." [9] Whatever this project may have been, nothing came of it, and Buchon remained safely but discontentedly in Berne for about five more years.

Courbet, though he lacked Champfleury's influence in official circles, also made some effort to facilitate his friend's return to France. The moment seemed propitious, he told Buchon late in 1855 or early in 1856: "The empress will soon give birth to a young emperor; here everyone is offering prayers; and the stock market is rising. I must tell you that I am

gambling on the Bourse. I have bought twenty-five Austrian bonds; the arrival of the new emperor ought to bring me some profit. . . . To you it will bring your release." [10] The only son of Napoleon III and Eugénie was born on March 16, 1856, but Buchon derived no benefit from the prince's birth.

In a letter to Bruyas written at Ornans in November 1854 Courbet described his recent visit to Buchon: "I found him sad as night in spite of his great literary success in Paris. I spent ten days with him in Switzerland. Switzerland is an exclusively agricultural country. That is restful; nobody takes the slightest interest in intellectual pursuits. Aside from that, from the standpoint of nature one can enjoy it immensely." [11]

THE ATELIER

In November 1854 Courbet gave Bruyas an account of his project for an enormous new picture, the *Atelier* (Plate 27), a canvas eight inches higher and only about three feet shorter than *Burial at Ornans*. Its full title was *The Painter's Atelier, a True Allegory Summarizing a Period of Seven Years in my Life as an Artist.* "I have had many trials since I left you," he wrote. "My life is so difficult that I am beginning to think my moral faculties are wearing out. Under the laughing mask you are familiar with I conceal within myself sorrow, bitterness, and a sadness that grips my heart like a vampire. In the society we live in one does not have to dig deep to find emptiness. Really there are so many fools; it is so discouraging that one hesitates to develop one's intelligence for fear of finding oneself absolutely alone. . . . When I returned to Ornans [from Berne] I went hunting for several days. That is one form of vigorous exercise I do not dislike. Then suddenly I was stricken with a frightful jaundice, so severe that I was nicknamed 'the Prince of Orange.' Just think what a fix that put me in, when I already had too little time to do what I had planned for the exposition. For a month and six days I did not leave my room. For fifteen days I ate nothing whatever. That frightened me,

and besides I have lost the paunch I used to have. In spite of everything I have succeeded in making the preliminary sketch for my picture, and now it has been entirely transferred in outline to the canvas. . . . It will be the most amazing picture one could possibly imagine. There are thirty life-sized figures. . . . I have two months and a half in which to finish it, and during that time I must go to Paris to paint nudes, so that in all I have two days per figure. You can see that I shall have no time for amusement." [1]

The project for a separate exhibition of Courbet's works had been provisionally set aside because Bruyas's father had refused to advance the 40,000 francs, and Courbet reluctantly resigned himself to participation in the great Exposition Universelle. The letter continued: "I have sent in a list of the pictures I shall show at the exposition. I shall have fourteen. I count on yours: my *Man with the Pipe* and the *Meeting*. What a pity we could not hold that exhibition of our own; it would have had a comprehensive and novel character, freed from all the old conceptions of the past. Most of the painters, it seems, are sending their entire stock. As for me, I shall send nothing previously exhibited except my *Burial* and my portrait [*Man with the Pipe*]. Now you must send me also [for incorporation in the *Atelier,* not for exhibit] my portrait in profile [*Courbet in a Striped Collar*], also yours, the two I painted at Montpellier, as well as that photograph of the nude woman I spoke to you about. She will stand behind my chair in the middle of the picture. . . . Perhaps it will incommode you to be deprived of these, but I shall keep them as short a time as possible. . . . I think the *Meeting* looks scorched and dark. This picture is very well thought of at Ornans. Tell the Sabatiers how much I like them, if you should happen to see them. Many messages also to all my acquaintances. . . . Tell them I have pleasant memories of them and of your country, and that I hope to return there some day and beat them at *mail.*

My family overwhelms you with compliments. Please convey mine to Mme Bruyas and your sister." [2]

A few days before Courbet's departure from Ornans for Paris at the end of November 1854 he wrote again to Bruyas: "I am disappointed that I shall not see you before I leave. I shall wait for you in Paris, you told me you would try to go there. I hear on all sides that I shall be the great success of the exposition, and in the newspapers they are saying that realism is triumphant. I need not tell you again how delighted my friends and I were with the charming hospitality you extended to us at Montpellier. In our affectionate relationship I should only wound you, dear friend, by paying you compliments." [3]

Between jaundice and cholera Courbet had lost so many weeks that he could not possibly complete the *Atelier* in time for delivery to the Exposition Universelle on the date specified in the rules, and he was obliged to request Nieuwerkerke to grant a postponement. The director of the Beaux-Arts evidently held no grudge on account of his recent snubbing, for he graciously conceded the favour. "At last I have obtained a delay of a fortnight," Courbet informed Bruyas, "on the plea of three months of illness. It was Français who obtained it for me. . . . I have had frames made at Ornans which I have just sent to the committee at Besançon so as to take advantage of the free transportation offered to exhibitors by the Government. . . . I have only four or five more figures to complete for the *Atelier*. . . . I had sworn that I would do it. It is done. You occupy a magnificent place in it. You are in the pose of the *Meeting* but the conception is different. You are triumphant and dominant. The painters of Besançon came to see it [the *Atelier*]. They were overcome. . . . If I have difficulties with the Government we can still carry out our great project, an exhibition of your entire collection combined with my pictures. My dear friend, I am half dead from work and worry." [4]

To Champfleury he write a more detailed description of the *Atelier:*

In spite of being on the verge of hypochondria I have undertaken an immense painting, twenty feet long by twelve high; perhaps larger than the *Burial,* which will prove to you that I am not yet dead, or realism either, for this is realism. It is the moral and physical history of my studio. . . . In it are the people who thrive on life and those who thrive on death; it is society at its best, its worst, and its average; in short it is my way of seeing society in its interests and passions; it is the people who come to my studio to be painted. . . .

The scene is laid in my studio in Paris. The picture is divided into two parts. I am in the centre, painting; on the right all the active participants, that is my friends, the workers, the art collectors. On the left the others, those whose lives are without significance: the common people, the destitute, the poor, the wealthy, the exploited, the exploiters; those who thrive on death. On the wall in the background hang the *Return from the Fair* and the *Bathers,* and [on the easel in the foreground] the picture I am working at. . . .

I shall describe the figures beginning at the extreme left. At the edge of the canvas is a Jew I saw in England as he was making his way through the swarming traffic of the London streets, reverently carrying a casket on his right arm and covering it with his left hand; he seemed to be saying: 'It is I who have the best of it'; he had an ivory complexion, a long beard, a turban, and a long black gown that trailed on the ground. Behind him is a self-satisfied curé with a red face. In front of them is a poor weather-beaten old man, a former republican veteran of '93 . . . ninety years of age, holding a wallet in his hand and dressed in old patched white linen. . . . He

is looking at a heap of cast-off garments at his feet (he is pitied by the Jew). Next come a huntsman, a farmer, an athlete, a pierrot, a pedlar of cheap textiles, a labourer's wife, a labourer, an undertaker's assistant [professional mourner], a skull on a newspaper, an Irishwoman suckling a child, a lay figure; the Irishwoman is also a souvenir of England; I saw this woman in the streets of London; her only garments were a black straw hat, a torn green dress, a ragged black shawl under which her arm held a naked baby. The textile pedlar presides over the whole group; he displays his rags to everybody, and all show the greatest interest, each in his own way. In front of him a guitar and a plumed hat occupy the foreground.

Second part: then come the canvas on my easel and myself painting, showing the Assyrian profile of my head [Courbet's profile was often described as Assyrian]. Behind my chair stands a nude female model; she is leaning against the back of my chair as she watches me paint for a moment; her clothes are on the floor in the foreground; there is a white cat near my chair. Beyond this woman is Promayet with his violin under his arm, as he is posed in the portrait he sent me; next to him are Bruyas, Cuénot, Buchon, Proudhon (I should like to see the philosopher Proudhon, who looks at things as we do; if he would sit for me I should be pleased; if you see him, ask him if I may count on him) Then comes your turn in the foreground; you are sitting on a stool with your legs crossed and a hat on your knees. Beside you, still nearer the front, is a woman of fashion, elegantly dressed, with her husband. Then at the far right, sitting on a table, is Baudelaire reading a large book; next to him is a Negro woman looking at herself very coquettishly in a mirror. At the back in the window embrasure can be seen a pair of lovers whispering to each other of love; one is seated on a hammock; above the window are voluminous dra-

peries of green cloth; against the wall are some plaster casts, a shelf holding the statue of a little girl, a lamp, and a few pots; also the backs of canvases, a screen, and nothing more except a great bare wall. . . .

The critics who attempt to judge this will have their hands full, they will have to make what they can of it. For there are people who wake up at night with a start, shouting: 'I want to judge! I must judge!' [5]

Many of the details described in Courbet's letter were altered by the time the picture was completed. On the left the heap of clothing at the veteran's feet was concealed by a new figure in the foreground, a seated poacher accompanied by his dog, introduced to balance the composition. In the centre Courbet added the figure of the boy—a little shepherd of the Franche-Comté—and transformed the painting on the easel, originally representing a miller leading his donkey to the mill, into a landscape of the banks of the Loue. On the right the sequence of friends standing in the finished picture, from left to right, was Promayet, Bruyas, Proudhon, Cuénot, Buchon. In front of Champfleury's stool a new figure of a boy sketching on the floor was added to balance the hat and guitar on the left. The Negro woman, who was almost certainly Baudelaire's mistress Jeanne Duval, was painted out, possibly at the request of the poet, who was at that time involved in an affair with another woman; but her ghostly outlines still show faintly through the overlying pigment. The background was greatly simplified; the shelf with its bric-à-brac, all but one of the plaster casts, and the hanging canvases were all eliminated; in their places only some sketchily indicated panels broke the flatness of the studio wall—a great improvement, as the picture was crowded enough without a cluttered background.

Courbet's references to his encounters with the Jew and the Irishwoman in London are extremely puzzling. No other record has been found of any sojourn in England; yet it is unlikely

that he would have invented for Champfleury's benefit a jour-
ney that had never taken place. Possibly he made a brief ex-
cursion to London in connection with his voyage to Holland
in 1847, to Belgium in 1851, or to Dieppe in 1852; no other
opportunities seem to have occurred.

The *Atelier* "may not be Courbet's masterpiece; it is at
least the keystone of his work." [6] It did in truth sum up in
graphic form his rather confused theories concerning realism.
The subtitle *Allégorie Réelle* called attention to the implicit
incompatibility between fantasy and reality, an incompatibil-
ity which Courbet attempted to deny by demonstrating that
an allegory did not have to be composed of mythological or
imaginary elements; it could be realistic, with figures drawn
from contemporary life and dressed in everyday garments. The
attempt was only partially successful: the relationship among
the generalized symbolic figures on the left, the realistic por-
traits of actual people on the right, and the half symbolic, half
realistic central group remains obscure, ambiguous, and in-
coherent, so that the picture "swings to and fro between its
two poles, Reality-Allegory, and cannot decide upon either;
it is a visual paradox just as its title is a verbal paradox." [7]

The symbolism of the various figures and accessories is fairly
obvious. In the left-hand group, representing social categories
as well as the follies and injustices of contemporary life, the
rabbi and the curé symbolize the hypocrisies which, in Cour-
bet's opinion, were inherent in all organized religions. The
veteran symbolizes neglected old age; the textile vendor, ex-
ploitation of the poor through temptation; the hired mourner,
the mockery inseparable from rituals associated with death;
the Irishwoman, abject poverty; the skull on the newspa-
per, the decadence of the press (Proudhon had called news-
papers the cemeteries of ideas) ; the nude lay figure, academic
art; the guitar and hat, romantic poetry. In the centre the
painting on the easel represents what Courbet considered the
only true art, realism, and the boy symbolizes the homage of

future generations. The figures on the right, representing the living arts, are personifications rather than symbols: Promayet personifies music; Proudhon, philosophy; Buchon, Champfleury, and Baudelaire are embodiments of literature; Bruyas and the handsomely garbed couple in the foreground are the patrons who support the arts.

Only a few of the figures in the right half were painted from models. For his own likeness Courbet adapted his self-portrait *Courbet in a Striped Collar,* lent by Bruyas for that purpose. The nude model was probably drawn from the photograph mentioned in Courbet's letter to Bruyas; Bruyas himself was copied from one of the portraits painted by Courbet at Montpellier (not, as Courbet had at first intended, from the *Meeting*); Promayet, Cuénot, Buchon, Champfleury, and Baudelaire were merely reproductions, slightly modified, of previously executed portraits. For some reason Proudhon never posed for Courbet, and his likeness in the *Atelier* was taken from an engraving made by some other artist.

The execution bears witness to the speed at which Courbet worked to complete the picture on time. Only the central group, the seated poacher, and the modish couple are really finished; the other figures are merely sketched in broad strokes. The pigment is laid on much more thinly over the whole canvas than in most of Courbet's works, so thinly that in places the reddish-brown priming shows through.

"I dare not tell you what I think of the *Atelier,*" Champfleury wrote to Buchon in April 1855, "for I am appalled by my own likeness which makes me look like a general of the Jesuits. I do not know where he [Courbet] could have seen me with such features. . . . Yet the resemblance is close enough for me to be recognized; and without fatuity, without conceit, I should not be pleased to have anyone see me in that guise." [8]

EXHIBITION: 1855

THE PAINTINGS to be exhibited in the French section of the Exposition Universelle were selected by a jury of thirty members presided over by Nieuwerkerke. The voting began on March 19, 1855, and ended on April 11. Of some seven or eight thousand works submitted by French artists, 1867 were accepted. Courbet sent fourteen pictures. Although he had informed Bruyas that only two previously exhibited paintings, the *Man with the Pipe* and *Burial at Ornans,* would be included, he changed his mind and added the *Stone Breakers, Young Women of the Village,* and the *Sleeping Spinner.* The rest were new: *Château of Ornans, Roche de Dix Heures, Rivulet of the Puits Noir,* the *Winnowers,* the *Spanish Lady,* the *Meeting,* the portrait of Champfleury, *Courbet in a Striped Collar,* and the *Atelier.*

To Courbet's fury three of his offerings, including the two largest, were rejected. As wall space was at a premium, the vast dimensions of the *Burial* and the *Atelier* may have had something to do with a decision in which every member of the jury except Français and Rousseau concurred; but Courbet was in no mood to make allowances for practical considerations. Certainly Nieuwerkerke could not be held responsible,

because as chairman he cast no vote. The unexpected rejections put an end to Courbet's hesitations concerning an independent exhibition of his own works, and he immediately took steps to carry out the project. "I am almost frantic," he wrote to Bruyas. "Terrible things have happened to me. They have just refused my *Burial* and my last picture the *Atelier* as well as the portrait of Champfleury. They declared that it was necessary at any cost to arrest the progress of my movement which has had a disastrous effect on French art. Eleven of my pictures were accepted. The *Meeting* was accepted with reluctance. They considered it too personal and too pretentious. Everyone has urged me to organize an exhibition of my own; I have agreed. I shall open a separate exhibition of twenty-seven of my pictures, new and old, with the explanation that I am taking advantage of the favour the Government have shown me by accepting eleven paintings for their exposition. To prepare an exhibition of pictures from my studio will cost me 10,000 or 12,000 francs. I have already leased the site for 2000 francs for six months. The construction will cost me 6000 or 8000 francs. The strange part of it is that this site is actually enclosed within the area of their exposition. At present I am negotiating with the prefect of police for the completion of the necessary formalities. I already have the 6000 francs you paid me. If you care to pay off the rest of what you owe me and to lend me the *Bathers,* I am saved. I shall make 100,000 francs at one stroke. . . . Paris is furious at my rejection. I am on the go from morning to night." [1]

The site selected was at 7 Avenue Montaigne near its intersection with the present Avenue George V. On May 16 Courbet and the builder, Legros, signed the contract for construction of the gallery: "I, the undersigned, Legros agree to build a temporary exhibition building . . . according to the plans prepared by M. Isabey, architect. . . . The construction will be of wood panels with a lining of hollow brick, covered on the exterior with plaster. Canvas door and grey wall-paper

in the interior . . . solid roof covered with zinc . . . glazed skylights . . . pine floors . . . office and vestibule covered with tarred paper . . . for the sum of three thousand five hundred francs payable . . . one thousand francs upon completion of framework and fifteen hundred francs upon termination of work, between June first and eighth, and the balance . . . three months after termination of work." [2] Legros was to forfeit one hundred francs for each day's delay after June 8 and to receive a bonus of fifty francs per day if he completed the building before that date.

The number of pictures to be shown increased as Courbet's optimism grew. "After a month of negotiations with all sorts of ministries," he told Bruyas, "and two interviews with the minister M. [Achille] Fould, I have finally received permission to hold an exhibition to which I may charge an entrance fee. It will be organized under extraordinarily independent conditions. . . . I shall be considered a monster, but I expect to make 100,000 francs. At present I am busy with the construction. I shall have thirty pictures in this private show. . . . My pictures at the exposition are miserably placed and I could not get them hung together, notwithstanding the regulations. In short they want to be done with me, they want to annihilate me. I have been in despair for a month. They deliberately rejected my large pictures, declaring that it was not the paintings they rejected, but the man. My enemies will make my fortune. This [rejection] has given me the courage to carry out my own ideas. . . . I shall win freedom, I shall save the independence of art. They are reeling under the blow I have struck at them, but my batteries were so well placed that they could not retreat. Your picture of the *Meeting* has made an extraordinary impression. In Paris they call it *Bonjour, Monsieur Courbet!* and the attendants are already busy guiding strangers to my pictures. *Bonjour, Monsieur Courbet!* is having widespread success. Very odd! From all quarters I receive suggestions and letters encouraging me in my project. The public expects it

of me. I am going to ask every owner of my works to be kind enough to lend them to me. I have just written to the director of the Lille museum for my *After Dinner at Ornans*. I shall have my *Burial,* my new *Atelier,* my *Wrestlers,* my *Return from the Fair,* my *Bathers. . . .* In addition I shall have portraits, landscapes, small paintings. Champfleury will prepare an annotated booklet for sale, and I shall also sell photographs of my pictures which I am now having made by M. Laisne. At present he is using a collodion process which I do not find very satisfactory." [3]

Although the Lille museum refused to lend *After Dinner at Ornans,* nearly all of the private collectors acceded to Courbet's wishes. When the exhibition opened on June 28, 1855 it comprised forty paintings and four drawings, including the portraits of Promayet, Champfleury, Baudelaire, Cuénot, Berlioz, Journet; three or four self-portraits; the *Atelier, Burial at Ornans, Return from the Fair,* the *Bathers,* the *Wrestlers;* four landscapes painted near Paris and nine or ten in the Franche-Comté. The catalogue, priced at ten centimes, contained a sort of manifesto setting forth Courbet's views on realism. The ideas may have been Courbet's but the phrases were composed by Champfleury:

The appellation of realist has been imposed upon me just as the appellation of romanticists was imposed upon the men of 1830. At no time have labels given a correct idea of things; if they did so, the works would be superfluous.

Without discussing the applicability, more or less justified, of a designation which nobody, it is to be hoped, is required to understand very well, I shall confine myself to a few words of explanation to dispel misunderstandings.

Unhampered by any systematized approach or preconceptions, I have studied the art of the ancients and the art

of the moderns. I had no more desire to imitate the one than to copy the other; nor was I any more anxious to attain the empty objective of *art for art's sake*. No! I simply wanted to extract from the entire body of tradition the rational and independent concepts appropriate to my own personality.

To know in order to create, that was my idea. To be able to represent the customs, the ideas, the appearance of my own era according to my own valuation; to be not only a painter but a man as well; in short to create living art; that is my aim.[4]

Champfleury returned to Paris from a visit to Buchon just in time to attend the opening, which he described to his exiled friend: "I did well to leave [Berne], for I arrived in time for the opening of the *Courbet-Exhibition,* and truly I should have missed one of the most amusing spectacles of my life. At noon Courbet, in a black suit, was awaiting his guests. I think the first to arrive was Théophile Gautier, who seated himself and inspected the pictures for an hour and a half, from time to time glancing out of the corner of his eye at Courbet who, for his part, did not dare to approach the enemy. Soon Proudhon arrived with his broad-brimmed hat. . . . In came two old ladies of fashion, haughty and curious, a little astonished. . . . When I came home tonight I no longer knew anything at all about the arts. All that I could be sure of was that the general effect was good and that Courbet's older pictures have grown in stature. . . ."[5]

In general the critics, when they condescended to review this impudent competition with the official exposition, were inclined to treat it as a joke, and a joke in bad taste at that. One of the few exceptions was Delacroix, who found much to praise in the *Atelier:* "They have rejected one of the most outstanding paintings of the times; but he [Courbet] is too sturdy to be discouraged by so slight a setback."[6] Gautier, the

"enemy," commented with relative mildness: "Instead of installing realism in a temporary building next to the exposition, M. Courbet would have done better to develop the great landscape painter that is in him; the *Roche de Dix Heures* . . . is worth looking at. . . . We shall not discuss M. Courbet's doctrines; we shall consider only the results, and we find that he is systematically throwing away a real talent for painting . . . and . . . we continue to believe that M. Courbet, under the pretext of realism, calumniates nature horribly." [7] Eugène Loudun was much more severe: "God save us from dwelling upon those painters who were known in Greece as *rhyparographists,* painters of filth. . . . What M. Courbet is trying to do is to represent people as they are, as ugly and coarse as he finds them . . . but it is all at the tip of his brush, there is nothing noble, pure, or moral in the head that controls his hand; he invents nothing, he has no imagination; he knows nothing but his craft; he is an artisan in painting as others are in furniture or shoemaking." [8] Maxime Du Camp was frankly outraged: "We like artists who carry their banners high, and we feel nothing but contempt for those who wave them at street corners. . . . M. Courbet himself has chosen . . . the place he wishes to occupy in the press; he has put his name and his *bombast* on the fourth page of the papers between the [advertisements for] *worm-killing pills* and *essence of sarsaparilla.* This is no longer within our province. In our department we are concerned exclusively with art, and now in any event we have nothing more to do with M. Courbet." [9]

The public response was no more encouraging. For a few days visitors came to satisfy their curiosity rather than to admire, but the attendance soon dwindled to a trickle even though Courbet cut in half the original admission fee of one franc. His dream of a profit of 100,000 francs turned into a nightmare of potential bankruptcy. Although Champfleury had changed by this time from an enthusiastic champion of Courbet into a disapproving critic—and in consequence had

begun to loosen the close bonds of friendship which had once united them—he loyally attempted to stimulate public interest by publishing a laudatory article. "The entrance fee to his [Courbet's] exhibition is fifty centimes," Champfleury wrote to Buchon on July 22, "the receipts have been small so far. No reviews except a few derisive ones. I had not intended to contribute anything, but in the end I wrote an article with which I am not satisfied, and I did that only in order to provide, to the best of my ability, publicity for this experiment so as to make it possible for Courbet to recoup his losses." [10]

Champfleury's article, published in *L'Artiste* on September 2, took the form of an open letter to George Sand, who in 1854 had expressed doubts concerning the validity of realism: "Some people say that it [Courbet's exhibition] is incredibly courageous, it is the overthrow of all institutions subject to the decisions of juries, it is a direct appeal to the public, it is liberty. Others say it is a scandal, it is anarchy, it is art dragged through the mire, it is the platform of a street fair. I confess, Madame, that I agree with the first group. . . . If there is one quality that M. Courbet possesses in the highest degree, it is *conviction*. . . . He advances in art with a sure tread, he displays proudly his point of departure and the goal he has reached, resembling in that respect the wealthy manufacturer who suspended from his ceiling the wooden sabots in which he had once walked to Paris." [11]

But while Champfleury could still be relied upon to make an effort to help Courbet out of a difficult situation, his praise was no longer wholly sincere. "I have not hidden . . . from Courbet what I think about his future," he wrote to Buchon on October 1, "though I restrained myself a little this year because of the ill will shown towards him [by others]; but a few years hence, when I shall publish a serious book about him, I shall not beat about the bush; I shall say frankly what I have seen in his works that I do not like. . . ." [12] Three weeks later he wrote again: "The fury directed against Courbet is

caused by a perfectly legitimate reaction against his exaggerated vanity, and I suffer a little from the rebound." [13] And in April 1856: "Neither doctrines nor explanations of his system can alter the fact that Courbet has gone off the track since the *Burial* and *After Dinner at Ornans*. Ever since he painted those two pictures I have regarded him as a man gone astray, influenced by public opinion, by criticism, trying to compromise, not succeeding, determined to cause a sensation and no longer faithful to his own temperament. You know how I defended him this year, but I based my plea solely on the *Burial*. I see in him plenty of talent, a craftsman-painter talent, but nothing more. Courbet is selling nothing, he is under fire. . . ." [14]

Although the exhibition brought Courbet little but financial loss and critical condemnation at the time, it proved in the long run of inestimable value to succeeding generations of artists. By challenging the authority of the bureaucrats it broke, once and for all, the strangle-hold of officialdom (at least in countries governed by democratic institutions), and it set the pattern for the independent exhibitions and one-man shows so prevalent today.

Months of hard work had left Courbet physically and mentally exhausted. "I am so tired I can scarcely stand up," he wrote to his parents late in August, "I feel a terrible yearning for Ornans." [15] But an invitation to visit Ghent delayed his return home, and in the friendly atmosphere of Belgium, where his work had always enjoyed greater popularity than in France, he quickly recovered his health and spirits. From Ghent he wrote early in September: "I am welcomed like a prince, which is not surprising since I am surrounded by counts, barons, princes, etc. Some of the time we are entertained at dinners, at other times we ride in carriages or on horses through the streets of Ghent. As to the dinners, I dare not mention them any more; I don't believe we are away from the table four hours a day. I think that if I were to stay longer

I should come home as round as a tower. In spite of all this I have already painted two portraits." [16] He had been to Brussels, Malines, Antwerp, and Termonde; he was about to visit Bruges and Ostend; and he proposed to return by way of Louvain, Liége, Dinant, Cologne, Mainz, Strasbourg, Mulhouse, and Besançon. He probably spent most of the autumn at Ornans, but he was obliged to go to Paris before the end of the year to close his exhibition. On December 9 he wrote to Bruyas: "I am busy dismantling my show. The time has expired. I must vacate the site, my head is spinning. . . . I am going to Ornans for three weeks, reluctantly, as I have work to do in Paris." [17]

CHAPTER XIV

FRANKFORT

THE STRAIN and turmoil of 1855 were succeeded by a relatively peaceful interlude. During 1856 Courbet divided his time between Ornans and Paris, painting assiduously in both places. The year was notable chiefly for his experiments in a new field which was to become increasingly important during the next decade: the representation of hunting scenes in the Franche-Comté mountains. Theretofore hunting had been merely a pastime to Courbet, the only sport he really enjoyed. His first two pictures in this category, *Fox in the Snow* and the *Dying Stag,* were probably painted in the winter or early spring of 1856 at Ornans, though they may have been completed in his Paris studio. His practised eye was able to catch and retain impressions of wild animals in rapid motion, of pursuing hounds and galloping horses. To refresh his memory he sometimes used quick sketches made on the spot, and he often painted the details from the carcasses of deer and other game supplied by a butcher's stall in the rue Montorgueil near the Halles Centrales.

In 1856 he also painted four or five landscapes, including two of the forest of Fontainebleau, as well as the *Woman with the Glove* (Mme Marie Crocq) and the *Amazon,* a woman in a riding-habit, generally believed to be the novelist and poet

Louise Colet. The identification is dubious; Louise Colet had curly blonde hair, whereas the hair of the *Amazon* (at least in the present somewhat grimy condition of the picture) appears to be very dark. Louise Colet was less well known for her own literary productions than for her successive liaisons with prominent men of letters, among them Victor Cousin, Abel Villemain, Alphonse Karr, and Gustave Flaubert. She met Champfleury in 1854 and may have added him to her list of lovers, but it is also possible that their relationship was merely Platonic and literary. "For the past two years," Champfleury wrote to Buchon in January 1856, "I have been associated with a blonde Muse, tall, strong, full of vigour, whose amorous adventures have caused something of a sensation. . . . For a long time I avoided paying her compliments on her poetry, which interested me not at all, or on the remnants of her beauty, which failed to stir me." [1] Champfleury intended to present Courbet to her, but both men failed to keep the appointment. Whether or not Courbet met her subsequently is uncertain.

On February 8, 1856 a pantomime entitled *Le Bras noir* by Fernand Desnoyers, one of the habitués of the Brasserie Andler, was presented at the Théâtre des Folies-Nouvelles. Courbet contributed the anouncement, a drawing of Pierrot frightened by the apparition of an enormous arm rising from the ground; a mediocre composition, like nearly all of Courbet's works in black and white. His first still life, *Vase of Flowers*, and the portraits of Clément Laurier and his wife also date from 1856 or possibly late in 1855.

Courbet did not exhibit in 1856, but he sent six pictures to the Salon of 1857: *Banks of the Loue;* two portraits, one of "Monsieur A. P." (probably Alphonse Promayet) , the other of the singer Gueymard in the title rôle of Meyerbeer's *Robert le Diable* at the Opéra; two hunting scenes, the *Quarry* and *Doe Lying Exhausted in the Snow* (Plate 29) ; and *Young Women on the Banks of the Seine* (Plate 30) . The *Quarry*

portrays the end of a day's hunting in a pine forest. At the left the carcass of a buck is hanging by one leg from the trunk of a tree. Two hungry hounds wait impatiently for a share of the meat; farther back one huntsman (Courbet himself) leans wearily against a tree while another, seated, blows his horn. In the *Doe Lying Exhausted in the Snow* the tired animal has fallen limply in her tracks, only the panic-stricken eyes indicating that she is still alive; five hounds about to close in for the kill are followed at a more leisurely pace by two huntsmen. It is a desolate scene: the winter sky is dark, and the white expanse of snow is broken only by a few wind-blown bushes.

Some critics professed to find *Young Women on the Banks of the Seine* shocking, vulgar, and immoral. It was in fact a pendant or sequel to *Young Women of the Village,* with Courbet's virtuous sisters replaced by a pair of richly garbed and unmistakably dissolute courtesans. One of the hussies, a brunette, has gone to sleep on the grass; her blonde companion, wearing a large hat, rests on one elbow while her other arm loosely holds a bunch of fresh-picked flowers. The women are shaded from the midday heat by the thick foliage of a clump of trees, and on the left a moored rowboat floats lazily on the blue waters of the stream. The models, though over-fed and beginning to grow flabby, are still handsome, and the colours are fresh and bright. For this picture Courbet made at least two preliminary studies, an unusual procedure for one who habitually drew his outlines direct on the canvas and painted over them rapidly, firmly, and without hesitation.

On the whole Courbet's offerings were well received. The jury awarded him another medal similar to the one bestowed in 1849, and most of the reputable critics treated him with unwonted respect. "The master painter of Ornans . . . has behaved well enough this year," wrote Théophile Gautier, "he has not installed realism in a booth like a freak at a fair, and he has exhibited . . . pictures which, with the exception of *Young Women on the Banks of the Seine,* are not too eccen-

tric. . . . If M. Courbet does not possess artistic intelligence he has at least the temperament. He is a born painter. . . . Nobody in our time applies colour, heaps on pigment, and wields a brush with more forceful simplicity; but do not expect of him composition, drawing, or style. . . . The *Young Women on the Banks of the Seine* . . . belongs in the extravagant category to which the artist owes his notoriety. It is a deafening tattoo on the tomtom of publicity to attract the attention of the unheeding mob. . . . Nevertheless one must note great progress. . . ." [2] Edmond About commented: "It was permissible to make fun of M. Courbet's painting in the days when he built platforms, opened shops, and fired pistols out of the window to lure people to his studio. This young artist, a little too young for his age, has frightened mothers of families, upset police commissioners, displeased dignified men, and terrified the Academy by the offensive display of certain trivialities; he seems to have realized at last that scandal does nothing useful for the dissemination of his only distinctive quality. This exhibition contains nothing outrageous . . . and it is in a calm and sober spirit that we are all now able to judge M. Courbet's talent. . . . He seizes nature like a glutton; he snaps up great chunks and swallows them unchewed with the appetite of an ostrich. . . . It is . . . in his landscapes that his talent appears most fully. He is at ease only in the heart of the country. . . ." [3]

In 1857 a new critic began to publish reviews of the annual Salons: Jules-Antoine Castagnary, destined to become Courbet's most intimate friend and confidant. As Champfleury's influence waned, Castagnary's waxed; his loyalty never wavered, and although he saw clearly the flaws in Courbet's character he remained his devoted champion until the end of the painter's life. Born at Saintes on April 11, 1830, Castagnary was eleven years younger than Courbet. He shared the painter's republican and anti-clerical views and, to a certain extent,

his artistic theories; he respected Proudhon though he deplored the philosopher's insistence upon social significance as the goal of art. Castagnary became a member of the municipal council of Paris in 1874 and a councillor of State in 1879. Appointed in 1881 to a post in the short-lived Gambetta cabinet, he resigned when that ministry fell in January 1882. From 1887 until his death on May 11, 1888 he served as director of the Ecole des Beaux-Arts. Most of his writings consisted of articles on art and artists, originally published in various periodicals and later collected in two volumes. In 1883 he published a small book, *Gustave Courbet et la colonne Vendôme,* in which he undertook to defend his dead friend's activities as a member of the Commune of 1871. The preparation of a full-length biography of the painter was cut short by Castagnary's death.

In his review of the Salon of 1857 Castagnary diluted praise of Courbet's works with cautious reservations: "Courbet is a sceptic in art, a profound sceptic. And that is really a pity, for he has very fine and very powerful qualities. His brush is vigorous, his colour solid, his depth often surprising. He grasps the external appearance of things. . . . But he does not see beyond that because he does not believe in painting. . . . Courbet is a valiant craftsman-painter who, lacking comprehension of the æsthetics of his art, unprofitably wastes splendid and rare qualities. As a genre painter he may formerly have believed that painting should have a social meaning; but at present he no longer believes any such thing. As a landscape painter he has viewed nature only through a tavern window. . . . It is as a painter of portraits that he seems to me to be at his best." [4]

Champfleury published no comments on the Salon of 1857, but in July he wrote to Buchon: "Impossible to tell you what I think of Courbet's pictures; I don't think anything of them, and in spite of your enthusiasm I see in them nothing but good, purely material painting. As to the *Young Women,* hor-

riblc! Horrible! Certainly Courbet knows nothing about women. You will think me embittered. I have always told you that since the *Burial* our friend has gone astray. He has kept his finger too much on the pulse of public opinion; he wants to please it, and he lacks the requisite flexibility. Courbet should remain a solid and honest native of the Franche-Comté." [5]

In late May or early June Courbet, this time accompanied by Champfleury, Schanne, and Bonaventure Soulas, paid a second visit to Bruyas at Montpellier. To take advantage of a reduction in the railway fare they travelled south with a large and lively party of botanical students. Champfleury described the journey to Buchon: "Although I was ill I went to the Midi, trailing after me Courbet, Soulas, and Schanne, all of us travelling at the expense of the Botanical Society. Thus we were three hundred botanists, paying only quarter fares on the railway. Of the three hundred perhaps not more than twenty were serious students; some got drunk, others went chasing after the girls. At Montpellier the police started off by hauling a dozen to the police station. . . . Fêtes were organized for us at Montpellier, banquets in honour of realism, splendid dinners. . . . Bruyas did the honours. The room was decorated with our portraits. Toasts; quarrels. North and South face to face. Schanne and Courbet very drunk. Statues thrown out of windows." [6]

The visitors did not remain long, and Courbet seems to have done little or no painting; his time was fully occupied with eating, drinking, and reunions with the friends he had made three years before. But the pleasure trip produced unexpectedly distressing consequences. After his return to Paris Champfleury published in the *Revue des Deux Mondes* for August 15, 1857, a short sketch entitled *Histoire de M. T——*, an episode in a series called *Les Sensations de Josquin*. The prototype of M. T—— was obviously Bruyas, and Champ-

fleury's unflattering and easily recognizable description seemed a poor return for the art patron's recent hospitality. The narrator was "Josquin": "As I was passing through the little town of S—— I was advised to visit the picture gallery of young T——, whose activities were the talk of the region. . . . The mania of young T—— consisted in collecting nothing but portraits of his own countenance." [7] When Josquin was admitted to the house he found the owner "lying languidly on a divan. . . . When I looked at M. T—— I received the impression of chronic illness rather than convalescence. . . . There was in his appearance something of a pretty woman who is bored, a mystic tortured by ecstasy, and the debility of a sensualist. . . . He thought himself the most beautiful of mortals and had never found a painter sufficiently skilled to reproduce his features with the aid of a brush." [8] After the visitor had inspected a number of the portraits, which he described in some detail, his host reverently opened the curtains of a richly ornamented tabernacle and exposed yet another picture that shocked and terrified Josquin: "It was the portrait of Christ! Christ crowned with thorns! . . . M. T—— had had himself painted as Christ!" [9] Josquin could stand no more: "I was in a hurry to leave that gallery in which I felt ill at ease." [10]

Although Champfleury's lampoon may not have been deliberately malicious, it was certainly in questionable taste. Bruyas, deeply offended, was at first inclined to suspect that Courbet might have assisted or at least encouraged Champfleury to write the story. When Courbet, who had not even read the sketch, heard, not from Bruyas himself but from Fajon, of his friend's suspicions he hastened to protest his innocence: "Before replying to your letter I should have liked to read the *Revue des Deux Mondes* so as to understand the situation. But without knowing what has happened, if M. Champfleury has been in the slightest degree offensive to my friend Bruyas I censure him severely, and I am deeply hurt that anyone could imagine that I had anything to do with it.

My dear friend Alfred Bruyas is the most courteous, the most honest, the most charming man I have ever met in my life. Furthermore he is one of the most intelligent men in Montpellier. I don't want him to have thought for a single moment of doubting my friendship and the sincerity of my feelings in this connection. Moreover everything in my previous association with him should prove the opposite. And you too, my dear Fajon, can bear witness to my statement, you know that my sincere friendship and my devotion to our dear friend have never failed. . . . M. Champfleury does exactly as he pleases, entirely without my co-operation of course; nevertheless on the basis of your letter I have taken him to task for this exploit. He replied that this sketch was written before he went to Montpellier and had been sent to the *Revue des Deux Mondes* a long time before his journey to the Midi. In short, my dear Fajon, you must remember that I am responsible only for my own works and that other people's thoughts and actions do not concern me at all. Please communicate all that I have written here to our dear friend as well as to any others who may be interested . . . because I have the honour to have no connection whatever with the affair, not even as an informant." [11]

Evidently Buchon also had accused Champfleury of poor taste, for the impenitent author defended himself vigorously: "The *Histoire de M. T——* does not altogether please you; many people will feel as you do. I knew that would happen, but what does it matter to me? This story had obsessed me for a long time; it poured itself willy-nilly from my pen, and I enjoyed writing it so much that the phrases took form by themselves. There were also many considerations which might have prevented me from writing it, [especially] the cordial hospitality of M. B[ruyas], but art is above all that." [12] Bruyas accepted Courbet's disavowal of complicity and apparently forgave the writer as well, for he was reported to have been seen walking arm in arm with Champfleury to a concert in the Champs-Elysées not long afterwards. But Courbet did not so readily

pardon the injury to his friend, and the incident perceptibly widened the breach between Champfleury and himself.

An exhibition of Courbet's works opened in Brussels in September. "I go to Brussels in ten days," he informed Fajon. "My pictures have had great success and have attracted crowds of people. Now they are in Belgium where they are producing the same effect." [13]

Work, exhibitions, and travel kept Courbet exceedingly busy during 1858. Among other pictures he painted the *Polish Exile,* a portrait of Mme de Brayer. He may have gone once more to Montpellier, for his *View of the Mediterranean at Maguelonne* is generally dated 1858, but it is possible that he painted it the year before and did not journey a third time to the Midi. He exhibited at Bordeaux, Le Havre, Dijon, and Besançon. He went again to Brussels in the late summer, and thence to Frankfort, where he remained from September 1858 until February 1859.

In Frankfort he was wined and dined, flattered and pampered by the local painters. "I ramble in foreign lands to find the independence of mind that is necessary to me," he wrote to his family, "and to get away from that [French] Government with which, as you know, I am out of favour. My absence has succeeded admirably; my stock is going up in Paris. Letters to me and to my friends from all sources say that my partisans have more than doubled and that in the end I shall be the only one left on the battlefield. I think that this year . . . will be a definitive year. It is not so much that I want to be a success. Those who are successes at the beginning are those who batter at open doors. Here in Frankfort a crowd of young people are followers of my doctrines." [14]

He sold the *Doe Lying Exhausted in the Snow* and another hunting picture to a collector in Frankfort, who also commissioned a landscape. During the winter in Germany Courbet painted at least five pictures: portraits of Mme Erlanger, wife

of a local banker, and of Jules-Isaac Lunteschütz; the *Lady of Frankfort,* a woman in a grey gown sitting in an armchair beside a tea table on a terrace, against a background of pines and a little lake; and two hunting scenes: *Exhausted Stag* and *Fighting Stags* (Plate 33). Lunteschütz, born at or near Besançon in 1822, had been a pupil of Courbet's former teacher Flajoulot. After a few years of study at the Beaux-Arts in Paris he established himself in Frankfort, where he became well known as a painter of decorative murals and of portraits, including several of his friend the philosopher Schopenhauer.

Fighting Stags, also known as *Rutting Time in Spring,* depicts two stags in mortal combat in a forest clearing, while a third, wounded by an antler thrust, bellows in anguish. "I saw similar combats in the game preserves of Hamburg [probably Homburg, not far from Frankfort] and Wiesbaden," Courbet wrote to Francis Wey. "I followed the German hunts at Frankfort for six months, a whole winter, until I killed a stag which I used, together with those killed by my friends, for this picture. I am absolutely sure of these poses. In these animals no muscle stands out; the battle is cold, the fury overpowering; their thrusts are terrible though they scarcely seem to touch each other; that can easily be understood when one sees their powerful antlers. Their blood is black as ink and their muscles are so strong that they can cover thirty feet in one leap, which I have seen with my own eyes. The antlers of the one I killed had twelve points (thirteen years) computed in the German fashion, equal to ten points in France; my bullet . . . hit him in the shoulder (it went through the lungs and heart) and when I fired a second time six buckshot entered his leg, which did not prevent him from going 150 metres before he fell. Just think how powerful he was!" [15]

To his parents Courbet gave an account of a ludicrous incident arising from this hunt, which had taken place on December 31: "It [the stag] is the largest killed in Germany in twenty-five years. . . . This aroused the jealousy of all Germany. The

grand duke of Darmstadt said he would not have had it happen
for a thousand florins. A rich manufacturer of Frankfort tried
to steal it from me, but all of the inhabitants . . . were on my
side. A petition was drawn up by the Society of Huntsmen and
signed . . . by forty of the principal (meaning the wealthiest)
huntsmen of the region, demanding the return of the stag to
me. There was a splendid commotion; the whole city has been
seething for a month. The newspapers were full of it. They
could not give me back the whole stag; it had been sold, *inad-
vertently,* by the Society, and *eaten*. But they gave me the teeth
and the antlers, and the Society presented me with a very fine
skin, but smaller, to make up for their error. I was also given
a photograph of the dead stag showing my bullet holes. . . .
After that one of the huntsmen gave a dinner at which seven
hundred glasses of Bavarian beer were drunk; it went on until
morning. I have gone hunting about ten times. I killed this
magnificent stag, four or five bucks, about thirty hares. . . .
When one has hunted in Germany one no longer wants to
hunt near Flagey." [16]

Courbet had at first used for the landscape background of
this painting a forest across the Main river from Frankfort,
but after his return to Ornans in February he substituted a
scene in the forest of Levier near the village of Flagey because,
as he explained to Wey, the time was "the beginning of spring
. . . when things growing near the ground are already green,
when the sap is mounting in the big trees, and when only the
oaks, the last to change, still retain their dry winter leaves.
The subject of the picture demanded that season of the year;
but in order not to fill it with the bare trees found at that time
[in Germany] I preferred to use our own countryside of the
Jura. . . . I painted it in . . . a forest half bare, half ever-
green." [17] Courbet's observation of nature was always acute,
his description vivid and precise. He never fumbled for words
as he did in his attempts to express abstract or philosophical
ideas.

MASTER AND PUPILS

DURING Courbet's absence in Germany he had left his studio in the rue Hautefeuille in charge of his sister Zoé and his friend M. Nicolle, Proudhon's former fellow prisoner. In Frankfort he received a letter from them informing him that two Russians had offered to buy all of the pictures in the studio. The prospect of so providential a windfall enchanted Courbet, who fixed the price at 76,000 francs. But the negotiations fell through; the Russians disappeared into thin air, and the painter damned Zoé and Nicolle for a couple of fumbling fools. Evidently his resentment soon subsided, for in 1862 he painted Nicolle's portrait.

It was probably either just before or during his sojourn in Frankfort that he purchased at Ornans a plot of ground on which he proposed to build a studio. The idea had been in his mind for some time; as early as November 1854 he had written to Bruyas: "I am about to buy a site for the construction of a studio. The price demanded is 4000 francs. I am reluctant to pay that much, for I find it dear. Nevertheless I must do it, as the property suits me very well." [1] This may or may not have been the site eventually chosen in the outskirts of Ornans on the main highway to Besançon. The building was not erected

until 1861. Max Claudet, a sculptor from Salins and a friend of Buchon's, described the studio as he saw it in 1864: "It was in the most complete disorder: canvases stacked against the walls, newspapers and books on the floor, jars filled with reptiles on the shelves, primitive weapons, given to him by the geologist Marcou, hanging on the partitions, paint boxes, clothing, etc., all mixed together. The studio was enormous; on a large flat space connecting the wall and the ceiling Courbet had painted two superb frescoes: a *View of the Escaut* [Scheldt] where the river flows into the sea, and the *Seine at Bougival* with fine trees mirrored in the water." ² The studio (Plate 5) still exists, now transformed into a warehouse filled with huge casks of wine, the property of M. Marguier, dealer in wine and grain.

During the spring of 1859 at Ornans Courbet painted two more hunting scenes, *Stag and Doe in the Forest* and *Stag on the Alert;* perhaps a landscape or two; and a portrait of Joseph Lebœuf, an impecunious sculptor who in return executed a statuette of Courbet in his painting smock. A *View of Ornans* (Plate 31) was probably painted either in 1859 or the year before; comparison with a photograph of the same scene (Plate 32) taken ninety years later demonstrates both the unchanged aspect of the provincial town and Courbet's realistic treatment of the subject.

In June Courbet went with Alexandre Schanne to Le Havre. According to Schanne's much later recollection they travelled with a party of botanists, but the musician must have confused this excursion with the trip to Montpellier in 1857. Schanne described their first meeting with Eugène Boudin, best known for his small luminous paintings of beaches, sea, and sky, who exerted a decisive influence on the youthful Claude Monet: "There we were at Le Havre in the rue de Paris. . . . Courbet discovered in a stationer's window some little seascapes carefully painted on panels and immediately asked for the

artist's address, as he wished to congratulate him. We were directed to the house of M. Boudin, then very young [he was actually thirty-six]. . . . M. Boudin received us and placed himself at our disposal as a guide to the district. Next day he took us to Honfleur and installed us in a rustic inn halfway up the cliff." [3] The inn was the farm of Saint-Siméon owned by *père* Toutain, so frequently patronized by landscape painters that it was nicknamed "the Barbizon of Normandy." Courbet recorded his sojourn at Honfleur in four pictures: the *Garden of Mère Toutain* painted at the farm, *Cliffs of Honfleur, Sunset over the Channel,* and *Mouth of the Seine.*

Courbet's vitality stimulated Boudin, who wrote in his notebook on June 16: "Courbet's visit. He was pleased with everything he saw, I hope. If I were to believe him I should certainly consider myself one of the talented men of our era. It seemed to him that my painting was too weak in tone; which is perhaps true . . . but he assured me that few people paint as well as I do." [4] Two days later Boudin noted: "Returned from Honfleur with Courbet. Spent a fantastic evening at de Dreuil's with Courbet and Schanne; it was monstrously noisy. Heads whirled feverishly, reason tottered. Courbet proclaimed his creed, needless to say in a most unintelligible manner. . . . We sang, shouted, and bellowed for so long that dawn found us with our glasses still in our hands. On our way home we made a din in the streets, which was very undignified. . . . This morning our heads felt dull. . . . We have watched Courbet at work, he is a valiant fellow. He has a broad conception that one might adopt, but nevertheless it seems to me rather coarse, rather careless in details. . . . I find in him great determination, but haven't people turned him into a fanatic by calling it eccentricity?" [5]

Schanne also described another unexpected encounter at Le Havre: "One morning as we were strolling round the harbour we were surprised to meet . . . Baudelaire. . . . Baudelaire explained that he was obliged to spend some time

with his mother, who owned a country house near the town; and he added: 'I shall bring you home to dinner and present you to her.' We were very much embarrassed as we had brought no proper clothes. But our friend insisted . . . so we could not refuse. I can still see Courbet bending himself double to offer his arm to the mistress of the house, who was very small. . . . The dinner, very sumptuous, was delightful in every way. . . . About nine o'clock we left . . . to take the night train to Paris." [6] Baudelaire accompanied them to the station and impulsively decided to travel with them to Paris, declaring with characteristic perversity that he hated to waste his time in the country when the weather was fine.

On October 1, after his return to Paris, Courbet invited a large company of friends and acquaintances to a gala *fête du réalisme* at his studio. Most of the guests were artists and writers, habitués of the Brasserie Andler and the Brasserie des Martyrs. The announcement printed on yellow paper gave a list, not meant to be taken too literally, of the entertainments: a play by Fernand Desnoyers "rejected by the Odéon"; a Haydn symphony to be performed, presumably solo, by Champfleury on the double-bass; a cancan by a certain Titine; piano selections "by somebody"; [7] and many other amusing divertissements (Plate 35).

Max Buchon's long exile had come to an end at last, and when Courbet returned to Ornans a few days after this gala evening he received a letter from his friend, dated October 11, inviting him to spend a few days at Salins and promising him an assortment of fine wines specially selected for the celebration of the reunion. Courbet visited Buchon a few weeks later and no doubt did full justice to the wine; he also painted a portrait, *Young Girl of Salins*.

He remained quietly at Ornans throughout the spring of 1860, painting and occasionally hunting. He produced several landscapes, including *Oraguay Rock* near the village of Mai-

sières; a portrait in profile, the *Woman with the Mirror;* and more hunting pictures, among them a canvas originally titled the *Huntsman* (which may have been painted in 1861) representing a rider on a grey horse galloping through the forest. Courbet subsequently painted out the rider and changed the name of the picture to the *Runaway Horse.* One winter day, while hunting in the forest of Levier near Flagey, he happened to witness an accident which suggested to him the subject of the finest of all his snow scenes: *Wreck in the Snow* (Plate 34). Under a sullen murky sky a diligence has stuck fast in the drifts; oxen from a neighbouring farm are straining to free the vehicle while the frightened horses plunge helplessly in the traces and the wretched passengers struggle on foot through the deep snow.

It was probably during this same spring that Courbet played one of his impish tricks on a young lady he had known since her childhood, Lydie-Marthe Chenoz. Lydie was born at Pontarlier in 1840, the daughter of Just-Fortuné Chenoz, a prominent solicitor of that town. In a letter written a quarter of a century after the event she gave an account of Courbet's prank: "In 1860 I was driving to Besançon with my father in a private carriage, and we stopped to rest at Ornans; just as we were leaving Courbet approached the carriage and begged my father and myself to stay overnight. 'We are going to have a concert,' he told us, 'and Lydie will play in it.' I protested, as you can imagine; he insisted; I resisted. Finally he persuaded us to go to the house of one of his friends for five minutes, as he assured us; during that time he returned to the carriage and, to make sure we would remain, sent it on to Besançon . . . to wait for us, he said. When we discovered the little trick I wept with disappointment and fury; I did not want to miss the theatre at Besançon. He consoled me as well as he could, invited us to supper, and escorted us that evening to the concert at Ornans, where I was obliged, willingly or unwillingly, to play a selection on the piano. He had arranged for flowers

to be thrown at me and bravos shouted, and swore in the presence of our friends that since I had given him my music he would give me some of his painting." [8]

Courbet kept his promise. On September 27, 1863 Lydie Chenoz married Charles Jolicler of Pontarlier, eleven years older than herself. In 1864 Courbet painted her portrait, in 1869 one of her three-year-old daughter Henriette, and in November 1872 one of Charles Jolicler. It has been suggested that Lydie became Courbet's mistress, but no evidence has been produced to indicate that she was more to him than a loyal, cherished friend and trusted confidante. The painter was on excellent terms with her husband, in whose house at 10 Grande Rue, Pontarlier, he was always welcome. Lydie was a lively and entertaining hostess: "Very intelligent, kindhearted, Mme Lydie Jolicler had retained after her marriage to a taciturn man the character of a spoilt child, merry, inconsistent, fond of pleasure. Gustave's visits were occasions for laughter. She would recall the years of her childhood, a thousand nothings that amused her. . . ." [9] Lydie died in 1897, her husband in 1899.

In 1860 Courbet was represented at four exhibitions: at Montpellier, Besançon, Brussels, and a private gallery in the Boulevard des Italiens in Paris. To the Salon of 1861 he sent five pictures: *Oraguay Rock* and four hunting scenes, including the *Fighting Stags*. He had intended to exhibit in addition a painting of human figures, but he had broken his left thumb during the winter and had been unable to work for six weeks. The Salon officials had refused to grant a postponement, he complained to Francis Wey; since the Government would not help him he would henceforth rely on private collectors: "Indeed, you know better than anyone that I act without calculation, without evasion, and that I expose even my faults to the public. Perhaps that is due to pride, but in any event it is a commendable pride because it deprives me, through my hon-

esty, of the profits my painting might bring me. In my poverty I have always had the courage to be what I am without shilly-shally, without deliberately attacking anyone; and yet, knowing my art as thoroughly as I do, it would have been easy for me to act differently; but it is difficult to abandon inherited principles." [10]

For the third time the jury awarded him a medal of the second class; but this inferior prize, so welcome in 1849 and acceptable even in 1857, had by 1861 become almost an insult. The critic Théophile Thoré protested: "We would not have given a stale repetition of the second-class medal to Courbet. . . . It would . . . have been proper to add Courbet and Doré to the French chevaliers [of the Legion of Honour]; nobody would have objected. It is said that Courbet's name was on the list and was scratched out by the emperor. Yet if Courbet . . . were to wear a red ribbon in his lapel, the European political situation would not be thrown into convulsions." [11] Perhaps Courbet would have accepted membership in the Legion if it had been offered in 1861; perhaps he would not. Nine years later he rejected it with scorn. Champfleury, for a change, found little to criticize in this exhibition: "Courbet seems to be having a genuine and widespread success this year," he wrote to Buchon, "in my opinion two of his pictures, *Fighting Stags* and *Orcagnon* [*sic*] *Rock,* are very important. . . ." [12]

Castagnary published an enthusiastic review in *Le Monde Illustré,* but either this article on Courbet or more probably the general tone of his comments on the Salon displeased his readers. One of the editors, Arnaud, warned him: "M. Pointel [the chief editor] has received several letters *execrating* your reviews of the Salon. . . . In your own interest I advise you to revise carefully the proofs of your Salon article for this week, to amend the style and soften anything too severe in the material." [13] Evidently Castagnary failed to comply, for a week later Arnaud dismissed him: "Every day the Salon reviews in the

Monde Illustré provoke violent objections to your opinions. M. Pointel, who understandably desires above all to please his subscribers, has instructed me to give you a message which is very painful to me. He asks me to tell you that, in view of these constant attacks, he finds himself regretfully obliged to take out of your hands the review of the painting exhibition of 1861." [14]

Castagnary had seen and praised Courbet's pictures at the Salon of 1857, but he did not meet the painter until 1860. His recollections of that first encounter at the studio in the rue Hautefeuille give a vivid description of Courbet at forty-one: "The painter emerged from a narrow little room built into a corner of the studio. He was in shirt-sleeves and slippers, his hair uncombed, his eyes heavy with sleep. . . . He asked our permission to finish his dressing and . . . went back into the little room. . . . In a little while he returned fully clothed, with his wooden pipe in his hand, and said as he lighted it: 'Would you like to see my pictures?' 'Yes,' I replied, 'I am eager to see some good painting.' 'Oh,' he said with a half smile, 'there is no lack of that here. . . .' While I inspected his works I took pains to look at the man. He was no longer the tall handsome boy described by Théophile Silvestre some years before. . . . Age had altered and slightly coarsened his striking features. . . . He was beginning to grow stout, and in his case corpulence tended to replace elegance. Nevertheless he had a curious and unusual look of the artist. His head was conical in shape, the prominent cheek-bones indicated determination, the highly developed base of the skull suggested a love of combat. A few white hairs streaked the fan of his splendid black beard, and his hair, flattened down on his skull like a nightcap, was greying at the temples; crow's-feet were appearing at the corners of his eyes; the complexion and wrinkles of maturity were already noticeable. But if his face had lost freshness and charm his features had acquired character. Their dominant expression was gay, cordial, gentle. Perhaps

because he was aware of his power, perhaps because he had confidence in the future, Courbet had not been defeated in the battle of life." [15]

Some time in 1861 Courbet and Buchon proposed to collaborate in the preparation of an illustrated book on hunting and huntsmen, but the project came to nothing. On June 3 Courbet's friends gave a banquet in Paris to celebrate his success at the Salon and the triumph of realism. His pictures were becoming more and more in demand at provincial exhibitions: he was represented that year at Marseille and Lyon, where his works were generally acclaimed, and the municipality of Nantes purchased the *Winnowers* for the local museum. In August he went to Antwerp to attend an exhibition of his paintings, including the *Fighting Stags,* which was enormously successful.

Courbet returned from Belgium convinced that realism was now firmly established, his theory vindicated, his long struggle for recognition won. This conviction was strengthened in the autumn when he received a petition from a group of young art students who, dissatisfied with the academic instruction offered by the Ecole des Beaux-Arts, begged him to open an atelier and teach them his system of painting. At first Courbet, who had always disapproved of schools and who prided himself on being self-taught, rejected the idea; but he allowed himself to be persuaded. He entrusted all of the business details to Castagnary, who found a suitable studio at 83 rue Notre-Dame-des-Champs. The lease was dated December 6, 1861: "M. Cibot, owner . . . agrees to lease . . . to M. Castagnary . . . as agent of the pupils of the Courbet atelier, a studio located on the ground floor of his house. This lease is made at the rate of nine hundred francs a year and for a period of three months. . . ." [16] When the lease was signed the term was apparently extended to four months. A few days later the students begin to arrive. Thirty-one were listed at the start,

and by the end of the month the number had increased to forty-two, each of whom paid twenty francs to cover the rent and other expenses. Courbet kept none of the money for himself. Of all these eager young artists only two, the engraver Léopold Flameng and the painter Fantin-Latour, were to become celebrated in later years.

In a letter to his students dated December 25, which Castagnary, who had composed or at least rewritten it, published in the *Courrier du Dimanche* four days later, Courbet made it clear that this was to be no orthodox school: "You have asked for the opening of an atelier of painting where you might freely continue your education as artists and you have kindly offered to place it under my direction. . . . I cannot permit any relationship of professor and pupils to exist between us. . . . I have no pupils, I cannot have any. Believing that every artist must be his own master, I cannot dream of becoming a professor. . . . In my opinion art and talent, to an artist, can be only means for the application of his personal abilities to the ideas and objects of the age he lives in. Especially in painting, art exists only in the representation of objects visible and tangible to the artist. . . . I maintain that the artists of one century are wholly incompetent to reproduce subjects drawn from an earlier or later century. . . . Nothing must ever be done over again. . . . Imagination in art consists in knowing how to find the most complete expression of an existing thing but never in inventing or creating the thing itself. . . . If beauty is real and visible it contains its artistic expression within itself. But the artist has no right to amplify that expression. He can modify it only at the risk of denaturalizing and consequently weakening it. . . . There can be no schools, there are only painters. Schools are useful only for the study of the analytical processes of art. No school can lead by itself to synthesis. . . . Therefore I cannot presume to open a school. . . . I can only explain to the artists who will be my collaborators, not my pupils, the methods by which, in my

opinion, one may become a painter; methods by which I my-self have tried to become one since I began, leaving to each one complete control of his individuality, full liberty of self-expression in the application of this method. For this purpose the organization of a group atelier, similar to the fruitful col-laborations of the Renaissance ateliers, may surely be of use . . . and I shall gladly perform any services you may require of me in order to attain it." [17]

The models were as unorthodox as the instruction, for in addition to the usual nudes Courbet introduced into the atelier an ox, a horse, and a buck. The ox was tied to an iron ring in the wall; the spavined nag was held by a groom; the buck was presumably stuffed. Since the livestock made no distinction between a studio and a stable, Castagnary could not have been greatly surprised to receive a request on February 2, 1862 to vacate the premises: "During the two months that your stu-dents have occupied the studio the wallpaper and the floor have already been reduced to such a state that I cannot de-cently rent it [again] until it has been repaired. If in two months so much damage has been caused by your tenancy, what will it be like by the end of the term after two more months?" [18] Courbet refused to move, and the atelier remained where it was until the lease expired early in April, when it closed forever.

The experiment had not been an outstanding success; many of the students grew bored once the novelty had worn off, and Courbet himself found that the work tired him and interfered too much with his own painting. But in the long run it con-tributed indirectly to the liberalization of teaching methods in other ateliers and even to some extent in the hide-bound Beaux-Arts itself. The principle that art students should not blindly obey rigid precepts but should, on the contrary, be trained to develop their own personalities was adopted by Horace Lecoq de Boisbaudran, an uninspired painter but an exceedingly gifted instructor who began to teach drawing and

painting at the Ecole Impériale in 1863 and who served as director of that school from 1866 to 1869. Among his pupils were Fantin-Latour, Jean-Charles Cazin, Léon Lhermitte, and the sculptors Jules Dalou and Auguste Rodin.

A few weeks before the atelier closed Courbet tried his hand at sculpture for the first time. In front of his pupils he modelled the *Bullhead Fisher* (the bullhead or miller's thumb is a small fish, three to five inches long, with a broad flat head), a life-sized statue of a nude boy wielding a fish-spear, which Courbet proposed to have cast in iron to adorn a fountain in the principal square at Ornans. He had conceived the project as early as the winter of 1853–1854, but for some reason he postponed its execution for eight years. It was a work of no great merit. Subsequently Courbet produced a few other bits of sculpture, all mediocre. He was in truth the master of but one art; not, as he fancied, of many.

SAINTONGE

CHARLES-AUGUSTIN SAINTE-BEUVE wrote to the dramatist Charles Duveyrier in April 1862: "The other day I was talking to Courbet; this vigorous and solid painter has ideas, and it seems to me that he has one great idea: to establish a kind of monumental painting appropriate to modern society. . . . Courbet proposes to convert our large railway stations into modern temples of painting; to cover these huge wall spaces with a thousand suitable scenes, previews of the chief points of interest through which the traveller will pass; portraits of the great men whose names are connected with the towns along the route; picturesque, moral, industrial, metallurgical subjects; in short the saints and miracles of modern society. Isn't that a magnificent idea, one that deserves encouragement? But Courbet needs the railway stations more than quires of paper. . . . You who act as midwife to men and minds, go to see Courbet, if you care to, and force his sensitive timidity and his naïve potent conceit to clarify and develop themselves. In a word, help him and he will help you." [1]

This was not a new idea, nor did it originate with Courbet. It had been suggested at least as early as 1848 in the *Démocratie Pacifique,* a journal edited by the social philosopher Victor

165

Considérant. In his book *Grandes figures d'hier et d'aujourd'-hui,* published in 1861, Champfleury had written in connection with a description of Courbet's *Departure of the Fire Brigade:* "The frescoes projected for railway stations would depict scenes no less unusual. . . . Is not the machine, the place it occupies in the landscape, sufficient to make a fine picture?" [2] But the proposal was not followed up, and in June 1864 Champfleury wrote to Buchon: "In the *Grandes figures* I outlined for Courbet a programme for the decoration of railway stations. He has not done it; it will be done." [3]

In May 1862 Max Buchon, then aged forty-four, married Héléna-Félicité Diziain, "daughter of a proctor at the Besançon *lycée,* aged twenty-one. . . . Sprightly, vivacious, witty, and outspoken, this companion seemed to have been given to him expressly to bring cheer to his intense but meditative and gravely sombre nature." [4] It is unlikely that Courbet was present at the wedding, for he was then preparing for his first journey to the Saintonge district in western France, a region of flat plains and broad horizons quite unlike his own mountainous Franche-Comté. Etienne Baudry, a wealthy dilettante, had invited Courbet and Castagnary to Rochemont, his château a mile or two outside the town of Saintes. Castagnary, a native of Saintes, had brought Baudry to Courbet's studio in Paris and persuaded him to purchase several of Courbet's pictures, including *Young Women on the Banks of the Seine.* At that time Baudry was "a budding writer . . . a patron of musical societies . . . and . . . holder of a patent for an invention to be fitted to all underwater pumps. . . . He was considered something of an eccentric, always . . . dressed in his *own* fashion." [5]

Courbet and Castagnary left Paris by the night train on May 30 and arrived next morning at Rochefort. A diligence took them in three hours to Saintes, where Baudry met them with a carriage for the short drive to Rochemont. Castagnary described the château as "a country house of very pleasing ap-

pearance, situated two kilometres from Saintes on the road to Saint-Jean-d'Angély. It was approached by an avenue between two rows of trees whose interlaced branches formed a vault of greenery. The house was built on a hill overlooking the Charente and providing a superb view. . . . It was this dwelling, very comfortably furnished and recently equipped with a fine studio, that Baudry placed at his guest's disposal. While the horse was plodding up the hill Courbet had surveyed the landscape with close attention as if he had been trying to absorb it through his retina. After lunch, which was long and merry, he asked as he lit his pipe if there was in the house a piece of canvas on which he might paint. Several were brought to him. He selected one a metre long and wide in proportion, and taking his palette in one hand and his palette knife in the other he began to paint from memory, reproducing the details he had observed from the road, a landscape which he finished in less than two hours, to the vast astonishment of the assembled neighbours. The surprising part of it was not so much the rapidity of execution as the character of the work itself. With its superbly modelled grove of young elms it was unmistakably a landscape of the Saintonge; but it was the Saintonge represented by its essential features. Half an hour's drive in a carriage had been enough for this astounding artist to assimilate this scene, so new to him, and he reproduced its aspect with a sureness of touch that won him the praise of all those present." [6]

Courbet remained in the Saintonge ten months, painting industriously and meeting a host of new and congenial friends. As usual he was the life of the party and the centre of attraction: "He was the flattered, spoilt, and petted guest," wrote Castagnary. "His simplicity, his freedom from affectation, his affability charmed everyone. . . . Visitors flocked to Rochemont. They came to watch the celebrated painter at work. . . . He painted joyously." [7] Baudry's young cousin Théodore Duret, the future art critic and biographer, visited Saintes

from time to time during Courbet's sojourn and drew from these and later meetings an impression of the painter's dual nature: "At Saintes the artist wholly devoted to his art, steeping himself in nature, a simple jovial man on friendly terms with the artists and neighbours; in Paris the artist combined with the leader of the realist school, the politician, the socialist, in which capacities he was constrained to strike attitudes, to write for and harangue the gallery; a great man within the sphere of his art, an incompetent in the political sphere." [8]

Among the artists who gathered round Courbet in the Saintonge were Louis-Augustin Auguin, landscape painter and pupil of Corot; the Alsatian portraitist and water-colourist Hippolyte Pradelles; and Arnold, a sculptor who "had all the naïveté of the artists of the Middle Ages and whose pencil designed works of the humblest kind. He worked more often for the churches and cemeteries than for private houses in the town." [9] Pradelles and Auguin lived at Port-Bertaud, a nearby village on the Charente river, and Courbet journeyed back and forth so often that when he finally left Rochemont his host received a bill for carriage hire amounting to 1200 francs.

In August Corot came to Saintes for a fortnight and renewed his acquaintance with Courbet. One day the two painters amused themselves by painting the same scene, a view of the distant town of Saintes from a field just off the road to Saint-Jean-d'Angély. "They worked on small canvases of the same dimensions," wrote Duret, "and agreed to finish at the same time. Two or three of us, their friends, watched them. They sat near each other, far enough apart so they could not see one another's work but not so far that they could not talk to each other and join in the conversation of the bystanders. In the picture Corot painted . . . he showed in the foreground the figure of Courbet painting." [10] Corot's little landscape is now in the museum at Liége; Courbet gave or sold his to Baudry.

The presence of onlookers never disturbed Courbet as he worked. Castagnary recorded that at Rochement "while he

painted he would smoke, chat, tell stories, burst into laughter, warble sweet notes in his high voice, or recite a couplet of his own composition. His hand was so skilled and so sure that he accomplished a great deal though he worked only in the afternoons and for just a few hours. But if Courbet displayed no self-consciousness at his easel he displayed still less at the table. The lunches were long, the dinners endless. They were enlivened by merry quips intermingled with serious discussions. We talked of politics, literature, and philosophy; we disparaged the empire just as all thinking people in France were beginning to do. After coffee we lit pipes and cigars and drank Strasbourg beer. . . . Auguin spoke in dialect, Courbet sang his repertoire." [11]

Courbet was the guest of honour at various entertainments that summer. On August 12 Baudry invited a number of friends to a large party at Rochemont. Four days later a huge fête was organized at Port-Bertaud in honour of Courbet, Pradelles, and Auguin. The festivities went on from Saturday evening through Sunday, and it was reported that one thousand people were present. Courbet wrote boastfully to Castagnary, who apparently had not attended this gala: "I was carried in triumph by the ladies of Port-Bertaud before two thousand people. . . . The fêtes will continue tomorrow, Sunday . . . and the steamboat will bring the visitors from Saintes; concert, fireworks, dancing in the Place Courbet [the principal square at Port-Bertaud, informally renamed by his friends to flatter the painter]." [12] On August 31 Baudry gave a still more elaborate outdoor party at the château, a party that outshone all the previous celebrations. Castagnary called it *pantagruélesque:* "The gardens of Rochemont were illuminated. Thousands of coloured glass lamps and Venetian lanterns . . . lighted the paths. . . . Coloured flares burned in the windows. . . . An immense crowd estimated at several thousand persons attended. . . . A band of forty musicians

played for the dancers. . . . Dancing went on all night." [13]
Since this was near the heart of the Cognac district the refreshments at all such gatherings included as a matter of course huge vats of potent brandy punch. One day Courbet and two or three convivial companions, after a meal of oysters washed down with white wine, decided to paddle down the Charente in a rowboat to clear their heads. They had been rowing energetically for some time when they were startled by a bellow of laughter from Courbet. He had just noticed that the boat was still tied fast to the pier.

Courbet's sojourn in the Saintonge was punctuated by a sequence of ephemeral love affairs similar to those at Montpellier eight years earlier, though it is not recorded that these western ladies languished in prison as often as their Mediterranean sisters. One was a certain Mme Boreau of Saintes, of whom he painted two portraits: one in a simple dark dress, one in a fashionable outdoor costume with a bouquet of flowers (Plate 37). Another mistress (or perhaps the same, for few specific details are known about these liaisons) was the proprietress of a local inn. In the letter describing the fête at Port-Bertaud Courbet informed Castagnary: "I am in love with a wonderful woman, who arranged my triumph." [14] And shortly before his departure from Saintes in March 1863 he wrote to the photographer Etienne Carjat, who was at that time editor of a Parisian weekly called *Le Boulevard:* "The ladies of Saintes are insistently demanding copies of my photograph taken by you; they . . . find that the one you took is the only good likeness. Please send me some to fill the void in their hearts. Send two large and several small prints of the one with the cane. . . ." [15]

In November 1862 Courbet moved to Port-Bertaud for a short time to paint landscapes in the valley of the Charente. He installed himself in a house adjoining that occupied by Auguin, who seems to have been a bit of a prig and who was

profoundly disturbed by Courbet's frivolity, dissipation, and apparent idleness. In January Auguin wrote a long, worried letter to Castagnary: "The exhibition in Paris [the Salon of 1863] is approaching, and our friend saunters about, sleeps, smokes, drinks beer, and does little, very little, painting, at least painting for the Salon. . . . His apathy pains me, all the more because I am forced to keep silent for fear that my comments might be misinterpreted. Fame involves obligations; well, my present desire is to see Courbet achieve the triumph that he will forfeit if he treats it so lightly; for him triumph must be in Paris, in his work, and his work does not flourish in the languor of provincial life; moreover he falls so easily into these habits of idleness! . . . He is a child . . . who has to be led by the hand; his strength is concentrated wholly in his talent; the man is *weakness incarnate.* . . . At times I deplore his vacillation, his want of determination. *I fear* that some day he will feel a grudge against the Saintonge because of the time and repute he has wasted here, and against his friends for not having dared to admonish him: 'Animal, shake off your fleas!' But one cannot do that. He resents advice. Still I am going to make a vigorous attempt. I shall be doing him a great service if I can make him realize that he is committing suicide." [16]

Auguin's anxiety was groundless. While Courbet was apparently frittering away his time he was actually producing an immense amount of excellent work, but he painted so rapidly that he could well afford to spend many hours in idleness. Auguin must have known something about Courbet's achievement, for in that same January both painters took part in an exhibition, for the benefit of a local charity, installed in three rooms of the town hall at Saintes. Corot showed five pictures, Pradelles forty-two, Auguin sixty-four, and Courbet forty-three canvases (all executed in the Saintonge) and two bits of sculpture, female heads cast in plaster. After the exhibition opened

171

Courbet added ten more pictures, displayed in a fourth room. The show was highly successful, and Courbet sold a number of his exhibits to Baudry and other collectors in the region.

During his ten months in the Saintonge Courbet painted at least sixty pictures, including some of his best landscapes: *Banks of the Charente, Rabbit Warren at Bussac, Valley of Fond-Couverte, Rochemont Park, Banks of the Charente at Port-Bertaud;* several portraits, among them one of Corbinaud, a prominent citizen of Saintes, who rejected the picture on the ground that Courbet had portrayed him as much uglier than he really was; the *Milkmaid of Saintonge; Boatmen on the Charente* rowing under a canopy of trees overhanging the river; the *Trellis* (Plate 38) , also called *Young Girl Arranging Flowers;* and a remarkable series of still lifes of flowers: *Magnolias and other Flowers* (Plate 39) , *Flowers on a Bench* (Plate 40) , *Peonies, Branch of English Cherry Blossoms, English Cherry Blossoms and other Flowers.* Before this he had made two or three tentative attempts to paint flowers, but never on such a scale or so successfully. It will always be a matter for regret that he did not produce more of these beautiful sensitive still lifes, so much more decorative than many of his more ambitious and, in his own opinion, more significant works.

RETURN FROM THE CONFERENCE

EARLY in 1863 Courbet wrote to his family that he was paint-
ing a "subversive" picture at Saintes: "It is a large canvas . . .
nine or ten feet long by seven or eight high [the actual dimen-
sions were approximately eleven feet by seven feet eight
inches]; this picture is . . . satirical and comical to the last de-
gree. Everyone here is delighted with it. I shall not tell you
what the subject is; I shall show it to you at Ornans; it is almost
finished." [1] The picture was *Return from the Conference*
(Plate 41) , representing a group of extremely drunken and un-
dignified priests returning from an ecclesiastical assembly. Such
conferences were held every Monday at one or another of the
parishes in the vicinity of Ornans, and although Courbet
painted the picture in the Saintonge he reproduced from mem-
ory, in his landscape background, the valley of Bonnevaux
near Ornans.

At the head of the rowdy procession is a young abbé leading
by the bridle a diminutive donkey almost crushed under the
weight of a fat inebriated priest, who is prevented from falling
out of the saddle by the supporting arms of a young ecclesiastic

173

on one side and an old one on the other. Next in line is a seminary student, holding up with some difficulty an aged priest who stamps his feet and brandishes his cane in drunken fury. On the right a curé of coarser peasant stock, holding an umbrella, is about to kick the small dog yapping in front of him. Four women, presumably servants, bring up the rear; two carry baskets on their heads. At the extreme left a farm labourer gapes and guffaws at the raffish churchmen, but his wife, on her knees, appears to find the spectacle more painful than amusing. A statuette of the Virgin adorns a roadside shrine hollowed out of a tree, and in the distance are the steep hills and perpendicular cliffs of the Franche-Comté.

The studio in Baudry's château could not accommodate so large a canvas, and moreover Courbet did not want to embarrass his hospitable friend by painting under his roof a picture that was certain to cause a scandal. Suitable quarters were found in the grounds of the imperial stud farm just outside of Saintes, where construction of a residence for the farm's director had been stopped, for lack of funds, after completion of the walls and roof. Baudry persuaded the director to allow Courbet to install in this empty shell a studio where he could work unseen by the prying eyes of the devout townspeople. But the secret leaked out, and the shocked citizens protested so loudly that the director of the stud hastened to oust the painter and his offending canvas. Courbet then moved to Port-Bertaud, where he lodged and completed the picture in the house of the ferryman, *père* Faure. There too he barely escaped eviction when Faure saw the unfinished painting and recognized, or thought he recognized, his own likeness in one of the pictured priests. The ferryman flew into a rage and could not be pacified until Courbet, appropriately enough, had poured down his throat two or three bottles of wine.

One day Courbet invited a few carefully selected friends to see the picture, and the visitors were astonished to see a don-

key, the model for the overloaded animal in the painting, rolling in a heap of straw at the foot of the painter's bed. In one corner a curé's soutane had been draped over a lay figure. Courbet does not appear to have posed any human models for this picture, though a few of the heads have been somewhat dubiously identified: the features of the abbé leading the donkey were said to resemble those of a barrister of Saintes named Poitiers, and the prototype of the laughing peasant may have been the sculptor Arnold. On the other hand the inhabitants of Bonnevaux in the Franche-Comté claimed that all of the figures, though painted from memory, were recognizable as characters in their own village, and that this same peasant was a local ne'er-do-well named Boillon. The curé of Bonnevaux, Didier, identified himself with the drunken priest on the donkey. Didier was "an extraordinary man, of herculean strength, with a huge body, huge feet, an enormous belly. A native of Ornans, he possessed to a great extent the characteristics of that region. Courbet and Didier, former schoolmates at the little seminary, were good friends; they both loved the old wine of the valley, and drank it. . . . When the curé . . . saw the photograph [of *Return from the Conference*] . . . which Courbet handed to him with an inscription, he . . . said severely: 'Gustave, you should not have done this.' " [2]

Courbet had never attempted to conceal his anti-clerical views; he was highly pleased with his satirical presentation of ecclesiastics as graceless, gluttonous tosspots, and he anticipated with the impish delight of a naughty child the inevitable storm of criticism. Actually he had no good reason to be proud of himself; aside from its obvious poor taste *Return from the Conference,* as a painting, was perhaps the least successful of all his large canvases. Courbet's humour was too heavy-handed for satire; what Daumier's pencil might have drawn brilliantly and devastatingly, Courbet's thicker brush made merely gross.

Courbet returned to Paris in March. With what seems like deliberate perversity he sent to the Salon of 1863 none of the splendid landscapes and flower paintings he had produced in the Saintonge. Instead he submitted four mediocre works: *Return from the Conference,* the *Fox Hunt,* a portrait of a woman identified only as "Mme L——," and a plaster cast of the *Bullhead Fisher.* The *Fox Hunt* portrayed a mounted huntsman in a forest, with a beater and a barking bulldog. A year or two later Courbet eliminated both human figures and changed the title to the *Huntsman's Horse;* it is also known as *Hunting Horse and Bulldog in the Forest.*

So many works by so many distinguished painters were rejected that year that Napoleon III, hoping to appease the indignant artists, authorized a rival exhibition, the Salon des Refusés, to accommodate the excluded offerings. As Courbet had foreseen, *Return from the Conference* was rejected by the jury of the official Salon, and the picture was regarded with such extreme disfavour that he was not allowed to present it even at the Salon des Refusés. Not at all disconcerted, Courbet placed it on exhibition in his studio, where for several weeks it attracted a swarm of critics, journalists, collectors, and seekers after sensation. Afterwards it was shown in London and in many continental cities, in all of which it achieved a *succès de scandale* but added little to Courbet's repute as an artist. "As you will have seen in the newspapers," he wrote to his parents on July 28, "I have sold my picture of the *Curés,* which has caused a great stir . . . to an American financier. . . . The picture has been in London for a week." [3] But for some reason the sale fell through, and the painting was eventually purchased by a devout Catholic who promptly destroyed it, having bought it only for that purpose. Nothing survives today except photographs and a rough copy of the painting, presumably Courbet's preliminary sketch. In fact not all of the photographs escaped confiscation; in April 1867 Courbet

informed Castagnary: " The police have just arbitrarily destroyed the negatives of the *Curés,* I don't know by what authority." [4]

Most of the professional critics treated Courbet's three accepted exhibits with contempt. Even the benevolent Thoré was disappointed, though he deplored the rejection of *Return from the Conference:* "Master Courbet is not seen to advantage this year in a small hunting picture. It should be noted that one of his paintings of manners has been rejected on the pretext of moral corruption. . . . I do not think Courbet will grow more pious on that account. But even if he is a bad Catholic he is still a good painter." [5] "That painting should concern itself with contemporary morality," Thoré continued, "is what seems dangerous to the conservatives. To portray stone breakers, diggers, and others condemned to rough work, is not that already an indirect attack against the classes that possess everything and do nothing? And then, after having presented the virtues of the toilers, to dare to display the vices or even the absurdities of privileged castes! . . . So this time Courbet, having painted a picture representing members of an especially favoured class, has been rejected by the Salon jury even though his medal should have exempted him from such official judgement. Moreover he has been forbidden to exhibit his picture at the Salon des Refusés. On what ground? Respect for morality! . . . But what harm can one find in this picture? . . . Have not provincial curés always the best cellars in the neighbourhood?" [6]

Champfleury refrained from published comment but expressed his opinion forcibly in a series of letters to Buchon. "Courbet's picture of tipsy priests has been rejected," he wrote in April, "it was inevitable. I have not seen it; but I know what it is about; and in view of Courbet's clumsiness I do not consider the choice of subject a happy one. He lacks all kinds of Parisian qualities that might induce the public to swallow such a morsel. Is this a bid for notoriety or mere naïveté? It

will certainly cause a scandal." [7] After the opening of the Salon Champfleury wrote again: "Bad news! The Courbets are execrable, carelessly painted, without colour or drawing. An abominable hunting scene. Didn't the lout have any friends [to advise him] in the region in which he stayed so long without giving a sign of life? . . . The portrait of a woman [Mme L——], strange and unpleasant. . . . Now he should paint a very fine picture to make us forget these horrors; but I understand that Courbet's constitution has been seriously weakened by two apoplectic strokes. I know Courbet is weary of the struggle. Unfortunately endowed with provincial shrewdness, he does not know his Parisian public well enough though he tries to beguile it just the same. . . . Truly all his friends are appalled. He has not destroyed the fine things he has already produced, but now he is committing himself to excessive effort instead of following the placid routine of landscape painting. If I had seen him I should have told him plainly what I am writing to you. It would have been painful but necessary." [8]

The reference to apoplexy was presumably based on a rumour then current in Paris that Courbet had been stricken by that malady during his sojourn in the Saintonge. There was no truth in it, as Baudry explained long afterwards; nothing more serious had happened to Courbet than a few superficial bruises resulting from a tumble off the back of a donkey.

That Champfleury had not seen Courbet since the latter's return to Paris was evidence of the estrangement already existing between them. Subsequent meetings only made matters worse. "Courbet has tired too soon," Champfleury told Buchon in June, " painting bores him. . . . All this could be remedied. I said this to Courbet without equivocation. But the man is befuddled by the chatterers, idlers, and jesters who overwhelm him with compliments to his face and merely establish more firmly his already exaggerated conceit. . . . I am sorry for Courbet, who has a weak spirit in a strong body. Now he needs five or six years of solitude at Ornans to recover from

this setback; if he thinks he has saved the world by his painting, he is a lost soul." [9] A few weeks later the sparks flew: "Courbet and I have had half a quarrel. I made some comments about his picture [*Return from the Conference*]; naturally he said the next day that I had sold myself to the Government. Thereupon I wrote him what I thought of his future if he could not curb this monstrous pride, which I foresaw would lead to fatal consequences." [10]

Almost alone among the critics, Castagnary loyally praised the offending and undeserving picture: "The *Return from the Conference* has caused a scandal. In this country of invective, laughter, and raillery, satiric painting is accepted with reluctance. . . . But God forbid that I should here defend such a subject! My only aim is to assess its artistic value. This picture ranks high among the master's works; it is an excellent Courbet. The colour is beautiful and clear. If the drawing is careless in places, this defect vanishes when balanced against the authenticity of the features and the charming simplicity of the poses. Never in his career as a painter has Courbet achieved such felicity in composition. The eye is truly bewitched and enchanted. Our grandchildren will be amused by this witty and merry picture; why could not their parents be permitted to enjoy it today!" [11]

PIERRE-JOSEPH PROUDHON

COURBET informed his family in July 1863 that the statue of the *Bullhead Fisher* was being cast in iron and would be completed by the end of September. He asked his father to commission his friend Charles Lapoire of Ornans to design a basin for the fountain in which the statue was to stand. The unveiling would take place on October 1 and would be celebrated by a banquet and other festivities to be attended by friends and journalists from Paris. Courbet himself would be unable to return to Ornans until August or even later because he was collaborating with Proudhon in a new project: "We are working together on an important book linking my art to philosophy and his work to mine; it is a pamphlet to be sold at my exhibition in England, with his portrait in it as well as mine. Two men who have synthesised society, one by philosophy, the other by art, and both of us from the same region. I must write seven more pages for him before six o'clock." [1]

He added more details in a letter to Buchon: "I have never written so much in my life. If you could see me you would die laughing. I am smothered in papers; every day I send Proudhon five or ten pages on the æsthetics of contemporary art and of my own art that I am trying to establish. . . . Ultimately

we shall have a definitive treatise on modern art and the direction in which I have led it in accordance with Proudhon's philosophy." [2] But the unaccustomed intellectual work had so exhausted him, and he was suffering such discomfort from constipation and a severe recurrence of his chronic ailment, hæmorrhoids, that he took a ten-day holiday at the seaside resort of Fouras near Rochefort, where he met some of his Saintonge friends, bathed in the Bay of Biscay, and soon recovered his health.

Proudhon's treatise, originally planned as a brochure of 120 pages, eventually expanded into a thick volume of 376 pages entitled *Du Principe de l'art et de sa destination sociale,* published in 1865 a few months after the author's death. Of the twenty-five chapters fifteen were composed entirely by Proudhon; the others were edited posthumously from his notes by his literary executors. Seven chapters were devoted to the history of art from ancient Egypt to Delacroix and Ingres; a good deal of the later portion of the work dealt with contemporary French art, with particular emphasis on Courbet. Although Courbet flattered himself by calling the book a "collaboration," Proudhon himself minimized the painter's contribution: "One day when I was beginning to work on this book I told Courbet that I thought I knew him better than he knew himself; that I would analyse him, judge him, and reveal him as a whole to the public and to himself. That seemed to frighten him; he did not doubt that I would make mistake after mistake; he wrote me long letters to enlighten me, letters which taught me very little, and he tried to persuade me that I was not an artist. To which I replied that I was as much of an artist as he was, not as a painter but as a writer . . . and that I considered myself perfectly competent in such matters. That seemed to relieve him a little, and he no longer tried to do anything but represent himself to me as he thought he was, not quite the same thing as he really was." [3]

Nevertheless Courbet was convinced that his communica-

tions to Proudhon had been of paramount importance. He was reported, perhaps apocryphally, to have said: "It is a good book . . . but too long; he [Proudhon] put too much into it; I had not told him all that!" [4]

In spite of his claim to competence in the field of art Proudhon actually knew little and cared less about most phases of æsthetics. He completely ignored such essential elements as colour, drawing, composition; his sole concern was with the subject, and he was interested in the subject only as a manifestation of social philosophy. If a picture had social significance it was a good picture; if it had not, or if its "message" failed to conform to his own preconceptions, it was bad. Brushwork was irrelevant. To Proudhon a painting was not a painting but a tract, a thesis. As an analysis of art this ponderous, narrow-minded, doctrinaire work was almost worthless; as a social document it had considerable merit. Courbet interested Proudhon not as a painter but as the leader of a movement; *Return from the Conference* appealed to him not as a picture but as a symbol of rebellion against established concepts. The following extracts relating directly or indirectly to Courbet are taken from various sections of the book:

> I do not propose here to become the advocate or sponsor of M. Courbet's caprices. Let him be judged at his true value in conformity with the principles and rules of art. . . .[5]
>
> With regard to Courbet I say that those who have treated with contempt the more or less eccentric works of this artist, as well as those who have tried to praise them . . . have shown mediocre judgement. They have not known how to analyse and classify him; they have not understood that in painting . . . the idea is the principal, the dominant element. . . . Now what is Courbet's idea . . . in his work as a whole? . . . Instead of replying they have hastily raised a standard on which is writ-

ten . . . REALISM; the critics have led the campaign, and here is Courbet . . . turned into a kind of sphinx to which the progress of French art seems to have been attached for ten years. . . . No, Courbet is not a sphinx, and his pictures are not monsters.[6]

I define . . . art as *an idealistic representation of nature and of ourselves directed towards the physical and moral improvement of our species.*[7]

Because realism received its name from Courbet; because it is he who, by his talent and audacity, most forcefully expresses the present trend; because . . . it is his picture of the *Curés Returning from the Conference* that inspired this study, I shall be forgiven for giving particular consideration to this artist.[8]

We have said that the principle of art and its reason for existence are in a special faculty of man, the æsthetic faculty. It follows that art cannot exist in the absence of truth and justice; that science and morality are its guides; that it is in fact but an auxiliary to them; that therefore its first law is respect for ethics and reason. On the other hand the old schools, both classic and romantic, maintain . . . that art is independent of all moral and philosophical controls, that it exists for itself. . . .[9]

It is against this degrading theory of art for art's sake that Courbet, and with him the whole school now called realist, boldly rebel and energetically protest. . . . The aim of art is to guide us to a knowledge of ourselves through the revelation of all our thoughts . . . all our tendencies, our virtues, our vices, our absurdities, and thus to contribute to the development of our dignity, to the improvement of our personalities.[10]

What Courbet wanted to present [in *Return from the Conference*] was not a more or less amusing scene of intoxication; it was not even the contrast . . . between sacerdotal decorum and an infraction of the rules of tem-

perance. . . . What Courbet wanted to demonstrate
. . . was the complete powerlessness of religious disci-
pline . . . to sustain the rigid virtue demanded of a
priest . . . and that the priest who sins is the victim of
his profession rather than a hypocrite or an apostate.[11]

I have not commented on the defects in his works: the
lack of perspective and proportion; certain flat dark tones
. . . certain carelessnesses . . . a tendency to caricature
. . . sometimes *brutality;* something shocking that pro-
ceeds, in my opinion, from a lack of complete integrity
with respect to his art and his principles. I shall not dis-
cuss the technicalities of the craft; I have no authority to
do so. I keep to my own field, the idea behind the work
and the school. . . .[12]

Courbet, more of an artist than a philosopher, has not
had all the thoughts I have expressed. . . . Certainly he
did not consciously put into his *Curés* the implications I
have seen and indicated. . . . But granting that what I
believed I saw in these figures was an illusion on my part,
the idea remains. . . .[13]

Courbet is a true artist in talent, habits, and tempera-
ment, and as such he has his pretensions, prejudices, and
errors. . . . Gifted with a vigorous and broad intelli-
gence, he has the mind of a man of the world; neverthe-
less he is nothing but a painter; he can neither talk nor
write; classical studies have left few traces on him. Though
he is built like a Hercules, the pen is as heavy in his hand
as an iron bar in the hand of a child. Though he talks a
great deal, his thoughts are disconnected; he has unre-
lated intuitions, more or less true, sometimes logical,
often sophistical. . . . One may define Courbet: 'A very
intelligent man, all of whose faculties are concentrated
in a single faculty.' . . . Courbet calls himself the most
personal and most independent of artists. Yes, independ-
ent in temperament, in character, in will, like spoilt chil-

dren who do only what they please. Yes, personal in the sense that he is too often concerned with himself and somewhat arrogant in his vanity; what is most unworthy in his pictures is precisely what betrays his own personality. . . . Courbet invented neither realism nor idealism, any more than he invented nature. . . . The truth is that . . . Courbet, in his realism, is one of the greatest idealists we have. . . .[14]

Although Proudhon's insistence upon the social function of art has long since been discredited, he displayed remarkably keen insight in his analysis of Courbet's character, if not always of his work. Nevertheless Emile Zola objected strenuously to Proudhon's treatment of the painter: "First of all . . . I am distressed to see Courbet involved in this affair. I wish Proudhon had chosen for his example another artist, some painter without any talent. . . . Moreover the philosopher has travestied Courbet. . . . Proudhon's Courbet is an odd character who wields his brush as a village schoolmaster wields his ferule. The least of his pictures, it would seem, is pregnant with irony and instruction. . . . I admit that some of his canvases might appear to have satirical intentions. . . . To me Courbet is simply a personality. . . . If Courbet, who is said to be very conceited, derives his conceit from the lessons he thinks he is teaching us, I am tempted to send him back to school. He should know that he is nothing but a poor, great, and very ignorant man. . . . He has nothing but the genius of truth and power. Let him be content with what he has. . . . Courbet is the only painter of our era; he belongs to the group of painters of flesh; his brothers are . . . Veronese, Rembrandt, Titian. Proudhon has seen his pictures and so have I . . . but he has seen them differently, ignoring all brushwork, from the standpoint of idea alone. A painting for him is a subject; paint it in red or green, it makes little difference to him! . . . I admire Courbet absolutely, while Proudhon admires

him only relatively. . . . His [Proudhon's] *rational art,* his realism, is in fact only a negation of art. . . . My art, on the contrary, is a negation of society, an affirmation of the individual, free of all rules and of all social demands." [15]

Naturally Courbet himself was delighted with the book, which he considered entirely a tribute to his own work; the chapters in which he was not mentioned made no impression on him. "It is the most wonderful thing one could possibly imagine," he wrote to Castagnary, "and it is the greatest boon and the greatest honour that a man could wish for in his whole life. Such a thing has never happened to anyone before. Such a volume by such a man on the subject of one individual! It's stupendous. All Paris is jealous and agape. This will add to my enemies and make of me a man without an equal." [16]

Courbet left Paris for Ornans in the autumn of 1863. The sensation produced by *Return from the Conference* had stimulated rather than discouraged him, and he resolved to paint at least two more pictures satirizing ecclesiastical foibles; but these never progressed beyond the stage of sketches. Instead he painted several less controversial canvases: a portrait of his friend Félix Gaudy, a wealthy landowner and enthusiastic huntsman; *Towing on the Banks of the Loue;* and the *Woman at the Spring,* a nude seen from the back, dipping one foot in a stream and holding her hand under a sparkling waterfall, a much slenderer and more graceful figure than the mountainous *Bather* of 1853. "Courbet is probably at Ornans now," Champfleury wrote to Buchon in November. "If you see him, try to keep him in the country as long as possible. He needs to refresh himself in contact with nature. He told Sainte-Beuve he wanted to paint another picture of curés. In my opinion that would be a mistake. . . . Courbet should paint simple subjects, landscapes of his own province; those are his true vocation; but great gods! Let him avoid symbolism and satire for which he has no talent!" [17]

Champfleury was right; Courbet's landscapes, portraits, and still lifes were far more successful than his painted commentaries on society. But the painter himself disagreed and was already at work on another large picture, the *Fountain of Hippocrene,* an allegory satirizing romantic poetry, into which he introduced the likenesses of several friends and acquaintances, including Baudelaire, Pierre Dupont, and Théophile Gautier. The painting was never completed, for reasons set forth in a letter written to Castagnary on January 18, 1864: "My life is a series of accidents. I had started an *epic* picture, a serious though comic satire; I had finished two-thirds of this picture which I intended to show at the approaching exhibition [the Salon of 1864], when yesterday, Sunday, I went to dine with one of my friends at some distance from Ornans; during my absence somebody [his sister Juliette] entered my studio; one foot of my easel was touching the door behind it, so that as soon as the door opened it knocked over the topheavy canvas and easel, and the chair I sit on went right through the canvas. Farewell, picture; I have no time to begin it again. The picture was a satire on modern poets, whom I portrayed in the act of drinking from the fount of Hippocrene in the sacred valley watered by the springs of Castalia and Permessus. Farewell, Apollo; farewell, Muses; farewell, beautiful valley I had created; farewell, Lamartine with wallet and lyre; farewell, Baudelaire with notes in hand, Dupont drinking, Mathieu with his guitar and sailor hat. Monselet was with them but remained sceptical. The fountain, invisible to Apollo's modern disciples, was visible in the foreground to the public. It was personified by a very beautiful nude woman (like the *Springs* of M. Ingres) , a handsome model from Paris, lying on a mossy rock and spitting into the water that was poisoning all the drinkers, some of whom were already hanged while others drowned. Gautier himself was smoking a chibouk beside a singing girl. I cannot describe everything, for if one could explain pictures, translate them into words, there would be no

need to paint them. Farewell, harsh criticism; farewell, recriminations; farewell, the poet's hatred of realism. The forthcoming exhibition will once more lack gaiety. . . . Nevertheless I shall not fail to be represented. . . . I shall begin a new picture. . . . Here I am enjoying a fine winter in the country." [18]

The new work was *Venus Tormenting Psyche by her Jealousy,* later retitled the *Awakening* (Plate 42). Psyche, blonde and nude, lies on a huge four-poster bed while the darker-skinned Venus lifts the curtain and glares malevolently at the sleeping girl. As Courbet had already imported a model from Paris for the ill-fated *Fountain of Hippocrene* he probably used her for one or perhaps both of these figures. Courbet had so often and so forcibly expressed his distaste for mythological subjects that Castagnary and other friends suspected that he had deliberately chosen the title in order to mislead the jury; that the picture had contemporary moral significance as a castigation of Lesbianism, and that the expression on the heavy features of Venus denoted not animosity but lust. Whether or not this interpretation was correct—as it may well have been—the picture was rejected by the Salon, notwithstanding the immunity theoretically guaranteed by Courbet's three medals, for the same reason that *Return from the Conference* had been rejected the year before: offence against morality. "Patience!" commented Thoré. "Courbet will arrive in the course of time even if his picture has been rejected. . . . Yet there are no curés in this new scandal, only women, women of our own day, who are doing—what they want to do. . . . The women of mythology and the Bible have the right to do as they please. . . . But for a mere nothing the young women of the Seine are accused of indecency." [19]

Courbet remained in the Franche-Comté during most of 1864, a phenomenally productive year. He painted at least a dozen landscapes in the vicinity of Ornans, including four versions of the *Banks of the Loue;* the *Valley of Chauveroche;* *Cascade of Siratu* near Mouthier; *Oak at Flagey; Mill Bridge*

at the source of the Loue; the *Crumbling Rock* near Salins, painted in three hours on a freezing afternoon at the request of the local geologist Jules Marcou, who had given Courbet the primitive weapons for his Ornans studio; *Rapids of the Doubs* near Morteau; and *Source of the Lison*. He also painted four or five hunting scenes, including *Poachers in the Snow;* and at Pontarlier, where he visited the recently married Charles and Lydie Jolicler, he executed the portrait of Lydie already mentioned and two landscapes: *Poncets Farm* and *Fir Trees.*

On one of these painting excursions Courbet was moved to make a generous gesture in behalf of an old friend, Charles Pouchon, which he recounted in a letter to his Parisian picture dealer, Luquet: "Passing through Mouthier I met poor Ponchon [*sic* in the printed version], the vine-grower and painter. This unfortunate man has a curious talent; he is like Holbein in his naïveté. I bought from him two small still lifes of fruit, though I have no need of pictures. One can't let a colleague starve to death, especially a colleague from one's own province. I shall send them to you to be sold; I recommend them to you particularly. To shame the rich people of the valley I paid him three hundred francs. . . . You will be doing a worthy act, and you may be sure M. Ingres could not do such still lifes and M. Flandrin could not produce the portraits he paints. But this man lives on charity, and when he has to pay for his own dinner he eats bread and garlic and a few nuts he is able to pick up." [20]

SALINS

AT the end of September 1864 Max Buchon, hearing that Courbet was painting near the village of Nans-sous-Sainte-Anne some ten miles from Salins, sent the sculptor Max Claudet and another friend—possibly Charles Toubin, former associate of Baudelaire and Champfleury as editor of the short-lived *Salut Public*—to invite the painter to visit him. Courbet accepted with pleasure, but insisted that he must first finish a landscape, *Source of the Lison,* and started off with Jérôme, the donkey he had bought to pull a cart containing his painting paraphernalia. His friends followed as soon as they had finished their lunch. "We . . . found the painter in a field facing the spring," Claudet reported, "with his canvas on the easel and Jérôme placidly grazing. . . . The wind was blowing hard, and just as we arrived the canvas fell over and . . . a projection on the easel went right through it. 'That's nothing,' said the painter. He turned it over, smeared pigment on the tear, and stuck paper over it, saying: 'It won't show.' . . . My companion . . . brought a heavy ladder which we set up and steadied as firmly as we could with bits of wood and large stones. Thus the painter could begin to work without fear of another mishap. 'You are surprised that my canvas is

black,' he said. 'Nature without sunlight is dark and dim; I do as light does, I pick out the salient spots, and the picture is done.' . . . At four the painting was finished. . . . Scarcely two hours of work to complete a canvas a metre wide! 'Now,' said Courbet, 'off we go to Salins!' All the equipment was stowed in the little cart; when the canvas was firmly tied on behind, we hitched up Jérôme who appeared annoyed by the interruption to his dinner. . . . At the village we picked up another donkey to help Jérôme, for the road ascended for six kilometres, and we followed on foot. . . . At the top we sent back the extra animal, and as the descent was ten kilometres long Courbet said: 'We must all ride in the cart.' So the three of us sat squashed like herrings, for master Courbet took up plenty of room. The donkey trotted down the hill; night fell, and we were soon in sight of Salins. . . . An ox-cart carrying a cask of wine came towards us; we swerved to the right to pass it, but the donkey took fright and . . . started off at a gallop. Courbet pulled on the reins so hard that the left one broke and the right one abruptly turned the donkey towards the precipice. The donkey, the passengers, and the cart went over the edge, but fortunately the two rear wheels caught on the parapet and held us suspended over the abyss. We . . . dragged back the donkey, the cart, and the picture; no damage was done. We went on more prudently without climbing into the cart again. . . . Buchon was waiting for us with a good supper which we ate with hearty appetites while we merrily narrated our misadventures." [1]

According to Castagnary, Courbet sometimes amused himself and his friends by ascribing to Jérôme the sagacity of a man and the discrimination of an artist: "He was a pretty animal, with a black hide, full of fire. . . . Courbet told fantastic stories about Gérôme [*sic*]. Gérôme could gallop like a horse, and the most arduous journeys never tired him. He knew the countryside better than his master, and on most occasions it was he who chose the scene to be painted. . . . Gérôme's

judgement was unerring; there was nothing left for Courbet to do but set up his equipment and paint. When Gérôme thought that his master had painted long enough and that it was time to go home he would tug at Courbet's sleeve. . . . Sometimes, growing impatient, he would poke his head between the two legs of the easel and run off with the canvas. Courbet would run after it. . . ." [2]

Courbet "was the most casual person imaginable," Claudet continued. "When he came to Salins . . . he intended to stay a week; three months later he was still there. His luggage consisted of the donkey and cart, a shirt and two pairs of socks; as to other clothing, he had only what he wore. When the cold weather came he bought a blanket from a Jew in the market; he had a hole cut in the middle for his head to go through, and that was his winter overcoat." [3]

Max Claudet, born in 1840, shared both Courbet's faith in realism and his disapproval of academic instruction. Except for a year of apprenticeship in the studio of a sculptor at Dijon and a few months of study in Paris Claudet was self-taught, "a practical philosopher who creates art, breeds animals, plants trees, cultivates his garden." [4] Some time later he installed a small kiln at Salins for the manufacture of provincial pottery. During Courbet's sojourn at Salins Claudet executed a medallion of the painter; he also modelled a bust of Buchon which now adorns the writer's tomb. Courbet himself produced a plaster medallion of Buchon's wife, whom he called the "mother of realism" [5] and whose animated features reminded him of a "swarm of mice." [6]

"I am delighted to hear that Courbet is working," Champfleury wrote to Buchon in October. "This rural environment will be better and healthier for him than the brasseries of Paris. I hope the country will make him forget his rôle of *saviour of the world* through painting; he is a robust painter, an excellent painter. So let him remain what nature made him, nothing but a painter." [7]

Max Buchon corresponded frequently with Victor Hugo, then in self-imposed exile at Hauteville House on the island of Guernsey, where he had taken refuge to escape punishment for his outspoken opposition to the imperial régime. In order to bring his two friends together and if possible to obtain permission for Courbet to paint Hugo's portrait, Buchon persuaded the painter to write to Hugo from Salins. The literary quality of the letter suggests that Buchon either dictated or carefully edited the document: "As you have said, I have the fierce independence of the mountaineer; I think it would be appropriate to inscribe on my tombstone, in the words of our friend Buchon: *Courbet sans courbettes* [Courbet without cringing]. You know better than anyone, poet, that our province is fortunately the reservoir in France of men who are sometimes subject to upheaval like the land to which they belong, but who also are often carved in granite. Do not exaggerate my value; the little I have done was difficult to do. By the time my friends and I had arrived you had already conquered the whole world like a merciful and just Cæsar. In your youth you and Delacroix did not have to labour, as I did, under the edict of the empire: *no prosperity except by our authority*. No warrants were issued for your arrest, your mothers did not build hiding-places in your houses, as mine did, to conceal you from the police. Delacroix has never seen soldiers break into his house and ruin his pictures with a bucket of kerosene by order of a cabinet minister. His works were not arbitrarily excluded from the exposition [of 1855], he was not obliged to show his pictures in ridiculous hovels outside of the exposition galleries, the official speeches of each year have not singled him out for public disparagement; he has not, as I have, had a pack of bastard hounds yelping at his heels by order of their masters, bastards themselves. Your struggles were concerned with art, questions of principle; you were not threatened with proscription. The pigs have tried to devour democratic art in its cradle; but as it grows, democratic art will

devour them. In spite of the oppression that burdens our generation, in spite of the exile of my friends who were hunted by hounds through the forests of the Morvan [a region in the department of Nièvre], there are still four or five of us left. . . . We are strong enough in spite of the renegades, in spite of the France of today and its silly sheep; we shall save art, intellect, and integrity in our country. Yes, I shall come to see you, I owe it to my conscience to make that pilgrimage. With your *Châtiments* [a satire published in 1853] you have half avenged me. I shall contemplate the spectacle of your sea in front of your charming retreat. Our mountain regions also provide scenes of unlimited vastness; the emptiness one cannot fill brings calm to the spirit. I confess, poet, I love solid ground and the orchestra of the flocks that inhabit our mountains. The sea! The sea! With all its beauty it saddens me! In its joyous moods it reminds me of a laughing tiger; in its melancholy moods it suggests crocodile tears, and in its howling fury a caged monster that cannot devour me. Yes, yes, I shall come, though I do not know to what extent I shall prove worthy of the honour you will do me by posing for me." [8]

It was an odd letter; Courbet's preoccupation with himself often caused him to minimize the tribulations of others. Actually Hugo had suffered far more for his political beliefs than Courbet had; and at the beginning of his career Delacroix had been obliged to struggle against the bitter opposition of the classicists. Hugo replied graciously: "Thank you, dear great painter. I accept your offer. The doors of Hauteville House stand wide open. Come when you please (except in June and July). I entrust to you my head and my thoughts. You will produce a masterpiece, I am sure. I like your proud brush and your courageous spirit." [9] But Courbet never went to Guernsey. The poet and the painter met for the first time, after Hugo's return to France, at the funeral of the latter's son Charles in the cemetery of Père-Lachaise on March 18, 1871. Hugo described the encounter: "Between two tombstones a

large hand was extended towards me and a voice said: 'I am Courbet.' At the same time I saw an animated and cordial face smiling at me with a tear in the eye. I clasped the hand heartily. It was the first time I saw Courbet." [10]

Courbet remained at Salins so much longer than he had planned to stay that his father came twice from Flagey to urge him to return to Ornans. In December 1864 Castagnary proposed to join him, a suggestion heartily welcomed by the painter in a letter dated December 10: "On Monday I am going to do a portrait of a lady [Mme Alfred Bouvet, whose three-year-old daughter Beatrice he had just painted] which will take several days. Therefore, since I cannot devote myself to you [at present], come to Salins in four or five days. Buchon will be very happy to make your acquaintance." [11] Four days later he wrote again: "In two or three days I shall be free; it will be most convenient for you to come to Salins, the railway will bring you right there. Thence . . . we shall go to Ornans. On the way I shall show you a great deal of the picturesque scenery of our district. I have with me the donkey and the landscape cart which will carry us; you will see Salins . . . Alaise . . . Nans and the source of the Lison. From there we shall go to see my mother at Flagey . . . we shall spend the night there, then proceed to my atelier at Ornans. Your arrival will give pleasure to everybody." [12] Castagnary left Paris on December 20 and spent about ten days in the Franche-Comté.

The unexpected news of Proudhon's death on January 16, 1865 shocked and grieved Courbet, who wrote to Castagnary: "In my sorrow caused by the irreparable misfortune that has befallen us, I nevertheless want to paint a historic portrait of my intimate friend, the man of the nineteenth century; I shall give my best to it. I have been promising him to do it for ten years. Please send me . . . the death-mask described in the *Moniteur*. . . . Send me what [photographs] my friend Carjat has taken. Ask him . . . to ask Reutlinger . . . for the large

photograph he [Reutlinger] took of the philosopher in the pose I suggested. Send me all this as soon as possible. . . . I want to represent him . . . with his wife and children. . . . I am giving up everything else for the present, I am waiting for these documents; if there is any painted portrait of him, no matter how bad, tell Chaudey or his [Proudhon's] wife to send it to me. . . ." [13]

To the attorney Gustave Chaudey, one of Proudhon's closest friends, Courbet wrote from Ornans on January 24: "The nineteenth century has just lost its pilot. . . . We remain without a guide; humanity and the revolution, adrift without his leadership, will once more fall into the hands of the military and the barbarians. . . . As to myself, I am in a state of mental prostration and discouragement such as I have known but once before in my life—on December 2 [1851, date of the *coup d'état*], when I took to my bed and vomited steadily for three days. . . . I cannot understand why you are leaving his head [Proudhon's death-mask] in the clay when I need it so badly. Have a cast made as soon as possible and send it to me in a tin box; not only do I want to paint his portrait but I also want to model a statue of him sitting on a bench in the Bois de Boulogne, where I used to talk with him every day, and I want to inscribe on the base an epitaph I have composed: 'Wiser than men, his knowledge and courage were beyond compare.' " [14]

The sculpture was never executed, but as soon as the "documents" arrived Courbet started work on a large painting, *Proudhon and his Family* (Plate 44), which he completed in thirty-six days. Carjat had sent not only the photographs taken by himself and Reutlinger but also a photograph of the death-mask and one of a portrait of Proudhon painted in 1860 or 1861 by a Belgian artist, Georges-Paul-Amédée Bourson. From these sources Courbet composed his picture representing the members of the family as they had appeared in 1853 in the garden of the house at 83 rue d'Enfer (now rue Denfert-

Rochereau) in which the Proudhons occupied the ground floor. In the painting the bearded philosopher, wearing blue trousers and a grey workman's smock, is seated on the steps leading to the garden, surrounded by books and papers. His eldest daughter, Catherine, three years old in 1853, sits in a little chair and tries to decipher the letters of the alphabet, while a younger child, Marcelle, plays on the ground. Marcelle had died of cholera in 1854, more than ten years before the picture was painted; Catherine, afterwards Mme Louis-Félix Henneguy, died in 1947 at the age of ninety-seven, one of the last people who clearly remembered Courbet.

In the picture as originally painted (Plate 43) Mme Proudhon, pregnant in 1853 with her third daughter, Stéphanie, occupied an armchair on the right; but in 1866 Courbet painted out her image and substituted for it a heap of garments piled carelessly in a sewing basket. He had never been satisfied with the likeness of Mme Proudhon, which he called "provisional"; after his return to Paris in the spring of 1865 he painted a separate portrait of her, intending to incorporate it in the larger picture, but in the end he decided to eliminate her altogether. At the same time he replaced the wall of the house behind the figure of Proudhon with a grove of leafy trees, removed the top step, and inscribed, on the riser of the step below, the initials P. J. P. and the date 1853. Because the bottom step already bore Courbet's signature and another date, 1865, many biographers have assumed that Courbet actually started the picture in 1853 and completed it twelve years later. It is possible that he had made a rough sketch in 1853, but even that is unlikely; Proudhon never consented to pose for him, and for the portrait of the philosopher in the *Atelier* he had been obliged to use an engraving by some other artist. Had Courbet possessed in 1865 his own portrait of Proudhon he would not have needed the photographs he so urgently demanded.

Courbet produced two other portraits of Proudhon after the

philosopher's death: one of the bust only, to serve as a pendant to the portrait of Mme Proudhon, the other a drawing of *Proudhon on his Deathbed* which Courbet executed to illustrate an issue of *La Rue,* edited by Jules Vallès, in 1868; but the journal was suppressed and the drawing was not published.

Proudhon and his Family may have been a labour of love, but it is one of Courbet's poorest paintings. The figures are detached from the background, the composition is awkward, and the work as a whole has an artificial appearance as if pieced together from photographs, as it was. At the Salon of 1865 it received an enormous amount of attention but almost no praise. Even Thoré found it "very curious and very precious, very ugly and very badly painted. I do not think I have ever seen such a poor picture by Courbet. . . . Most astonishing . . . are the feebleness of execution and the vulgarity of the total effect." [15]

As might have been expected, Champfleury detested the picture. In April 1865 he attempted to explain to Buchon the gradual estrangement between himself and the painter: "One word in your last letter upset me: you accuse me of wanting to *control* Courbet. This time I must explain myself frankly. . . . One cannot be associated with a man for fifteen years, spending almost eight hours a day with him, without loving and understanding him. When I lost touch with Courbet it was in order to isolate myself, to think, study, work, and try to improve myself. Courbet has continued his night-owl existence which I never shared, and I have come to realize that, gifted with great talents as a painter, he has let them drown in beer. . . . Courbet's stomach was too strong, mine too weak. . . . Just think how advantageous to me Courbet's success would have been! We are of the same age, we have fought side by side. For a long time his name was coupled with mine, my name with his; and certainly we have both lost some of our power by separating. I resolved never to write a word that might offend Courbet, but notwithstanding our friendship I could

find nothing to say with my pen that would have pleased him. Note that it is not precisely the subjects selected by Courbet that shock me. If they were painted with sufficient skill it would make little difference to me whether he portrayed a bather, a group of curés, or Proudhon's family; but the man, being at heart instinctively aware of the decadence of his brushwork, tries to make up for it by choosing sensational subjects. And that is why, in the opinion of even those friends who have a material interest in defending him, this picture of Proudhon will do him a great deal of harm. . . . I shall see Courbet again without resentment . . . but I think it will be difficult for me to defend him with my pen in the future." [16]

This is the last item in the published series of Champfleury's letters to Buchon. Whether or not it actually ended their long correspondence is uncertain, but it may well have; Buchon sided with Courbet, and his friendship with Champfleury undoubtedly cooled if it did not terminate altogether. Between Courbet and Champfleury the break was final, but they had been drifting apart for so many years that the change was almost imperceptible. No record exists of any subsequent encounters, though they may have met from time to time by chance at exhibitions or other public gatherings.

Between January and March 1865 Courbet completed several half-finished landscapes, including one of his many views of the *Rivulet of the Puits Noir* (Plate 45), and sent either this or another version of the same subject to the Salon together with *Proudhon and his Family*. Making due allowances for seasonal changes in foliage and water level, a comparison of the landscape with a photograph taken in 1949 (Plate 46) demonstrates Courbet's fidelity to the forms of nature.

In the spring he went to Besançon to contribute a picture to a local lottery, presumably for charity. There he saw in an exhibition a still life of flowers by a certain Céline N— (surname unknown) of Lons-le-Saulnier. Apparently Courbet

had met her before the exhibition; in any event he fancied himself in love and, despite all his vows to remain a bachelor, wrote an uncharacteristically sentimental letter to his confidante Lydie Jolicler, asking her to arrange a marriage between him and Céline. The letter was sent from Ornans on April 15: "Now my dear Lydie, I confess I see a cloudless horizon ahead. You who are my go-between, the custodian of my happiness, you who hold my future in your hands, you who can change the course of my life with a word or a gesture; fly, lovely carrier pigeon, fly as fast as your wings will take you to Lons-le-Saulnier and bring me back a bird of paradise like yourself. The season is ripe, every bird is building its nest. At the exhibition at Besançon I saw the flowers painted by the bird who enchants me by day, who enchants me by night; I shall plant as many groves as possible at Ornans to persuade her to build her nest there. Dear lady, you who can do whatever you please, fly, fly! Let us hope that we [Céline and I] may beget a generation of painters and artists of all kinds, we shall produce a more intelligent race than the one now existing in our country. The activity demanded by the kind of life I have made for myself exhausts me, I should like someone to help and comfort me; my liberty is very precious, but birds love freedom; it is what gives them their charm, and their adornment is their own plumage so they owe nothing to anybody. . . . But go, but go, beautiful lady; in my impatience, it seems to me that you do not stir. Forgive me for not having come to Pontarlier sooner; *had I but wings,* as the saying goes, I should already have made a hundred flights to you know where. But how difficult life is, how troublesome and wasteful; I had to go to Besançon, they wanted me to paint a picture for their lottery; I did two or three, now I am free for the moment. Next Tuesday I shall go to Pontarlier. . . ." [17]

One wonders why Courbet needed Mme Jolicler's intervention, why he did not go to Lons-le-Saulnier and woo the lady himself. Instead he went to Paris, whence he wrote to Lydie

again in June: "You will see how unlucky I am, in the first place because I could not see you in Paris, in the second because I have just answered a letter from Stéphanie [Stéphanie's identity is unknown; perhaps she was Céline's sister] and in my haste I again forgot to ask for Céline's portrait [probably a photograph], I forgot to send them mine and to give them my address in Paris; one would think I had gone completely mad. Céline is more eager than I am, that is as it should be, she must be the one who wants it [marriage] if she is to be happy. I am too fat! I am too old! Those are the awful facts; nevertheless . . . I am one of the youngest of my contemporaries among those who are well known or famous. It is impossible to become a success, except as a notary, until one has done some work. But that [Courbet's age, forty-six] must be unimportant to her, since she thought of marrying M. de Lamartine [the writer and politician Alphonse de Lamartine was then seventy-five; his wife had died in 1863]. As to my corpulence, alas! Marriage will take care of that, the duties of a husband and the lack of opportunities to drink beer will be enough. . . . I sent these ladies two pictures, one for Stéphanie and the other for Céline, but I want the one from her exhibition and I told them that if our plans should come to nothing I should at least have the picture as a souvenir; and I also told them that if this should end in disappointment I should kill that little devil of a Lydie, because you know you are the scapegoat . . . and there must always be a victim. . . . I have been cordially welcomed [in Paris] by everyone, and all of my [former] pupils came to invite me to dine with them." [18]

This seems to be the nearest Courbet ever came to marriage. For some reason the plan progressed no further, and Courbet soon forgot his infatuation. By November he was writing to his family that he was tired of all such nonsense and wanted to hear no more about it.

TROUVILLE

LATE in the summer of 1865 Courbet went to Trouville, where he remained three months—exceedingly busy months during which he painted between thirty-five and forty pictures. Twenty-five of these, some with figures, some without, were seascapes, which he preferred to call *paysages de mer*, sea land-scapes. They included the *Villa of Mme de Morny at Deau-ville, Sunset on the Rocks at Trouville*, the *Isolated Rock, View of Trouville*, the *Black Rocks*, the *Storm, Departure of the Fishing Fleet*, the *Fisherman's Boat, Girl with Sea-Gulls*, and *Girl in a Canoe*. In spite of what he had written to Victor Hugo concerning his preference for mountain scenery, the sea always fascinated Courbet; and these Trouville seascapes, full of light and air and without a trace of social significance, rank among his most pleasing works. In addition he painted a num-ber of portraits of fashionable ladies with whom he had be-come acquainted at Trouville, among them Mlle Aubé, the Hungarian Princess Karoly, and the Duchess Colonna di Cas-tiglione, *née* Adèle d'Affry, a sculptress who signed her work with the pseudonym Marcello.

Courbet's plunge into smart society demanded a more elab-orate wardrobe than he had brought with him. On September 8 he wrote (Plate 36) from the Hôtel de France, Trouville, to

Bain, his concierge at 32 rue Hautefeuille: "I am obliged to remain here for some time longer, I have an enormous amount of work to do. I have already painted two portraits and begun a large picture. I have done two landscapes and shall do more. By chance I painted the portrait of a Hungarian princess, it was so successful that now I have so many visitors that I cannot work. All the other ladies want me to paint their portraits. I shall do one or two or three to satisfy the most insistent ones. Therefore you must send me some clothes; I think that under the piano there is a box in which you can pack my black tail-coat, my trousers with the small checks, my lilac-tinted waist-coat, my overcoat made of *orléans* [a light wool-and-cotton cloth], and as many shirts, socks, and handkerchiefs as possible. I shall be much obliged if you will send these by express tomorrow, I think you need only deliver them to the omnibus in the Place Saint-André-des-Arts [a few yards from Courbet's studio]. Greetings to everyone. I expect to remain here three more weeks, the sea is delightful." [1]

But the weeks went by, and Courbet was still at Trouville when he wrote to his parents on November 17: "My fame has doubled and I have become acquainted with everybody who might be of use to me. I have received more than two thousand [!] ladies in my studio, all of whom wish me to paint their portraits. . . . Besides the portraits of women I have done two of men and many sea landscapes. . . . I have bathed in the sea eighty times. Only six days ago we bathed with the painter Whistler who is here with me; he is an Englishman who is my pupil." [2]

Of course James McNeill Whistler was American, not English; nor had he ever been Courbet's "pupil." Whistler had come to Paris at the age of twenty-one just in time to see Courbet's one-man exhibition in 1855. During the following decade they met several times, and Courbet's influence was clearly evident in the younger painter's early work. By 1865 that influence had declined, though the artists were still good friends;

but two years later Whistler flatly denied that any such influence had ever existed. "Courbet and his influence were disgusting," he wrote to Fantin-Latour in the autumn of 1867. "The regret and rage and even hatred I feel for that now would perhaps astonish you, but here is the explanation. It isn't poor Courbet who is loathsome to me, or his works either. I admit, as always, their qualities. Nor am I complaining of the influence of his painting on mine. It has had none, and none will be found in my canvases. It couldn't be otherwise, for I am very personal and I was rich in qualities which he had not and which were adequate for me. But this is why all that was extremely harmful to me. It is because that damned Realism made an immediate appeal to my painter's vanity and, disregarding all traditions, cried aloud to me with the assurance of ignorance: 'Long live Nature!' Nature, my dear fellow, that cry was a great misfortune for me." [3]

At Trouville Whistler was accompanied by Joanna Heffernan (afterwards Mrs Abbott), a beautiful Irish girl with magnificent copper-coloured hair who had been his model as well as his mistress for about five years. Courbet had probably met Jo, as she was always called, in Paris in 1861 or 1862 while Whistler was painting her as the *White Girl*. In 1865 at Trouville Whistler permitted her to sit for Courbet, who painted a portrait of Jo looking in a mirror, entitled the *Beautiful Irishwoman* (Plate 47). Subsequently he made two almost identical copies of this portrait.

About November 20 Courbet returned to Paris, whence he wrote to Castagnary on January 3, 1866: "I acquired an immense reputation at Trouville with my portraits of ladies and views of the sea. . . . Now I am enjoying an incredible success in Paris. In the end I shall be without a rival; with determination one can achieve anything. The Comte de Choiseul and his sister the Marquise de Montalembert have just left my studio. They bought some sea landscapes. Father Hyacinthe has men-

tioned me in his lectures at Notre-Dame." [4] Charles Loyson, known as Father Hyacinthe, was a Carmelite friar whose aim was to reconcile Catholic dogmas with modern science. His eloquent sermons in the cathedral of Notre-Dame were exceedingly popular, but his opposition to the dogma of papal infallibility brought about his excommunication in 1870. He lived in Geneva and London for several years, married an English or American lady, and returned to Paris in 1877 to found an Old Catholic church, in which he continued to officiate notwithstanding his marriage.

During January Courbet wrote somewhat less jauntily to Alfred Bruyas, from whom he had heard nothing for a long time: "I have written to you once or twice. I sent you the book [*Du Principe de l'art*] by my poor friend Proudhon, as well as a photograph of the curés [*Return from the Conference*], but have received no acknowledgement. I might well believe you were dead. Fortunately there are travellers who tell me that you are living in an Eldorado you have built for yourself. Some of them tell me you are in love, which would excuse your silence. . . . You would be amazed to know how much painting I have done since our last meeting. I think I have already produced a thousand pictures, if not more, and yet because of ill will, ignorance, and absurd bureaucracy I am still in the same position you found me in. I should so much like to see you again; I wish I had the time and opportunity to return to Montpellier. . . . I had a wonderful time there, thanks to you. . . . Some time ago you offered me some of Troyon's works in exchange for my own. If you still feel so inclined, send me a Troyon and I shall send you a landscape of my own province. . . . I should like you to send me some money for Proudhon's widow. Forgive my presumption, but one can ask such things only from kind-hearted people. Since before his death he [Proudhon] appointed me one of the guardians of his family, I must appeal to everybody." [5]

Bruyas noted in the margin of this letter: "Received neither

letters nor book from this good friend at that time." [6] But he replied promptly and contributed five hundred francs. Later in January Courbet wrote again: "Thank you very much for the money you sent me for the Proudhon family. . . . In a few days I shall send you a superb landscape representing profound solitude in the depth of the valleys of my native region [*Solitude, Banks of the Loue,* probably commenced in the Franche-Comté in 1864 or 1865 and completed in Paris]. It is certainly the best one I have and perhaps the best I ever painted in my life. . . . Now you will have all of my best works. . . . I am just finishing it. . . . At present I am very busy with preparations for the next exhibition [Salon of 1866]. I have only a month and a half; I shall exhibit a landscape somewhat like yours but with roedeer in it, also a female nude." [7]

These pictures were the *Covert of the Roedeer* (Plate 48) and the *Woman with the Parrot.* The *Covert,* now in the Louvre, is the most beautiful of Courbet's landscape-and-animal compositions. At the left an antlered buck munches the tender spring leaves of a vine growing at the base of a huge tree; a doe lies beside him at the edge of a rippling mountain stream, the rivulet of the Puits Noir, and another buck stands in the shallow water under the arching trees. The colours are lighter and fresher than in most of Courbet's landscapes; the background, painted in the Franche-Comté, is in fact almost faultless, but the animals, added in Paris some months later, stand out a little too sharply from their surroundings and betray the fact that their models were carcasses hired from a game butcher, not living denizens of the forest. The picture was painted on the canvas that Courbet had previously used for the damaged and unfinished *Fountain of Hippocrene.* The *Woman with the Parrot* is a voluptuous nude with uncombed reddish hair, lying on the same four-poster bed that appeared in the *Awakening* and idly playing with a parrot perched on her left hand.

The opinions of the critics varied, but this year Courbet had the majority on his side. Even Maxime Du Camp grew a trifle mellower: "If a knowledge of how to paint were enough to make an artist, M. Courbet would be a great one; still he is only a painter, nothing more, a very skilful craftsman. . . . His *Covert of the Roedeer* is a remarkable canvas which needs only a better understanding of spatial perspective to make it an excellent picture." [8] Castagnary wrote a long review praising the *Covert* without reservation, the *Woman with the Parrot* with only a few minor criticisms of the drawing; yet he preferred the nude for the oddly doctrinaire reason that he "could never admit that a landscape, even a perfect one, might rank above a human figure, even though imperfect." [9] When Castagnary's eulogy was called to Courbet's attention, the painter is reported to have commented patronizingly: "I think it will be of service to him." [10] Thoré exulted: "Who would have thought that the great success of the Salon of 1866 . . . would be Courbet's! . . . I am not the one to explain this unforeseen shift in public opinion. Courbet is certainly unchanged. He has always had the same profound and poetic feeling for nature, the same sensitive brushwork, the opulent palette, the sure touch that seems to pick up the colour and form of objects and transfer them to the canvas." [11]

Courbet himself made no attempt to hide his jubilation. "*They* [the conservatives, the academicians, the bureaucrats] are slain at last!" he wrote to Urbain Cuénot in April. "All the painters, all painting, are topsy-turvy. The Comte de Nicuwerkerke sent me word that I have produced two masterpieces and that he is delighted. All the jurors said the same thing without a word of dissent. I am unquestionably the great success of the exhibition. There is talk of a medal of honour, of the cross [of the Legion of Honour]. . . . The landscape painters are knocked flat. . . . I told you long ago that I would strike them right in their faces with a blow from my fist; they have felt the blow." [12]

Courbet was awarded neither medal nor cross, but he did receive official encouragement in the form of a tentative offer from Nieuwerkerke to purchase the *Woman with the Parrot* for the state and the *Covert of the Roedeer* for the private collection of the empress. A dispute with regard to the conditions of sale prevented consummation of the transaction and resulted in an exchange of acrimonious correspondence, though the misunderstanding appears to have been an honest one on both sides. Courbet claimed that the director of the Beaux-Arts had visited his studio before the opening of the Salon and had made a definite offer to buy the *Woman with the Parrot* for 10,000 francs, subject only to the condition that the painter would make no alterations to the picture, then almost completed; and that he had later obtained the director's consent in writing to some minor changes in the disposition of the drapery. On the other hand Nieuwerkerke insisted that no price had been fixed, though he was willing to pay 6000 francs; and that Courbet had failed to mention that the other painting in which the director was interested had already been sold to the stockbroker and art patron Lepel-Cointet.

Courbet wrote an irate letter accusing Nieuwerkerke of bad faith, to which the director replied indignantly on July 2: "I have just received your extraordinary letter. . . . As I can permit nobody to question my integrity I shall remind you of the facts which you have strangely misrepresented; if you wish you may consult the person who served us as intermediary. . . . This person, M. Frond [Victor Frond, editor of the *Panthéon des Illustrations Françaises au 19ᵉ Siècle*], called on me one day to ask if I had any prejudice against you, and why the administration of Beaux-Arts . . . never bought your pictures. . . . I replied that I had had few personal meetings with you, that our relations were very courteous, that I admired in your talent the elements I thought worthy of admiration, that generally your pictures were not the kind to be encouraged by the Government, but that I should be happy to

avail myself of the first opportunity to place one of your works in the Luxembourg. 'I am glad to find you so well disposed,' said M. Frond, 'for Courbet is in a very difficult position just now, he must sell one of his pictures and he is painting one that will probably furnish the opportunity you are looking for.' I went to your studio, I selected one of your pictures [one of the many versions of the *Puits Noir,* also known as the *Shaded Stream,* which Nieuwerkerke did buy on behalf of the empress for 2000 francs and which did not enter into this controversy]; and when I saw your *Woman with the Parrot* I . . . promised to buy it after the exhibition if you finished it in the same style as you began it. There was no question of price! . . . In writing to me, sir, you have distorted the truth, for you have made two other entirely false statements. I never told you I would buy your *Fighting Stags,* and when I asked the price of the landscape you exhibited this year [*Covert of the Roedeer*], not for the administration of Beaux-Arts but for the empress . . . I did not know it had been already sold. Such a subterfuge, sir, would have been foreign to my nature, and moreover why should I have had recourse to it? Am I in your debt, that I should have to pretend to be trying to oblige you? You also say that the papers have announced that I had promised to pay 10,000 francs for your picture, and that since I did not deny this allegation I tacitly acknowledged its truth. Do you think, sir, that I have time to read every little journal and . . . note the printed errors? Come, sir, admit that you were not quite in control of your faculties when you wrote me that letter. . . . I have asked M. Frond to . . . inform you that henceforth I wish to have no further relations with you of any kind whatever." [13]

Courbet sent pictures that year to a number of smaller exhibitions: at Bordeaux, Lille, Brussels, Frankfort, and in Holland. Some time during 1866 or possibly the following year (it is often difficult to assign precise dates to Courbet's works

because he frequently commenced pictures in one year and completed them much later) he painted a portrait of the artist Amand Gautier; the *Lady with the Jewels* depicting Castagnary's young mistress placing her trinkets in a casket; a portrait of a woman entitled the *Seeress;* the *Conscript's Departure,* an anecdotal composition of a soldier's farewell to his family; and the *Funeral Feast* portraying a wake in a Franche-Comté village. Vaguely dated between 1865 and 1870 is *Preparation for the Wedding,* an unfinished and none too successful attempt to present a scene faintly reminiscent of Hogarth. In the centre the bride is having her feet washed, while on the right women are setting a table for the feast and on the left other attendants are making the marriage bed.

In September Courbet accepted an invitation from the Comte de Choiseul to spend a month or two at Deauville, whence he wrote to his sister Juliette on September 27: "Since August of last year I have not stopped painting. . . . After my very unpleasant clash with M. de Nieuwerkerke (whom I reduced to silence) I came to Deauville, where M. de Choiseul has been urging me for a long time to visit him. I yielded to his entreaties because a change was absolutely necessary, my mind was so confused I could no longer think clearly. Here I am living in a terrestrial paradise, alone with this young man who is really charming. He has the genuine grand manner and distinction of the most courtly era in France. . . . The routine of our life here is very simple but extremely luxurious. There are six servants to wait on us. At night the menservants are dressed like prefects in black suits, white cravats, and pumps. The table is covered with dishes and cutlery of chased silver. A basket of flowers in the middle of the table, a bowl of magnificent fruit at each corner of the basket. Every wine imaginable. The walls of the salon and the other rooms are hung with silk brocade . . . the colour is pearl grey. There are canopies over the beds. . . . I shall stay here eight or ten days longer. . . ." [14]

Courbet bathed in the sea every morning, went on excursions by carriage or steamboat to Jumièges, Yvetot, and other points of interest in the vicinity. His hospitable host threw open the doors of the villa to Courbet's friends, among them Boudin and Monet. "My dear Boudin," Courbet wrote, "at M. de Choiseul's request I invite you to dinner with your wife tomorrow, Wednesday, at six in the evening. I have already asked M. Monet and his wife, who accepted last night at the Casino. . . . Call for Monet on your way here, and please come, all four of you. I shall expect you without fail." [15] Monet was then living with his mistress, Camille, but they were not married until 1870. Courbet had met Monet several times in Paris; he had seen and admired the younger painter's exhibits at the Salons of 1865 and 1866, had encouraged him by praising his work, and had assisted him with occasional small loans, or more probably gifts, which Monet sorely needed at that time.

Excursions and entertainments did not prevent Courbet from working, and during his sojourn at Deauville he painted portraits of the two Nodler brothers; two seascapes, *Dunes at Deauville* and *Seashore near Trouville;* the *Breton Spinner,* a woman spinning in a field as she watches her grazing flock, painted near Honfleur; and *M. de Choiseul's Greyhounds,* a pair of beautifully groomed animals, one grey, one black.

Courbet returned to Ornans about the end of October. During the winter he worked steadily, painting another *Bather,* a somewhat ungainly figure of a nude woman, whose arms are badly out of drawing, dipping her toes in a woodland brook; *Poverty in the Village,* a snow scene depicting a peasant woman bent under the burden of a huge bundle of faggots, leading a goat and preceded by a little girl; a *Mounted Huntsman Finding the Trail;* and *Siesta* (Plate 49), representing two teams of harnessed oxen resting in the shade of a grove; in the background is the loaded hay-wagon; under the trees a farm girl is

sleeping, and at the right are two young farmhands, also asleep, for whom the models were Marcel and Olivier Ordinaire, the sons of Courbet's friend Dr Edouard Ordinaire of Maisières. Apparently Courbet also revisited Salins, where he painted portraits of Max Buchon (Plate 19) and his wife. But the largest and most important picture produced that winter was the *Hallali du Cerf* (Plate 50) or *Stag at Bay,* the *hallali* being a hunting cry or a blast on a huntsman's horn announcing an imminent kill. This canvas, approximately fifteen feet in height by eighteen in breadth, represents the death struggle of a stag in the snow surrounded by a pack of yelping hounds. One of the hounds has sunk its teeth in the stag's hind leg, another is savagely attacking it by the throat while a huntsman (Courbet's friend Jules Cusenier) with upraised whip tries to prevent the dog from tearing the stag's hide to pieces. At the right another huntsman (Félix Gaudy), mounted, watches the combat; at the far left one of the hounds, gored by the stag's antlers, lies wounded on the snow.

Another wrangle over the purchase of a picture plagued Courbet during the winter. Several months earlier the broker Lepel-Cointet had bought *Covert of the Roedeer* for 10,000 francs and at the same time had promised to pay 16,000 francs for *Venus and Psyche* (the *Awakening*) if Courbet would add a few touches to the drapery so as to cover a little more of the nude figure of Venus. The painter made the alteration, but the broker evidently regretted his purchase, perhaps because he considered the picture too daring to be hung in his family's dwelling, and neglected to claim or pay for it. After several unsuccessful efforts to persuade Lepel-Cointet to accept the picture Courbet brought suit before the Tribunal de la Seine. Courbet's barrister, Gustave Chaudey, pointed out that Lepel-Cointet obviously considered himself the owner as he had already offered to resell the painting to another collector, Khalil Bey. To support this contention Chaudey submitted a letter he had received from Khalil Bey: "I remember very well that

when I visited M. Courbet's studio one day I noticed this picture and expressed my desire to own it. M. Courbet replied that he could not sell it to me, for he had sold it just the day before to M. Lepel-Cointet. I persisted, authorizing him to offer M. Lepel-Cointet a profit of 1000 francs. . . . Two days later M. Courbet . . . informed me that M. Lepel-Cointet would not give up the picture for less than 25,000 francs, which . . . would give him a profit of 9000 francs. I . . . emphatically refused . . . preferring to order from M. Courbet a new picture, which he has painted for me." [16]

This letter settled the matter, and on July 26, 1867 the court ordered Lepel-Cointet to accept the painting and to pay Courbet the price agreed upon. Some seven or eight years later, when Courbet was living in Switzerland, he was visited by a dealer who had just acquired *Venus and Psyche* and who offered him 1000 francs to paint a green parrot perching on the upraised hand of Venus. Courbet complied with this odd request, but as the parrot had no significance in connection with the legend of Venus and Psyche, the painting became known thenceforth as the *Awakening*.

Khalil Bey was a wealthy Turk or possibly Egyptian (Egypt was then under Turkish suzerainty) who had formerly served as Ottoman ambassador at St. Petersburg. Passionately fond of gambling and of all kinds of gaudy entertainments, spectacles, and fêtes, he was at the same time an amiable cultivated gentleman who enjoyed the conversation and companionship of serious writers and artists. He appears to have first met Courbet in 1864 at the suggestion of Sainte-Beuve. His collection comprised about one hundred pictures, including works by Ingres, Delacroix, Théodore Rousseau, Meissonier, Decamps, Gérôme, Fromentin, Chassériau, Diaz, Corot, Greuze, Vernet, Boucher, and some of the Dutch and Flemish masters. Khalil Bey also owned six Courbets: three hunting scenes, the nude *Bather* of 1866, and two pictures painted to order for this collection. When Khalil Bey had refused to pay Lepel-Cointet an

exorbitant profit for *Venus and Psyche* he had asked Courbet to make a copy for him, but the painter produced an entirely new picture instead. This was *Laziness and Luxury,* or the *Sleepers,* in which the Lesbian element was far more obvious than in *Venus and Psyche.* Two nude young women, one blonde, the other brunette, are sleeping on a rumpled bed; one of the brunette's legs lies on top of the blonde's thigh, the other rests against her bedfellow's torso. Scattered over the bed are a necklace, a comb, and a few hairpins; at the right a vase of flowers stands on a small table; another table at the left holds a carafe, a glass, and a bowl. The sensuality of the subject is heightened by the beauty of the flesh tones and the smooth, almost caressing, quality of the brushwork.

Even more sensual was the other picture that Courbet painted especially for Khalil Bey, the only actually pornographic work he ever produced or at any rate the only one that has been recorded. It was a small picture, so anatomically realistic as to be almost photographic, of a woman's pubic region. Khalil Bey showed it only to his friends and kept it locked within a sort of cabinet or tabernacle, on the outer panel of which was painted an innocuous landscape of a château in the snow. Soon after his acquisition of this picture Khalil Bey went bankrupt, and in January 1868 most of his collection was sold at public auction. The *Sleepers* and the untitled painting in the cabinet were not included in the sale, but were subsequently disposed of privately.

EXHIBITION: 1867

THE GOVERNMENT had announced another Exposition Universelle, similar to that of 1855, to be held in Paris in 1867; and once more Courbet planned to compete with the official display by opening an independent show of his own works at the same time. Part of the great exposition was situated in the Champs-Elysées, part in the Champ-de-Mars on the left bank, with an art exhibition in each section. Courbet leased a plot of ground just between the two subdivisions, in the Place de l'Alma, very near the site of his one-man show of 1855. Under the supervision of the same architect, Léon Isabey, he constructed a gallery somewhat larger and much more solidly built than that of twelve years before, for he proposed to use it thereafter for annual exhibitions and to boycott the official Salons in the future. The building cost about 30,000 francs; with installations and accessories about 50,000. By 1867 Courbet had accumulated sufficient funds from the sale of pictures to finance the project himself without assistance from Bruyas or other friends. "This time," he wrote to Bruyas from Ornans in February 1867, "I shall erect a permanent gallery to last for the rest of my life and shall send almost nothing more to the exhibitions of the Government, by which I have been so badly treated." [1]

He sent only three pictures, all of minor importance, to the official exposition: a hunting scene of hounds chasing a hare, the *Seeress,* and the old self-portrait *Courbet in a Striped Collar* borrowed from the Bruyas collection. On March 2 he wrote to Chaudey, who was handling his suit against Lepel-Cointet and wanted the painter to come to Paris: "Let the lawsuit go, I am riveted to Ornans at present by more pressing matters. . . . I am painting a picture eighteen feet long [the *Hallali*] of great artistic importance. It is a snow scene, I tried to complete it for the Champs-Elysées exhibition but cannot do it before March 10. I have taken advantage of the metre of snow that has fallen in my district to execute this picture, which I have had in mind for a long time. In the circumstances I should have to appeal to the Comte de Nieuwerkerke for a prolongation of time, which I shall not do after the dispute between us last year. But . . . I shall show it in an exhibition I am organizing myself, or in one held by the Belgians if they ask for it. . . . I am worn out with fatigue and cannot think any more, I work with a reflector until one-thirty every morning. . . . I cannot go to Paris now, especially as my mother is very ill." [2]

Later in the spring Courbet spent a few weeks at Maisières, whence he wrote to Castagnary on April 21: "At present I am visiting Dr Ordinaire in order to finish a picture. It is a picture of hayfields and oxen [*Siesta*], it will be as good as the roedeer [the *Covert*]; since I saw you I have painted at Ornans and Maisières the death of a stag [the *Hallali*]. . . . In addition six other winter scenes, four of them studies, and the *Poachers* [probably started two or three years earlier], and the poor woman leading her goat and begging from door to door [*Poverty in the Village*]. I have never worked so hard in my life, I have great hopes for these works, with these alone one could hold an exhibition. If I assemble all my winter and snow pictures I shall have about twenty, my seascapes will add about thirty. Then with the flower group, the portraits, the land-

scapes, the animals, genre pictures, hunting scenes, pictures of social conditions, *Burial at Ornans,* and the sketches, I shall easily accumulate three hundred pictures, some in my own possession and others which I can secure without difficulty. . . . Dear friend, you may be sure I did well to send [almost] nothing to the Government exhibitions. I sent only three pictures to the Champ-de-Mars, all poorly hung and hard to see though they were not large. . . . I also demanded, in conformity with the rules, [the exhibition of] my famous landscape [the *Puits Noir*] . . . now belonging to the empress and borrowed from her collection at Saint-Cloud. . . . According to Isabey my gallery will be completed by the fifth of next month [May], so it cannot be opened until the fifteenth; but of course it will stay open for a year. . . . I shall leave Ornans May 1, as I cannot place my pictures in Isabey's building before that date. We shall have a complete exhibition, with or without admission fees according to circumstances. If Napoleon insists upon inaugurating it he must deliver a speech on the Luxembourg, for such inaugurations without speeches annoy the inhabitants of Maisières and Ornans." [3] The emperor did not inaugurate Courbet's exhibition, with or without a speech; it is most unlikely that he ever thought of doing so.

Late in April Courbet asked Bruyas to lend four or five pictures: "If you decide to do me this favour it will be the last time I shall trouble you. This is true for several reasons: one is that this will be the definitive exhibition of my works, another is that I am growing old, very old. We are growing old in spite of our intellectual resilience. . . . If this is not a success I shall be ruined again. That is no joke at my age! . . . How much work is needed to do anything good! I did not ask you to send the pictures sooner because I wanted to be sure I could arrange the exhibition, which encountered obstacles on all sides. The municipal authorities of Paris kept me in suspense for a month and a half in connection with the site. Finally we discovered, but too late, that they wanted a bribe

of 100,000 francs. . . . I hope to see you at the exhibition. My mind is distracted by work and worries." [4]

Bruyas sent a portrait of himself, the *Bathers,* the *Sleeping Spinner,* and the *Man with the Pipe.* But by the time his exhibition was ready to open at the end of May Courbet had become so confident of success that he tried to persuade Bruyas to share his imminent triumph by constructing a gallery next to his own for the exhibition of the entire Bruyas collection of contemporary paintings, to be shipped from Montpellier: "I have had a cathedral built on the most beautiful site in Europe, by the Pont de l'Alma, with an unlimited horizon, on the banks of the Seine and in the centre of Paris! And I have astonished the entire world. You see money can be used in other ways than depositing it with notaries for selfish gain. . . . I shall triumph not only over the moderns but even over the old masters. . . . Your goal as a collector is the same as mine. Bring your whole collection, I shall add to it, we shall build a second gallery next to the one I have already erected. We shall earn a million [francs]. . . . What are 50,000 francs to you? If you lose them you will still be able to live in accordance with your tastes. . . . I have insured [my exhibition] for 600,000 francs, I wanted a million. If you decide to build a gallery it can be done in a month. Mine will remain open a year. . . . Perhaps forever, if we purchase the site together." [5] Bruyas had known Courbet too long and too well to be impressed by all this bombast. He did not build the adjoining gallery or send his collection to Paris.

Courbet had evidently expressed similar views on the uses of money to André Gill, who printed the following letter, in a facsimile of the painter's handwriting, on the cover of *La Lune* on June 9, 1867: "My dear M. Gill, I am accused by everybody of having spent too much money on the exhibition of my pictures. The money I earn should be spent by myself, for to deposit it with a notary would be to admit my inability to spend it more usefully." [6] Above this text was a large coloured carica-

ture, executed in Gill's most sprightly manner, representing the obese figure of Courbet, arrogantly posed with his right foot in the thumb-hole of a huge palette, holding a handful of brushes and proudly contemplating an immense full-face portrait of himself; in the foreground are a jug and glass foaming with beer.

At first Courbet had proposed to exhibit 300 pictures, then 200, then 140. When the exhibition opened it actually contained 115 items subdivided into nine groups. The first group, labelled simply "pictures," was an important but miscellaneous assortment of eighteen old and new works including the *Hallali, Fighting Stags, Burial at Ornans, Return from the Fair,* the *Stone Breakers,* the *Bathers* of 1853, *Young Women of the Village, Young Women on the Banks of the Seine,* the *Sleeping Spinner,* and the *Woman with the Parrot.* The second group comprised eighteen landscapes; then came seven snow scenes, twenty-three seascapes, twenty-five portraits, four still lifes of flowers painted in the Saintonge, fifteen studies and sketches, three early drawings, and two pieces of sculpture, the *Bullhead Fisher* and the medallion portrait of Félicie Buchon. On the last page of the catalogue appeared a note: "This exhibition includes scarcely one quarter of the works of M. Gustave Courbet. In order to make it complete it would have been necessary to assemble a certain number of important pictures . . . and nearly three hundred canvases scattered throughout the principal cities of France and abroad. . . . As the dimensions of the gallery will not permit the painter to show all of his works at one time, he proposes to replace the pictures with others from time to time as he receives new consignments." [7] During the course of the exhibition he did add about twenty pictures, including the large *Proudhon and his Family,* considerably altered since 1865.

In spite of Courbet's boastful anticipations of triumph the exhibition was far from a success. Loyal critics like Thoré and

Castagnary made valiant efforts to attract visitors, but the majority of the reviews were half-hearted or frankly unfavourable. In fact the exhibition of 1867 filled fewer newspaper columns than its predecessor of 1855, and the number of paid admissions scarcely covered the current expenses, leaving Courbet without compensation for the entire cost of the building and installations.

On July 13 Courbet sent a hurried note to Castagnary: "Tomorrow Monday at one-thirty the students are coming in a body to my exhibition at the Pont de l'Alma. I think it essential that you should be there. I am afraid that their demonstrations might cause me to lose my lawsuit [against Lepel-Cointet] which is now practically won. . . . It will be better if you are there, they are demanding to see the curés [*Return from the Conference,* which was not exhibited]; I have already added *Proudhon and his Family.* . . . I have eliminated the wife, finished the children, repainted the background, retouched Proudhon; now I think it is superb. . . . Don't fail me tomorrow, there will be plenty to do." [8] Whether the students did or did not cause a disturbance has not been recorded.

Courbet's precarious financial situation was improved to some extent by the unexpected sale of the *Stone Breakers* for 16,000 francs and *Poverty in the Village* for 4000. Courbet hoped that the news would stimulate interest in his exhibition. "This is the most helpful sale that could have occurred in the circumstances," he told Castagnary in August. "Please see what effect it is having all along the line. It is imperative that all the papers should announce this event, which is of the greatest importance at this time." [9]

The meagre receipts from admission fees did not even flow intact into Courbet's pockets. He was cheated by one of the ticket collectors, Michel Radou, a former non-commissioned officer in a zouave regiment, who was in charge of the entrance turnstile: "But not all turnstiles are infallible; the dishonest zouave discovered how to manipulate this one so that it would

let two people pass through while the mechanism registered only one. Moreover . . . he would admit visitors through a back door but collect entrance fees from them just the same. Yesterday the zouave was called before a jury on a charge of embezzlement. The leader of the realist school appeared as a witness. He testified with grave good humour. He estimated the amount of Radou's larceny at not less than three or four thousand francs; nevertheless he was the first to appeal to the jury for mercy towards this zouave who had acted bravely on the battlefield but who had momentarily turned aside from the path of duty and succumbed to the temptation of drink. The jury, less lenient than M. Courbet, sentenced Michel Radou to two years of imprisonment." [10]

Late in August Courbet visited his friend Fourquet, a Parisian chemist on holiday, at the little seaside resort of Saint-Aubin-sur-Mer about twenty miles west of Trouville, where he bathed in the sea and painted a seascape, the *Waterspout,* and two views of the *Beach at Saint-Aubin;* but he found the resort too isolated and dull and returned to Paris after ten days.

Courbet had promised to illustrate *Le Camp des bourgeois,* a nondescript collection of essays, short stories, and dramatic dialogues by Etienne Baudry, his host in the Saintonge in 1862; but while the painter procrastinated the author and the publisher grew more and more impatient. Finally Baudry went to Courbet's studio, one day in November 1867, and settled down to read aloud a chapter of his book in which Courbet was represented as delivering a lecture on a project for the exhibition of pictures in railway stations—a project not unlike that suggested by Champfleury many years earlier. Within a few minutes Courbet began to draw, and Baudry repeated the procedure day after day, each time reading aloud some portion of his manuscript that flattered the painter's ego, until Courbet had finished the ten drawings required. In the published volume there are twelve illustrations, but two

are not by Courbet although they are signed with his initials. Like almost all of Courbet's work in black and white, these illustrations are commonplace and poorly drawn.

Courbet's exhibition remained open about six months instead of the year or more he had anticipated. He had lost a good deal of money, not only through the apathy of the public and the peculations of Radou but also by the theft of several paintings. Just where or when the pictures were stolen is uncertain. "At the moment I am engaged in a ridiculous occupation," he wrote to Bruyas early in 1868. "I am hunting down thieves. I am trying to recover pictures stolen from various places. Only yesterday two of them, stolen some time ago in London, were sold at auction. They fetched 4500 francs. It is painful to see this money change hands and be unable to claim it." [11] Some months later at least one of the missing canvases was retrieved by the architect Isabey, who wrote to Courbet: "I don't want to trouble you to fetch the picture I have recovered from the thieves, so I am sending it to you." [12]

Still clinging to the forlorn hope that he might in time be able to reopen his exhibition on a permanent basis, Courbet delayed the demolition of his gallery for a whole year, but in the end the municipal authorities forced him to tear down the empty and disintegrating structure. "The building must be removed," Chaudey warned him in December 1868. "It is still there, but *without a roof.* . . . Don't let this situation grow worse. If the building is not demolished immediately you may find yourself involved in additional expense. . . ." [13] The structure was torn down, and at the painter's request Isabey stored the timbers and other portions in a warehouse near the Porte de la Chapelle in the northern outskirts of Paris.

MUNICH

"OUR family is full of news just now," Courbet wrote to his sisters in January 1868. "You tell me my sister Zoé is going to marry M. Eugène Reverdy [a painter] and that my father and mother are about to share their property with their children. These are very desirable changes that will contribute to everybody's happiness. . . . Now Juliette must get married. Zélie and I will remain unwed. Her health is too frail for marriage, and I have my art which does not mix at all with marriage. . . . [My father] proposes that I, as the eldest of the family, should have the largest share of the estate. That is ridiculous. He hasn't progressed since the Middle Ages, he would like to re-establish entailed estates and titles of nobility. If 1793 had not already destroyed such fine ideas I should make it my business to destroy them in the present circumstances. Not only do I not want to be favoured, I desire on the contrary to receive less than my share. This is not because I am in debt to my family; if my education cost more than that of you other children, on the other hand I have taken nothing from the family purse for more than twenty years, which makes things more or less even. . . . I am well aware that you have grudged me nothing and that all three of you have shown me much

good will, and I shall always appreciate your conduct. In spite of what my father suggests . . . give me only those assets you do not want and keep for yourselves the properties that will earn an immediate profit." [1]

This was quite sincere on Courbet's part. Though by no means indifferent to money he was sufficiently in agreement with Proudhon's dictum, "property is theft," to scoff at inherited wealth. Consistency had never been one of Courbet's outstanding virtues; it would not have occurred to him to denounce Bruyas, Baudry, the Comte de Choiseul, or any of his other wealthy friends, and he gladly accepted their hospitality and patronage; but as far as he himself was concerned he preferred to live on his own earnings—as he was well able to do—and owe little or nothing to his family.

At the Salon of 1868 Courbet exhibited only two pictures: *Roebuck on the Alert* and the *Beggar's Alms*. The latter belonged to what he called his "roadside" series, a group that included the *Stone Breakers, Return from the Fair,* and *Return from the Conference.* Fifteen years earlier he had proposed to paint a picture of a gypsy and her children but had abandoned the idea. Now it materialized again in a different guise. Under a tree at the left a swarthy gypsy sits by her cart, suckling a dirty baby; in front of her is a mangy snarling cur. In the middle of the road a very tall thin beggar, leaning on a crutch and wearing grotesque rags, gives a copper coin to the older child whose poverty is more abject than his own. It is not one of Courbet's masterpieces, but it is interesting for one reason: it is the last "socialist" picture he ever painted. The critics were almost unanimous in their disapproval, and even the benign Thoré commented: "No doubt Courbet is surprised at the coolness shown by his friends towards the old beggar in rags who hands a small coin to the gypsy child. But his friends are surprised that, in order to personify generous poverty, the humanity that persists valiantly and sturdily in spite of the

224

most extreme indigence, he has deliberately chosen such a horrible and repulsive figure." [2]

Courbet painted several nudes in 1868, including the *Woman in the Waves,* two versions of a *Sleeping Woman,* and the *Three Bathers* (Plate 51), perhaps the loveliest of all his nudes. In addition he produced two portraits: one of the poet Pierre Dupont, the other of the lawyer Gustave Chaudey. "My portrait hanging in my office is stirring up endless controversy," Chaudey wrote in December. "The artists and connoisseurs approve; the ladies disapprove. They say you have tried to discredit me in the eyes of the fair sex. . . . It's very amusing." [3]

Courbet may also have painted his first portrait of General Cluseret in 1868. Gustave-Paul Cluseret had had a colourful career. A graduate of the military academy at Saint-Cyr, he had served in the French army from 1848 to 1855, when he resigned with the rank of captain. In 1860 he joined Garibaldi's forces as a colonel and took part in the Sicilian campaign. A year later he went to the United States and commanded a detachment of Federal troops during the Civil War, emerging with the rank of general, which, he claimed, had been bestowed on him by Abraham Lincoln in person. In 1866–1867 he participated in the Fenian uprising in Ireland, and after his return to France he became a member of the socialist International Working Men's Association, usually called the First International. An influential opponent of Napoleon III, Cluseret was to play a prominent part in the Commune of 1871.

During 1868 two anti-clerical pamphlets, both illustrated by Courbet, were published in Brussels. *Les Curés en goguette* was a none too subtle diatribe against clerical gluttony and inebriety. "Many priests," declared the anonymous author, "are no doubt deserving of respect for the heroism with which they resist the temptations presented by the idleness and sen-

sual stimuli of their profession. . . . This little book is not directed against such philosophers. . . . Its aim is to set forth the actions and exploits of certain merry colleagues who more closely resemble disciples of Epicurus than followers of Him who often lacked even a stone to serve as a pillow." [4] Courbet contributed six black-and-white drawings, carelessly executed and cheaply printed. All were conceived in the mocking spirit of *Return from the Conference,* a reproduction of which served as frontispiece. The other illustrations represented a curé ringing a bell to summon the priests to mass; clerics sampling food in the kitchen before dinner; a drunken brawl at the table; bedtime, with a maid holding the head of a vomiting curé; and two intoxicated priests riding home from the conference in a pig-farmer's cart.

The other anonymous pamphlet, *La Mort de Jeannot,* recounted the melancholy history of a Hungarian officer named Waltzer, known as Jeannot, who had been blinded in battle in 1814 and sent to a hospital in a French village, where he was cared for by a peasant woman, Jeannette. After his release from the hospital the blind veteran lived in a cellar with Jeannette and earned a meagre living by peddling snuff and rat poison. Thirty years later Jeannot, then nearly eighty, lay on his deathbed. By threatening the couple with eternal damnation the village curé induced Jeannette to turn over to him a thousand francs, the savings of her lifetime. The doctor, telling her she had been a fool, sent her to demand the return of her money, but the curé claimed that it had already been given to a convent for the benefit of the poor. When Jeannette appealed to the head of the convent she was forcibly ejected. Sympathetic peasants then tried to tear down the convent walls, but were stopped by the municipal authorities, who charitably took care of Jeannot until he died a week later, and of Jeannette for the rest of her life. For this sentimental tale Courbet provided four illustrations, of inferior quality, depicting Jeannot as a pedlar, Jeannot's death, Jeannette's ex-

pulsion from the convent, and the peasants' assault on the walls.

In 1872, with Courbet's permission but without his active participation, the firm that had published *Les Curés en go-guette* and *La Mort de Jeannot* brought out *Les Misères des gueux* by a friend of Courbet's, Dr Blondon, who lived at Besançon and wrote under the pseudonym of Jean Bruno. The book contained fifty-seven illustrations engraved from paintings by Courbet, some with the original titles, others with captions altered to fit episodes in the story. These crudely drawn, shoddy reproductions by an anonymous craftsman bore little resemblance to the originals and added nothing to Courbet's repute.

During the summer of 1868 Courbet sent eleven pictures, including *Return from the Conference,* to an exhibition at Ghent. In addition he was represented in exhibitions at Besançon and Le Havre. "Tomorrow I am going to Le Havre," he informed Bruyas on September 10, "where I have eight pictures. . . . When I return . . . I shall go to Ornans and paint some new pictures, well studied and socialistic. . . . My head is splitting from worry. Now my hair is turning white." [5] At Le Havre Courbet met Monet again, and together they called on Alexandre Dumas, whom they had never known but who received them cordially. Dumas and the two painters spent several days at Etretat: "Whenever Dumas and Courbet were not talking, they were singing or cooking together. . . ." [6] Courbet did not suspect that within three years the novelist's son, the younger Alexandre Dumas, would become one of his bitterest enemies.

Early in October various Parisian newspapers published a report (which proved to be without foundation) that Courbet had presented himself as a candidate for the chair left vacant by the death, in March 1868, of François-Edouard Picot, a painter of historical subjects and one of the forty "immortals"

of the conservative Académie Française. Courbet had just returned to Ornans, where he received the unwelcome news from Castagnary. He replied with an indignant denial: "One must admit that it is a good joke [to suggest] that I should replace M. Picot, M. Picot who by his own efforts and influence brought about my rejection for seven years by the Salons of 1840 to 1848, when I was producing the best pictures I ever painted. . . . How could I, in imitation of M. Picot's stupidity, inflict vengeance on the martyrs who are now entering upon careers in the arts, for what I was made to suffer in my own youth? . . . No; established organizations, academies of all kinds, authoritarian regimentation, indicate evil conditions and impediments to progress. If the revolution of February [1848] had not occurred perhaps my painting would never have been seen. . . . An academician is placed by our social organization in a false position. How can you expect such a man to acclaim budding talents and so diminish his own value, to finish himself off out of pure altruism while he is still alive? . . . No; the time has come for somebody to have the courage to be honest and to declare that the Academy is a harmful and tyrannical institution, unable to fulfil its ostensible mission. Until now there has never been a national art, there have been only individual attempts and artistic experiments in imitation of the past. . . . At present France seems to be trying to recover the spirit of art that has been lost. Why? Because she has an idea to uphold and liberty to establish. . . . To assist this movement it is necessary to give the national genius a free hand, to do away with commissioners, protectors, academies, and above all academicians. Free academies may remain in which young people without funds can work. Open the museums, that is all one can do for art. Therefore I most humbly deny my fitness to be a member of the Academy." [7]

Courbet remained at Ornans until May or June 1869, painting little but absorbed in a new project: the design and con-

struction of a light carriage similar to a tilbury but with only one wheel. He had inherited a little of his father's passion for impractical inventions, and for weeks the new vehicle kept him as busy and happy as a child, to the intense amusement of his friends. "Yesterday I saw Courbet with the Vulcan he is inspiring," Dr Ordinaire wrote to Castagnary on December 18. "They are both in the throes of planning and execution. The forge glows and the anvil rings. *Père* Courbet had produced a cart with five wheels. The son, being cleverer, has invented the *Monocycle*. I am the one who instantly thought of a name for this vehicle, even though I am not much of a Greek scholar. This is a fine example of the meeting of extremes in the same family. At first I teased the inventor mercilessly. But he has worked out his scheme so well, designing every part of his one-wheeled carriage . . . that I have begun to take the thing seriously. . . . If he finishes it successfully in all respects I think cripples, jockeys, and other lazy people will use it to scurry like rats along the Champs-Elysées and the boulevards, and the inventor will make money. So I am urging him to apply for a patent as soon as possible. One of our manufacturers has already offered to build them. . . . Luckily the artist has found an exceptionally good smith, skilful and intelligent. He is known as *Le Diable* and in truth he could very easily play the part of Mephistopheles. His volcanic imagination is stimulated by the new invention to such a degree that he will forget to get drunk until the work is completed." [8] Needless to say the one-wheeled tilbury was never produced commercially, and Courbet soon lost interest in his invention.

Some time during 1869 he painted portraits of the poet Gustave Mathieu and the painter Paul-Joseph Chenavard. At the Salon he was represented by three pictures already shown at his one-man exhibition of 1867: *Siesta,* the *Hallali,* and *Mountains of the Doubs.* Shortly after his arrival in Paris he suffered another financial misfortune. "A terrible disaster has

befallen me," he told Castagnary on July 5. "M. Delaroche [presumably a picture dealer] has just gone bankrupt, and now I am once more reduced to beggary. He owed me 25,000 [francs] for my twenty-five seascapes of Trouville, plus 5000 I lent him in cash. I must testify at one o'clock on the seventh at the Chambre de Commerce. I shall collect only one or two per cent. . . . I really have no luck." [9]

In mid-August Courbet went to Etretat, where he found the painter Narcisse Diaz and his son Eugène, who often swam with Courbet in the sea. One day the young man ventured too far out and almost drowned before Courbet, a powerful swimmer, could rescue him and bring him back to shore. "I have been at Etretat for the last twenty-five days," Courbet wrote to Castagnary on September 6, "if I had been able to see you before I left [Paris] I should have tried to take you with me. This country is charming. There is still time for you to spend a week here. It is very hot, the bathing is delightful. I have already painted nine seascapes which I find satisfactory. To-morrow I shall start a seascape 1 m. 60 [5 feet 4 inches] wide for the exhibition [Salon of 1870]. I have never shown one of this kind." [10] Among these seascapes were *Cliffs at Etretat* (Plate 52) and *Stormy Sea* (Plate 53), also known as the *Wave*. Before he left Etretat he had sold five of the seascapes for a total of 4500 francs.

Good news reached him almost simultaneously from two other quarters. At the International Exposition in Brussels his pictures were awarded a first gold medal; and during an exhibition in Munich, to which he had sent the *Woman with the Parrot*, the *Stone Breakers*, the *Hallali*, and *Oraguay Rock*, the young king Ludwig II of Bavaria (not yet insane) bestowed on him the cross of the Order of Merit of St. Michael. Though he objected on principle to official decorations and awards he gratefully accepted these, for reasons set forth in the letter to Castagnary quoted above: "The situation is saved! By *demand* of the artists of Munich and of the awards commit-

tee I have just been named a chevalier first class of the Order
of Merit of St. Michael by the king of Bavaria. At the exposi-
tion in Brussels organized along the same lines, that is with
the artists electing the jury and the jury rendering its verdicts
without interference by the Government, I have just been
awarded the medal . . . unanimously. This gives the *lie di-
rect* to the regimentation of the arts . . . by the French ad-
ministration. Here at last are two decorations I can accept be-
cause they are given by our competitors of their own free will.
Moreover this [Bavarian] decoration (if any decorations are
admissible) is more logical than the cross of [the Legion of]
Honour, it is called a cross of Merit. . . . What has happened
is very important, for the Germans and the Belgians have an
overwhelming desire to follow my [school of] painting, and
the exhibition in Munich, among others, was held for that
reason. They are anxious to abandon all their old methods.
. . . During the twenty years that I have been exhibiting in
Belgium I have always exhibited at my own expense and at a
loss, thanks to the French Government (the Belgian Govern-
ment were wary too). It is only the independent artists who
have risen above this ill will and this influence. . . . If you
cannot come to Etretat, accompany me to Munich. I shall
leave on the twentieth or twenty-fifth in time for the celebra-
tions which begin on October first. Try to come, we shall be
welcomed triumphantly. . . . I promise you we shall laugh
heartily, it will be an occasion one should not miss. If you can
give this news adequate publicity it will be the death of all
who have been decorated officially." [11]

Since Castagnary was unable to accompany him Courbet
went alone to Munich, where he remained about six weeks.
The Bavarian artists showered him with attentions, entertain-
ments were given in his honour, and he was invited by Ludwig
II, an enthusiastic admirer of Richard Wagner, to paint a
scene from *Lohengrin* on the walls of the royal bedchamber;
but he was obliged to refuse this commission. One of the

events that Courbet enjoyed most was a beer-drinking contest; sixty competitors appeared on the first day, fifteen on the second, ten on the third; at the end of the fourth day Courbet was declared the winner over his two surviving rivals. But he also found time to work, and copied rapidly but with extraordinary fidelity a self-portrait by Rembrandt, *Hille Bobbe* by Frans Hals, and a portrait of Murillo by Velázquez.

Courbet's technical facility astonished the Bavarian painters. At the request of several members of the Bavarian Academy, including the director Wilhelm von Kaulbach, he demonstrated his skill by painting with his palette knife, in an hour or two, a forest scene in the environs of Munich. Some days later he expressed a desire to paint a nude. Kaulbach summoned his servant, who had often posed for her employer, and within a few hours Courbet completed the *Lady of Munich*. The blonde fleshy model, seen from the back, lies on a bed in front of a window through which an autumn landscape is visible; the striped ticking of the mattress shows beneath the rumpled sheet. At the left a small dog is sleeping on a chair. Just before his departure from Munich, in response to a request from his Bavarian disciples for a souvenir epitomizing his own character, he quickly painted a picture of his pipe (without which he was rarely seen) and inscribed below it the motto: "COURBET, without ideals and without religion." [12] He is said to have used the same phrase occasionally on his writing-paper, surmounted by a drawing of two crossed pipes.

On his way back to Ornans Courbet passed through Switzerland, where he remained long enough to paint half a dozen pictures, including a *Landscape at Interlaken*. From that town he wrote to Castagnary on November 20: "I left Munich a fortnight ago. . . . In Germany they know almost nothing about good painting, they are all concerned with the negative elements in art. One of their chief preoccupations is perspective; they discuss that all day. Another important element is the accuracy of historical costumes. They are greatly interested

in anecdotal painting, and every wall in Munich is covered with frescoes, like wall-paper, full of red, blue, green, yellow, pink robes. . . . As to sculpture, it's incredible. One could easily count three thousand statues in the city. They all look alike. I suggested a simple arrangement. If the heads were fitted with screws they could be changed every fortnight, and then ten statues would be enough. . . . I leave for Ornans tomorrow." [13]

Either on the way to Ornans or shortly after his arrival he visited Charles and Lydie Jolicler at Pontarlier, where he painted a portrait of their three-year-old daughter, Henriette, and one of a friend of the Jolicler family, Mme Sophie Loiseau.

The year ended sadly; early in December he heard that Max Buchon was dying. Courbet hastened to Salins, whence he wrote to Félix Gaudy on December 8: "I . . . find Buchon suffering from an anthrax [probably a malignant ulcer or fistula] in his backside. He is in bed, very ill. . . ." [14] Buchon died on December 14, and two days later Courbet gave Castagnary a somewhat different account of his friend's last illness: "My old friend Buchon, my poor cousin, died in my arms on Tuesday at six in the morning. He died of blood-poisoning due to typhoid fever, and with good reason! During the last fifteen years he had eaten so much carrion that he would have needed the stomach of the eagle of Boulogne to digest it. . . . Buchon was a gallant soul, supremely unselfish, exceedingly modest and sensitive, always working for others instead of for himself, never permitting anyone to do him honour or pay him a compliment. His courage was invincible. Despite all the ill treatment he had endured he had the courage of his convictions, a spirited and formidable eloquence; nobody dared to oppose him because, with his Franc-Comtois nature, he never acted unless he was right twice over. And his authority in the region was very great, his fine intelligence enabled him to nominate the opposition deputies in both [the departments of] the Jura and the Doubs. He concerned himself constantly

and untiringly with the problems of the people; what brought on his last illness was the defection of a democratic newspaper to the Orléaniste [royalist] party; the slightest deviation from probity and honesty wounded him to the quick. Even his poetry was simple and unpretentious; he tried to occupy the least possible amount of space on earth. . . . He thought of death as the end of a journey, a harbour. . . . Towards the last he proposed to draw up a democratic French constitution patterned after those of Switzerland and America, so as to be ready when the time should be ripe. It was I who suggested this idea to him after my return from Switzerland, where I had talked with politicians. . . . I go back to Ornans tomorrow." [15]

WAR

At the beginning of 1870 the empire of Napoleon III was disintegrating. Early in January the emperor was forced to call upon a liberal statesman, Emile Ollivier, to undertake the formation of a new Government pledged to constitutional reform, a "third party" designed to steer a middle course between the reactionary imperialists and the radical republicans. To Courbet, who respected Ollivier and had painted a portrait of him, the change in the political atmosphere seemed highly encouraging. For a long time he had dreamed of an association of artists, wholly independent of bureaucratic control, to sponsor, organize, and administer unofficial exhibitions. Now circumstances appeared to favour such a project.

In February he was informed by Emile-Charles-Julien de La Rochenoire, landscape painter and president of the Association des Artistes Peintres, that he had been unanimously nominated by a committee of the association as a candidate for membership on the jury of the Salon of 1870. Although he wanted no connection with the Salon except as an exhibitor, he felt obliged to accept; but in his reply, dated February 4, he took advantage of the opportunity to urge the formation of an independent group: "If I have proved nothing else I have

at least demonstrated that without privilege, without protection, and without being a partisan of Napoleon, one can follow an artistic career if one has the right temperament. I have just returned from two countries in which I achieved outstanding success: Belgium and Bavaria; artists are independent there." [1]

Next day he wrote from Ornans to Castagnary: "It [the nomination] is the most annoying thing that could have happened, but I must submit to it. . . . I replied that it was time for the artists to recover their independence. . . . I referred them [the committee] to you (I don't know whether or not they will come) so that you can draw up a petition to the Chamber [of Deputies] which will appeal to the logic of the new Government, proposing that they [the Association des Artistes Peintres] should henceforth be attached to a ministry independently instead of to the [imperial] house. . . . If this proposal is adopted the Chamber would turn over to them the Palais de l'Industrie [where the Salon was usually held]; the sponsors would be paid out of the entrance fees, so would the cost of pictures purchased by an appointed committee and those bought for the lottery; this committee would also distribute the awards, for only from such a source would they be acceptable. All this would not prevent the precious house of the emperor from buying pictures with its own money instead of [as at present] with our admission fees. . . . Moreover the annual receipts from entrance fees should be spent at once, with no provision for a sinking fund. The bureaucracy should exist only for the duration of the exhibition, because it would ultimately produce a series of little governments. Also the entire personnel connected with past and present exhibitions . . . must be changed because all of these scoundrels are completely corrupt at heart and swindlers as well. . . . But all this will not come true, for artists do not like independence and the others are too fond of governing. . . . My dear friend, since Buchon's death I have been unable to work, for two

months I have been sunk in overpowering lethargy; I have taken two or three purges but I feel that my liver is still out of order. I think this is due to previous fatigue. . . . I shall be in Paris in a week to send my pictures to the exhibition." [2]

Courbet did not have to serve on the jury after all; in the final election he received almost, but not quite, enough votes to qualify as one of the eighteen judges. Although he did not live to see his hopes fulfilled, independent exhibitions have now been firmly established for many years; the official Salon has declined steadily in prestige and is today but one of many exhibitions, and by no means the most important, held annually in Paris.

Courbet sent only two seascapes, *Stormy Sea* and one version of *Cliffs at Etretat,* to the Salon of 1870. "I think," wrote Castagnary, "that this year the last remaining detractors will admit defeat, and that praise of the great painter will be unanimous." [3] He was right; nearly all of the reviews were favourable. At the same time purchasers flocked to Courbet's studio. During the single month of April he sold almost forty pictures for a total of approximately 52,000 francs and received additional commissions from ten collectors. The *Woman with the Parrot* and five seascapes were bought by an art patron of Dijon, M. Bordet, whose portrait Courbet painted that year. Negotiations for Courbet's marriage to Bordet's sister, Mme de Villebichot, were opened but soon broken off; the painter's conviction that art and marriage would not blend was too strong, and this appears to have been the last time he even considered the possibility of matrimony. But he remained on friendly terms with the family, and a little later in the year Bordet persuaded him to contribute to an exhibition of paintings at Dijon for the benefit of the women of Le Creusot, where a strike in the armament works had brought severe hardship to the families of the unemployed labourers.

In Paris that spring Courbet painted a portrait of Castagnary. He also purchased for only 3500 francs a collection of

so-called old masters from Mme de Planhol, who had inherited them from her uncle M. de Naglis, a diplomat during the reign of Charles X. The collection comprised approximately five hundred paintings, plaster busts, and *objets d'art,* including pictures "attributed to" Rubens, Holbein, Titian, Veronese, Velázquez, and many other painters of the first rank. Any one of these canvases, if genuine, would have been worth far more than the cost of the entire collection. Actually they were almost worthless copies. It is difficult to suppose that Courbet, who after all knew a good deal about painting, was sufficiently naïve to have believed in their authenticity; but if he realized or even suspected that his acquisitions were something less than masterpieces he never admitted it. "I have found a wonderful bargain," he informed his family in May. "I have leased an apartment [at 24 rue du Vieux-Colombier] for 1300 francs [a year] in order to leave [these treasures] where they are. They are worth perhaps 300,000 francs. I dare not think of them or look at them. I paid on the spot so that there would be no question. . . . Among other things there are about ten pictures by Rubens that are worth an enormous sum." [4]

At this time Courbet and Castagnary were often seen at the Café de Madrid in the Boulevard Montmartre, frequented by writers, artists, and radical politicians, many of whom were soon to become prominent under the Commune and the third republic. Among the habitués were Léon Gambetta, the journalists Auguste Vermorel and Jules Vallès, the photographer Etienne Carjat, the future communards Paschal Grousset and Raoul Rigault. Courbet found himself in sympathy with their revolutionary doctrines, and it was largely through these friends and acquaintances that he was drawn, within the year, into the political arena.

The minister of Beaux-Arts in the liberal Ollivier cabinet, Maurice Richard, made repeated efforts to demonstrate the new Government's respect for Courbet. He invited the painter

to dinners and receptions, but Courbet, though he liked Richard personally, always refused to attend; to him a bureaucracy under the empire, however benign it might be, was still a bureaucracy from which he wanted no favours. In June Richard requested Courbet's old friend Dr Ordinaire to ask the painter informally if he would accept the cross of the Legion of Honour. Courbet evaded the interview by slipping away to L'Isle-Adam, some twenty miles north of Paris, where the landscape painter Jules Dupré was living. On June 22 the *Journal Officiel* announced that Courbet had been awarded the cross on the preceding day. Courbet returned to Paris at once and, probably with Castagnary's assistance, composed a dignified letter to Richard rejecting the unwelcome honour:

It was at the domicile of my friend Jules Dupré at L'Isle-Adam that I learnt of the announcement in the *Journal Officiel* of a decree designating me a chevalier of the Legion of Honour. This decree, from which my well-known opinions concerning artistic awards and noble titles should have exempted me, was enacted without my consent, and it was you, *monsieur le Ministre,* who felt impelled to take the initiative in the matter.

Do not be afraid that I misunderstand the sentiments that inspired you. Having been appointed minister of Beaux-Arts as successor to a pernicious administration which seemed to be dedicated to the task of destroying art in our country and which would have succeeded in doing so by corruption or violence if it had not been thwarted by a few honest men who appeared here and there, you have tried to mark your accession by an act diametrically opposed to the procedures of your predecessor.

Such acts do you honour, *monsieur le Ministre,* but permit me to tell you that they cannot in any way change either my attitude or my decisions.

My opinions as a citizen forbid me to accept an award

that belongs essentially to a monarchical régime. My principles reject this decoration of the Legion of Honour which you have bestowed on me in my absence.

At no time, in no circumstances, for no reason whatever, would I have accepted it. I should be still less likely to do so now, when betrayals are multiplying in every direction and the human mind is saddened by so many selfish recantations. Honour consists in neither a title nor a ribbon, it consists in actions and the motives leading to actions. Respect for oneself and for one's ideas compose its greater part. I honour myself by remaining faithful to the principles I have proclaimed all my life; if I were to abandon them I should lose my honour in order to grasp its symbol.

My sentiments as an artist are no less opposed to my acceptance of an award distributed by the state. The state is incompetent in matters relating to art. When it undertakes to bestow awards it is usurping the function of popular taste. Its intervention is altogether demoralizing, injurious to the artist whom it deceives as to his true worth, injurious to art which it shackles with official conventions and which it condemns to the most sterile mediocrity; the wisest course is to keep its hands off. By leaving us free it will have fulfilled its duties towards us.

So permit me, *monsieur le Ministre,* to decline the honour you have thought proper to offer me. I am fifty years old and I have always lived in freedom; let me end my life free; when I am dead let this be said of me: 'He belonged to no school, to no church, to no institution, to no academy, least of all to any régime except the régime of liberty.' [5]

This letter, published in *Le Siècle* and reprinted in many Parisian and provincial journals, stirred up a storm of controversy that raged for several weeks. While some of the com-

ments were adverse, many applauded Courbet's independence and courage. Congratulatory letters poured in, including one signed by about forty of his friends at home: "Your friends at Ornans will seldom have a more favourable opportunity to express the sentiments of esteem and affection they feel towards you. . . . As a citizen who has just affirmed, in the face of authority, your invincible faith in democratic principles, you are also entitled to our heartiest congratulations, and we believe that the decoration you refused would have contributed no additional splendour to your glory. All of us who know you . . . pay tribute to your courageous resolution. . . ."⁶

In Paris Courbet's defiance of bureaucracy was celebrated by a banquet at the Restaurant Bonvalet in the Boulevard du Temple. Chaudey presided, and most of the painter's friends were present, including Daumier, who shared the limelight with Courbet because he too, much less ostentatiously, had refused the cross of the Legion. But the outbreak of war abruptly superseded Courbet's sensational letter as a topic of conversation. "War is declared," he wrote to his family on July 15, "the peasants who voted in the affirmative will pay dear for it. Right at the beginning 500,000 men will be killed, and that will not be all. They say the Prussians are already at Belfort and are marching at once on Besançon. . . . Everybody is leaving Paris. In five or six days I shall go to some seaside resort, perhaps to Guernsey to see Victor Hugo, and return by way of Etretat. Despair is general. . . . Write to me . . . for if the Germans come to Besançon I shall go there at once. . . . I am overwhelmed with compliments [for refusing the cross], I have received three hundred flattering letters such as no man in the world has ever received before. In everyone's opinion I am the greatest man in France. M. Thiers [Adolphe Thiers, at that time an anti-imperialist member of the Chamber of Deputies, later first president of the new republic] invited me to his house in order to felicitate me, even

princesses came to see me for the same purpose, and a dinner for eighty or a hundred people has been given in my honour. All the journalists and men of learning in Paris were there. In the street I have to keep my hat in my hand like a curé. I was delighted by your approval. . . . The testimonial from the people at Ornans was diplomatic and half-hearted, *don't tell anyone I said so.* . . . The Ordinaires played a shabby part in this affair, they did not come to the banquet. I see them seldom, I let them go their own way. The step I have just taken is a wonderful achievement, it is like a dream, everybody envies me, I haven't a single opponent. I have so many commissions [for pictures] at present that I cannot supply them. . . . In any event I shall be at Ornans in September. . . . My sensation lasted three weeks in Paris, in the provinces, and abroad. Now it is over. The war has taken my place." [7]

But he did not go to Guernsey or Etretat or Ornans that year. The victorious Prussian armies advanced rapidly, and on August 9 he informed his family: "We are passing through an indescribable crisis, I do not know how we shall come out of it. Monsieur Napoleon has declared a dynastic war for his own benefit and has made himself generalissimo of the armies, and he is an idiot who is proceeding without a plan of campaign in his ridiculous and criminal pride. We are beaten all along the line, our generals are resigning and we are expecting the enemy to enter Paris. . . . Today we are marching . . . to the Chamber to declare the downfall of the empire. . . . The empire has led to invasion. If this invasion rids us of it we shall still be the gainers, for in one year of his reign Napoleon costs us more than an invasion. I believe we are going to become Frenchmen once more. I cannot return home now. My presence is needed here, and besides I have a good deal of property to protect in Paris. . . . Don't worry about me. I have nothing to fear from anyone." [8]

· · ·

On September 2 Napoleon III surrendered at Sedan, and two days later the empire came to an end with the establishment of the republican Government of National Defence, in which Gambetta served as minister of the Interior and Jules Simon held the two portfolios of Beaux-Arts and Education. The imminent investment of Paris by the German forces necessitated measures for the protection of the city's art treasures. On August 30 Nieuwerkerke had already ordered the removal of the most valuable paintings; on September 1 the first convoy from the Louvre left for Brest, and others followed during the next three days. Then shipments were stopped because it was feared that the cases and crates containing works of art might be removed from the vehicles carrying them to the railway station and used in the construction of barricades. Immediately after the proclamation of the republic on September 4 Nieuwerkerke resigned his directorship of the Beaux-Arts.

On September 6 a group of artists met unofficially at the Sorbonne to create an Art Commission charged with the protection of works of art in Paris and its environs. Courbet was elected president. The other members were the painters Daumier, Veyrassat, Feyen-Perrin, and Lansyer, one of Courbet's former pupils; the sculptors Auguste Ottin, Moulin, Le Véel, and Geoffroy Dechaume; the engraver Bracquemond; and the ornamental draughtsman Reiber. The commission took its duties seriously: it supervised the removal of works of art from secondary museums in and near Paris and their storage in the vaults of the Louvre, took precautionary measures against fire and theft, packed up valuable manuscripts and books, and ordered the placing of sand-bags round certain outdoor monuments and statues to protect them from the expected bombardment. One of the commission's first assignments was the inspection of several mysterious cases in Nieuwerkerke's apartment, believed to contain pictures which the former director had intended to ship clandestinely to some

unknown destination; but they proved to hold nothing but ancient arms and armour from the museum at Pierrefonds, sent to Paris quite legitimately to save them from destruction by the Prussians.

Courbet's decision to remain in Paris alarmed his father: "You know that your mother and I are old and that your sisters are in delicate health; come to us as soon as possible, we expect you without fail; for in these critical times and under the shock of invasion a family should be united. . . ." [9] "I have read my father's excellent letter with great sympathy," the painter replied, "but I cannot comply with your desires at the moment. The Parisian artists as well as the minister Jules Simon have just done me the honour to designate me president of arts in the capital. This pleases me because I did not know how to serve my country in this emergency, having no inclination to bear arms. Moreover it is impossible to believe that the German invasion will extend as far as Ornans; even if it should do so you have in your hands a powerful talisman, my cross of honour from Bavaria which is of a high order, you will find it and the certificate in the dresser in my room. Germans have great respect for their institutions; show it to their leaders and you will have absolutely nothing to fear; you agree with me that public duties must be fulfilled first." [10]

On September 9 he posted another letter to his parents: "I cannot return to Ornans now. . . . I don't think I have anything to fear, I shall be at the Louvre and I shall be in less danger in Paris than in the provinces, where I should be obliged to take an active part [in the war]. . . . I think the Prussians are near Paris, I do not yet know whether or not there will be a siege. I think communications will be interrupted. In the event of my death my sisters are to take the money I have deposited with M. Henriot, invested in the Lyon [Paris-Lyon-Méditerranée] railway. I shall also leave a note with my concierge or the attorney Chaudey." [11] This was followed by a curious postscript: "My sisters Zélie and Juliette

only," [12] which presumably referred to the distribution of his railway securities. Evidently he and Zoé had already quarrelled; thenceforth the breach between them was to grow wider year by year.

On September 24 Jules Simon appointed an official agency, the Archives Commission, "to inspect the archives of the Louvre and trace to their source any frauds that may have been committed by functionaries of the fallen Government." [13] This commission originally comprised five members including the chairman, the philosopher Etienne Vacherot, but a few days later Courbet and the critic Philippe Burty were added. The commission discovered no frauds or unauthorized removals of public property; practically all of the curators and other museum officials appointed under the empire, many of whom continued to exercise their functions after September 4, had in fact been men of unimpeachable integrity. Courbet and Burty, though unable to dispute this verdict, withdrew from the Archives Commission on December 1 because they could not approve the retention in office of functionaries who had served under the imperial régime. "The Commission of the Archives of the Louvre having completed its task," Courbet wrote to Simon, "please accept my resignation which is necessitated by my inability to sign the report. In any event I could not ratify the acts of the empire or support the men who served it, no matter what appearances of propriety they may have been able to give to their proceedings. Moreover by the time we came to close the stable doors the horses had vanished, and our work could be nothing but a farce. . . . Since the present Government are not committed to revolution the work of this commission is condemned to sterility because it cannot bring about . . . radical reforms in the budget and personnel of the museums. Still hoping to be of service, I retain with pleasure the mission assigned to me by the group of artists and confirmed by yourself." [14]

• • •

The siege of Paris lasted from September 19, 1870 until January 28, 1871, when the minister of Foreign Affairs, Jules Favre, signed an armistice at Versailles. As the German ring tightened and successive sorties by the defenders failed, conditions within the city grew worse and worse. Actual bombardment did not begin until January 5, but long before that date hunger, cold, disease, and a series of abortive insurrections had taken a heavy toll.

With the assistance of some literary collaborator (probably Victor Considérant, mentioned in the preface as the "instigator"), Courbet composed two open letters, one addressed to the German army, the other to German artists, which he read in the auditorium of the Théâtre de l'Athenée on October 9 and which were subsequently published in pamphlet form. The first letter urged the besiegers to go home, for the Parisians would never capitulate: "Winter is approaching, my poor friends, and you batter at our gates with heavy hammers. . . . Go your ways! We have been told you are jealous of us, of our country, of our renown; that is a pity, for we have never been jealous of you in any respect whatever. . . . You talk of civilization! I have seen you in action; I have seen you not knowing how to invite a guest to dinner; I have seen you at home, not eating but guzzling food four times a day. . . . When you go home, cry: 'Long live the Republic! Down with frontiers!' You will only benefit thereby; you will share our country as brothers." [15]

To the German artists he reiterated the theme of brotherhood and proclaimed an ideal of European unity, an ideal which, though apparently still far from realization, has been revived persistently since 1945: "You whose honesty and loyalty we praised, you who disdained petty selfishness, you the intellectual elite, one would take you today for nocturnal marauders come without shame . . . to despoil Paris. . . . Do you value your nationality? Once you are free we shall help you if you will only say the word. In that event only, you

will establish Alsace and Lorraine as neutral free countries as pledges of our alliance . . . and in those mutilated, crucified provinces, forgetting the wounds that bleed in our flanks, we shall again clasp your hands and drink to: 'The United States of Europe!' " [16]

Less idealistic but more immediately effective was his donation of a seascape to a lottery, the proceeds of which were used to purchase a cannon, cast by the Cail foundry and nicknamed *le Courbet,* for a battalion of the National Guard stationed in the Grenelle quarter of the fifteenth arrondissement. Another contribution to the war effort was made without his consent and very much against his will: during the siege much of the building material salvaged from his 1867 exhibition gallery and stored near the Porte de la Chapelle was confiscated by a defence committee, headed by Henri de Rochefort, and used in the construction of barricades.

Courbet's pacifist principles kept him from bearing arms, but he did pay one visit to the front lines, escorted by Dr Pierre Boyer, then a young officer in the medical corps, who led him to an advanced post near a bridge over the Bièvre river, a mile or two south of the city limits, where there was some intermittent sniping. Long afterwards Boyer wrote an amusing account of the episode: "I had known Courbet rather intimately, I had sometimes accompanied him on his nocturnal prowls . . . but I saw him most frequently during the siege at the famous tavern of *père* Laveur. . . . The site of our field hospital was . . . very dangerous; on our right were the Prussian batteries at Bagneux and Châtillon, in front the batteries at Bourg-la-Reine, on our left the batteries of L'Hay. . . . There was also shooting on the left in the direction of a little grove; we deposited Courbet behind a wall in an armchair . . . and went to see if anybody had been wounded. . . . When we returned Courbet greeted us with undisguised satisfaction. 'I was beginning to grow old here,' he said. 'They have been shooting . . . I heard the bullets whistle.' . . .

'Then we shall find the bullets, come with me.' For a man who had had no experience of gunfire, Courbet . . . took it very calmly . . . and he had not even let his pipe go out. The Prussians had actually fired near Courbet but a little to the right. . . . We walked towards the walls of the mill . . . but found nothing. . . . While he puffed like a seal, bending over to search in the rough grass . . . I . . . handed him a bullet, and another one a minute later. . . . The adventure was a success, Courbet carried away the tangible proofs. That night, detained by my duties, I could not go to Laveur's and enjoy listening to the master's account of his expedition. Perhaps that was just as well, for . . . the bullets . . . had certainly been fired by real Prussians, but not on that day; I had a collection of them and, at the crucial moment, had fished those two out of my pocket!" [17]

THE COMMUNE

DURING the four months following the downfall of the empire the republican armies had suffered an almost unbroken succession of defeats, and by January 1871 liberals as well as radicals, especially in Paris, had lost faith in the Government of National Defence. The inept leadership of Louis-Jules Trochu, governor of Paris and commander-in-chief of the troops defending the capital, was held responsible for the sufferings of the inhabitants during the siege and for the eventual capitulation of the city. In the diplomatic field Thiers, sent on a tour of European capitals to enlist the support of foreign Governments, failed to obtain a single promise of assistance. For some time the French Government remained in besieged Paris and maintained a delegation at Tours, which became the centre of military resistance after Gambetta, escaping from Paris to Tours in a balloon on October 7, reorganized the republican forces. Ably seconded by Charles de Freycinet, Gambetta infused new life into the dispirited armies but was unable to turn defeat into victory. In December, when the Prussian advance made Tours untenable, the seat of government was transferred to Bordeaux, and elections were held on February 8 for a National Assembly. A substantial majority of the pro-

vincial deputies, many of whom favoured a restoration of the monarchy, clamoured for peace at any price; only the predominantly liberal and radical delegates from Paris demanded further resistance. The majority prevailed, and on February 12 the Assembly empowered Thiers to negotiate terms of peace. The preliminary pact was signed at Versailles on February 26 and ratified on March 1, after which the French Government returned to Paris from Bordeaux. The signing of the treaty of Frankfort on May 10 formally ended the war.

In January the Prussians had invaded the Franche-Comté. At Ornans German troops, billeted in Courbet's studio, had damaged the building and looted a portion of the contents, but had made no attempt to molest the family. Of course Courbet attributed their survival to the virtues of his Bavarian decoration. In a letter to his father dated February 23, 1871, he described his life during the siege and raged furiously against the authorities: "You give me an account of the disasters at Ornans which I had anticipated; I was very uneasy about all of you. . . . Here in Paris the siege was a *farce,* but that was not the fault of the inhabitants, who wanted to fight *to the limit;* the Government in Paris, who . . . did not want the republic to save France, were to blame. . . . All that crowd of traitors, rogues, and idiots who governed us have never fought anything but sham battles, killing a great many men for nothing. These murderers lost not only Paris but France as well by paralyzing and discouraging as much as they could. . . . Those scoundrels used torture to make the inhabitants surrender. Having decided upon capitulation from the start, they tried to glorify themselves by making it appear to be demanded by the people. They stationed 200,000 National Guards at the fortifications where only 25,000 were needed. At the municipal butcher shops they established queues of 2000 people, which formed at six in the afternoon to get a bit of horseflesh half the size of one's fist at ten the next morning. One had to stand in the queue oneself, so that

women, old people, and children spent the winter nights in the open and died of rheumatism, etc. . . . On the last day there was no bread; that was another fraud, there were warehouses containing 400,000 kilos of food that was being allowed to rot while our bread was made of sawdust and oat-straw. During this entire period M. Trochu, a *nincompoop*, would not attempt a single determined sortie, and whenever the National Guard gained ground they were ordered to retreat next day. . . . The real enemies of France were not the Prussians, they were our friends the French reactionaries assisted by the clergy. M. Trochu called for novenas and prayed for a miracle from St. Genevieve, he proposed a religious procession; you can imagine how we laughed. . . . Bombs struck our house and the one opposite; I have had to leave my studio and take lodgings in the Passage du Saumon. Recently the people of Paris proposed to make me a deputy, and I received 50,666 votes without having made a single move. If my name had been printed on the list and if people had been sure I would accept, I should have had at least 100,000. . . . I did not suffer at all during the siege, I happened to need purging and I wasn't hungry. I am thin now, that is good. . . . I shall go to Ornans as soon as I can. . . . I knew very well that my cross of honour would be useful. . . . I am distressed that my studio [at Ornans] has been damaged, it will have to be repaired as well as possible." [1]

It was quite true that Courbet had received more than 50,000 votes in the election of February 8 for delegates to the Assembly, and if his name had been proposed soon enough to appear on the printed list of candidates he might well have been elected. His socialist friends had hastily improvised a campaign in which he himself took no active part. The lodgings at 14 Passage du Saumon (now rue Bachaumont, in the second *arrondissement*) were rented from a dressmaker, Mlle Gérard, on January 6. Fearing further damage to 32 rue Hautefeuille, Courbet transferred most of his paintings to the

Passage du Saumon. Some weeks later he sent fifteen or twenty important canvases to the dealer Durand-Ruel in the rue Laffitte.

Courbet's bitter resentment against the generals, the Government, and the reactionary majority in the National Assembly, while doubtless unfair in many respects, was shared by thousands of disillusioned Parisians. In the opinion of the conservative Government the National Guard, still armed and composed largely of republican extremists, constituted a serious threat to public order. Supported by the Assembly, Thiers, whose official title was *chef du pouvoir exécutif* but who was to all intents and purposes premier, sent a detachment under General Joseph Vinoy to seize the artillery of the National Guard in Montmartre during the night of March 17–18. The attack failed; many of Vinoy's regulars revolted and joined the National Guard; two generals were killed; and the Government fled to Versailles. On March 19 the elective central committee of the National Guard, the only effective authority remaining in Paris, proclaimed the establishment of the Commune.

The central committee promptly occupied the Hôtel de Ville and, with the consent of the mayors of the various *arrondissements,* organized an election on March 26. In the sixth *arrondissement,* with a population of 75,438 and registered voters numbering 24,807, only 9499 votes were actually cast. Four delegates to the governing body of the Commune were allotted to the sixth *arrondissement,* in which nineteen candidates, including Courbet, presented themselves. He was not elected but received 3242 votes, which put him in sixth place. Because two of the winning candidates failed to attend the meetings of the Commune, supplementary elections were held on Sunday, April 16; two additional delegates were chosen from the sixth *arrondissement,* and this time Courbet was elected, though the total number of ballots cast amounted to

only 3469, of which Courbet received 2418. His election was validated on April 19, five weeks before the end of the Commune's brief tumultuous existence.

Meanwhile Courbet's time had been fully occupied with projected reforms in the administration of museums, exhibitions, and other institutions connected with art. On April 5 he issued an appeal to the Parisian artists: "Revenge is ours. Paris has saved France from dishonour. . . . Today I appeal to the artists . . . Paris has nourished them like a mother and given them their genius. Now the artists should devote all their efforts . . . to the rehabilitation of her moral character and the re-establishment of the arts that constitute her fortune. Therefore it is urgently necessary to reopen the museums and to make serious plans for an exhibition in the near future. . . ." [2] At a meeting of a small group of artists at the Ecole de Médecine on April 7 Courbet, as chairman, submitted proposals for specific reforms "in accordance with the spirit of the Commune": [3] the artists were to elect two delegates from each of the Parisian *arrondissements* (of which there were then twenty-two) ; this committee of forty-four would then appoint directors, curators, and other personnel of all public museums, and formulate rules for exhibitions; the Ecole des Beaux-Arts, the fine arts section of the Institute of France, and the French Academy in Rome were to be abolished, though the building of the Ecole des Beaux-Arts might remain open to students who would choose their own teachers and organize their own courses of study; artists who disagreed with the majority would be assigned separate galleries for their exhibitions; awards would be distributed by vote of the exhibitors, but all medals and decorations were to be abolished.

To give effect to these measures the Commune, on April 12, authorized Courbet to summon a meeting in the large auditorium of the Ecole de Médecine. The meeting, which was open to the public, convened on April 13 and was attended by

about four hundred people: "The hall was completely filled and all the arts were liberally represented." [4] One of Courbet's associate chairmen read a manifesto establishing a federation of the artists of Paris founded on three basic principles: "The free expansion of art released from all governmental control and all privilege. Equal rights for all members of the federation. The independence and dignity of each artist guaranteed by all, through the creation of a committee elected by universal suffrage of all the artists." [5] The duties of this committee, to be known as the Commission Fédérale des Artistes, were to preserve the treasures of the past through its administration of public museums; to encourage and support living art by organizing local, national, and international exhibitions; to stimulate future artists by undertaking educational reforms; to publish periodically an *Officiel des Arts*.

The committee was to consist of forty-seven members: sixteen painters, ten sculptors, five architects, six engravers and lithographers, and ten decorative or industrial artists. At the election of this committee on April 17 Courbet received the greatest number of votes, 274 out of a total of 290. Among the other painters chosen were Bonvin, Corot, Daumier, Amand Gautier, Manet, and Millet; among the engravers, Bracquemond, Flameng, and André Gill. Many of these were named without their consent; some were not even in Paris. A few protested indignantly against their inclusion, and many more ignored their appointments and absented themselves from the committee's deliberations. None of the painters and engravers mentioned above except Courbet, Amand Gautier, and André Gill participated actively in subsequent meetings.

Courbet conscientiously attended these sessions, held at first in the Louvre and transferred on April 25 to a building in the rue de Rivoli formerly occupied by the ministry of Beaux-Arts. Ambitious plans were proposed, but before many of them could be put into effect the Commune collapsed. Nevertheless the committee did carry out a few of the projects out-

lined in the manifesto of April 13. Some of the galleries in the Louvre were reopened, but although Courbet afterwards claimed credit for this step, it was probably taken by the director of the museum, Barbet de Jouy, on his own initiative rather than in obedience to the committee's order. On May 2 the committee fulfilled its promise to abolish the Ecole des Beaux-Arts, the fine arts section of the Institute, and the Academy in Rome, and for good measure suppressed the French Academy in Athens as well. On May 17 it dismissed the directors and associate directors of the Louvre and the Luxembourg, for whom it substituted its own members: Achille Oudinot, Jules Héreau, and the sculptor Dalou at the Louvre; André Gill, Jean Chapuy, and Gluck at the Luxembourg.

On April 21 the central authority of the Commune appointed a committee on public education consisting of five members: Courbet, Verdure, Jules Vallès, Jules Miot, and J.-B. Clément. One of Courbet's first acts after the validation of his election on April 19 and his installation as a member of the Commune was to protest against the arrest, by the Commune, of his friend and attorney Gustave Chaudey. Chaudey was in fact neither a radical nor a reactionary, but a sincere middle-of-the-road republican who had whole-heartedly supported the revolution that overthrew the empire. After September 4 he served as mayor of the ninth *arrondissement* until November, when he failed to be re-elected and was appointed to a subordinate post at the Hôtel de Ville. He neither joined nor actively opposed the Commune, which nevertheless suspected him, for no very convincing reason, of plotting against its authority. The chief source of these suspicions was the influential attorney general of the Commune, Raoul Rigault, who had for some time held a personal grudge against Chaudey. By order of Rigault the unfortunate lawyer was arrested on April 13 and incarcerated in Mazas prison. "The Chaudey affair is scandalous," [6] Courbet protested at a session

of the Commune on April 23, but neither his efforts nor those of other sympathizers could prevail against Rigault's vindictiveness. The pleas of Chaudey's wife did eventually secure his transfer on May 19 to a more comfortable cell in a section of Sainte-Pélagie prison reserved for political prisoners and called ironically the *pavillon des princes*. On the night of May 23, the last night of the Commune, Chaudey was executed by a firing-squad under Rigault's personal supervision in the courtyard of Sainte-Pélagie. Next day Rigault himself was killed in the street fighting that brought the Commune to an end.

Menaced from without by the troops of the Versailles Government, torn by internal dissension and disorganization, the Commune was doomed; but Courbet could as yet perceive no signs of imminent collapse. He was obviously enjoying the intense activity, the bustle and excitement of committees, meetings, discussions, proclamations. On April 30 he wrote to his family a letter overflowing with naïve enthusiasm and self-importance: "The people of Paris have plunged me into political affairs up to my neck. President of the federation of artists, member of the Commune, delegate to the mayor's office [of the sixth *arrondissement*], delegate for public education; the four most important posts in Paris. I get up, I eat breakfast, I attend and preside at meetings twelve hours a day. My head is beginning to feel like a baked potato. In spite of all this headache and the difficulty in understanding social problems to which I have not been accustomed, I am in heaven. *Paris is a true paradise;* no police, no nonsense, no oppression of any kind, no disputes. Paris runs by itself as if on wheels. It should always be like this. In short it is sheer bliss; all the [communard] Government departments are unified and independent. It is I who have set the pattern with [my organization of] the artists of all kinds. . . . The notaries and bailiffs belong to the Commune by which they are paid, also the registrars. As to the curés, if they wish to hold services in

Paris (though nobody wants them to) they will be allowed to rent churches. In our leisure moments we fight the *blackguards* of Versailles. We all take turns. They can fight for ten years as they are doing without being able to enter [Paris], and when we do let them in, it will be their tomb. We are safe within our walls, we are losing very few men while their losses are tremendous; that is no misfortune, for all of the Versailles crowd . . . will have to be liquidated for the sake of peace; there we find all the police spies with their blackjacks, the soldiers of the pope, the cowards who surrendered at Sedan; and their politicians are the men who betrayed France: Thiers, Jules Favre, Picard [Ernest Picard, minister of the Interior], and other scoundrels, former lackeys of the tyrants. . . . I don't know, my dear parents, when I shall have the pleasure of seeing you again. I am obliged to carry out energetically all the tasks entrusted to me, tasks for which I have had so much inclination all my life . . . [although] I have always been isolated within my own individuality; to be in harmony with the Commune of Paris I have no need to ponder, I need only act instinctively. The Paris Commune is more successful than any other form of government has ever been. . . . I have had bad luck, I have lost everything I took so much trouble to accumulate: that is my two ateliers, the one at Ornans through the Prussians, and the building for my exhibition [of 1867] . . . which was used in the barricades against the Prussians." [7]

The harmony between Courbet and the Commune did not last much longer. By the end of April Paris was besieged, bombarded, and almost surrounded by the Versailles troops. As an emergency measure the Commune proposed on April 28 to create a Committee of Public Safety of five members and to confer on this committee unlimited powers to act in the name of the Commune. On May 1 the committee was established by a vote of forty-five to twenty-three. The issue split the Commune into irreconcilable majority and minority groups. Cour-

bet voted with the minority and added his signature to a statement setting forth the reasons for opposition: "Whereas the establishment of a Committee of Public Safety will inevitably entail the creation of a dictatorial power which will contribute nothing to the strength of the Commune; whereas this establishment will be in direct opposition to the political aspirations of the electoral rank and file, which the Commune represents; whereas therefore the creation of any dictatorship by the Commune would be in fact a usurpation of the sovereignty of the people, we vote in the negative." [8] On May 17 the minority published a manifesto explaining at greater length their disapproval of the committee. On this point Courbet's position was entirely consistent; he had always violently opposed and distrusted all forms of dictatorship, and not even the Commune could make him violate his principles.

During the wrangle over the minority manifesto on May 17 Courbet announced his resignation as delegate to the mayor's office, though apparently he sent no formal letter to that effect. It would have made little difference, for the Commune had but a week more to live. Notwithstanding his opposition to the Committee of Public Safety he carried out his duties as chairman of the artists' committee to the end. One of these duties concerned the house of Adolphe Thiers in the Place Saint-Georges. Early in May Thiers had sent from Versailles several bundles of anti-Commune proclamations to be pasted on walls throughout Paris. On May 10 the Committee of Public Safety retaliated with an order for the demolition of his house and confiscation of the contents, which comprised valuable furniture and books, marbles, antique terra cotta statuettes, Spanish and Flemish ivories, Chinese lacquers, and a very fine set of Italian Renaissance bronzes.

Although Courbet hated Thiers he respected the collection, and at the Commune session of May 12 he expressed anxiety as to the fate of these works of art, pointing out that the

bronzes alone were worth perhaps 1,500,000 francs and deserved a place in a museum. After some discussion the Committee of Public Safety appointed a committee of five, including Courbet, to supervise the packing and transportation of the valuables. Ultimately, the Committee decreed, the linen was to be distributed to hospitals, the *objets d'art* to public museums, the books to public libraries; furniture and salvaged building materials were to be sold at auction, the proceeds to go to the widows and orphans of slain soldiers of the National Guard. The Committee did not know that, several months earlier, Thiers had had the foresight to deposit some of his rarest items in the cellars of the Institute of France. For several days, while wreckers were pulling down the house, Courbet and his colleagues conscientiously made inventories of the contents, saw them carefully packed, and sent them for temporary storage to a warehouse on the Quai d'Orsay. When bombardment threatened to damage the warehouse the Thiers collection was transferred to the Tuileries, where part of it perished in the flames that destroyed the palace on May 24.

Courbet probably appeared for the last time at a session of the Commune on May 21, when he voted for the liberation of General Cluseret. Cluseret, who had been appointed minister of War by the Commune in April, was a brave officer but a bungling administrator. Because of his ineffectual organization of the defence of Paris he was arrested on May 1 and charged with treason against the Commune, though his real crime was incompetence. After the fall of the Commune he escaped to Switzerland.

The entry of the Versailles troops into Paris on May 21 was followed by a week of desperate hand-to-hand struggles and murderous street battles in which some 7000 men, women, and children were killed. By May 29 communard resistance had ceased. Before the end of June, according to more or less reliable estimates, the vindictive executions ordered by the

Versailles Government accounted for 25,000 to 30,000 additional victims. The communards too had been guilty of brutal excesses, though on a smaller scale; they had slaughtered hostages and summarily executed many of their suspected adversaries, some as harmless as Chaudey.

THE COLUMN

THE TUMULT and the shouting in connection with the Vendôme Column subsided so long ago that it is now difficult to realize that this impressive monument in the Place Vendôme, so familiar to and admired by tourists as well as Parisians, was for more than sixty years considered an abomination by all French republicans, a symbol of the hated empire founded by Napoleon I and revived by Napoleon III.

The design and proportions of the column are similar to those of Trajan's Column in Rome. Each of the monuments is decorated with a continuous spiral band in relief representing scenes from military campaigns, but the Roman column is marble, that in Paris bronze. When Napoleon signed the order for the construction of the Vendôme Column on October 1, 1803 it was intended to place a statue of Charlemagne at the top. On March 14, 1806 the minister of the Interior, Champagny, informed the emperor that the statue of Charlemagne had been presented to the city of Aix-la-Chapelle, and suggested the substitution of an effigy of Napoleon himself. The emperor agreed and wrote in the margin of the letter an order to the minister of War to deliver, for the column and statue, 150,000 pounds of bronze to be melted down from

such Russian and Austrian cannon as were least suitable for military use. The statue, modelled by Antoine Chaudet, represented Napoleon in the garb of a Roman emperor, crowned with laurel and holding a small figure of a winged Victory.

The column thus became, in the eyes of the French people, a glorification of the Bonaparte dynasty, a Napoleonic rather than a national monument. After the Bourbon restoration in 1814 Chaudet's statue was removed and melted down, the metal being incorporated in the equestrian statue of Henri IV located beside the Pont Neuf, and its place on top of the column was taken by a white royalist flag. By a decree of April 8, 1831 Louis-Philippe ordered for the column a new bronze statue of Napoleon, this time clad in his uniform, designed by Gabriel Seurre. During the revolutionary year of 1848 many republican partisans, including Auguste Comte, demanded the demolition of the column, but the insurrection ended before any action was taken. By order of Napoleon III the Seurre statue was superseded in November 1863 by a third effigy of Napoleon I, designed by Augustin Dumont and, like Chaudet's original figure, draped in the robes of a Cæsar. The displaced statue by Seurre was re-erected at the end of the Avenue de la Grande-Armée at Courbevoie, a suburb just beyond Neuilly.

Immediately after the surrender at Sedan and the fall of the second empire many prominent citizens and influential newspapers clamoured for the destruction of the hated column and its conversion into artillery. As a good republican Courbet heartily agreed that the column should at least be removed from the Place Vendôme, though he opposed the destruction of the ornamental bronze sheathing. According to his own recollection six years later, the subject was introduced on September 6, 1870 at the meeting that organized the unofficial Art Commission. The artists present unanimously proposed the demolition of the column, but Courbet declared that his duties as a protector of the arts "by no means involved the destruction of any monument in Paris; that the assumption of

such a destructive right would make it easy, by the adoption of one æsthetic standard or another, to demolish every monument in existence. I proposed an amendment to the effect that we should transport the column to the Invalides after *unbolting* it with care. This proposal was adopted by acclamation. I was instructed to present a petition to the Government of National Defence, who made no response. . . . I also suggested placing at the foot of the column [presumably on the site of the removed column] a large book in which citizens would inscribe their names. . . . This motion was not adopted." [1]

The accuracy of the above statement is questionable, for Courbet made it in a letter written in 1876 when it was vitally important for him to prove that he had consistently, from the very beginning, opposed the total destruction of the column. His actual recommendations at the meeting of September 6 were probably much less specific. Certainly the phrasing of his petition to the Government on September 14—a petition that was to affect profoundly the remaining years of his life—was ambiguous enough:

Citizen Courbet, president of the Art Commission charged with the preservation of the national museums and works of art, elected by a general assembly of artists:

Whereas the Vendôme Column is a monument devoid of any artistic value, tending to perpetuate by its character the ideas of wars and conquests which were appropriate to the imperial dynasty but which the opinion of a republican nation condemns;

Whereas it is for the same reason in conflict with the genius of modern civilization and with the ideal of universal brotherhood which must hereafter prevail among nations;

Whereas it wounds the natural susceptibilities of European democracy and renders France ridiculous and odious

in the eyes of that democracy [the following words were
in the original draft but scratched out: 'and whereas it
is to be feared that the enemy, should misfortune enable
him to enter our city, might cause the violent destruction
of this monument by inflaming the populace'];

Resolves,

That the Government of National Defence should au-
thorize him [Courbet] to unbolt [*déboulonner*] this col-
umn, or that they should take the initiative themselves
by delegating this task to the administration of the Artil-
lery Museum and by ordering the transportation of the
construction materials to the Hôtel de la Monnaie [the
Mint].

He also desires that the same steps be taken with respect
to the statue [of Napoleon I by Seurre] which was re-
moved [from the column] and now stands in the Avenue
de la Grande-Armée at Courbevoie.

Finally he desires that the street names which recall
victories to some people, defeats to others, be eliminated
from our capital and replaced by the names of benefactors
of humanity or by names appropriate to their topographic
locations.[2]

Courbet's use of the curious word *déboulonner*, not found
in French dictionaries, was subsequently made much of in his
defence against the charge of responsibility for the demolition
of the column. André Gill suggested that the very unconven-
tionality of the word intrigued the painter: "A new unknown
word slipped into Courbet's head would cause a disturbance,
an obsession, like the humming of a beetle in a jug." [3] Whether
or not Courbet actually coined the word, it indicated (or was
assumed by his partisans to indicate) that he proposed not the
complete destruction of the column but merely the methodi-
cal removal and preservation of the bronze plates covering the
shaft and pedestal. His advice that the dismantling should be

undertaken by employees of the Artillery Museum, not by ordinary workmen, confirmed this view; on the other hand his mention of the Mint suggested that the ultimate destination of the metal was to be the melting-pot. The wording of his petition also indicated that he knew little about the construction of the column. He evidently assumed that it consisted of nothing but a thin shell of bronze, a gigantic hollow tube, whereas in fact the bronze plates were firmly fastened to and supported by a massive stone cylinder enclosing a circular staircase.

At that time Courbet himself probably had only a vague idea of his intentions with regard to the disposition of the materials composing the column. A month later he explained his meaning much more clearly. On October 5 he wrote to Etienne Arago, mayor of Paris, that his petition had been misunderstood; that he had never advocated the destruction of the monument but desired only "the removal, from the proximity of a street called rue de la Paix, of a mass of melted cannon which perpetuates the tradition of conquest, pillage, and murder, and which is as absurdly out of place as a howitzer in a lady's salon among the shops, filled with silk frocks, laces, ribbons, fripperies, and diamonds, that adjoin the establishment of Worth, the favourite dressmaker of the courtesans of the empire. Would you preserve in your own bedroom the blood-stains of a murder? Let the bas-reliefs be transferred to a historical museum, let them be set up in panels on the walls of the court of the Invalides; I see no harm in that. Those brave men [the maimed veterans in the Invalides hospital] captured these cannon by the sacrifice of their limbs; the sight [of the bronze reliefs made from the cannon] will remind them of their victories—since they are called victories—and especially of their sufferings." [4]

At this point Courbet let the matter drop until after the establishment of the Commune. In his letter of February 23, 1871 to his father he wrote briefly: "I wanted to demolish the

Vendôme Column, I could not obtain permission from the Government, [though] the people approved." [5] This time he used the word *démolir*, not *déboulonner*, but the variation probably had no significance; Courbet never expressed himself precisely in his informal letters.

Meanwhile other individuals and groups continued to agitate without success for the total destruction of the column. On October 2 the armament committee of the sixth *arrondissement* unanimously approved a report by one of its members, Dr Robinet: "The municipal authorities of the sixth *arrondissement* propose that the metal for cannon is to be taken from the column erected in the Place Vendôme to Napoleon I. In addition to the practical utility of this procedure, it will be of immense moral benefit to rid republican France of an odious monument which insolently commemorates the execrable and cursed dynasty that has brought the nation to the verge of destruction." [6]

The Vendôme Column was the principal but not the only target of popular resentment against the Bonapartes. Shortly after the fall of the empire the Government of National Defence took steps to prevent destruction by the mob of other imperial relics: a bas-relief by Barye of Napoleon III on horseback was removed from the Cour du Carrousel and stored in a safe place; a statue of Eugène de Beauharnais, stepson of Napoleon I, was replaced by an effigy of Voltaire; Arago ordered the name of the Boulevard du Prince-Eugène in the eleventh *arrondissement* changed to Boulevard Voltaire; and the prefect of police, Comte Emile de Kératry, preserved Seurre's statue of Napoleon I at Courbevoie by dumping it in the Seine under the Pont de Neuilly. For some reason Napoleon's tomb in the Invalides was never threatened with destruction by the republicans; nor was the Arc de Triomphe, which, unlike the Vendôme Column, was regarded as a collective memorial to the heroic armies rather than a personal tribute to the emperor.

At a session of the Commune on April 12, 1871—four days before Courbet's election to that body, seven days before the validation of his election and his first participation in its deliberations—the assembled delegates ordered the destruction of the Vendôme Column:

> The Commune of Paris,
> Considering that the imperial column in the Place Vendôme is a monument of barbarism, a symbol of brute force and false glory, an affirmation of militarism, a negation of international law, a permanent insult by the victors towards the vanquished, a perpetual threat to one of the three great principles of the French republic, fraternity, DECREES:
> First and only article: The column in the Place Vendôme will be demolished.[7]

There was no mention of "unbolting" the bronze plates or of their future disposition, but the Commune evidently did not propose to preserve them. In the *Journal Officiel* for April 20 appeared the announcement: "The materials composing the column in the Place Vendôme will be offered for sale. They are divided into four lots: two lots of construction materials, two lots of metal. The lots will be disposed of separately by means of sealed bids addressed to the administration of Engineers [of the War ministry], 84 rue Saint-Dominique-Saint-Germain."[8] This measure as well as the original decree had been voted before Courbet took his seat. It was not until April 27 that Courbet made his first and only statement concerning the column at a session of the Commune, as reported in the *Journal Officiel: "Citizen Courbet* demanded that the decree of the Commune with respect to the demolition of the Vendôme Column be put into effect. Perhaps [he suggested] it might be advisable to retain the monument's pedestal, on which the bas-reliefs record the history of the [first] republic;

the imperial column would be replaced by a figure symbolizing the revolution of March 18 [1871]. *Citizen J.-B. Clément* insisted that the column should be entirely broken up and destroyed. *Citizen Andrieu* said that the executive committee was attending to the execution of the decree; the Vendôme Column would be demolished in a few days. *Citizen Gambon* proposed the appointment of citizen *Courbet* to assist the citizens in charge of the operation. *Citizen Grousset* replied that the executive committee had placed the work in the hands of two engineers of the highest standing who had assumed all responsibility for its execution." [9]

Afterwards Courbet claimed that he had been misquoted, that he had demanded the *déboulonnement* of the column, not its demolition. He may well have been inaccurately reported; many other members made similar complaints, for at that time the Commune did not require the reading of minutes, and the secretaries merely handed their notes, without verification, to the editors of the *Journal Officiel*. Courbet's reference to the "history of the republic" betrayed his ignorance; the reliefs on the pedestal actually represented trophies of Napoleonic campaigns and had no more connection with the republic than the decorations on the shaft. The report indicated that Courbet had not been consulted or even informed concerning the measures already taken for the demolition. Nevertheless the painter was subsequently held accountable for the decree of April 12 ordering the destruction of the column. The real author of the decree, Félix Pyat, a member of the executive committee of the Commune, failed to acknowledge his responsibility until three years afterwards, too late to save Courbet.

On May 1 the Commune concluded a contract for the demolition of the column. Courbet's signature did not appear on the document: "Between the *Commune of Paris* . . . and *citizen Iribe,* civil engineer, *member of the Positivist Club of Paris and acting in that capacity* . . . it has been agreed as

follows: . . . Citizen Iribe undertakes to accomplish on May 5, anniversary of the death of Napoleon I, the successful overthrow of the said column . . . except the pedestal which will be destroyed by the Commune of Paris, on the following conditions: The operation will be performed . . . for 28,000 francs payable . . . in cash immediately after the demolition. . . . He [Iribe] will not be responsible for damage to the monument itself, but he affirms his ability to avert any danger to neighbouring buildings during or as a result of the operation. He also personally guarantees payment to the owners of such buildings for any damage they may suffer. The Commune of Paris undertakes . . . to assist the project by any means in its power." [10]

Unable to complete his arrangements in time to pull down the column on May 5, the contractor postponed the operation twice, first until May 8 and finally until May 16. On that day all was prepared, and the demolition (Plates 54 and 55) was announced for two in the afternoon: "At the base of the shaft on the side . . . facing the rue de la Paix a triangular cut extending through about one-third of the diameter was made; and on the opposite side on the same level the stone was sawn through and iron wedges were inserted, the lowest bronze plates having first been removed. A very strong cable was looped round the top of the column at the height of the platform and attached to a pulley which was connected by a cable passing through it three times to another pulley fixed to the ground. From this the cable was wound round a winch placed opposite the column near the intersection of the Place Vendôme and the rue Neuve-des-Petits-Champs. This winch was firmly anchored to the ground. To deaden the fall the ground had been covered by a bed of sand, on top of which twigs and a thick layer of manure were spread. . . . Since noon a large crowd had assembled in the rue de la Paix near the Place Vendôme, into which access was forbidden to the public. . . . About half past three the winch started to turn; the cable

stretched and grew taut. . . . After the strain had been applied for several minutes something was heard to snap; the pulley fixed to the ground . . . had just broken. The contractor . . . sent for a stronger one which was soon installed. . . . About half past five several military bands of the National Guard, assembled in the corners of the square on the side nearest the rue Saint-Honoré, played the *Marseillaise*. All was ready for renewed application of tension to the cable. It had been stretched tight for only a few minutes when the column was seen to tilt. When it had inclined very slightly from the perpendicular it suddenly broke into segments which crashed to the ground, making a tremendous noise and raising a thick cloud of dust. Immediately the spectators . . . surged forwards to the immense ruin, clambering onto and examining the blocks of stone. Several members of the Commune made brief speeches; red flags were brought from headquarters and placed on the pedestal of the column." [11]

A correspondent of *The Times* of London reported that the column fell at ten minutes to six: "The concussion was nothing like what had been expected. No glass was broken or injury done to the Square, excepting that the Column forced itself into the ground. The excitement was intense. . . . It was forbidden to take away any fragments, and people were searched before leaving the Square." [12] The statue of Napoleon "had fallen beyond the heap, and, having smashed the pavement into splinters, lay a wreck, with one arm broken and the head severed from the body. . . ." [13] Courbet was almost certainly among those who watched the demolition, but he took no part in the oratory and apparently remained in the background. "Naturally Courbet was there," Castagnary wrote some years later, "but merely as a spectator. . . ." [14]

ARREST

AFTER the entry of the Versailles troops into Paris on May 21 some of the leaders of the Commune managed to escape to England, Belgium, or Switzerland, but many more were arrested. All through the bloody week that preceded the end of communard resistance Courbet remained at his post and assisted Barbet de Jouy, who had been reinstated as director of the Louvre, to protect the national collections from damage. He could probably have escaped quite easily to Switzerland by way of Besançon or Pontarlier, but apparently he anticipated no danger to himself, though he did take a few elementary precautions. Leaving his possessions with Mlle Gérard in the Passage du Saumon, he moved on May 23 to the domicile of an old friend, a maker of musical instruments named A. Lecomte, at 12 rue Saint-Gilles in the third *arrondissement*. After the painter's arrest Lecomte explained that, having no interest in politics, he had been unwilling to refuse hospitality to Courbet, whom he had known for twenty years.

On May 30 the police entered Mlle Gérard's house and seized a trunk filled with Courbet's papers; on June 1 they sequestrated in the basement of the same house 206 canvases already mouldy from dampness, two cases containing other

pictures, and an antique panel; on June 2 they searched the studio at 32 rue Hautefeuille as well as the apartment of a Mme Romenance at the same address, and sealed the door of the studio. The ostensible purpose of these searches and sequestrations was to determine whether or not Courbet had stolen works of art from public galleries or from the Thiers house, although Gonet, the police commissioner in charge, admitted that "our ignorance of matters pertaining to art did not permit us to decide whether the said canvases were by Courbet or whether they came from galleries." [1] Everything found was in fact Courbet's property except a small antique figurine and the head of a statuette which he had picked up in the debris of the Thiers mansion, intending to add them to the rest of the collection at the first opportunity.

This was but the beginning of a series of disasters. On May 28 the municipal council of Ornans signified its disapproval of Courbet's activities during the Commune by ordering the removal of his statue, the *Bullhead Fisher,* from the fountain in the public square. The decree was executed on May 30, and the statue, with one arm broken off, was turned over to Régis Courbet. For some reason this insult by the authorities of his native town wounded Courbet more deeply than many of the more serious catastrophes that followed; again and again in his letters he railed against the injustice of the act and threatened vengeance upon its perpetrators. A few days later worse news arrived: his mother, whom he adored, had died at the age of seventy-seven.

On the night of June 7 Courbet was arrested in Lecomte's apartment and taken first to the Foreign ministry for identification, then to the prefecture of police, where he was interrogated for an hour and locked up for the night. Next morning he sent a messenger to Castagnary with a hastily scribbled note: "I was arrested last night at eleven, I was escorted to the ministry of Foreign Affairs, then I was brought to the police station at midnight. I slept in a corridor crammed with other

prisoners and now I am in a cell, number 24. I expect to be taken to Versailles soon; if you could come to see me I should be very glad to talk with you a little. . . . My situation is not amusing. This is what one's heart leads one into." [2] Interrogated again on June 8, he maintained that he had become a member of the Commune only in order to be in a position to protect the nation's art treasures and that he had consistently opposed the excesses committed by extremists.

Meanwhile fantastic rumours circulated concerning his fate; in default of authentic information the journalists gave free rein to their imaginations. "Many fables have been published in the newspapers," wrote one correspondent, "about the painter bandit Courbet. . . . Some report him dead of apoplexy at Satory [a fortress near Versailles]; others claim that he has taken refuge in Bavaria. We are able to rectify these errors. Courbet poisoned himself at Satory. His death was slow and excruciatingly painful. Chance put us in touch with one of the gendarmes on duty at the time of Courbet's arrival. This gendarme was present when he died and showed us the mound under which he is sleeping his last sleep." [3] According to another version Courbet "was at the [ministry of] Marine when our troops captured it. He tried to hide in a cupboard too small for his bulk, so he was easily discovered. When he was recognized by an officer he attempted to resist; a shot blew his head off." [4]

Since all pro-Commune and even mildly liberal papers had been suppressed, Courbet's enemies had the field to themselves. Innumerable spiteful cartoons and caricatures of the painter appeared within a few weeks, dozens of articles and hastily printed pamphlets attacked him viciously. Henry Morel called him "that hippopotamus swollen with pride, fattened with folly, besotted with brandy, who with his own weight drags down . . . into the morass a host of insignificant and inoffensive people who attempt to kiss his foot, the shape of which resembles that of a horse less than that of an

ass." [5] Most scurrilous of all was a long article by the younger Alexandre Dumas published in *Le Figaro:* "The Republic must produce spontaneous generations . . . for example, what fabulous intercourse between a slug and a peacock, what genetic antitheses, what bristly slime, could have spawned the thing called Monsieur Gustave Courbet? In what hothouse, by the use of what manure, as a result of what mixture of wine, beer, corrosive mucus, and flatulent bloating can have grown this hollow hairy gourd, this æsthetic belly, this imbecile and impotent incarnation of the Ego?" [6]

From the Conciergerie prison adjoining the prefecture of police Courbet wrote reassuringly to his family on June 11: "I cannot return home soon because the terrible events that have occurred recently require my presence in Paris. . . . As to the municipal authorities of Ornans, who have dared to insult my family as well as myself, I shall have an account to settle with them later. . . . At the moment I am a prisoner until more tranquil times, which will soon follow, enable me to clear myself. I expect to show France the example of a man who has the honour to do his duty in all circumstances." [7]

Castagnary used all his influence as an editor of *Le Siècle* to obtain Courbet's release or at least some alleviation of his discomfort. He received little encouragement from Emile Duriez, an official in the ministry of Justice, who wrote on June 14: "What you ask is very difficult. The unlucky Courbet is one of the most compromised members of the Commune. I shall do what I can, but I do not know that I shall be able to do anything." [8]

Unfortunately the only members of Courbet's family near at hand were the two he disliked and had quarrelled with, Zoé and her husband Eugène Reverdy; but he was now in no position to reject help from anyone. During the difficult months ahead Zoé did her duty nobly in her own fashion. Though her excitability, her tactlessness, and her outspoken

opposition to his political creed often irritated her brother to the point of frenzy, he was forced to admit grudgingly that she had devoted herself to his welfare and had spared no pains to minister to his comfort while he was in prison. Zoé and her husband lived in Paris at 4 rue d'Assas, but at the time of Courbet's arrest were at the château of Bréac near Ablis, about forty miles away. From Bréac Reverdy wrote to Castagnary on June 13: "I thank you in the name of Gustave's family and in my own for the negotiations you have already undertaken and those you propose to undertake with influential people who may . . . be able to improve his unhappy situation. . . . Certainly my wife and I regret that he paid no attention to us, for his sister's warm heart and her love for him would have kept him from allowing himself to be drawn so deeply into politics, and we would have saved him and restored him to the arts in which his undisputed pre-eminence should have satisfied him. In spite of his ingratitude towards us . . . we offer him all our devotion. . . . I have requested a power of attorney . . . in order to safeguard his interests as well as possible, to collect his pictures and possessions that are now scattered all over the world. Very sad news has just been added to our misfortunes; his poor mother, hearing of his predicament and the rumours of his death, could not survive this terrible blow. She died on Saturday June 3 at nine in the evening at Flagey." [9]

To this Zoé added a postcript: "It is in adversity that one finds one's real friends. I expected no less from you and I . . . join my husband in thanking you in advance for what, I hope, you will do for my unhappy brother. . . . Tell him that we have forgotten the past, that it is our separation that has caused the damage, since I have been unable to surround him with my devotion. . . . My brother, *in spite of everything,* has lived honourably for fifty years; he has been the pride of his province, his family, and his country. . . ." [10]

At the same time Courbet's family and friends in the

Franche-Comté were pulling all the strings they could grasp. "Courbet's father has written to Grévy [Jules Grévy, president of the National Assembly from February 16, 1871 to April 2, 1873]," Dr Ordinaire informed Castagnary on June 18. "I could not do so myself because I had incurred—probably because of my independence—the displeasure of that man who is stuffed with pride and aristocratic ideas. But since he could perhaps do a great deal for our poor friend, I shall write to Dorian [Frédéric Dorian, formerly a minister in the Government of National Defence] . . . to use all his influence with the great Grévy or with anyone else. . . . Let us make every effort to obtain for him [Courbet] exile in America or elsewhere. . . . [Félix] Gaudy . . . leaves for Paris tomorrow; he will see you and do whatever he can." [11]

Four days later Ordinaire wrote again: "Two busy-bodies, Champfleury and Reverdy . . . have written to Courbet's father and have asked him for powers of attorney to enable them to assemble the painter's works in a safe place and, if necessary, sell them. But his father does not think himself justified in disposing of his son's property during the latter's lifetime, and he is right. Moreover he [Courbet] is intensely prejudiced against his brother-in-law and would resent his meddling in his affairs." [12]

At the Conciergerie Courbet was allowed to have his meals brought in at his own expense from the Brasserie Laveur, but he complained that the dirt, the vermin, and above all the close confinement in a cell were affecting his health. Preliminary charges against him were drawn up on June 17, and at the end of the month he was taken to Versailles in a prison van, with manacles on his wrists, for a brief interrogation, after which he was brought back to the Conciergerie. An English acquaintance, Robert Reid, made a praiseworthy but ineffectual effort to help by writing on June 26 to *The Times:*

. . .

M. Courbet, the late Minister [*sic*] of the Fine Arts for the Commune, and at present on the eve of his trial at Versailles, gave me the following letter for publication in answer to a charge made by the English Press that he personally had destroyed several works of art in the Louvre.

I received the letter from his own hands in the Hôtel de Ville the morning before the entry of the Versailles troops into Paris:

'May 20, 1871.

'Not only have I not destroyed any works of art in the Louvre, but, on the contrary, it was under my care that all those which had been dispersed by various Ministers in different buildings throughout the capital were collected and returned to their proper places in the Museum. In like manner, the Luxembourg was benefited. It was I who preserved and arranged all the works of art removed from the house of M. Thiers. I am accused of having destroyed the Column Vendôme, when the fact is on record that the decree for its destruction was voted on the 14th [*sic*] of April, and I was elected to the Commune on the 20th six days afterwards. I warmly urged the preservation of the bas reliefs, and proposed to form a museum of them in the Court of the Invalides. Knowing the purity of the motives by which I have been actuated, I also know the difficulties one inherits in coming after a *régime* such as the Empire.

'G. COURBET.'

The many false accusations that have been brought against him by the Press, and the critical position in which he is placed, claim our sympathy as a duty in giving publicity to the truth.[13]

On July 4 Courbet was transferred to Mazas prison, as Zoé informed Castagnary: "Gustave is at Mazas since yesterday

morning, he has had an interrogation, he is ill and begs to be moved to a hospital. . . . We do not know whom to apply to, if you could advise us . . . you would give us great pleasure." [14] Castagnary promptly appealed to Duriez at the ministry of Justice, who replied: "I think it would be better for your friend to be tried in a civil court. The evidence would be examined more carefully and his resources for defence would be more complete. . . . Except in case of absolute necessity the request for transfer to a hospital could not be considered; in my opinion such a petition would be very illadvised. A display of resignation would be proper and sensible." [15]

Courbet did not depend exclusively on the help of his friends and family. During June he himself wrote appeals to Grévy and to the minister of Education, Jules Simon. Grévy recommended a barrister, Lachaud, for whom Courbet prepared voluminous notes as a basis for his defence. The suggestion that he might be tried by a civil tribunal was brushed aside by the authorities, who ordered him to appear before a military court, the Third Council of War of the first military division, in Versailles at the end of July. The indictment was formulated by one of the court secretaries, M. de Planet, on July 25. On the whole this report stated the case with commendable fairness: it admitted that Courbet had voted against the establishment of the extremist Committee of Public Safety, that he had concerned himself chiefly with matters pertaining to the preservation of art works, that he had conscientiously supervised the removal of the contents of the Thiers house, that he had not been a member of the Commune when the decree ordering the demolition of the Vendôme Column was passed, and that he had urged the "unbolting" of the column and the preservation of its bronzes. Nevertheless he was to be held responsible for certain offences: "In consequence, we advise that Courbet, Gustave, be tried before the Council of War for (1) participation in a movement designed to

change the form of government and to incite the citizens to take up arms against each other; (2) usurpation of civil functions; (3) complicity in the destruction of a monument erected by public authority, the Vendôme Column, by assisting those who committed this crime in the acts which prepared, facilitated, and consummated it." [16]

Zoé now attempted to enlist the aid of Alfred Bruyas, by this time a confirmed invalid in Montpellier. "We have seen our poor father," she wrote on July 26, "who came to Paris to see our unfortunate brother. . . . He [Courbet] has been interrogated and the trial will open Sunday [July 30] or Monday July 31. . . . I pray you, sir, if you have any friends who might be acquainted with the military authorities who are to try Gustave, ask them to look upon him merely as an artist who tried to devote himself to the arts. . . . We are knocking at every door, and all the influential and highly placed people are responding cordially. Let us hope. We have seen Gustave. He is very much changed. And we are very sad." [17] Zoé followed this almost immediately with another letter asking Bruyas to appear as a witness: "All the eminent people in France and the neighbouring countries have requested seats. It will be almost impossible to get in. Only witnesses have the right [to be admitted]. M. Lachaud urges us to appeal to all true friends who are willing to help my brother. . . . If you could possibly come to Paris and aid Gustave on Monday at Versailles as a friendly witness for the defence you would render us an immense service." [18]

Bruyas was far too ill to travel, but he wrote to Lachaud: "I understand you are in charge of the defence of my friend G. Courbet. I am altogether unfamiliar with politics and have maintained with the celebrated painter only an artistic relationship which has enabled me to appreciate the nobility and honesty of his character. Therefore I refuse to believe that he can have been in any way involved in the horrors in Paris. If this testimony . . . is of any value, you may use it in any way

279

you think proper." [19] To Zoé he sent a telegram explaining his inability to attend the trial, as well as a sympathetic letter: "I need not tell you that Gustave's predicament . . . distresses me deeply and that in spite of the attacks made upon him I cannot and will not believe him guilty of the designs of which he is accused. Permit me to express all my hope that your brother's judges will take into account the subversive influences to which he yielded, and realize that they have before them an artist who may have been led astray but who has nothing in common with political murderers. . . ." [20]

CHAPTER XXVII

PRISON

THE MILITARY court, unperturbed by the raucous clamour of journalists and pamphleteers, treated Courbet with surprising consideration. Colonel Merlin, president of the tribunal, expressed regret that so talented an artist should have blundered into such a predicament. Courbet was tried with eighteen other members of the Commune and was not called to the stand until August 14. In reply to Merlin's questions he maintained once more that all of his activities under the Commune had been constructive: he had protected national property, voted against the extremist majority, saved the Thiers collection, and attempted to preserve the bronze sheathing of the Vendôme Column. The prosecution called only two witnesses, neither of whom produced any damaging evidence. Mlle Gérard testified merely that the painter had lodged in her house from January 6 to May 23, that she had then asked him to leave because she did not wish an arrest to take place on the premises, and that he had always behaved with propriety. Joseph Duchou, a concierge employed in a building in the Place Vendôme, thought he had seen Courbet, in a short dark jacket, clamber up a ladder and strike the first blow against the column on May 16. The court obviously disbelieved the

concierge, and Courbet retorted that the only dark clothes he ever wore were long-tailed *redingotes* and that his paunch made it impossible for him to climb ladders.

On the other hand the defence presented more than a dozen witnesses and held a dozen more in reserve. Vialet, president of the Société d'Assistance Publique of the sixth *arrondissement,* deposed that Courbet had restored to him documents confiscated by the National Guard. Cazala, director of the periodical *Le Magasin Pittoresque,* testified to the painter's character and the moderation of his political beliefs. Barbet de Jouy, director of the Louvre, and Philippe de Chennevières, director of the Luxembourg—both of whom had been dismissed by the Commune and reinstated after its collapse—affirmed that Courbet had contributed notably to the preservation of art treasures in public museums, not only before and during the Commune but also in the week of tumult following the entry of the Versailles forces. Dorian, to whom Dr Ordinaire had appealed, declared that Courbet was an intelligent artist but an inconsistent and inexpert politician. Etienne Arago, the former mayor, had never considered the painter a politician at all. Jules Simon, minister of Education, testified somewhat unwillingly that the Art Commission under the Government of National Defence, to the presidency of which Courbet had been elected in September 1870, was an unofficial body; the painter's position was not that of a civil functionary, therefore he had not usurped civil functions. At a later session on August 17 Paschal Grousset, one of the co-defendants, who had been kept in solitary confinement at Versailles and had not heard of the accusations against Courbet until they were disclosed at the trial, voluntarily gave evidence to the effect that Courbet had had no connection whatever with the decree ordering the demolition of the column, the negotiation of the contract, or the demolition itself. During the session of August 22 Courbet was accused of complicity in the theft or disappearance from the Tuileries of a silver statue, two metres high,

representing *Peace;* but four days later Merlin announced in court that the figure had been found in the cellars of the Louvre.

Even the prosecutor, Gaveau, handled Courbet gently, declaring that it saddened him to see "an artist of great talent in the midst of these depraved men whom laziness and envy had turned into criminals." [1] Nevertheless he held Courbet responsible for his support of the Commune and participation in its acts. Lachaud delivered his speech for the defence on August 31, pleading with great earnestness and skill for an acquittal. Although his own political sympathies were with the empire, he considered Courbet's conduct meritorious. Point by point he summed up the evidence in the painter's favour. Afterwards Courbet acknowledged the attorney's conscientiousness and ability but complained that Lachaud, as a Bonapartist, had treated him coldly and had refused to shake his own client's hand.

The long ordeal had undermined Courbet's health; he had grown thin and haggard, his hair had turned white, and the chronic discomfort caused by hæmorrhoids became so acute that he was obliged to sit on a cushion while the court deliberated. Shortly after the trial began he was moved from a cell to the military hospital at Versailles, where his condition at once improved. Zoé did what she could for him, but by this time she was also feeling very sorry for herself. She stressed her own sacrifices in a letter to Bruyas: "As you well know, I have appealed to every heart, knocked at every door, moved heaven and earth. . . . I go to see him as often as possible. It is so difficult to be obliged to go to Versailles every day and at the same time to do what is necessary in Paris. Though my husband is not rich he grudges no sacrifice, and in spite of our self-denial our expenses are heavy. No matter, we are carrying on bravely, for we must get Gustave out of this scrape no matter what it costs! . . . As he is ill I obtained his transfer to the military hospital. . . . In the future may he listen only to

his true friends and occupy himself with nothing but his painting. . . . I read to Gustave all the letters received from friends. That is a great pleasure for the poor prisoner." [2]

On August 27 Courbet himself wrote to Juliette: "I was very glad to be transferred to this hospital, where I am very happy. I have entirely recovered from the torment caused by confinement in a cell; solitude weakens the mind. . . . I am as thin as I was on the day of my first Communion, you would be amazed. Sister Clotilde is taking care of me, she is extremely kind to me and gives me all the food she can, in defiance of the rules. . . . Our causes have been pleaded for several days, the barristers are doing their utmost. I have the best barrister in Paris. Moreover he is in good standing with all factions. M. Grévy found him for me. If I should be sentenced merely to exile I do not intend to appeal; I shall serve my sentence without asking them for mercy because I don't want those who have had the impudence to persecute me, after having performed such notable services as I have performed, to be able to rid themselves of me so easily. I want to retain the right to denounce them at any time. Here the opinion of the majority is that I shall be acquitted. If I am condemned to prison I shall request that the sentence be changed to exile. If I am acquitted I think I shall spend a week or two at the seaside before going to see you, for two reasons: because I have great need of sea bathing, I have not had a [sea] bath this year . . . secondly I want to denounce the municipal authorities of Ornans immediately after the trial, before I return home. . . . Those people, those idiots are nothing but assassins; their decision [to remove the *Bullhead Fisher*] presupposed my condemnation, and if I had not gone into hiding I should certainly have been shot. The question of the column has entirely vanished from my case. . . . The only charge remaining against me is that I joined the Commune in order to accomplish my mission [the preservation of works of art]. . . . Moreover I am proud to have been a member of the Com-

mune in spite of the accusations against it, because that type of government, resembling in principle the Swiss system, is the ideal government; it eliminates ignorance and renders war and privilege impossible. . . . If I go to Switzerland I shall have you all join me, I shall go to Neuchâtel. . . . Don't answer this for a week, whatever you write might compromise me, especially [letters from] my father." [3]

Courbet was far too optimistic. On September 2 the court sentenced him to imprisonment for six months in addition to the three months he had already spent behind bars since his arrest. He was also condemned to pay a fine of five hundred francs as well as his proportionate share of the costs of the trial. Each of the convicted men was made jointly and severally responsible for the total costs, and as most of them were without funds Courbet paid the quotas of thirteen of his fellow prisoners in addition to his own, amounting in all to 6850 francs. Theoretically he was entitled to sue his co-defendants for reimbursement, but the chances of repayment were so slight that he voluntarily renounced all claims against the other communards. Courbet himself realized that his punishment was mild in comparison with the harsh sentences imposed upon most of the culprits, and he still hoped for a commutation.

On September 3 he announced the verdict to his family: "I have been condemned to six months in prison, I still don't know why. Those people [the judges] are trying to please the public. Even after it had been proved that I had had no connection with the destruction of the column they insisted all the same that I had participated in it. . . . I think they intend to give the impression that everyone is guilty, and pardon me later; that is not the same [as an acquittal] for me, as if it were not for this verdict I could have denounced the municipal authorities of Ornans. I don't know yet whether I shall simply be released or have my sentence changed to exile. . . . I don't propose to appeal so as not to upset their plan [to

commute or modify the sentence]. They have also sentenced me to pay a fine of five hundred francs, I don't know why. They think I am rich, that is a very prevalent notion. It must be that I look rich, perhaps because I am fat. We shall see how this turns out, but it is almost certain that I shall not serve a term in prison. My comrades have received very severe sentences, some to prison, others to deportation, and two of them to death, but these [death sentences] will not be carried out. Everyone thought I would be acquitted; I didn't think so because I know those people and how irritated they are by the contempt we showed for them in our proceedings in Paris. . . . Don't worry; all this nonsense has no effect on me." [4]

This was whistling in the dark; the court had no intention of commuting or reducing his sentence. After the verdict Courbet was moved to a temporary prison in the Orangerie at Versailles, where he was forced to sleep "in three centimetres of vermin." [5] On September 22 he was transferred to the old prison of Sainte-Pélagie in Paris, situated in the rue du Puits-de-l'Ermite between the rue Monge and the Jardin des Plantes. Founded in 1665 as a refuge for retired prostitutes, the ancient building was "stricken by senile leprosy; no matter how often it is cleaned, renovated, repainted, it sinks under the weight of its great age. . . ." [6] The prison was demolished in 1899. It contained no cells, only dormitories and a few cubicles reserved for prisoners who could afford to live *à la pistole:* that is, to have their meals brought in from a restaurant at their own expense. For political prisoners there was also the *pavillon des princes* in which Chaudey had been incarcerated. Courbet was not admitted to this more comfortable section, but he availed himself of the privilege of the *pistole*. His food was sent in from the Brasserie Laveur and he enjoyed the privacy of a cubicle, number four, containing an iron bed, two tables, and three chairs. The door was locked at night but left

open during the day so that he could visit other prisoners or walk in the grim courtyard. To his intense disgust he was required to wear the regulation prison uniform, grey trousers and jacket.

"I have been in Sainte-Pélagie since yesterday," he wrote to Castagnary. "They have insisted on treating us like common criminals, not political prisoners; we are among thieves up to our necks. Every effort has been made to humiliate us. . . . Please ask the prefect of police for a permit to visit me, also [permits for] my sister and brother-in-law. I have business to settle with regard to an apartment I rented for the use of a club in the rue du Vieux-Colombier [where his spurious old masters were stored], I should feel relieved if you would advise my brother-in-law a little in this matter. . . . If any of my friends wish to come with you, request permits for them too." [7] But it was not until December 15 that Castagnary was granted permission to visit Courbet twice a week.

Courbet had not touched a brush for more than a year, but the enforced idleness of prison life made him eager to paint again. Another letter to Castagnary told of his frustration: "An incomprehensible thing has happened, I am not allowed to work. In spite of my requests and those of my sister, M. Valentin [General Valentin, prefect of police] will not permit it. . . . This distresses me all the more because I have had an idea: to paint a bird's-eye view of Paris with a sky like the skies in my seascapes. The opportunity is unique; there is a gallery round the roof of the building . . . with a splendid view, it would be as interesting as my Etretat seascapes. But with . . . unheard-of brutality I am forbidden to have my tools, and I am the only one treated like that in Sainte-Pélagie, where everybody is forced to work. I am required to make felt slippers, and since I don't know how, I pay [instead] five sous a day out of my twenty francs a week, in addition to my *pistole*. . . . You are in touch with Gambetta, explain this to him

and ask him to send instructions or an order [for a picture] which will oblige me to work. . . . Hurry, for the weather is fine and I must take advantage of this opportunity." [8]

To Juliette he wrote on September 29: "I never have a chance to write, my freedom is restricted, I can neither write nor receive letters unless they pass through the hands of the prefect, who is very disagreeable. That is why I told you not to write, because things that seem most innocent and most natural are interpreted here in a strange way. . . . I am feeling better and am recovering my health. . . . Now I can be in the open air and am allowed to walk and to talk to people, although they [the authorities] have had the effrontery to put us with thieves and murderers. All this matters little to me, you know, I defy them to humiliate me. . . . I receive letters of congratulation from all over, from Germany, England, Switzerland; everybody supports me except the reactionaries and those in the pay of the Government and of Napoleon. . . . My sister [Zoé] is making herself ill with worry, her pride is wounded. As to myself, it has only made me laugh the whole time, so don't be uneasy about me. I lack nothing here. . . . I have already served a month, there are only five more. . . . People talk so much here that there is no time to do anything. I shall try to get my paints and work a little. I don't know if my sister will succeed in having me moved to a nursing home. . . . There I could receive friends and employ models. . . . I am told you are anxious to come here; I beg you, I pray you not to come, it would distress me to know that you were alone on the way here and in Paris, which is very dangerous. You might be imprisoned, it is almost certain that you would be; my sister [Zoé] has not been because she is married, but all the sisters and brothers and fathers of my friends are in prison. The greatest pleasure you and Zélie can give me is to remain at home and above all not to worry. . . . I cannot be home for the wine-making this year. I am thinking constantly of what you are doing." [9]

Zoé finally persuaded the prefect to allow Courbet to paint in his cubicle. Models were forbidden, but Zoé brought fruit and flowers for still lifes. On November 30 she wrote to Bruyas: "It is impossible to tell you how much I have done, how much I have suffered. . . . Only the results could make you understand. Gustave has suffered a great deal emotionally and physically. Solitary confinement drove him mad. . . . Then his health was very poor and I could not arrange to have him cared for. Nevertheless . . . I managed in the end to convince them [the authorities] after a fashion. I collected all the documents for his defence, all the decrees relating to the demolition of the column . . . Gustave had never signed any of them. He is not a *destroyer*. . . . He is the only man who at such a time devoted himself completely [to his mission] even when the Commune threatened every day to shoot him as a reactionary [this was a figment of Zoé's melodramatic imagination]. . . . I visit him at Sainte-Pélagie twice a week. I have been permitted to bring him brushes, but two square metres provide very little space [for painting]. He . . . is not allowed to work outside his room. Gustave's health has improved greatly since his return to Paris. . . ." [10]

Courbet painted a whole series of small fruit and flower compositions in his cramped little cubicle, but most of them were decidedly inferior to the flower paintings executed in the Saintonge nine years before. He also painted a portrait of one of the turnkeys, and on the wall next to his bed he sketched the head of a girl with a flower in her hair. Her head appeared to be resting on the painter's pillow, and it was reported that the warden, deceived by the realistic representation, became furiously angry at the sight of a woman in the prisoner's bed but ended by laughing heartily when he discovered that the hussy was merely a painted image. The small self-portrait *Courbet in Sainte-Pélagie* (Plate 56) may have been executed in the prison but was more probably done from memory after his release. The still life *Apples and Pomegranate in a Bowl*

(Plate 57) was painted either at Sainte-Pélagie or a few months later at Neuilly.

Courbet's mood fluctuated constantly between defiance and self-pity. Among his devoted correspondents was Lydie Jolicler, to whom he wrote a touching letter from Sainte-Pélagie: "In these moments of dreadful solitude between life and death (for you could never imagine what we have suffered) I involuntarily think of my youthful days, of my parents, my friends; I have revisited in my thoughts all the places I went to as a child with my poor mother (whom I shall never see again, that is my most profound and indeed my only sorrow amid all the disasters that have befallen me since I saw you). In the mirror of my mind I saw again the fields of Flagey where I walked with her, looking for hazel-nuts, the fir woods of Reugney where I went for raspberries. . . . I remembered the cakes she baked for me in her oven. . . . I have been robbed, ruined, slandered, dragged in chains through the streets of Paris and Versailles, overwhelmed by stupidities and insults; I have crouched in prison cells . . . slept with riff-raff on floors crawling with vermin, been transferred and retransferred from prison to prison, in hospitals surrounded by the dying, in police vans . . . with a gun or revolver at my throat, for four months. But alas, I am not the only one, there are two hundred thousand of us living and dead. Ladies, women of the people, children of all ages, some of them still at the breast, in addition to the homeless children wandering about Paris without father or mother, imprisoned by thousands every day. Since the beginning of the world nothing like this has happened before; among no other people, in no history, at no time has there been such a massacre, such a revenge." [11]

Without Courbet's knowledge Zoé was waging a determined campaign to induce all her brother's friends to write letters urging him to abandon politics and confine his future activities to painting. She had repeatedly importuned Bruyas, who answered politely but who understood better than Zoé that

such advice would be resented by the painter. Now it was the turn of Lydie Jolicler, to whom Zoé wrote on December 1: "I am asking all our friends to use all their powers of persuasion to make my brother promise to occupy himself with nothing but painting; his life will be too short to complete his work; he should turn a deaf ear to and recoil from those false friends who seek only to destroy him. . . . Let what I ask appear to originate with you; do not tell my brother or even my sisters that I have requested your intervention; coming from me it would have no effect." [12] On December 12 Zoé wrote again, more casually and more informatively: "Gustave asks me to thank you for the superb box of Ornans cheese you sent him; he has suffered a good deal for several days, it is so cold he cannot take a bath. I am able to bring him all sorts of things, and I try to think of everything possible. I brought him his brushes and canvases; his window is large enough, he is on the second floor facing south; he has a stove in his little room, he keeps a fire burning; I bring him flowers and fruit to paint . . . I brought him a large bunch of holly full of red berries to decorate his room." [13]

Zoé was right, of course: Courbet was a painter, only a painter; he should never have held public office, never have presided over a meeting, never have joined the Commune. But his political convictions were deeply rooted; his social philosophy, though muddled, was sincere. His helplessness forced him to accept Zoé's somewhat meddlesome assistance while he was ill and in prison, but he accepted it reluctantly. In particular he resented her possessiveness; Zoé never let him forget that he was dependent on her for everything from a branch of holly to his rehabilitation as a citizen. He was grateful, but he detested her just the same.

HOSPITAL

THE IMPROVEMENT in Courbet's health lasted only a few weeks. By mid-December he was suffering from acute indigestion, and the hæmorrhoids were causing him such agony that an immediate operation seemed imperative. This time Zoé's efforts to secure her brother's transfer on parole to a nursing home were successful, and he left the prison on December 30. She also obtained the services of the most celebrated surgeon of the day, Dr Auguste Nélaton.

"Gustave is seriously ill," Zoé informed Bruyas. "His free and independent nature cannot stand confinement, he needs exercise and liberty. . . . And in spite of all my attempts to entertain and distract his active mind I foresaw that he would die if I could not shorten his term. So I redoubled my efforts. But unfortunately General Valentin, who was prefect of police in Paris, was violently antagonistic. . . . He has been replaced none too soon, for he would have caused a revolution. His successor, M. Renaud, is as polite as the general was brutal. . . . The prefect [Renaud] made a special trip to Versailles [to arrange the transfer], asked for Gustave's parole of honour, and allowed me to move him to the nursing home of Dr Duval, 34 Avenue du Roule . . . in Neuilly. This was

advised by Dr Nélaton, whom I begged to visit my brother. He found that my brother . . . had an intestinal stricture in addition to hæmorrhoids. His condition was very grave and required an operation. . . . Gustave can now receive visitors without difficulty, he is a prisoner on parole and may not leave the premises. But he has a large garden and is very well off. Alas! What will be the end of all this! I tremble. Heavens, what sufferings! I haven't told my poor father about this, he would be too unhappy. My husband and I will carry on our rescue work to the end." [1]

While he waited for the operation Courbet painted fruit and flowers at the nursing home. On January 1, 1872 Mme Duval gave him an orange with stem and leaves attached, and an hour or two later he presented her with a painting of the little branch as a New Year gift. "At last, after storms we have fine weather again!" he wrote to his family on January 4. "For your New Year celebration as well as my own I must announce that I am finished with those miserable prisons. I made use of an infallible scheme which, I think, was awaited impatiently by the rascals who run the Government, for they were as weary as I was of knowing that I was in prison. . . . The method I employed will cost me a good deal but that doesn't matter; when one has spent seven months in a prison cell . . . one has had enough; it needs only three months of it to drive an ordinary person mad. I must tell you that I have not suffered very much; my mind was occupied and I did not lose my cheerful humour for an instant. I suffered more for you and for my companions in captivity than for myself. The only thing that saddened me was my mother's death. I also suffered greatly from my hæmorrhoids, and it was those that enabled me to free myself from my horrible situation. I thought that if I were to engage the greatest surgeon in Paris, M. Nélaton, nobody would dare to refuse him anything, and that is the way it turned out. He had me moved to a nursing home, where I am in paradise. I have never been so comfortable in my life.

I have a large garden to walk in, a pleasant room. I eat extremely well at the family table and there are guests almost every day, good friends. I was a friend of their [the Duvals'] son who died under the Commune; in fact I had dined at their house in the past. It costs ten francs a day but that doesn't matter. . . . My sister Zoé and her husband have gone to an incredible amount of trouble for me. In fact they have done three times as much as was necessary, but that is part of my sister's over-zealous character. I should be very grateful to them; while I was in prison they visited me regularly twice a week and supplied me with everything I needed." [2]

Ten days later Zoé wrote to Bruyas that her brother was much better, "but the operation is absolutely necessary, for if the intestine should close up entirely an opening would have to be made in his side, which would be a thousand times worse. . . . As to myself, I have been enduring martyrdom for a year. I hope that my frightful sufferings will at least have a happy ending. At present Gustave is painting fruit. He had never done that before. A large picture, a dozen pears, apples, etc., heaped attractively on a table, with a fireplace at one end of the room, his dressing gown on an armchair. . . . Gustave is delighted with himself. He says he has never painted anything with such lovely colours." [3]

The operation for hæmorrhoids was performed about January 20 by Nélaton, assisted by his son and Dr Auger. The surgeons offered to give Courbet chloroform but he refused it, declaring that he could stand the pain. In her next letter Zoé spared Bruyas none of the clinical details, but there is no need to inflict them on other readers: "The patient suffered agonies, but he told them [the surgeons] to use all their skill and he would endure the pain until it killed him. It lasted forty-five terrible minutes. . . . So far all is well. Dr Nélaton promises complete elimination of the hæmorrhoids. . . . And when they are cured the surgeons will proceed to dilate the intes-

tine. . . . As soon as the operation was over, Gustave, who is very brave as you know, asked for his pipe, and that same evening he got up, crossed the garden, and went to dinner. He will not stay in bed in spite of his dreadful pain. . . . He works all day. . . . I hope that as soon as he is well Gustave will take your advice and leave Paris until the turmoil subsides. He will seek repose for his body and his mind among his true friends and occupy himself seriously with painting. I am very much annoyed because I can already see the fine fellows who caused all our troubles clustering round Gustave again. It is to their interest to try to influence him and keep him as a scapegoat. Gustave has a weak character, he does not know how to resist. He must go away." [4]

By "fine fellows" Zoé apparently meant all of her brother's acquaintances whose political opinions did not agree with her own. At Neuilly Courbet received visits and sympathetic messages from many friends, including Boudin, Monet, Amand Gautier, the Comte de Choiseul, and the Laveur family. The true friends with whom Courbet was to stay were presumably the Joliclers. Zoé wrote to Lydie on January 29: "You invite my brother to visit you and proceed to Switzerland. The sooner the better, for the poor man has great need of rest and tranquillity. . . . Dismiss politics, they are a noxious quagmire. Persuade Gustave . . . that painting restores the soul and that the creation of a few masterpieces may make him forget the horrors he has just endured. Gustave is exhausted in body and above all in mind . . . prison affected him frightfully; he would have lost his mind there if I had not followed him step by step, rebuilding his morale and cheering him up. . . ." [5]

Technically Courbet remained a prisoner in Dr Duval's custody until his term expired on March 2. He stayed at the nursing home until May, slowly recovering his strength and bracing himself to face his family and friends as well as the hostile municipal authorities at Ornans. The intestinal opera-

tion was as successful as the other had been. "Gustave is completely cured," Zoé told Bruyas. "From Dr Nélaton one must expect miraculous results. . . . We have just sent about thirty pictures to Durand-Ruel . . . who is holding an exhibition of paintings by modern artists. We hope this will be helpful to Gustave." [6] Nélaton refused payment for his professional services but agreed to accept a landscape which Courbet painted for him in the Duval garden. Altogether Courbet produced about forty pictures at Sainte-Pélagie and Neuilly.

After his release from parole Courbet called on Victor Hugo, whom he had probably not seen since their first meeting in the cemetery the year before. Hugo noted on April 25: "Courbet came to talk with me about some pictures which he considers unsalable. These pictures are by Guignet, a pupil of Decamps. 'This kind of painting,' said Courbet, 'no longer has any reason to exist.' I do not agree." [7] Courbet may have painted a portrait of Hugo at this time, but it is unlikely; if Hugo had posed for Courbet he would surely have recorded the event.

Some time during that spring of 1872, apparently at her brother's request, Zoé appealed again to Bruyas, this time in behalf of the musician Alphonse Promayet who, like Bruyas himself, was dying of tuberculosis: "Permit me, sir, to interest you in one of our friends whom you met long ago at Gustave's. . . . He is from our province, our very devoted, very much loved childhood friend. . . . This is his story: he loved music but because he was poor he was unable to succeed as he would have wished. Poverty forced him to take a post as teacher in a family in Russia. They liked him so well that they placed in his charge a young student with whom he returned to France. For ten years Promayet worked to educate his pupil, of whom he made a prize scholar. His pupil's family is named Romanoff and is related to the Russian imperial family. When our friend brought the young Romanoff back to Russia the family wanted to keep him [Promayet] there permanently.

. . . But our friend has an eccentric streak in him. He insisted that it would be wrong for him to remain after his task was accomplished, that he would feel in the way. He left them. He took a position with another family, that of the first chamberlain at the Russian court. There he became ill, he lived in a new house and contracted I don't know what nervous ailment. He returned to Paris to recover, but the Romanoffs watched over him. They sent his former pupil to accompany him, and at the time of Gustave's trial they were in Paris. Then they had to go to Amélie-les-Bains for the winter. Now the doctors are sending him to Montpellier to consult specialists. The Romanoffs wrote to me that Promayet's pupil will go there in June and his mother, Mme Romanoff, will join him. . . . But I promised them to ask you to be kind enough to visit our poor friend in the meantime and give him advice." [8] Bruyas did what he could, but Promayet was beyond help and died at Montpellier about a month after his arrival.

The only acquaintance who turned a deaf ear to Zoé's requests for assistance to her brother was Champfleury. Knowing how close he and the painter had once been, she asked him to write a series of articles for *Le Figaro* or some other paper recalling Courbet's thirty years of service to French art. This, she thought, would expedite her brother's rehabilitation in the eyes of the public. But Champfleury replied coldly that he had contributed three articles on Courbet many years earlier, that these had been reprinted in his recently published *Souvenirs et portraits de jeunesse,* and that he would write no more: "This means that I have said all I can about Courbet and that a definitive judgement on the man, his work, and his life must now come from the next generation. As to those who steered Courbet into evil ways and made him wander from the path which it would have been easy for him to tread, I cannot follow their manœuvres. One would have to furnish [in order to write such articles] facts rather than opinions, and I have

lost sight of Courbet for ten years, during which I have lived and studied in solitude." [9]

Courbet had lost a good deal of property during the past year: his Ornans studio had been damaged and stripped of its contents, first by the Prussians, then by the French authorities after the Commune; the construction materials salvaged from his exhibition of 1867 had been converted into barricades; the Government had sequestrated but apparently had not removed the pictures stored in the cellars at 14 Passage du Saumon. In the spring of 1872 he suffered additional losses through thievery. About thirty of his cherished "old masters" were taken from his rented apartment in the rue du Vieux-Colombier, and the fact that they were worthless did not diminish their value in his eyes. More serious was the theft from the Passage du Saumon of some twenty of his own canvases, including *Mère Grégoire, Poachers in the Snow,* the *Lady of Frankfort,* four or five landscapes, and about eight seascapes.

No Salon had been held during the turbulent year of 1871. To the Salon of 1872 Courbet submitted two pictures, the *Lady of Munich* and a still life painted at Dr Duval's, *Red Apples on a Garden Table.* Both were rejected on political grounds. Of the twenty members of the jury only two, Eugène Fromentin and Joseph Robert-Fleury, voted against his exclusion. For similar reasons Daumier's offerings were refused, and the judges punished Puvis de Chavannes, who had originally been a member of the jury but who had resigned in protest against the injustice to Courbet, by rejecting his painting as well. The leader of the anti-Courbet faction was Meissonier, who demanded the exclusion of the convicted communard not only from the Salon of 1872 but from all future exhibitions. Among the older painters Courbet had few friends and many bitter enemies; he had ridiculed them too often in the past, and they took full advantage of this opportunity to snub him in return. Even before Courbet's trial, when Castagnary had sug-

gested to Daubigny the submission to Thiers of an appeal, to be signed by a number of prominent artists, for leniency towards Courbet, Daubigny had replied: "We should collect only three signatures: mine, Daumier's, and Corot's; not one more." [10]

Courbet's rejection raised a storm of controversy in the press. Most of the newspapers supported Meissonier, but a few defended Courbet. Castagnary protested: "The reason M. Meissonier has chosen to make himself ridiculous . . . is a mystery easily solved by those who know to what extent the moral servitude of the empire of Napoleon III has degraded the artists. . . . M. Meissonier . . . has shut the doors of the Palais de l'Industrie against her [the *Lady of Munich*]; so be it; but if she should ever knock at those of the Salon Carré in the Louvre, Giorgione, Titian, and Correggio would rise to welcome her." [11]

Perhaps the most effective denunciation of the verdict was a satirical playlet by Ernest d'Hervilly published in *L'Eclipse*. The scene was the Palais de l'Industrie during a session of the Salon jury. Three pictures were submitted. Meissonier ordered them placed with their backs to the jury: "I repeat that this year we do not scrutinize. We judge." [12] The first canvas, by an editor of *Le Figaro* (a violently anti-Courbet journal) was accepted at once. The second, by a chiropodist, was also accepted because the painter loved the Vendôme Column, though Robert-Fleury protested: "But this picture is repulsive. It depicts a set of toes all covered with corns and it looks as if it were painted with treacle." [13] To which Meissonier retorted: "I like treacle very much. . . . Henceforth treacle will be my favourite colour." [14] But the third picture, representing a paper cornucopia filled with fried potatoes, was rejected as communard propaganda; in Meissonier's opinion the frying was obviously a reference to the burning of the Tuileries. Having accomplished their task, the members of the jury adjourned to judge the horse show next door.

RETURN TO ORNANS

On Courbet's way home from Paris only one unpleasant incident occurred. "I had a great success on my return to my own province," he told Castagnary, "first at Dijon, then at Dôle; at Besançon I had a mishap, I had gone to drink beer at the Cercle des Canotiers [Rowing Club] which has 120 members; while I was standing on the pavement a Bonapartist grocer, who had remained inside the club after we left, smashed the glass I had drunk out of. I had a very hard time keeping him from being thrashed, but a week later he was expelled from the club by eighty-four votes to six." [1] The grocer was subsequently reported to have committed suicide. Courbet arrived at Ornans on May 26, 1872, escorted by his father, the Ordinaire family, and a group of friends riding in four carriages. The whole party proceeded to the Café de l'Annette, where more friends, eager to demonstrate their sympathy with the painter and their contempt for the hostile municipal council, convivially celebrated the prodigal's return.

Courbet spent much of his time with the Ordinaires (whom he had long since forgiven for their attempt to persuade him to accept the Legion of Honour cross) at Maisières, whence he wrote to his sisters at Flagey in July: "Sometimes I am at

Maisières, sometimes at Ornans. But I cannot go to Flagey in this hot weather. . . . I bathe in the Loue. I have also painted four landscapes at the Puits Noir and at Maisières. I have not been wasting my time. . . . Everything is going well. If the Commune has caused me unhappiness it has also increased by half my sales and my prices; that is, during the past six months I and other owners of my pictures have sold my works to the amount of 180,000 francs. In such circumstances one can afford to let people howl. I have painted some fish caught by the Ordinaire sons. They weighed nine pounds, they were magnificent. . . . Also [a painting of] some mushrooms [which he gave to Dr Ordinaire]. . . . When it gets cooler I shall come to see you. This weather is bad for me. I need complete rest at present because I have suffered too much during the past two years; my liver has been out of order. So you will forgive me for not going to see you more often." [2]

To Castagnary he wrote from Ornans on August 14: "I was ill for a month with a swollen liver, the cause of this malady was a fire at Maisières during which I had to carry hectolitres of water for four hours to extinguish the flames in a house belonging to royalists; and to think that I have been called an incendiary makes it all the more disgusting. . . . Several painters are arriving in our province. We already have Rapin, Jean-Jean Cornu, some Swiss artists, and Pata. The last-named told me that one of my pictures has just been sold in London for 76,000 francs (which shows that the Commune has raised my prices). . . . I have also sold my *Return from the Fair* to Durand-Ruel for 10,000 francs." [3] The swollen liver was in fact a symptom of cirrhosis, due to excessive consumption of alcohol over a long period of time.

Unable to indulge in the brisk walks and hunting expeditions he had formerly enjoyed, Courbet bought a horse and carriage and drove about the countryside, occasionally stopping to sketch, but for the most part merely relaxing, slowly regaining his health and peace of mind in the sun and air of

his beloved mountains. On September 16 he visited the town of Morteau, where his friend Alexis Chopard, who had repaired the mutilated statue of the *Bullhead Fisher* after its arbitrary removal from the fountain, presided at a banquet for thirty guests given in honour of the painter. As a token of gratitude for this friendly gesture Courbet presented the displaced statue to the municipality of Morteau, where it still remains. A copy was subsequently placed in the fountain at Ornans. It was probably about this time that the death of Courbet's illegitimate son occurred, for he told the news to Lydie Jolicler during his sojourn at Pontarlier in November, when he painted the portrait of Charles Jolicler.

Another excursion took him to the village of L'Hôpital-du-Gros-Bois and the grotto of La Glacière de la Grâce-Dieu. Near the grotto he encountered a pretty peasant girl, decided impulsively to make her his mistress, and appealed to a certain Cornuel, about whom nothing more is known, to act as intermediary. Courbet's two very curious letters concerning the comely but elusive Léontine indicate that misfortune, ill health, and the approach of old age had in no way diminished his swaggering conceit. "You can see," he wrote to Cornuel on October 6, "that with my artist's eye and my great experience of life, in five minutes I guessed everything you think about Mlle Léontine. I saw in her an upright, honest, sympathetic, simple character; that is what I have been looking for for twenty years, because I think that in the eyes of people who know me I have a precisely similar nature. I found her in a forest, in everyday clothes, occupied with her work, which I approve of. All members of my family feel the same way. That [hard work] does not offend our social superiority! This chance encounter, which I had always foreseen, was understood by the friends who were with me; as we came out of La Glacière they said to me spontaneously: 'There is a woman who would suit you. An artist should be surrounded by agreeable and simple people.' I had already reached the same con-

clusion before they spoke. When I returned to Ornans I consulted my sisters, who were of the same opinion. I went to Pontarlier, I mentioned my project to some very intelligent and sensible ladies of Pontarlier, who wanted to accompany me to persuade Mlle Léontine to live with me. For I must tell the truth. I have suffered so much during my life, I have rendered so many services to everybody, I should be so much inclined to render a service to an honest person, that it is inconceivable that Mlle Léontine, notwithstanding the stupid advice she may receive from the peasants, should not accept the brilliant position I offer her. She will be unquestionably the most envied woman in France and she might be reborn three times without ever finding a position like this, since I could choose a woman of any station in French society and never meet with a refusal. With me Mlle Léontine will be absolutely free, she may leave me whenever she wishes; money means nothing to me, she will never regret her relations with me. My dear Cornuel, remember that with [the proceeds of] two days of work I can give her such a dowry as no other woman in the village has. In short, if she comes to me I promise that she will be the happiest woman in Europe. In this matter let her consult intelligent people, not the villagers. It is for you, my dear Cornuel, to convince this family who can know nothing about who I am. I count on you. Write me what to do, whether I should go to see her again either at La Glacière or at L'Hôpital-du-Gros-Bois. Arrange some meeting for me and spend what money is necessary to settle it as soon as possible, for I must work and go to Switzerland. If it can be arranged I shall take her with me. . . . In the eyes of the public, what difference can it make whether she occupies my house or yours?" [4]

To Courbet's naïve astonishment and profound disgust, Léontine spurned this alluring prospect of a golden future. Three days later he wrote to Cornuel again: "As you know, I wrote Mlle Léontine a very serious letter in which I made

offers which many young women of a class far superior to hers would have been delighted to accept. It seems that I was mistaken with regard to this young woman, for instead of replying frankly to an honest proposal she thought it necessary, as I predicted, to consult her young man, who seems to me to have assimilated all the cleverness of Nancray [a village near Besançon] and who answered me with the most sentimental of village ballads which might amuse the village yokels but which we could never comprehend. From this I conclude that Mlle Léontine prefers a hovel and the heart of an idiot, who reminds me of a soldier on leave or in retirement, to an established position which would assure her future as well as mine. Whatever happens, my dear Cornuel, I shall always be grateful to you for the friendly services you have been good enough to render me in this affair. If this is to be the end of it, please find out if the reply was given with her consent and at her suggestion. But tell her plainly that to me, in any event, all the young men, all the village clods possess intellectual qualities almost equal to those of their oxen, without having the same market value." [5]

As usual Courbet quickly recovered from his frustrated love affair, but he was unable to shrug off other worries so easily. Persistent ill health made him irritable and interfered with his work. The political situation alarmed him: though he had so often and so bitterly denounced Adolphe Thiers, president of the republic since August 30, 1871, he was horrified to learn that the Thiers régime, which was in fact relatively liberal, was in danger of being overthrown by a reactionary faction in the National Assembly, a faction that favoured additional punishment for Courbet himself and other former members of the Commune.

Because Courbet could no longer exhibit at the Paris Salon, Castagnary urged him to send some of his pictures to an international exposition soon to be opened in Vienna. Courbet

replied in January 1873: "I have read in *Le Siècle* a proposal by twenty-three deputies in the Chamber which is fantastically insane. It would merely oblige me to reconstruct the Vendôme Column at my own expense. . . . This is more serious than it seemed at first; if the vote in the Chamber succeeds in condemning me, they will confiscate my mother's property, later my father's, and worst of all, my pictures. What shall I do? . . . I should like you to . . . find out about this in the Chamber and also from a lawyer . . . whom you once recommended to me; for it costs a great deal of money to register simulated sales [to evade confiscation]. Try to look ahead and inform me so that I can arrange them [the sales] before the Chamber votes. I shall not exhibit in Vienna. I wrote to the [exposition] administration to find out if I could exhibit independently without the endorsement of a foreign Government; they replied that I could not exhibit except under the auspices of the French committee headed by M. Du Sommerard, which is impossible because I denounced him and his administration when, in association with M. de Nieuwerkerke, he organized an exhibition in London while the Prussians were in Paris. Nor shall I exhibit in Paris this year, I am fed up with all those people; all that crowd of intriguers and toadies, stupid flunkeys without talent, disgust me. I have been ill all winter with pleurodynia [rheumatic pains in the side] and an *enlarged liver; I was afraid of dropsy.* I have many orders for pictures that I have not yet been able to fill, and now that I am on the point of being able to work again, along comes another vexation worse than all the others. I was delighted to see *père* [Dr] Ordinaire, who has helped me greatly and courageously in my distress. We have lived together almost the whole time since I left you. I have also engaged a servant who takes care of me and cooks for me. . . . During the Commune I had a woman in Paris, a noblewoman, who adores me; I don't know what to do with her because she has illusions concerning me and my financial resources. We are

having a frantic correspondence, she is charming, don't tell anyone about this. . . . In addition I have three lawsuits on my hands in Paris." [6]

There were several ominous notes in this letter: the imminent downfall of the Thiers Government, which was to bring further disaster to Courbet; the first mention of the dropsy which was to cause his death within five years; the charming lady who stirred up a hornets' nest a few months later; the lawsuits, only one of which—the least important—was decided in his favour.

Courbet brought suit against Léon Isabey, the architect who had designed the gallery for his one-man show of 1867 and who had afterwards, at the painter's request, stored the construction materials in a warehouse, for damages estimated at 25,000 francs incurred through the unauthorized use of the materials in barricades during the Prussian siege. The tribunal, deciding that Isabey was not responsible for the loss, awarded Courbet nothing. The defendant in Courbet's second action was Dr Robinet, former president of the republican club to which Courbet had leased one of his two apartments at 24 rue du Vieux-Colombier; Courbet sued for unpaid rent and was awarded 251 francs. The third suit was brought against Courbet by Mlle Gérard, his landlady at 14 Passage du Saumon, who at first had presented a bill for board and lodging amounting to 911 francs. This Courbet had agreed to pay on condition that the dressmaker would restore to him certain articles of furniture and other items he had left in her house. Unfortunately the painter had added to this reasonable request a threat of legal action if she failed to comply. Mlle Gérard, being a woman of spirit, promptly increased her demands: she now claimed 365 francs for unpaid rent, 500 for food, 660 in repayment of loans she had made to Courbet, and 1000 for defamation of character, a total of 2525 francs. On April 4, 1873 the Tribunal Civil de la Seine condemned Courbet to pay 1211 francs and costs.

The woman who had been Courbet's mistress during the Commune was a Mme G—, *née* Mathilde Montaigne Carly de Swazema, who claimed to be of noble birth and who offered the painter "a chaste heart and a virgin soul," [7] neither of which he had ever demanded or desired. Actually nothing better than a mercenary adventuress, she attempted to beguile him with romantic protestations of ideal love. To one of her letters written in this vein Courbet replied testily: "The ideal! The ideal! My God, what in the world is it, this ideal? . . . You think, my dear friend, that by using the words heart, soul, sentiments, aspirations to the infinite, without knowing what goes on in the world, you are in a position to control everything. You are mistaken. . . . If you wish, I shall show you what love really is. Look at the peasants, I have known them since my childhood." [8] And he proceeded to describe the physical brutality, the carnality without tenderness prevailing in his own province. In another letter written in November 1872 he told Mathilde: "I am a man, as everybody knows, who shrinks from nothing provided that I can rationalize it and reconcile it with my conceptions and my logic; through my efforts to accomplish this, life has hurled me from the heights into impossible depths. But as I have in my nature the resilience of the mountaineer I never remain prostrate, I rise from my ashes to defy society and constantly to assert my nature and my own way of living, feeling, and maintaining my freedom in spite of men, their spies, and their laws, in short I am always trying to achieve my independence and my liberty without false shame. . . ." [9]

By the time Courbet realized, in the late spring of 1873, that what Mathilde "adored" was his money rather than himself, he was making desperate efforts to salvage as much of his property as possible in order to avoid its confiscation by the state to pay for the re-erection of the Vendôme Column. When he notified his former mistress that he wanted nothing more to do with her, she retaliated by revealing that the painter had

307

clandestinely transferred the titles to some of his property and that he had shipped pictures from Paris to Switzerland to protect them from seizure by the French authorities. Although these allegations were true their disclosure did the tattler no good, for it was discovered at the same time that Mathilde and an accomplice had committed various acts of extortion, fraud, and blackmail, and that Courbet was only one of their many victims. In August both were tried, convicted, and sentenced to prison. Courbet was summoned as a witness but did not appear; he was then no longer in France.

In spite of the anticipated opposition of Du Sommerard, Courbet now proposed to send several pictures to the Vienna exposition as part of an exhibit sponsored by the dealer Durand-Ruel, if arrangements could be made to protect his canvases against confiscation. He wrote to Castagnary on January 24: "If Durand-Ruel exhibits me under the auspices of Du Sommerard the pictures must belong to him [Durand-Ruel] or *be thought to belong to him* legally. . . . See if *that can be managed,* in any event I shall send you a document for Durand-Ruel authorizing my brother-in-law, who has the keys to my studio, to deliver any pictures you and Durand-Ruel select for the exhibition; you should also notify my attorney, M. Duval, who is now prosecuting the thieves who stole my pictures from the Passage du Saumon [some of the pictures had been found; the rest did not come to light until two years later]. . . . Here, to be safe from confiscation by the Chamber, I am going to a notary to register the gift [to Juliette and Zélie] of all I own, my studio [at Ornans] and everything else, as well as my share of the property inherited from my mother. Nevertheless I shall stipulate that I may continue to enjoy the use of my studio until my death. As to the removal of my pictures from the rue Hautefeuille and the rue du Vieux-Colombier, I think the simplest way would be to send them to M. Jolicler at Pontarlier, for from that point I shall have them sent to Switzerland as soon as I find lodgings there. . . .

There will be nothing left except my share of my father's property after his death, but he might be willing to disinherit me as the law permits. . . . I am still rather ill." [10]

Four days later he wrote to Castagnary from Besançon, where he had gone to arrange for the transfer of his property: "Please have my pictures in my studio [in Paris] packed immediately. Send them to the following address: M. Tramut . . . at Montbéliard [Doubs]. . . . The first shipment will comprise pictures painted by myself, immediately after them you will send the old masters. You will notify me of the departure of each shipment, also [notify] M. Viette at Blamont (Doubs). . . . To advise M. Viette about this, write him a letter about some trifling matter without mentioning the shipment. . . . Keep this secret from my brother-in-law. You and Durand-Ruel are to pay all necessary expenses, or you might remove the pictures on the pretext that they are to go to the Vienna exposition. Let Durand-Ruel into the secret. . . ." [11]

Courbet's anxiety was by no means groundless; he knew that the successors to the unstable Thiers Government would try to force him to pay for the column, and Castagnary had warned him that Eugène Reverdy, a partisan of Bonaparte, was working against him. "I shall tell you something that you must keep to yourself," Courbet wrote to Castagnary on February 9, "I am afraid my brother-in-law is a member of the secret police and is specifically assigned to keep me under surveillance [this was probably untrue]. He is impudent, lazy, a man without employment whose source of income is unknown to me and who is trying to exploit me; by their stupidity he and my sister have done me all the harm that can be done to a man, and I have only one regret in connection with the Commune: that because of our kinship I was obliged to accept their help, but that is finished. . . . I want to keep nothing but my pictures. . . . I am giving up my mother's bequest, my studio, and my lands; that is not too dear a price for the fall of the column." [12]

The exhibition problem was solved by a group of Austrian artists who invited Courbet to show his pictures at a private club in Vienna instead of at the official exposition. They also urged Courbet to visit their city, and for a moment he was tempted to go. On March 19 he suggested that Castagnary might accompany him: "In Vienna I shall be in touch with all foreign powers and the whole world outside of France, where I never want to exhibit again as long as I live. At Ornans I already have orders for more pictures than I can supply, I must absolutely take some pupils in order to fill them. It is a regrettable thing to be obliged to do, but I am the one who has reaped all the benefit from [the notoriety connected with] the Commune. . . . At present I have commissions for more than fifty pictures. . . . If I had joined the Commune for this very purpose I could not have had a greater success; I am delighted. As to my brother-in-law, I shall instruct him through my attorney to hand over the keys of my apartments to the concierges and not to concern himself with my affairs in future. How tired I am of his pretensions! You may be sure, my dear friend, that the Vienna exhibition is the happiest event in my life . . . I am on friendly terms with all those people and have the same ideas. As to France, I have never really belonged here, I don't like the people. . . . If you come to Vienna, as I hope you will, we shall . . . amuse ourselves as you have never amused yourself, I promise you. *That is my country.* . . . I have renounced my inheritance from my mother, but I could not sell my lands and my studio, I abandon them to the political fury of the majority. . . ." [13] Nevertheless he made one more attempt to save these unsold properties by mortgaging them to friends.

The solicitor Charles Duval wrote stiffly to Castagnary on April 5: "On April 1 I received a letter from M. Courbet asking me to instruct M. Reverdy to turn over the keys of his two apartments to M. Legrand [Durand-Ruel's employee]. . . . I have since heard that MM. Reverdy and Legrand have met

and are following M. Courbet's instructions. I cannot and will not do anything more. I shall neither take charge of the keys nor be present when the inventory is taken; such duties are appropriate neither to my profession nor my character. Moreover I emphatically disapprove of all that M. Courbet is doing to safeguard property which is not in danger and will never be seized. I have written to him that I consider the precautions he is taking neither effective nor proper." [14] Duval was mistaken; only these precautions saved Courbet from complete destitution during the remaining years of his life.

In March Courbet partially avenged the removal of his *Bullhead Fisher* from the public square by calling to the attention of the prefect of the Doubs department, Baron de Sandrans, the ineptitude of the local authorities: "At present the trees of the Iles-Basses at Ornans are suffering unbearable mutilation, a mutilation apparently ordered by an administration that is incompetent in such matters, and executed by careless workmen who are concerned only with the production of firewood. I beg you in the name of the inhabitants of my district to be good enough . . . to forbid this vandalism. . . . All that is needed is to lop off the few weak branches which might fall on passers-by, and to have it done by experts." [15]

Courbet was too ill and too worried to do much work, though he did paint one picture, the *Calf*, already mentioned in connection with the legend that the wife of the animal's owner had infuriated the painter by scrubbing off the mud and dung. But nothing that Courbet painted in the last eight years of his life could compare in quality with the works of his golden age, the two decades between 1849 and 1869. He was not an old man—in 1873 he was fifty-four—but his creative power was definitely on the wane. The war, the turmoil of the Commune, the ordeal of trial and imprisonment, and his shattered health had taken their toll. He had burnt too many candles at both ends. In addition to his physical decline

he had undergone what might be called a degeneration of moral fibre, demonstrated by his unfortunate decision to avail himself of the services of pupils, or more accurately apprentices, in order to supply the demand for pictures he was unable to complete himself. Five years earlier he would have scorned such assistance; whatever his faults and weaknesses may have been, his artistic integrity had always been unimpeachable. But adversity had dulled the keen edge of his principles; now he was willing to palm off on unsuspecting purchasers, as genuine Courbets, pictures only partly painted by his brush. The extent of his participation varied from picture to picture. Some of the works of 1873 and later years were executed almost entirely by his own hand, others owed little to Courbet except the signature. Of course he had excellent precedents: Rubens and many other Renaissance painters had operated what amounted to art factories, using apprentices to paint in backgrounds and minor figures. It must also be admitted that to Courbet the temptation at this time was very great. He had lost a great deal of money and knew that he was in imminent danger of losing more; he had given away most of his property; and he was in dire need of funds to finance the flight to Switzerland he was already planning in the event that the threatened bill for reconstruction of the column should actually be presented.

Courbet chose three assistants: Marcel Ordinaire, a son of his old friend the doctor; Jean-Jean Cornu; and Cherubino Pata. They were not without talent, and after Courbet's death Marcel and Pata continued to paint presentable landscapes superficially resembling the works of their former master, but weaker in design and usually muddier in colour. Little is known of Cornu's later career, if indeed he had one. Young Marcel Ordinaire was educated, like Courbet, at the Ornans seminary and, again like Courbet, went to Paris ostensibly to study law. Encouraged by Courbet and with the approval of his own parents, he decided to become a painter. Pata was

Swiss, a native of the Italian-speaking canton of Ticino. According to Gros-Kost, whose reports must always be taken with a grain of salt, Pata ran away from his Alpine village at the age of twelve and made his way to Locarno, where he was refused admission to the art school because he could not pay the tuition fee of ten francs. He then took refuge in a monastery in which his cousin was a monk, and remained there for three years painting the walls and ceiling of the chapel. Shrewd, energetic, witty, frivolous, perhaps not altogether trustworthy yet apparently sincerely loyal and devoted to Courbet, he soon became indispensable to the painter, not only as an apprentice but also as secretary, man of affairs, and general factotum.

With the collaboration of his three eager assistants Courbet now engaged, shamelessly but profitably, in a feverish bustle of mass production. In four days they painted ten pictures destined for American collectors; within six weeks they turned out forty. "We have more orders than we can handle," Courbet wrote to his sisters on April 26. "There are a hundred pictures to be painted. The Commune will make me a millionaire. . . . We have already delivered twenty, we must deliver as many more. Pata and Cornu are doing well; Marcel has returned and will work too, I hope, for I pay them a commission on the pictures they prepare for me. Pata and Cornu have already received 1800 francs. But my father must not try to discourage them and meddle with something that does not concern him, something he cannot understand . . . my father should mind his own business. We are making 20,000 francs a month." [16]

FLIGHT

THIERS and his ministers resigned on May 24, 1873 and were succeeded by a new Government, preponderantly royalist and Bonapartist in composition, and a new president, Edmé-Patrice-Maurice Mac-Mahon, Duke of Magenta, marshal of France, and former commander-in-chief of the Versailles army which had overthrown the Commune. Shortly before the end of the Thiers régime a bill had been submitted to the National Assembly providing for the reconstruction of the Vendôme Column. On May 30 the Assembly adopted the measure with an amendment, introduced by members of the new Government, to the effect that the entire cost, to be computed by a civil tribunal, was to be paid by Courbet.

This vindictive and unjust decree had no precedent; no single individual or group had previously been held responsible for damage to public property incurred during an insurrection. The Government had paid for the rebuilding of the Thiers mansion, the two terminal pavilions of the destroyed palace of the Tuileries which now form the western extremities of the Louvre, and other damaged structures; the municipality of Paris had footed the bill for repairs to the Hôtel de Ville. And if any citizen was to be forced to pay for the Vendôme Column, many individuals were more directly respon-

sible than Courbet, who had not even been a member of the Commune when its demolition had been ordered. But Courbet was a prominent figure, he had not fled as so many of his colleagues had done, he had many enemies official and unofficial, he was believed to be wealthy. In every respect he was an ideal victim.

Courbet now doubled his efforts to prevent the confiscation of his property, especially of his pictures. He distributed most of his remaining personal possessions, odds and ends of furniture and the few pictures that happened to be at Ornans, among Pata, Cornu, Dr Ordinaire, and Dr Blondon, with the understanding that they were to be returned if and when Courbet could safely claim them. He authorized a friend in Paris, Cusenier, to store the furniture left in the studio in the rue Hautcfeuille, soon to be demolished to make room for the expansion of the Ecole de Médecine. He instructed Durand-Ruel to send all of his works then on exhibition in Belgium, London, and Vienna to Switzerland by routes not passing through France.

Zoé and her husband were still pestering Duval for an authorization to collect and dispose of Courbet's pictures. Evidently they had prevented the removal of the canvases from the rue Hautefeuille by Castagnary and Durand-Ruel, for on June 15 Courbet wrote Zoé a furious letter ordering her in the most peremptory terms to hand over the pictures for immediate shipment to new destinations. His own works were to go to Alexis Chopard at Morteau, the so-called old masters to Dr Blondon at Besançon: "So nothing short of a legal attachment could persuade you to release my pictures! It is incredible that a man should not be free to dispose of his own property. I have already issued forty authorizations in this connection, I shall issue ten more and that is all, since you persist in sacrificing my interests to your own. Contrary to the views of the whole of France you have managed to convince even M. Duval that it is a crime to protect my interests. . . . You must absolutely

consider this letter my final authorization." ¹ About the same time he wrote to Chopard: "I should like you to send me at once the name of an agent at La Chaux-de-Fonds [in Switzerland] with whom you will deposit my pictures. . . . I should also like to know whether bonds now registered in my name can be made payable to bearer in Switzerland more safely than in France. The confiscations are beginning." ²

Many of Courbet's paintings did eventually reach Switzerland through devious channels, but because of Zoé's obstinacy it was too late to save them all. On June 19 the new minister of Finance, Pierre Magne, an uncompromising Bonapartist, ordered the sequestration of Courbet's property throughout France. In Paris, Besançon, Ornans, and Flagey swarms of zealous bailiffs descended upon the painter's family and friends and confiscated everything in sight. The studio in the rue Hautefeuille was turned inside out and the concierge, Bain, was forbidden to allow anything to be taken away. Pictures in the galleries of Durand-Ruel and other dealers were seized. The railway companies were instructed not to transport anything belonging to Courbet. The prefect of the Doubs officially accused two of Courbet's friends at Besançon, the painter Jules Arthaud and the accountant Louis Sancey, of fraud in connection with the transfer by Courbet on June 17 of some of the Paris-Lyon-Méditerranée railway's bonds.

Without waiting for the tribunal to fix the cost of the column's re-erection, this same prefect, the Baron de Sandrans, tentatively appraised the indemnity at 500,000 francs. Courbet replied with an emphatic protest: "In the official writs served by your orders upon various inhabitants of the Loue valley you do me the honour to estimate my resources at 500,000 francs, which gives me in the public eye a financial status I do not deserve. . . . Note . . . that I have inherited from nobody in my life and that it is by forty years of strenuous toil that . . . I have been able to earn a living and at the same time to render acknowledged services to art both in France

and abroad. There was a time when I could have contributed, under protest, a small part of the sum you attribute to me . . . for the reconstruction of this column which you lament and which I did not overthrow, but which was overthrown by public opinion and the decree of a social revolution. Two years of war and revolution during which I devoted myself unselfishly to the preservation of works of art . . . deprived me of the little I had earned by the labour of a lifetime. . . . I cannot live unless I practise my art. Please tell me whether I am still permitted to paint pictures and sell them freely in France or abroad for my own profit, or whether I am to be henceforth a slave condemned to work for the benefit of a master who is the *state of France,* in whose name you issue writs." [3]

Courbet foresaw that if he refused or failed to pay the amount determined by the civil court—and the sum was certain to be greater than his assets—he might well be sentenced to a long term of imprisonment. Having seen more than enough of the inside of a cell, he did not propose to repeat the experience. The only alternative was flight. "When you receive this letter," Dr Ordinaire informed Castagnary on June 23, "our friend will be in Switzerland. . . . This voluntary exile may seem an excess of precaution, but once a state embarks on an arbitrary course anything may happen. . . . [Zoé] is trying to separate him from his republican friends whom she calls riff-raff. Only a fortnight ago she wrote that to me, without realizing that she was insulting me." [4] But Courbet changed his mind overnight, and next day Dr Ordinaire wrote again: "When we went yesterday evening to say farewell to X [Courbet] . . . who was to have gone during the night, we found he had reconsidered. Notions of chivalry convinced him that it would be undignified for him to fly from the enemy and that it would be nobler to be arrested and imprisoned. So he will remain. . . . In this affair there are elements as clear as a bottle of ink." [5]

Still Courbet hesitated to take the plunge. "Tell me if my liberty is endangered," he wrote to Castagnary on June 28, "if so I shall go to Switzerland. I will not go to prison again, I am tired of that. . . . They have just confiscated the contents of my studio in the rue Hautefeuille, it's incredible. It is my sister who has done all the damage, she has turned all Paris against me because everyone hates her so, *she is a scourge* I cannot get rid of." [6]

On July 4 M. Planard, delegated by the prefect of the Doubs to conduct a search for Courbet's concealed assets, reported: "It is extremely difficult to discover precisely whether or not M. Courbet has hidden pictures or furniture in his father's house [at Flagey]. According to the information I have received, mainly from the police, the house of Courbet's father has always been closed to the inquisitive public. Strangers are received only at the door, with great caution. If one is admitted it is only as far as the kitchen, and one cannot remain there long. The only people admitted to the interior are those who hold the same views [as Courbet] and who are very careful not to divulge what is done or said in their hero's house. . . . But it is certain . . . that a few days ago Courbet drove his carriage to his father's domicile and departed on foot. The next day Courbet's father, to satisfy the neighbours' curiosity, claimed that he had bought the carriage from his son. Is this true? We do not know. We do know that it is at Flagey and that . . . it may be worth 2000 to 2500 francs." [7]

Ordinaire sent Castagnary more news on July 16: "The prefect of the Doubs, going further than the prefect of the Seine, has issued writs of confiscation against everyone who, he thinks, might hold any article or security belonging to our friend. . . . On the other hand the Government are spurring on the trial with unparalleled ardour so as to reach a verdict before the courts recess. The persecution is ferocious. The situation of X is all the more precarious because his sister, meddling in his affairs, has without his consent retained M.

318

Lachaud as his barrister. . . . He resents being defended by this common person who has no conception of distinction and of artistic feelings. Here he is once more thrown to the wolves, he says, and defended by a political enemy. In anticipation of arrest he has decided to take the waters as soon as the doctors tell him to. We are counting on you to advise us as to what precautionary steps we should take. . . . Write to me as soon as you can, for he and his family are exceedingly uneasy. . . ." [8] The doctor's use of the symbol "X" and his reference to taking the waters, as well as Courbet's own mention of Vichy in his next letter, were obviously intended to mislead any functionary who might intercept this correspondence.

Castagnary suggested a subterfuge which might delay the proceedings against Courbet: denunciation of another former member of the Commune who had escaped to America, beyond the reach of the French Government. Courbet replied from Maisières on July 21: "You advise me to accuse Rastoul [of responsibility for the demolition of the column]. Why choose him rather than any of the others? You tell me it is because he is in California, which would give me a respite of six months. I should be glad to do it if I could be sure I would not be arrested as a precautionary measure in the meantime. But as they are capable of anything I do not know what to say about it, for this respite of six months might turn out to be a boomerang which would bring me six additional months of prison or exile. Nevertheless I leave the decision to you. My family and I would very much like you to serve as an adviser at my trial, since you are the only man in Paris who knows me thoroughly. . . . I am really ill with a liver complaint and the commencement of dropsy, and I am going to take the waters at *Vichy*, whence I shall write to you immediately. Act as you think best, for you know my incompetence in such matters." [9]

When Courbet wrote this letter he had definitely decided to escape and had already made careful plans for his flight to

Switzerland. On July 20 he had written to Lydie Jolicler: "The hour of departure has come, misfortunes are at hand and will end in exile; if, as seems probable, the court sentences me to pay 250,000 francs it will be one way to finish me off. Now I must leave France surreptitiously, for my comdemnation will mean five years of prison or thirty years of exile if I do not pay. Therefore M. O. [Marcel Ordinaire] and I will go to Laverine [La Vrine] and arrive there at five o'clock Wednesday afternoon; we count on you to meet us there with a closed carriage, either Jolicler or the doctor [Dr Paul Gindre, a friend at Pontarlier] or M. Pillod, and drive us direct to Les Verrières [a Swiss village about one mile beyond the frontier] where we shall have dinner. All this must be done in absolute secrecy, so we count on one of you without expecting you to reply. There is no time to lose, the trial will be held Thursday." [10] This trial must have been merely a preliminary hearing, for the court did not announce its verdict until the following year.

On Wednesday, July 23, 1873 Courbet lunched for the last time with his father, Zélie, and Juliette at Flagey. At two o'clock he departed with Marcel Ordinaire and three hours later reached La Vrine, a tiny crossroads hamlet on the main highway between Besançon and Pontarlier. There they paused for refreshment at an inn, the Hôtel des Voyageurs, then owned by Jules-César Fernier and now the property of his grand-daughter, Mme Marguerite Carrez. The closed carriage was waiting, but instead of sending her husband or a friend Lydie Jolicler had come to the rendezvous herself. Passing through the outskirts of Pontarlier, the vehicle and its occupants crossed the frontier into Switzerland. That night Courbet and Marcel slept at Fleurier, five miles beyond Les Verrières.

BON-PORT

AT Fleurier Courbet lodged in the house of a Mme Schopfer at 16 rue de l'Industrie. He did not yet feel altogether safe; Fleurier was too near the frontier. In his search for a permanent domicile he visited one Swiss town after another: Neuchâtel, Fribourg, Lausanne. Vevey, near the eastern end of the Lake of Geneva, pleased him, and he would probably have remained there had not some of the townsfolk, possibly influenced by a secret agent of the French Government named Jominy, exhibited unmistakable hostility towards a stranger who was reputed to be a dangerous revolutionary.

After several weeks of indecision he settled at a lakeside town adjacent to Vevey, La Tour-de-Peilz, where he lodged at first in the residence of the local pastor, Dulon, hoping that a background of unimpeachable respectability might soften the temper of the neighbours; but the protection offered by the clergyman's piety failed to compensate, in Courbet's opinion, for the frugality of his table. He moved to the Pension Bellevue, then to the Café du Centre, an establishment owned by a certain Budry, "a man with the strength of an athlete, formerly a butcher, who kept at a distance all those who threatened to molest the painter. . . ." [1] Budry also helped

Courbet to conceal the pictures he had had sent to Switzerland from the prying eyes of any French agents who might attempt to confiscate them. Inside one of the huge casks of wine in the cellar of the café Budry constructed a secret compartment into which Courbet tucked the rolled canvases. A few gallons of wine were left in the other section of the cask so that, if the tap had to be opened, the flowing liquid would avert suspicion. But no French agents appeared, and in time Courbet removed the pictures to his own studio and displayed them openly.

Before the end of 1873 he leased a fisherman's house at 9 rue du Bourg-Dessous which had once been a tavern known as Bon-Port, a name the painter liked and decided to keep. Bon-Port was to be his home for the four remaining years of his life. It was a long structure of one storey with the narrow end facing the lake, containing a kitchen, dining-room, bedroom, and a combined salon and studio in which Courbet exhibited his own works and some of his salvaged "old masters." The furniture was sparse and cheap: in the bedroom a porcelain stove, an iron bed with a single mattress; in the studio a few stools and easels. On the east side a large garden shaded by plane trees extended along the lake and commanded a splendid view of the mountains of France on its southern shore, only a few miles away but as inaccessible to Courbet as the mountains of the moon.

The house, considerably remodelled, is now the property of M. Pierre Hofmann, an attorney. When Courbet lived there a sort of shed or penthouse at one end, since demolished, was occupied by Auguste Morel and his wife, refugees like himself. Morel, by profession an assayer of precious metals, had been appointed director of the municipal pawnshop in Marseille during the Commune and had subsequently escaped to Switzerland, where he lived on a small allowance from his brother who, being more conservative politically, had replaced him in the pawnshop. As Courbet kept no servants at Bon-

Port, Mme Morel attended to the housework and cooking. The Morels took excellent care of Courbet until the end, and in return Courbet gave lessons in painting to Morel, who soon became proficient enough to serve as an apprentice and contribute his brush-strokes to a number of paintings signed by the master. For in Switzerland Courbet continued to make use of the pernicious aid of his pupils: Marcel Ordinaire remained with him almost the whole of the first year, and Pata skipped merrily back and forth across the frontier, carrying messages, running errands, and daubing canvases to be retouched and signed by Courbet.

In order to prepare his plea for the defence at the forthcoming civil trial, the barrister Lachaud needed the notes Courbet had written for him prior to the criminal trial of 1871, but Zoé Reverdy had appropriated these and refused flatly to give them up. With the help of Dr Ordinaire, who came to see him in October, Courbet attempted to reproduce this memoir, but he could no longer recollect details or summon up the energy to make much of an effort. His will had weakened and his self-discipline relaxed; moreover he was drinking too much and seemed to take a perverse delight in irritating his worried friends.

Dr Ordinaire wrote to Castagnary from La Tour-de-Peilz on October 13: "We are here, I, my wife, and Marcel, with C. and I am going to help him to rewrite the memoir which we shall send you promptly. . . . The master has painted several excellent pictures at Fleurier, Chillon, and in the Valais [the canton southeast of Vevey]. At present he is painting a sunset over the Lake of Geneva, on the shore of which our domicile (Pension Bellevue) stands. . . . He also has a room at Veytaux-Chillon [about four miles to the southeast] in the house of M. Enoch. . . . He is in good health in spite of his misfortunes. . . . I think it was Signor Cherubino [Pata] who introduced the master to certain dishonest picture dealers, in par-

ticular Berneim [? Bernheim]. . . . As a result so many urgent orders poured in that C., unable to cope with them by himself, had a number painted by Pata, by another young man [probably Morel], and a few by Marcel. He [Courbet] then added his brush-strokes and signed them, and Mme Pata delivered them and collected the proceeds, which she sent to the master more or less intact after deducting her commission. But Berneim multiplied by forgeries the output of this factory, and Cherubino is said to have been the principal author of these forgeries with which Paris and Belgium have been contaminated. . . . Everyone believes that P[ata] supplied the forgeries; I have very good reason to think him capable of it. . . . Some time before his departure for Switzerland our friend painted a real masterpiece of a *Calf*. . . . He is so dominated by P. that he permitted him to copy this as soon as it was finished and to sell the copy to Berneim for 500 francs with the signature *Pata after Courbet*. Now Mme Pata wrote a week ago that Berneim had resold the same picture, *signed Courbet*, for 10,000 francs. . . . Courbet is so infatuated with his *alter ego* that he laughs at his reprehensible speech and conduct . . . and calls him the most honest man in the world. . . . In obedience to his instructions Pata has copied some of his landscapes . . . to be sold . . . at 1000 francs, he says. Meanwhile there are orders at Lausanne, Vevey, and Geneva amounting to more than 15,000 francs which he does not fill. . . . I wanted to write an item for the newspapers warning the public against these impudent forgers, but he would not let me. I shall soon return to France with my wife and Marcel and I shall bring with me the unhappy knowledge that in Courbet's interest I have made very devoted but very useless efforts. I very much hope that a frenzy of regular work will follow his bacchanalian frenzy. I think you have more influence over him than I. But if you think it necessary to warn him concerning his commercial *patasseries* [a play on the word *pâtisseries*, pastries] do it carefully, for he is so *empatassé* [an-

other pun and another dig at Pata, *empâté* meaning crammed or sticky] that perhaps one should not attack him too directly on this subject. Please don't drag me into it." [2]

Two months later Dr Ordinaire returned to La Tour-de-Peilz and by means of patient but relentless prodding forced Courbet to rewrite at least some of his notes for the trial. "My mind has been so confused," Courbet wrote to Castagnary in December, "that neither M. Ordinaire nor I have had the courage to perform this stupid task all over again. We have done it after a fashion, crudely and inadequately. . . . On top of other misfortunes I must have M. Lachaud to plead my case. . . . But we shall have to put up with Lachaud, he has already been paid 3000 francs in advance. . . . I hope Lachaud will be able to postpone the trial which was to have been held at the end of this month; the longer the delay the better. . . . We are doing very well here, we are going to have an exhibition of pictures in a shop in Geneva. We have produced a great many landscapes, there is nothing else to paint in Switzerland." [3]

The plural "we" indicated that the painting factory was still grinding out batches of rubbishy canvases. Courbet's drinking alarmed his friends, who alternately pleaded and protested without effect. The suspicion with which he had at first been regarded by the townspeople soon melted away in the warmth of his convivial good humour, to be superseded by an even more baneful hospitality At his favourite rendez-vous, the Café du Centre, he was always surrounded by a group of topers; the table at which he habitually sat is still preserved there, with his name and the dates of his sojourn at La Tour-de-Peilz, 1873–1877, inlaid in the wooden top. He had been a fairly heavy drinker of beer and wine all his life, but never before had the compulsion to drink been irresistible. Now that he was forbidden beer on account of his illness he substituted the apparently light but actually insidious local Swiss white wines that wrecked what remained of his health. Of

these he consumed enormous quantities, often as much as twelve litres (more than ten quarts) a day, in addition to absinthe and other liquors.

Dr Ordinaire, profoundly distressed, wrote confidentially to Castagnary on Christmas Day: "My dear friend, a few days ago you received at last Courbet's incomplete memoir relating to the column. In the covering letter that accompanied it our friend gave you to understand that my head was as confused as his own, and this charming insinuation will serve me as an excuse to inform you concerning his mode of life which all my efforts have not yet been able to change. To begin with, more than two months ago I succeeded in pinning him down to a few conferences which enabled us to write out most of the document in question, but since then he has escaped from me on the pretext that he could not do two things at once: that is, drink and dictate to me what had to be written for his defence. Now he has drowned himself with the perversity of a savage in the white wine of the canton of Vaud. The hospitable but dangerous custom of the inhabitants is to invite their friends and acquaintances to drink in their cellars, where superb casks or barrels are stored. One glass is kept constantly filled and each guest is required to empty it in turn. The fame of C. and his picturesque if not always rational conversation have earned him numerous invitations to bacchanalian revels which sometimes last until five in the morning. This in addition to the bottles emptied at the café during the day. The need to sleep off his wine usually keeps him in bed until noon, and after that he insists that he is unable to do anything but drink, so he drinks and prides himself on being the foremost drinker in the canton of Vaud, a claim disproved from time to time by his drunken condition. The most injurious effect of this simple white wine is not instantaneous drunkenness, which it causes less readily than our French wines, but in excess it kills slowly but surely, as is proved by the great number of widows in the canton of Vaud. One of its most common effects is to produce

an incurable palsy in the arms and hands. How Courbet would enjoy that! In vain the people of this region and even the proprietor of our favourite café himself have co-operated with me to point out the dangers that threaten him; he pays no heed to experience, he replies that whoever has been accustomed to drinking will continue to drink and that after a day or two of abstinence his wine drains off without leaving any trace in his system. An invitation from friends in Lausanne completed his downfall; instead of returning after dinner he vanished into the cellars and remained there ten days. I went to rescue him from this cesspool and was repulsed without ceremony. Finally sickness triumphed where I failed; he came back very ill and swearing never to drink again, a drunkard's vow forgotten the next day! To do him justice I must tell you that when his father arrived to spend a few days with him he summoned up the energy to paint his [father's] portrait in two sittings. It is a fine picture. . . . *Il signore* Cherubino Pata . . . is an astute Italian. . . . It did not take him long to attach himself to him [Courbet] like an octopus, and since then he has never let go. His spirits are unperturbably blithe and jaunty. . . . To judge by his own words he is absolutely without morals and capable of anything. Married and the father of a family, he enjoys humiliating his wife at every opportunity and demonstrating his contempt for her solely because she is a native of the German part of Switzerland." [4]

The portrait of his father was one of the very few works of Courbet's Swiss period that recalled the vigorous painting of earlier years. At seventy-five Régis Courbet was a robust and still handsome old man, though almost stone-deaf.

In January 1874 Dr Ordinaire informed Castagnary: "Since my last letter C. has worked a little but he continues to expose himself to the murderous shells from the *Swiss cannon*. . . . You say you are satisfied with the memoir so we should be also." [5] The good doctor went home but returned to La Tour-de-Peilz for a few days in March, after which Pata accompanied

him back to France and succeeded in creating a more favourable impression. From Maisières Dr Ordinaire reported to Castagnary on March 22: "I fear I have criticized him [Pata] to you too severely. I have talked with him a great deal during these last few days while the master was snoring and sleeping off his wine . . . and I think . . . he appears to be worse than he really is. He realizes that last year's commercial productions . . . have harmed Courbet, but he claims that, like Cornu and Marcel, he never worked for C. except at the latter's request and that my son has done at least as much damage as he has, because his [Marcel's] paintings, resembling Courbet's much more closely than his [Pata's] own, were scarcely retouched by the master. . . . He denies that he ever produced forged Courbets himself but admits that his name and his wife's intervention have tended to discredit the genuine ones. . . . He also tells me that he has never received payment for certain expensive trips and certain outlays or for his daily services. Courbet would never give it a thought and he [Pata] has not wanted to present a bill. He cares as little about that as about morals and conjugal love. This man with his light-hearted frivolity is very strange, but I am beginning to agree with C. that he is not dishonest. But why has he such a shifty look? . . . He will return to La Tour-de-Peilz in two months, I do not know when I shall go. . . . False Courbets are also being forged at Geneva, and we have identified the forger, a penniless young art student named Delaunay. He claims that he sells them unsigned for twenty or twenty-five francs to the dealer Leclerc. The plan is to prosecute the latter, who signs them [with Courbet's name] for exportation to America." [6]

Many—perhaps most—of the pictures attributed to Courbet after 1872 are open to suspicion, either as canvases only partly painted by his brush or as out-and-out forgeries. Even those unquestionably by his own hand are, with very few exceptions, mediocre in comparison with his earlier works. He

painted a large number of landscapes: views of Bon-Port from his lakeside garden (Plate 58), boats on the lake, the mountains in sunshine and storm, various aspects of the nearby castle of Chillon (Plate 59). Almost all were tainted by the superficial prettiness of picture-postcards. The few portraits he produced in Switzerland were better, though still far from masterpieces. In 1874 he painted the *Vine-tender of Montreux,* a portrait of Cary Blank, a little girl then twelve years old, who lived until 1948 and was one of the last three or four survivors among those who remembered Courbet. In the picture she is posed rather woodenly in regional costume with a basket strapped to her shoulders and a hoe in one hand. Seventy-four years later she recalled that Courbet was "very stout, with a big belly, a fine beard covering a round smiling face, and thick grey hair. I heard him whistling and singing constantly. Whenever he stopped painting it was to fill his pipe. He was very kind to me and fed me sweets so that I would hold the pose." [7]

Probably in the same year Courbet painted a portrait of Henri Rochefort, who had been arrested as a communard sympathizer and transported to the penal colony in New Caledonia, whence he escaped to Switzerland in 1874. Paul Pia, a Geneva picture dealer, wrote to Castagnary on September 23: "On one of my business trips I found Courbet at La Chaux-de-Fonds, and we travelled together to Neuchâtel where I heard of the arrival of H. R. [Henri Rochefort; Pia used the initials to protect the escaped convict], who . . . wanted to see me. I informed Courbet who at first proposed to return to La Tour[-de-Peilz] but then headed for Geneva, where he is now. But I think he will go back to La Tour presently. . . . We are planning an excursion for Thursday: H. R., his daughter, Lockroy [pseudonym of Edouard Simon, a radical journalist and politician], Mme Charles Hugo, and your humble servant are going to La Tour, where the master will paint a portrait of H. R." [8] Rochefort disliked the portrait and refused to ac-

cept it, possibly because Courbet had depicted too realistically the sallow complexion acquired in the tropics.

Courbet also produced a few bits of sculpture in Switzerland. As a token of gratitude to the land of his exile he modelled and presented to the town of La Tour-de-Peilz a bust of *Helvetia,* also known as *Liberty,* represented as a woman wearing the Phrygian cap of liberty and the cross of the Swiss confederation. It is a lifeless, unimaginative work, no better and no worse than his other three-dimensional figures. The model is said to have been Lydie Jolicler, but that seems improbable; the features are too heavy. The bust was cast in bronze at a foundry in Vevey by craftsmen more accustomed to iron than to the finer metals, and the coarse sand of the mould blurred some of the details. The bust is now in the Place du Temple in front of the Hôtel de Ville of La Tour-de-Peilz, where whatever nobility it might have had is marred by an excessively high and extraordinarily ugly pedestal. Three other copies exist: one at Martigny in the canton of Valais, one in the museum at Besançon, one at Meudon between Paris and Versailles. Courbet himself was well pleased with this inferior production, which he described to Castagnary in February 1875: "I have just made a *Republic of Helvetia. . . .* It is splendid, everybody is delighted with it. I am having it cast in a mould, and I should like you to tell me if I should send a copy to the exhibition [presumably the Paris Salon of 1875. He did not send it, and it would almost certainly have been rejected had he done so]. She [*Helvetia*] is vigorously modelled and makes a superb effect; she is assertive, resolute, powerful, generous, kind, smiling; she raises her head and gazes at the mountains. . . ." [9]

A few months earlier he had designed a medallion, the *Lady of the Lake,* representing the head of a young woman surmounted by the outspread wings of a sea-gull, which now adorns the façade of a building on the Quai Perdonnet at

Vevey. The model was probably the Marquise Olga de Tallenay, a friend of the Duchess Colonna di Castiglione whose portrait Courbet had painted in 1865. It was almost certainly to this lady that he addressed these gallant phrases, probably composed by some more sophisticated friend, in November 1874: "It is the function of the ladies to offset by their emotions the speculative rationality of men; I shall always be grateful to Mme Colonna, feeling sure that she made efforts to help me while I was in prison. You came to see me, to see my pictures, to see an exile, a victim who misses his family, his country; you came to see a worker who has devoted his life to the service of art in France. . . . Madame, you have enchanted my house; you have enchanted my thoughts, my imagination, by the astounding beauty of your person, of your kindness, of your sympathetic soul. I cannot hope to repay the pleasure you have given me; but permit me to give you a little souvenir. I thought you were pleased by a little painting of falling snow; I send it to you, just accept it."[10] A note dated merely "Sunday" from Olga de Tallenay was presumably the reply: "I accept joyfully and gratefully the charming souvenir. . . . I shall be at home tomorrow at three, and if you will be good enough to come at that hour to give me the answer to my request I shall be delighted to receive you."[11] What the request was is unknown, but another undated note from the marquise probably referred to the medallion: "The cast of my head has arrived; should I send it to you first or have it taken direct to the moulder?"[12]

The bust of *Helvetia* was set in place and inaugurated on August 15, 1875, and on the same day Courbet opened an exhibition in his studio of his own works plus an assortment of his bogus "old masters." The printed handbills announced: "An exhibition of 130 old and modern pictures, among which the public will be pleased to find, in addition to canvases by the undersigned G. Courbet, works by the most famous masters (Murillo, Van Dyck, Veronese, Rembrandt, Rubens, etc.,

etc.) , will open at La Tour-de-Peilz on Sunday August 15. The modest entrance fee, fixed at fifty centimes so as to be within the reach of everyone, is intended for the relief of the inhabitants of the canton of Geneva whose property has been damaged by hail." [13]

Courbet's exile had not quenched his enthusiasm for the acquisition of spurious old masters. In his letter to Castagnary of March 22, 1874 Dr Ordinaire described a picture Courbet had just bought in Geneva from an Italian junk dealer. It portrayed a woman in antique garb, with her left breast exposed, dancing in a magic circle surrounded by three demons. Courbet insisted that the painting was by Pierre Prud'hon and that the subject was Circe. He had paid 8000 francs for it but asserted that it was worth 100,000; when he reached Lausanne on the way home he offered to resell it for 200,000; by the time he arrived at La Tour-de-Peilz the value had risen to 300,000. "C.'s excitement over his *Circe* is so intense," Ordinaire wrote, "that he declares it is the most beautiful picture in the world, not excepting any of his own works." [14] Four days later Courbet himself boasted to Castagnary: "I have just discovered something tremendous, it is worth at least 300,000 or 400,000 francs. I think it represents Circe summoning her demons and setting fire to the temples." [15] His outlay of 8000 francs for a worthless picture was a reckless extravagance he could ill afford. "I am beginning to be absolutely ruined," he told Castagnary a year later, "one cannot sell paintings in Switzerland." [16]

Good news reached him in the spring of 1875: the rest of the pictures stolen from the Passage du Saumon in 1872 were recovered. On February 24 a mysterious correspondent who identified himself cryptically as "H. K. 113" and gave no address other than *poste restante,* Paris, wrote to Castagnary: "I have just heard that you are looking for the pictures painted by Courbet that were stolen from him. It seems that you have already found some of these pictures but do not know where the others are. I know where these pictures are kept and I am

in a position to tell you in whose hands they are; but . . . I want a reward, the amount to be arranged between us if you accept my proposition." [17] Next day Castagnary agreed to the conditions but heard nothing until March 5, when H. K. 113 demanded 2500 francs. Negotiations continued, and the missing canvases were eventually returned. Courbet believed H. K. 113 to be "a lover of the Gérard woman," [18] his former landlady.

Several friends in addition to Dr Ordinaire crossed the frontier from time to time to visit the painter: Castagnary, Lydie Jolicler, Dr Blondon, the attorney Dufay who afterwards married Max Buchon's widow. Courbet's door was always open to other refugees who lived near La Tour-de-Peilz: Rochefort, General Cluseret, the eminent geographer Elisée Reclus, whose prison sentence had been commuted to exile at the request of various European geographical societies. Courbet contributed generously to the support of those refugees who were without funds, donated pictures to be sold for their benefit, and kept on his mantelpiece a cigar box into which visitors were expected to drop offerings for the poor.

One of his most intimate friends among the exiles was André Slomczynski, usually called Slom, who helped Reclus to prepare maps and drawings for his monumental *Nouvelle géographie universelle*. Slom was born at Bordeaux in 1844, of Polish parentage, and studied drawing in Paris at the Ecole des Beaux-Arts. During the Commune he had acted as secretary to Raoul Rigault, Chaudey's executioner, but he evaded arrest and almost certain death by escaping to Switzerland. Slom soon became a member of Courbet's household and served the painter devotedly. Courbet commenced a portrait of him but never finished it. In 1879 Slom married Emma Blank, elder sister of the Cary Blank who had posed for the *Vine-tender of Montreux*. He returned to Paris in 1882, after the amnesty, and died in 1909.

During the years of Courbet's self-imposed exile Lydie Joli-cler is said to have ventured twice across the frontier alone in a carriage which she drove herself, and to have transported Courbet in utmost secrecy to Pontarlier, where he remained hidden in her house for a few days on each occasion. But his letters indicate that he had no stomach for such risky excursions, and the evidence that he made them is dubious, depending exclusively on the recollection of Lydie's daughter Henriette, who was eight or nine years old at that time. Henriette Jolicler, afterwards Mme Dreux, was still living in 1948 and shared with Cary Blank and two or three others the distinction of being one of the last who remembered Courbet.

The painter kept in close touch with his family and displayed deep interest in the most minute details of the Flagey routine. In January 1875 he wrote to Juliette: "You must be very clever to have removed, while the police were watching, the money I had hidden in the piano. I shall reward you at once. I give you the 480 francs it would earn in interest, for yourself, Zélie, and my father, because you must buy some Burgundy for Zélie [who was ill]. I have a cask of Burgundy in the cellar at Ornans; I authorize you to take it. . . . You can transport it to Flagey without shaking it too much. It will require two strong men; let them take it just as it is and place it in the cart without turning it. You will let it settle at Flagey. But if our police officers, my custodians, have already drunk it, forget about it." [19]

The Burgundy did Zélie no good, and this sister, always the frailest member of the family, died late in May. On May 29 Courbet poured out his grief to Juliette: "Your letter and the dreadful misfortune we have suffered have distressed me deeply; my poor dear girl, now you alone must bear the burden of taking care of us all, my father and myself. . . . I have wept all the tears in my body; my poor Zélie, who never knew any pleasure in her whole life except to serve and give pleasure to others. What a sad life this poor sister has had without com-

plaining, always ill, always brave, always kind! Our lovely sister will always be graven in our memories, as will our mother, precisely as if they were alive. But it is of you, my dear, that I am thinking. What a difficult time you will have until I come home! I wanted to feel that you [and Zélie] would be together all my life. I should have been happy, and it would have been the greatest joy you could have asked for; I should not have had to worry about you, I should have needed only to help you and to live with you. Now you must try to find some needy, unfortunate, well-bred woman to assist you with the work to be done. As to me, my dear, you know that we shall always be inseparable if you wish it so and that I am ready to help you in every way. I worry too about my father who loved our poor sister so dearly. . . ." [20]

PROSECUTION

AFTER successive postponements Courbet's case finally came before the civil tribunal of the department of the Seine (Paris) on June 19, 1874. Victor Lefranc, prosecutor for the administration of Public Domain, affirmed Courbet's responsibility for the demolition of the Vendôme Column, arguing that although Courbet did not actually sign the decree of April 12, 1871, that decree was based on and inspired by his petition of September 14, 1870. Lachaud's denial failed to convince the judges. On June 26 the tribunal confirmed the validity of the confiscations of Courbet's property that had already taken place, authorized additional seizures of anything that might have been overlooked, and condemned him to pay the entire cost of the column's reconstruction, the amount of which could not be fixed until the work was completed.

In a belated and wholly unsuccessful attempt to rescue Courbet, Félix Pyat, a member of the executive committee of the Commune who had escaped to London, publicly assumed the responsibility for the decree ordering the destruction of the column, the authorship of which had until then been in doubt. In a letter to *The Times* dated June 23, 1874 and printed the following day Pyat wrote: "According to your

Paris correspondence relating to the Courbet trial, M. Victor Lefranc, the ex-minister, now the attorney for the Government, bases his accusation against the former member of the Commune on the assumption that the reasons that prompted the decree were the same as the artist's reasons for desiring the demolition of the column. That is not altogether true—far from it! But M. Victor Lefranc has looked at the matter with only one eye. The Paris Commune decreed the overthrow of the column for exclusively political reasons. Rightly or wrongly, as history will decide, I took the initiative in this affair as a member of the Executive Committee without consulting Courbet or his distaste, as a creative artist, for this imitation of a Roman monument. I drew up and proposed the decree in these purely democratic terms [here followed a quotation of the entire decree]. . . . Not the slightest reference to art! Thus the artist did not inspire or even vote for this 'socialist' decree. For this decree, you will note, was passed on April 12 [1871], and the artist did not become a member of the Commune until the 20th [*sic*; actually the 19th] after the supplementary elections. If on the 27th the Executive Committee delegated the artist to carry out the decree, it was solely in order to preserve such portions [of the column] as might have some artistic value [this was Pyat's error; Courbet had been delegated to supervise the demolition of the Thiers house, not of the column. On April 27 Gambon had indeed suggested Courbet's appointment to the committee charged with supervision of the destruction of the column, but when it was pointed out that the work was to be handled by a contractor Gambon's proposal was dropped]. Therefore I cannot permit the responsibility for the destruction to rest on Courbet; such as it is, I assume it as my due. I make this declaration, as spontaneous as it is sincere, for the benefit of a great painter whom they [the Government] are trying to ruin after having tried to kill him; and I hope that *The Times* will be good enough to help me to obtain justice for him."[1]

Courbet promptly entered an appeal, but more than a year later, on August 6, 1875, the Court of Appeals confirmed the verdict. On November 19 Duval informed him: "The department of Public Domain has just forbidden the distribution of properties bequeathed by your mother and . . . Zélie. . . . This move will prevent the settlement of these two estates. . . . I am expecting from day to day to learn that you have been ordered by the Government to pay an indemnity of 400,-000 or 500,000 francs. Our only strategy . . . is to gain time, wait for the elections [in the following February], wait for the new Chamber. Then we shall decide what steps to take according to circumstances." [2] In the same letter Duval broke the news that the picture dealer Durand-Ruel, who owed Courbet a considerable sum, was liquidating his business; the solicitor would try to collect the amount due, because although the Government would undoubtedly confiscate it, it would reduce by that much Courbet's indemnity and might even be returned to the painter if the state should ever relinquish its claim against him.

Duval wrote again in March 1876: "I have received from the Government a *provisional* demand for the payment of 286,549 francs 78 centimes. . . . You will be condemned to pay this. I can see no way to save you from this fate." [3] A week or two later, against Castagnary's advice, Courbet composed (as usual with much editorial assistance), had printed, and distributed a long open letter to the newly elected senators and deputies of the National Assembly, many of whom were more liberal than their immediate predecessors: "The experience of an already long career has robbed me of many illusions . . . but there is one I cling to, a belief in the justice and generosity of the French people. . . . Therefore I appeal now to a tribunal higher than all others . . . I appeal to the members of the Assembly elected on February 20, 1876 against the decision of those elected on February 8, 1871." [4] Again he restated all

the familiar arguments in his favour, but the letter had no effect.

The adverse decision by the Court of Appeals caused Courbet, somewhat unreasonably, to lose confidence in his solicitor Duval; he had always distrusted, with no more justification, the barrister Lachaud. On August 28 he complained to Castagnary: "I am still in suspense, so worried that I cannot work. My father, who is growing very old, writes constantly and urges me to leave [Switzerland] now that the [former reactionary] deputies are no longer in the Chamber. It is heart-breaking, I am beginning to think it is my solicitor who is keeping me in captivity in collusion with Lachaud. With all the people we know, it cannot be impossible to obtain a definite assurance [of a safe-conduct] either from the minister of the Interior or the prefect of police, with a *certificate in writing* that I can show to the frontier police, so that I can take a holiday in the Franche-Comté. You and E[tienne] Baudry have told me that the son of M. Dufaure [the premier, Jules-Armand Dufaure] could arrange this; if he can't there are others; I have written about this to my solicitor who is a swine and a thief, I think; he has done nothing about it. . . . M. Thiers came to see my statue of the republic [*Helvetia*] at La Tour-de-Peilz, fortunately he did not call on me. . . . Next Monday or Tuesday I shall go to Vallorbe on the frontier . . . to see my father, the poor old man is dying of worry and grief. He is coming to discuss our affairs at Ornans." [5]

Duval also had a grievance. "For two months," he told Castagnary on December 1, "I have been writing to M. Courbet and asking him for answers to very important questions. I have not had the slightest sign of life from him." [6] Courbet took up the refrain four days later: "I can't supply any more information. In three and a half years I have written more than five volumes [of notes and memoirs]. And I have never been able to learn from either my solicitor or my barrister why I had to go into

339

exile and what risk of imprisonment I should run [by return-
ing to France] if I could not pay. . . . My solicitor gives me
no advice, takes no steps whatever; M. Lachaud does even less;
consequently I have become, without knowing anything about
such things, the *solicitor* of my solicitor. . . . With this sword
of Damocles hanging over my head for so long it is impossible
to stave off *delirium tremens,* enervation, stupor, and especi-
ally the siren [alcohol] that leads to madness. Impossible to
work, and in addition there is my family in a state of profound
sorrow. . . . If they [the Government] insist that I must pay
this *unjust* indemnity, I must at least . . . keep my atelïer at
Ornans in any circumstances (it was mortgaged legally before
my prosecution) ; I could never build another. . . . If they
try to invalidate the mortgage I think I shall give up paint-
ing." [7]

The Government could now estimate more precisely the
cost of the column's reconstruction. On January 8, 1877 Cour-
bet wrote to Castagnary: "You know better than anyone that
I cannot pay 333,000 francs. It is hard enough for me to pay
the solicitor and barrister; at present I am completely ruined
and am selling no pictures. . . . I think it will soon be time
to put all this out of my mind; all these inanities must come to
an end, these perpetual worries, these legal documents of
which I understand absolutely nothing and against which I
cannot in any event defend myself, because it is not natural to
torment a man in this way for three or four years. . . . You
are the only man I know who has helped me in this business.
We must obtain from J[ules] Simon [who had succeeded Du-
faure as premier] a safe-conduct permitting me to visit my
family, to see how they are, to reassure my old father, to cheer
up my sister [Juliette] who devotes her life to him. In that way
I can recover the peace of mind I need so badly in order to
work again." [8]

Courbet did not propose to risk his liberty by returning to
France without a safe-conduct. On the same day he wrote im-

patiently to his father: "You surprise me by saying the same thing over and over. It hurts me, for one would think you do not understand what I write to you. Tell me, yes or no, if you want me to cross the frontier and then spend *five years* in prison. I am doing all I can here to reach a solution. . . . The gendarmes are arresting everyone who resembles me at all the frontiers, especially near Pontarlier. Once when I was at La Chaux-de-Fonds some of my friends, for a joke, persuaded me to cross the Doubs [into France]. I had nothing to fear; at the first sight of a gendarme I should have swum back. . . . What happened? Next day the French gendarmes arrived on the scene, asked questions, and crossed into Switzerland to interrogate the Swiss gendarmes, whom they told that I must not try that again as they had a warrant for my arrest. If you care to pay 330,000 francs for me I can return at once. . . . I am as anxious to return to Ornans or Flagey as you are [to have me do so]; but you must be patient." [9]

The authorities were almost ready to present their final bill for the reconstruction of the column. Duval reported on February 10: "While you have not answered my letters and seem to take no interest in your situation, I have succeeded in negotiating an arrangement with the Government. I have made an agreement in accordance with which a verdict will be rendered condemning you to pay 323,000 francs . . . but you will be given time to pay it at the rate of 10,000 francs a year. . . . It is understood that no prison sentence will be pronounced against you. Henceforth you will have complete liberty and will be subjected to no more prosecutions and annoyances. I tried to stipulate for annual payments smaller than 10,000 francs but could not obtain better terms. The Government demanded 25,000 or 30,000 francs a year. . . . In about a month all should be settled and you will be able to recover your freedom." [10]

The definitive judgement was proclaimed on May 4, 1877. Courbet received an itemized bill for the re-erected column:

341

Disbursements by the ministry of Public Works fr. 286,549.78
Disbursements by the ministry of Education and Beaux-Arts 23,420.00
Additional disbursements by the ministry of Public Works 13,121.90

TOTAL fr. 323,091.68

The Government did not suggest the payment of interest during the liquidation period, except that five per cent would be charged on any overdue instalments; the addition of interest would have raised the total to an astronomical and obviously uncollectible sum. 10,000 francs were to be paid each year in semi-annual instalments, beginning January 1, 1878, which allowed more than thirty-two years for settlement of the entire debt. Courbet was fifty-eight years old. "I can see him," Castagnary commented sarcastically, "on the first day of his ninety-second year, rubbing his hands and saying: 'At last I have paid for the column; from now on I shall work for myself.' " [11]

ZOÉ

A MONTH or two after Courbet's flight to Switzerland his sister Zoé moved to Ornans with her husband and two very young sons, settled down in the old Oudot house which she and her sisters and brother had inherited jointly from their mother, and proceeded to make a thorough nuisance of herself. She was growing more capricious and irresponsible every year, and in her disordered mind most of the "true friends" to whom she had appealed so confidently in her brother's behalf two years before had now become his (and her own) worst enemies. Obsessed by this delusion, she turned against Courbet's most loyal partisans: Castagnary, Dr Ordinaire, and the Joliclers. Bruyas alone remained in her good graces, presumably because illness kept him in Montpellier and unable to play an active part in Courbet's affairs.

To Bruyas she wrote in August 1873, probably before her departure from Paris: "Alas! My poor brother is ill. . . . He has had to leave France to find peace. Ever since he had the misfortune to meet C[astagnary], that contemptible journalist of *Le Siècle,* my brother has been ruined, for this exploiter has lured him away from painting and forced him to adopt his [Castagnary's] political doctrines. Oh! Sir, if you knew the in-

famous conduct of this journalist you would be appalled. He has enlisted the support of the O[rdinaires] from our own province. They declare that my brother must renounce his family and all who do not share their views, that they alone know the part that my brother must be made to play. Since my brother is distracted, these scoundrels write in his name, they try to make him assume responsibility for the acts of their party and to repudiate [the verdict of] the Council of War which acquitted him [!] for lack of proof of his guilt. C[astagnary] claims that this will bring glory to my brother and make friends for him, and that he should pay for everyone. Alas! He has been robbed so thoroughly by his friends that he has nothing left; what will become of my father and of our whole family who have sacrificed themselves for him? All his life as an artist must be wrecked by the ridiculous politics of C[astagnary], to become the plaything of all these scoundrels." [1]

Dr Ordinaire, who knew very well what Zoé thought of him and cordially reciprocated her dislike, wrote to Castagnary from La Tour-de-Peilz in October: ". . . Courbet has been negotiating to obtain from Mme Reverdy the memoir and other documents concerning the affair of the column that she has in her possession. But after replying at first more or less evasively she has recently, at Ornans where she is at present, told C[ourbet]'s family plainly that she has turned everything over *to the authorities* and that whoever wants these papers can demand them from them [the authorities]. So she has become her brother's implacable enemy, both by the hatred she feels for all his friends (including ourselves) and by her prejudicial actions. She feels that the absolute domination she has always tried to exercise over the person, opinions, and activities of our friend has escaped her, which makes her furious." [2] In December Courbet reported: "We have never been able to obtain the memoir from my sister, *who is demented I think* [Courbet's underlining]. . . ." [3] He probably did not mean this literally, but unknowingly he had hit the nail on the head.

If Zoé was not yet technically insane she had for some time been exhibiting the preliminary symptoms of lunacy, but her mental degeneration was so gradual that nobody then understood the true cause of her erratic and seemingly perverse behaviour.

In January 1874 Zoé resumed her correspondence with Bruyas: "You will have seen by the newspapers that this wretched trial will commence at the end of February or the beginning of March [it was postponed until June], and we are almost sure that he [Courbet] will lose, for the isolation in which MM. C[astagnary] and O[rdinaire] have kept my brother and their efforts to make him pay for that whole infamous crowd of people to whom we owe the physical and moral destruction of my entire family have caused us to lose all hope. C[astagnary] and the O[rdinaires] are trying to prevent me from supplying the evidence which would liberate my brother and to force him to assume responsibility for these acts by persuading him that they will immortalize him! . . . My brother has no notion of what these exploiters are doing to him. . . ." [4]

Courbet's fury kept pace with his sister's hysteria. "Now is the time," he wrote to Castagnary in February 1875, "to get rid of M. Reverdy, who is a Bonapartist agent and a great danger to my family and myself as well as to you, Ordinaire, and everybody we know. My sister, who is a monster, wishes to ruin me and is trying to lay hands on my money, through police action, even in Switzerland; they call everyone thieves." [5] In April Courbet railed against the misdemeanours of the Reverdy family at home: "They have caused extraordinary confusion at Ornans and have instituted a reign of terror by intimidating people with the support of the Government. They . . . write anonymous letters purporting to come from the police of the town of Besançon. You cannot imagine how they have treated my family, they are trying to kill my father during my absence and to terrify my sisters with threats

and coarse insults so as to seize our property. . . . He [Reverdy] began by taking possession of our house in a violent manner and pocketing the keys of all the rooms, then those of the cellar, so that my poor old father, arriving from Flagey with his latchkey, was obliged at his age to sleep for two nights on the staircase to avoid a scandal. He has written to me: 'I am miserably unhappy in the presence of people like that, I must have an iron constitution to survive such trials.' Finally he was attacked with violent insults and peremptorily thrown out of our house. Now he lodges at the Hôtel de France . . . when he goes to Ornans, and when my sisters [Zélie and Juliette] go there they live with their friends. Recently my father drove in a carriage to take some wine from his cellar, he found there was none left and had to buy wine [the ultimate humiliation to an owner of vineyards]." [6]

At about the same time Courbet wrote an irate letter to Zoé, whom he addressed formally as "Madame Reverdy": "The judicial authorities in Berne have received through diplomatic channels the denunciations signed by you and transmitted by the French Government, requesting them [the Swiss] to investigate my person and my property. The Swiss Government, considering these denunciations a manœuvre altogether incompatible with individual liberty, became alarmed and communicated them to me through the Swiss courts. But the judiciary of this country took pains to judge as it deserved this criminal attack upon me, and it was in all the better position to perceive the calumny because the magistrates whose duty it would have been to conduct this investigation are all men who invite me to dine with them every week. It is not enough for you to have scandalized the whole of the Franche-Comté by your vile conduct, you must also cause a scandal in the country in which I have to live. In view of such an infamous act, on top of so many others, I must warn you to leave the house [at Ornans]. . . . You should without regret leave this house which you have stripped so thoroughly that my father is

obliged to buy his wine in the town and live at the hotel. . . . This outrageous behaviour must cease, as must also the anonymous letters you write every day to my father, my sisters, and myself. These letters are so repulsive that they are unreadable. Only people without honour like yourselves would use such methods. It is time to bury the innumerable calumnies you are spreading about my friends, whom you call thieves and who have not yet haled you into court simply out of regard for the family. There has been enough of this; take care that your parricidal nature does not come to a bad end." [7]

With reciprocal extravagance and injustice Courbet and Zoé blamed each other for Zélie's death. "It is really the persecution to which they [the Reverdys] have subjected all of you that killed my poor sister," Courbet wrote to Juliette, "it is the grief that swells the liver which aggravated the disease of that organ from which she was already suffering." [8] And in January 1876 Zoé confided to Bruyas: "Poor Zélie, it seems as if the disasters brought upon us by my brother will never end, and she was deeply affected by them, they caused her death as well as the sad condition of my father, who is absolutely deaf, stricken with grief by my brother's follies." [9]

Zoé wrote again to Bruyas, probably early in 1876: "Alas! If my poor brother had been wise enough to rely more upon your advice, if he had remained within the circle of true friends like yourself, he would be happy and at peace today. Instead, having fallen into the hands of false and dangerous men . . . as well as of all those fine fellows who have imitated his painting and do not hesitate to sign Courbet's name to the most villainous daubs ever seen [Zoé was on firmer ground here, but she should have blamed her brother, not his apprentices], these rascals have not only ruined the man by hurling him into the abyss from which he cannot save himself but also destroyed the artist by signing their works with his name. You have no doubt seen in the newspapers that an infamous pamphlet written by his vile friends [possibly Courbet's own open letter of

March 1876 to the National Assembly], which could not be printed in France without danger to its authors, has been published in Switzerland over Courbet's signature. It was intercepted and confiscated at the frontier, an additional black mark against my brother whose mind is so disordered that others speak and act in his name without his knowing the first thing about it. . . . My poor father is quite prostrated by the various misfortunes my brother has brought upon us." [10]

Bruyas, tired of Zoé's eternal accusations and complaints with which he had no sympathy, sent a sample to Courbet, who wrote to Juliette in February 1876: "Mme Reverdy has just written a crazy and wicked letter to my friend Bruyas at Montpellier. This is the third letter my outraged friends in that region have written to me [about her]. She has written a despicable letter. She accuses me of every crime. Bruyas is horrified and does not intend to answer it. She is an infernal monster. I don't understand how you could allow this riff-raff to leave your house [evidently Courbet thought the Reverdys were about to depart] without taking an inventory of everything in it; so now all the accumulations of my lifetime have disappeared, my manuscripts, my catalogues, my pictures, articles of all kinds, everything is gone. . . . The Reverdys have robbed me of pictures valued at 100,000 francs. In one of their letters they accuse J[olicler] of the thefts, but they [the Reverdys] have plenty of them [Courbet's pictures]. You should have their house searched and recover what they have belonging to you and me." [11] Bruyas was not to be annoyed by Zoé much longer. He died at Montpellier on January 1, 1877.

Courbet complained to Castagnary in April 1876: "The Reverdys at Ornans are selling the pictures they stole from the rue du Vieux-Colombier, from my studio, and from the Passage du Saumon." [12] And again in August: "My share of my mother's estate has been sequestrated; my sister Juliette has bought it all in order to drive out the Reverdys, but it is impossible, they insist on remaining in spite of everything. They

have a store-room at Ornans full of my pictures which they are selling off one by one. If I try to claim them they will turn them all over to the Government." [13] Included in the property Juliette purchased from her brother was his share of the house at Ornans in which he had been born and in which Zoé and her husband had ensconced themselves. Zélie being dead, Juliette had apparently bought not only Courbet's share of their mother's estate but Zoé's as well. About a month after the painter's death Juliette wrote to Castagnary: "She [Zoé] has plagued her family all her life; since my mother died she has caused us all kinds of difficulties . . . for four years she has occupied our house at Ornans against our wishes; I have had to buy up the house and lands at the request of Gustave and my father, who did not want them to pass into the hands of strangers. . . ." [14]

Eager as Courbet was to have Zoé and her husband dislodged from the Ornans house, he feared that their expulsion might entail additional losses. "My father writes me that he is going to oust the Reverdys," he wrote to Juliette in May 1877, just after the amount of his indemnity had been finally determined. "That is dangerous too; they will take with them everything that belongs to us. You will have to inspect their trunks; you will have to do it with official sanction as you would if they were servants, for now they no longer have any business to meddle with my property." [15] The Reverdys resisted eviction, and in September Courbet wrote again: "You must absolutely tell Fumey [Courbet's lawyer at Besançon, who handled his local business] at once to put seals on the contents of our house, to which they [the Reverdys] have no right. They belong to my father and to me; so write to Fumey, it is my father's duty unless he wants me to be robbed of thirty or forty thousand francs, perhaps fifty thousand, by those people. And if that should happen, on what would he expect me to live and pay for the column?" [16]

It was a long, unhappy, acrimonious, often petty and sordid

family quarrel which could have been avoided had Zoé's mental illness been diagnosed in time. It would then have been possible to curb her activities, and at the same time her brother would have treated her more gently if he had known the true cause of her apparently malicious behaviour. The part played by Eugène Reverdy remains shadowy, though the evidence suggests that he was brutal, avaricious, and unscrupulous. He was probably far more responsible than his psychopathic wife for the intrigues and persecutions that embittered Courbet's last years.

DEATH

EVEN after the ratification of Duval's pact with the Government on May 4, 1877, Courbet hesitated to return to France. "I still have business to settle here," he wrote to Castagnary from La Tour-de-Peilz on May 14, "and then I must spend some time at Ornans, where my father is waiting for me with great impatience. I don't know when all that will be finished, I shall go to Paris as soon as I can." [1] But because the pact did not specifically guarantee a safe-conduct into France he postponed his departure from week to week, not altogether trusting Duval's assurances that he would not be molested and that his remaining pictures would not be confiscated.

His doubts were by no means baseless, for during much of the year a constitutional crisis threatened the stability of the French republic, which under the quasi-dictatorship of the president, Mac-Mahon, was far from a true democracy. Following the elections of February 1876 by which the Chamber had acquired a republican majority and the Senate an augmented republican minority, the ministries headed by Dufaure (March to December 1876) and Jules Simon (December 1876 to May 1877) had been relatively liberal; but on May 16 Mac-Mahon forced Simon to resign and installed a reactionary

monarchist, the Duc de Broglie, as premier. Late in June Mac-Mahon, with the support of the Senate, dissolved the Chamber and to all intents and purposes governed without a parliament until October, when new elections returned a very large republican majority to the Chamber of Deputies, which Mac-Mahon was then obliged to reinstate. In a final effort to retain absolute control the president dismissed Broglie on November 23 and replaced him with another reactionary, General Rochebouët. This cabinet lasted only three weeks; the Chamber refused to vote appropriations, and on December 13, 1877 MacMahon reluctantly recalled to the premiership Dufaure, who formed a liberal Government and brought the crisis to an end.

All of these political events affected Courbet directly. He could not feel safe in France while Broglie held power, and by the time a republican Government had been re-established he was much too ill to travel. Throughout the summer his dropsy, resulting from an alcoholic cirrhosis of the liver, grew steadily worse. By autumn his condition was alarming. On October 8 he went to La Chaux-de-Fonds, "a village lost in the mountains where there is nothing but snow and clock-makers," [2] and entered the private hospital of Dr Guerrieri, an Italian physician highly recommended by friends at Vevey and La Tour-de-Peilz. According to the printed stationery of this institution, situated at 36-A rue Fritz Courvoisier, Guerrieri was prepared to cure "all kinds of rheumatisms, arthritis, sciatica, nervous ailments, glandular diseases, skin diseases, paralysis, neuralgia, heart diseases, etc." [3] Unfortunately Courbet had fallen into the hands of a quack whose treatments, consisting chiefly of steam baths and purges, only weakened the patient and accelerated the progress of his illness. Although probably nothing could have saved him at this stage, proper treatment might have prolonged his life a few months.

First reports were encouraging. A friend at La Chaux-de-Fonds, Leloup, informed Castagnary on October 31: "I have wanted to write several times on Courbet's behalf but he would

never make the effort [to dictate a letter], he would not believe he was ill. Actually he is much better since he came here . . . we have taken away from him the little white wine of Vevey and in fact almost all wines; with good care we hope to cure him. His father and sister [Juliette] have come to see him; his morale is excellent." [4]

Auguste Morel struck a less optimistic note on November 4: "Courbet is seriously ill. . . . I have just returned from La Chaux-de-Fonds, where I went with two other people from this region to see Courbet, and our first impression was bad. . . . I have just written to a friend of Mlle Juliette's [perhaps Dr Blondon of Besançon] . . . suggesting a consultation of doctors and the immediate adoption of measures which might increase the chances of saving him, if there is still time. I hope for the best, but not if he continues the present treatments, especially in such a cold climate. . . . I forgot to tell you that Courbet's dropsy is very extensive; he has grown terribly thin, his abdomen is enormous and his legs are swollen to above the knees." [5]

Fritz Eberhardt, another friend at La Chaux-de-Fonds, sent a bulletin to Dr Blondon on November 10: "At present his legs are tremendously swollen and are beginning to exude liquid. The Italian doctor wants to apply blisters to his legs. I should like to have your opinion about this. Courbet thinks he is a little better. . . . He has no appetite at all but is always very thirsty. . . . I am writing at Courbet's request." [6] Three days later Juliette told Blondon: "I have received a letter from Mme Jolicler. . . . Lydie says she has just written to Gustave and has proposed to bring him to Pontarlier; I don't know what he will reply. If he should consent I think he would need a safe-conduct from the prefect." [7]

Meanwhile Castagnary had been urging Courbet to go to Paris for treatment at the nursing home of Dr Dubois; the October elections made it almost certain that he could enter France safely, especially on the plea of illness. But Courbet

would go to neither Pontarlier nor Paris. "Impossible to persuade him to make the journey to Paris," Leloup answered on November 16. "His excuses are the difficulties of travel, his distended belly . . . the inconveniences of the Dubois hospital, etc., etc. He is really very ill. . . . His family continues to pay no attention to him. Oh yes, Mme Reverdy has written to a Catholic curé at La Chaux-de-Fonds asking him to visit her brother and convert him to a belief in God!!" [8] Later that day Leloup sent a second letter to Castagnary: "The wonderful steam baths have not reduced the swelling at all. . . . In my opinion the presence of the Parisian doctor you mention is urgently necessary. But Courbet will not hear of it. He does not want a doctor; do you know why? Because he is afraid of being tapped. If one mentions this operation he thinks he is being condemned to death. . . . His family at Ornans neglects him completely. His sister [probably Juliette] does not write except to pester him about business matters, powers of attorney, etc. They are true Franc-Comtois peasants. . . . I believe it is high time . . . to send the doctor from Paris with or without his [Courbet's] consent. Has the financial situation anything to do with this? He constantly declares that he has no money. Is this fact or fancy?" [9]

Courbet himself was probably responsible for his family's apparent neglect. He had always shown the most affectionate consideration for his parents and sisters (except Zoé) and he did not want his father or Juliette to know how desperately ill he really was. The doctor recommended by Castagnary was Paul Collin, assistant to the celebrated surgeon Jules Péan who had taken over Nélaton's practice after the latter's death in 1873. On November 23 Courbet left the Guerrieri hospital for the house of his friend Eberhardt, who called in another physician, Dr Buchser. On the advice of this doctor, who found Courbet much the worse for his weeks at the hospital, Eberhardt immediately urged Dr Blondon to come for a consultation.

On the same day Courbet dictated a letter to Castagnary: "Your last letter certainly gives me excellent advice with regard to my illness, unfortunately it is impossible for me to follow it at the moment. In this excessively cold weather I cannot leave this place. I am well cared for at La Chaux-de-Fonds, although I am aware of the virtues of the treatment I should be given in Paris. . . . I have received from Dr Blondon very precise information concerning the trial [the pact of May 4] with details supplied by the solicitor Duval. I quote the principal passages: 'This is the result of our computations: (1) The state has already collected from confiscated property the sum of 18,521 francs. (2) The costs of the trial amount to 11,750 francs. Thus the sum of 6800 francs belonging to you remains in the hands of the state. . . . Will the state retain this sum as security or as an advance payment [on the indemnity]? That is what we must ascertain. Why . . . does the state claim the right to sell your pictures that are at Durand-Ruel's? This sale does not appear to me to be necessary or *indispensable* as stipulated in the agreement. All you owe the state at present has been paid, so that instead of selling more of your things the state should repay you 6800 francs.' . . . You see from this that the state has no right to sell my pictures, as it is in debt to me at the moment." [10]

This unnecessary forced sale, which took place in the public auction rooms of the Hôtel Drouot in Paris on November 26, was a final demonstration of vindictiveness ordered by the expiring Broglie cabinet. Only ten canvases were offered, none of great importance; one or two were unfinished, one was a sketch. The entire lot sold for less than 10,000 francs, including *Proudhon and his Family* at 1500. All of these pictures had been found in the studio in the rue Hautefeuille, together with a miscellaneous collection of bric-à-brac which was sold at the same auction for infinitesimal prices: a mahogany piano, tables and chairs, eight easels, two paint-boxes, a number of frames, rolls of unused canvas, bedding, and "a quantity of

rubbish." [11] The dispersal of his personal property hurt Courbet as much as the pecuniary loss, for he had always clung to and cherished his possessions, no matter how dilapidated or worthless they might be.

With the original surplus of 6800 francs plus the proceeds of the auction of pictures and "rubbish" the state now held about 18,000 francs belonging to Courbet, almost four times the amount of the first semi-annual payment due on his indemnity. Nevertheless Courbet instructed Duval to pay 5000 francs more on January 1, under protest, if the Government insisted.

Courbet returned to Bon-Port on December 1, so bloated with serous fluid that his girth measured sixty inches; it was necessary to transport him in a special railway coach equipped with double doors. Two or three days later Dr Blondon, who had arrived from Besançon, and old Dr Farvagnie of Vevey tapped him and drew off twenty litres (almost eighteen quarts) of fluid, which relieved him for a few hours until the cavities refilled.

On December 12 Courbet dictated what was to be his last letter to Castagnary: "These seven weeks [at La Chaux-de-Fonds] . . . cost a great deal; in addition since my return here I have had to call in two specialists who operated on and tapped me. All this is ruinously expensive and I assure you my funds are exhausted, quite exhausted. So it will be impossible for me to pay anything to the state at present. . . . And now, my dear Castagnary, I take leave of you with the hope . . . that our unhappy country may soon emerge from the terrible crisis it is passing through. In foreign lands one would blush to be a Frenchman if one did not have the burning conviction that right and justice will have the last word. The Swiss are disgusted by the patience of the French people. May the French at least prove to the Swiss that if they are patient they

will be so until the end, but only until the end of Mac-Mahon-ism!" [12]

On December 18 Courbet sent for Dr Collin, but before he arrived from Paris four days later, Dr Farvagnie tapped Courbet for the second time, again drawing off eighteen or twenty litres. The incision failed to heal, and for four days the fluid continued to flow so that the patient "was literally bathed in ascitic liquid in spite of almost constant sponging." [13] Collin found him "much worse than I had expected or than he himself realized. He was in bed. He rarely left it. Occasionally, when the fatigue of lying in bed became too much for him, he was carried to a sofa and lay there, prostrated by his malady. . . . Courbet's condition seemed hopeless to me. . . . He had only one wish . . . that was to bathe in the lake. . . . 'If I could only stretch out in the waters of the lake,' he would say, 'I should be cured.' . . . Baths gave him great relief and seemed to relax his whole ailing body. Two men would carry him to his tub and he would remain in it until weakness overcame him completely. It required pleadings and long arguments to persuade him to leave it. . . . And he constantly asked to have his forehead sponged with cold water. . . . Unquestionably Courbet had aggravated his illness by excessive consumption of beverages. Until the end he still drank about two litres of liquid daily. . . . Unfortunately it was the local wine that has created so many widows in this district, and Courbet had conceived the idea of mixing it with milk, a peasant custom, which gave him violent indigestion. . . ." [14]

As the end approached, Courbet faced the prospect of death calmly and courageously. He appeared to worry more about financial problems than about his health. He wanted company, and many of his refugee friends visited him regularly, including Edgar Monteil, who had shared his imprisonment at Versailles in 1871 and who now came to chat with him almost every day. The news of Mac-Mahon's long overdue capitula-

tion to the opposition of the republican majority, and the installation of the Dufaure cabinet, cheered Courbet immensely. He continued to delude his family with optimistic bulletins concerning his health. "Don't be at all uneasy," he wrote in a shaky hand to his father and Juliette on December 23, "and remain quietly where you can be warm, if that is possible at Flagey. I shall pay the 5000 francs to the Government [on January 1], who insist on it. I have delegated Fumey and Blondon as well as Castagnary to handle these negotiations. I can no longer trouble my head about all this nonsense, I have had enough of it for five years." [15]

This was the last letter he ever wrote. He was failing rapidly: "He had a wild look in his eyes and his speech became inarticulate; one had to repeat what one said to him . . . and after the twenty-eighth he was tormented by hiccups recurring every few moments." [16] In spite of his own reassuring messages, reports of his extremely grave condition finally reached Flagey, and on December 29 his father hurriedly departed for La Tour-de-Peilz, stopping at Besançon on the way to obtain more specific information from Dr Blondon. "I have just packed my father off to La Tour," Juliette wrote to Blondon the same day. "I did not know he intended to pass through Besançon. . . . You know more about our dear patient's condition than I do, I do not understand how his malady can have made him, who was always so strong, so thin and weak in so few months. Is it possible that we must lose him? This thought, which grieves me and saps all my courage, is all the more painful to me because all our lives we had promised each other to remain together. The prospect which rises before me like an unsuspected obstruction will wreck my life." [17] Régis Courbet, arriving late on the twenty-ninth or early on the thirtieth, found his son sitting up but extremely weak: " 'Here, Gustave,' he said, 'I have brought you a little present. It is a dark lantern from our house.' And he added to that a pound of French tobacco. It made Courbet smile." [18]

His father sat with him all day, during the course of which Juliette joined them. The hours passed peacefully enough. At nightfall on December 30 Courbet summoned Dr Collin, complaining that "he had just felt a tearing sensation in his left side with excruciating pain in the abdomen; it was probably caused by the breaking of a cyst in the spleen. . . . He told me then: 'I don't think I shall live through the night.' . . . I applied poultices soaked in laudanum, but they were not enough to relieve the pain. He begged me to give him a subcutaneous injection in the affected area. By that time his eyes had become cavernous, his mouth dry and blackened. The hiccups continued. About half an hour after the injection of morphine he fell asleep. It was then approximately eight o'clock at night. Courbet woke up about ten and remained for some time in a state of somnolence. He spoke a few words, then lost consciousness. He began to sink about five in the morning. . . ." [19]

Shortly after six o'clock on the morning of December 31, 1877 Courbet died.

JULIETTE

An hour or two after Courbet's death Dr Collin telegraphed to Castagnary: "Gustave died six this morning see Duval immediately family has decided to pay nothing." [1] This referred to the first instalment of the indemnity, due the next day. Collin's letter followed promptly: "Poor Courbet breathed his last at six o'clock this morning without the slightest suffering. He died surrounded by his friends and by his old father, whom I had sent for. . . . I telegraphed you to ask you, at the family's request, to stop payment by M. Duval, although Courbet had written to him to pay the 5000 francs due on the first [of January]. I also telegraphed to M. Duval to countermand that payment." [2]

In the name of Courbet's family Morel sent a telegram to Louis Niquet, a refugee sculptor living in Geneva, to come to La Tour-de-Peilz to model a death-mask. Niquet arrived on January 2 and moulded the effigy, for which he refused the fee offered by Courbet's father, saying that he had been the painter's friend and hoped to earn a few francs from the sale of plaster copies of the mask. Some weeks later the sculptor, who was extremely poor, asked Régis Courbet to repay his actual expenses amounting to 272 francs; but the old man refused,

and Niquet was obliged to appeal to Dr Blondon to intervene in his behalf. Whether or not the intervention accomplished its purpose is unknown.

Régis Courbet wished his son's remains to be interred in France with the religious rites that the painter himself would certainly not have wanted. At first Juliette was inclined to agree, but later she changed her mind and wrote to Blondon: "My first thought was to bring my brother home, to his own country, but after considering the matter I feel that my brother does not belong to us exclusively. Switzerland has claims to him as well as France and his family. Gustave's wish was to be buried in Swiss soil until it could be ascertained whether or not France wanted him. . . . Our family owes a debt of gratitude to Switzerland, which offered hospitality to my brother in his adversity. . . . I am not considering my own preferences in this matter . . . but in this wish of Gustave's I feel a desire to . . . conciliate everyone. Gustave loved me very much, and his idea of a burial in Switzerland would give me an excuse to avoid a religious funeral; he expected me to see to that. I shall respect my brother's wishes and at the same time do no violence to my own religious convictions." [3]

The corpse was placed in a leaden casket encased in an outer coffin of oak so that it could be exhumed and subsequently transported to France. On January 3, 1878 Courbet was temporarily laid to rest in the mortuary of the cemetery at La Tour-de-Peilz. Pata described the funeral ceremony to Castagnary: "It commenced at half past eleven in the presence of at least five hundred people. The cortège arrived late because so many friends came from La Chaux-de-Fonds, Fribourg, Lausanne, Geneva, as well as the entire populations of Vevey, Montreux, and La Tour. The weather was perfect. A great many wanted to deliver speeches. M. Rochefort spoke first, but his tears choked him and he could not finish. Dr Blondon of Besançon came next, and he too was interrupted by the weeping of all those present. Later two speeches were made

by gentlemen of this region." [4] Régis Courbet, deciding after much hesitation to leave the body in Switzerland for some time at least, bought a plot in the graveyard, in which Courbet was buried on May 10. Slom designed a monument, a headstone of rough granite into which he set an oval plaque of marble inscribed with the painter's name and the dates of his birth and death. Surrounding the grave were eight truncated pyramids of granite linked by massive chains.

On May 8, 1878 the local authorities took an official inventory of Courbet's possessions at La Tour-de-Peilz. Among his papers the inspectors discovered a small unsealed envelope containing a photograph of the deceased painter, on the back of which was written:

> This is my testament.
> I bequeath all of my property to my sister Juliette.
> Written by my hand, Tour-de-Peilz, on the third of June one thousand eight hundred seventy-seven.
>
> <div align="right">G. COURBET.[5]</div>

Courbet had left nothing whatever to Zoé, which was not surprising in view of his many long-standing grievances against her. But in the autumn Juliette received a very strange document from Duval: a letter addressed to Duval from Lausanne, dated October 5, 1878 and signed "Philibert": "One day at Vevey I met the painter Courbet. He was terribly depressed. 'Anything might happen,' he said, 'I count on you. Promise me to carry out my wishes when the time comes and to pass them on to my solicitor in Paris, M. Duval, 189 rue Saint-Honoré. He knows about everything and will undertake to discharge my obligations.' He [Courbet] told me many things. Emotion overcame us both when he spoke to me of his sister Zoé, his brother-in-law Reverdy, and their children. We clasped hands. He asked me for paper and wrote what I am sending you. I think the moment has come. . . . In doing my

duty, I trust that you will do yours." [6] Enclosed in this letter was another will supposedly written by Courbet:

Vevey (Switzerland) .

This is my only testament:

I designate my sister Reverdy Jeanne-Thérèse-Zoé Courbet my sole heir.

Written by my hand.

Gustave Courbet, *painter.*

23 November 1877. [7]

In the margin was written: "Also my mother's house in the Iles-Basses at Ornans, which belongs to me. I acquired it by legal purchase [this was the house in which Courbet had installed his first studio in 1849, not the house in which he was born]." [8]

Duval wrote a covering letter to Juliette: "I send you a copy of a letter and a will that I received yesterday by post from Lausanne. I do not know this M. Philibert. I am writing to Mme Reverdy . . . and I am asking her as well as you what I should do about this will. I think somebody is trying to play a hoax." [9] Of course Juliette disputed the authenticity of this second will, and her attorney, Coulon, found it easy to convince the Besançon tribunal that it was a forgery, and an exceedingly transparent and amateurish forgery at that. The Reverdys were unable to produce the mysterious Philibert or even to establish his identity, for he had never existed except in the imagination of Zoé or her husband. Moreover, as Coulon pointed out, on the date of the alleged encounter at Vevey Courbet had been immobilized by illness at La Chaux-de-Fonds. On April 2, 1879 the court declared the second testament a fraud and confirmed the validity of the original will in Juliette's favour.

Juliette, who had always shared her brother's antipathy to Zoé, never forgave her sister for this bungling attempt to steal

her inheritance. For Juliette could be extremely harsh and stubborn when she chose, especially if money was involved, and her rancour continued without abatement even after it became obvious that Zoé had not for a long time been responsible for her actions. Zoé's mental instability increased very gradually, and it was not until June 29, 1888 that she was committed to an asylum at Saint-Ylie about two miles from Dôle. There she remained, hopelessly insane, for seventeen years, and there she died at the age of eighty-one on June 4, 1905.[10]

Juliette's resentment persisted after her unhappy sister's death. About 1911, in order to prevent the acquisition of any of the family properties by Zoé's descendants, she gave the house at Flagey and about fifty acres of land to a neighbour, Félix Bourgon, the present owner; and at the same time she distributed to other friends in the region the rest of her farmlands and vineyards. Nevertheless she apparently permitted one of Zoé's sons to serve as temporary curator of a Courbet museum which she proposed to establish, about 1909, in the painter's former studio at Ornans. Charles Léger reported in 1910: "I was received by M. Reverdy who is, in a way, the present curator of the museum. The installation . . . was not yet completed. . . . M. Reverdy played the host with enthusiasm; I found him modelling a bust of Courbet which seemed to be a striking likeness; he devotes his talent, all his talent, to the cult of the master he reveres." [11]

Courbet's nephew must have been then about forty years old. He was still at Ornans in 1922, when he was interviewed by another visitor: "I learnt that, of the Courbet family, there was, alone, a remaining nephew living at Ornans. . . . [Zoé] neglected her two sons, sending them to be reared by peasants and placing them later at a semi-charitable school. Her mind became totally unbalanced after the death of her husband and she died in the belief that he had been spirited away by her enemies. This son made an unfortunate marriage, which ended in a complete separation from wife and children. . . .

He returned to Ornans some twenty years ago [about 1900].
. . ." [12] Juliette abandoned the museum project a few years
before she died. Nothing was done to revive it until 1938,
when a society called Les Amis de Gustave Courbet was or-
ganized to perpetuate Courbet's memory and, if possible, to
purchase and install a museum in the house in which the
painter was born. The outbreak of World War II interrupted
the negotiations, and after the war the house was no longer
for sale. In 1947 a small museum was inaugurated in the Hôtel
de Ville at Ornans by the Amis de Gustave Courbet, whose
president, Robert Fernier, a painter and a native of Pontarlier,
is a grandson of the Jules-César Fernier who owned the Hôtel
des Voyageurs at La Vrine when Courbet passed through on
his way to Switzerland in 1873.

In November 1877 Juliette, knowing that Courbet might
die, had written to Dr Blondon: "I rely on you very much;
whatever happens, you are my brother's friend and will take
his place in our midst." [13] Courbet had hoped that his favour-
ite sister would marry the doctor, and for some time it seemed
that his wish might come true. For five years after the painter's
death Blondon devoted his time unsparingly to Juliette's in-
terests, dealing with lawyers and functionaries, helping with
inventories, attending to innumerable business matters con-
nected with Courbet's estate. At first Juliette rewarded his
loyalty with sincere gratitude and affection, but in the end she
turned on him and accused him, apparently without justifica-
tion, of embezzlement. Dr Blondon died in poverty at Besan-
çon in 1906.

Republican opposition forced Mac-Mahon to resign on Jan-
uary 30, 1879, when he was succeeded by the liberal president
Jules Grévy. One of the first acts of the new Government was
to grant an amnesty on March 3 to all former members of the
Commune. By a supplementary decree of August 14, 1880 the
state abandoned its claims to compensation from those who,

like Courbet, had been condemned to pay fines or damages. Juliette, who had refused to pay any instalments on Courbet's indemnity after his death, received an official notice: "I have the honour to inform you that . . . the minister of Finance has decreed that the Public Domain will not prosecute the heirs of M. Courbet . . . for recovery of the civil assessments levied upon him . . . which are considered cancelled by the amnesty. As to the pictures and other property sequestrated by the prefecture of the Doubs . . . you and your co-heirs are at liberty to regain possession of them. . . ." [14] But the state did not return the sums previously collected by confiscation and forced sales.

Old Régis Courbet died at Flagey on May 28, 1882, aged eighty-four, and was buried in the churchyard of the neighbouring village of Chantrans. Juliette moved to Paris, where as the years passed she became more and more of a "character" and indulged in all the eccentricities of aged spinsterhood. She wore outmoded dresses and fantastic hats which she had saved for years, and claimed to have been engaged at various times to seven different men, photographs of whom she displayed on one table. She made a cult of her brother's memory, filling her apartment in the rue de Vaugirard with souvenirs and bric-à-brac that reminded her of him. To a certain extent she appeared to identify herself with Courbet, almost as if she had lived his life and painted his pictures herself.[15] She died in Paris in 1915 at the age of eighty-four.

Courbet's body remained in its temporary grave at La Tour-de-Peilz for more than forty years. In June 1919, the centenary of the painter's birth, Juliette's heirs Mme Lapierre and Mme de Tastes, in accordance with Juliette's last wish, had his corpse exhumed and reburied at Ornans. At the same time Slom's original monument and boundary stones (Plate 3) were transported from Switzerland to the Ornans cemetery to mark the final resting place of Gustave Courbet.

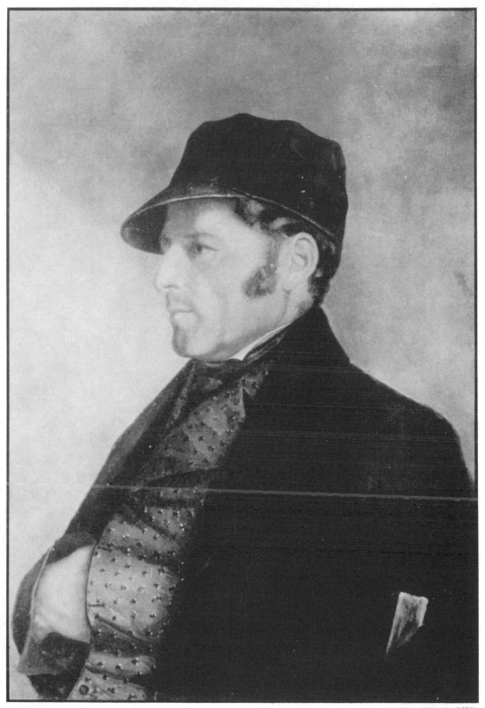

1. PORTRAIT OF REGIS COURBET

ABOUT 1842. PETIT PALAIS, PARIS

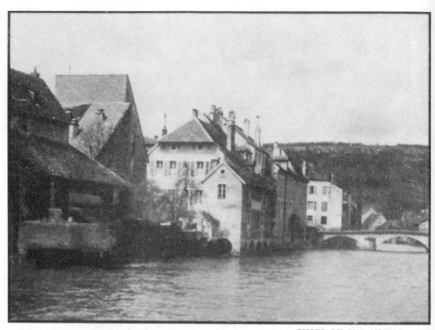

2. THE HOUSE IN WHICH COURBET
WAS BORN, ORNANS

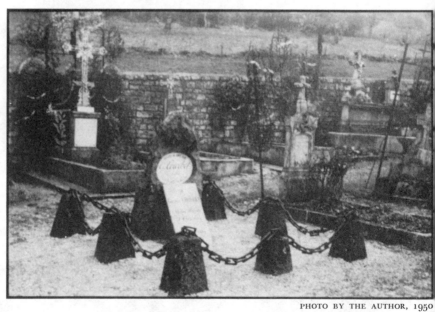

3. COURBET'S GRAVE, ORNANS

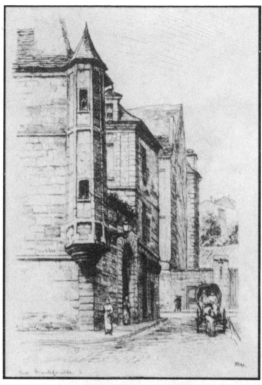

4. COURBET'S STUDIO
AT 32 RUE HAUTE–
FEUILLE, PARIS

FROM AN ETCHING BY A.-P.
MARTIAL IN *Gustave Courbet*
BY COMTE H. D'IDEVILLE

5. [*below*] COURBET'S
STUDIO, ORNANS

PHOTO BY THE AUTHOR, 1950

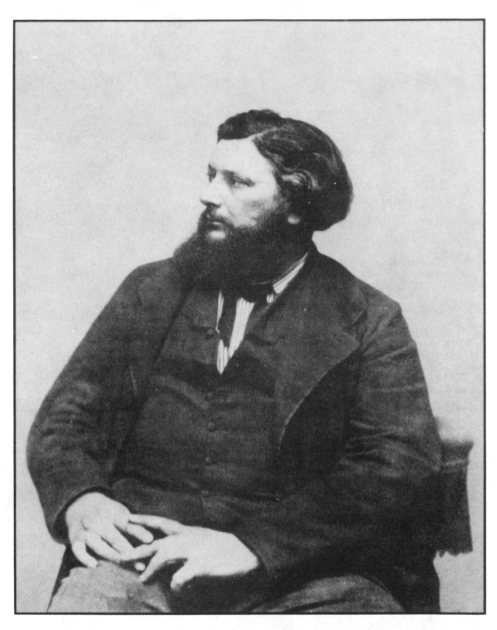

6. A PHOTOGRAPH OF GUSTAVE COURBET

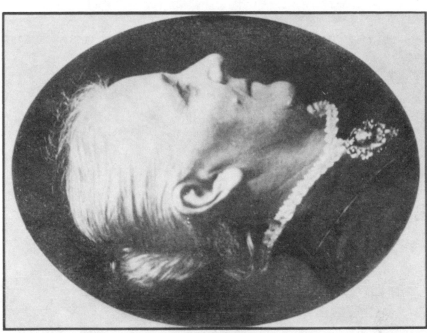

7. PORTRAIT OF JULIETTE COURBET

ABOUT 1844. PETIT PALAIS, PARIS

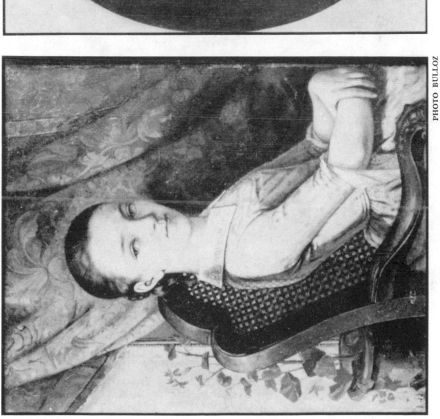

8. A PHOTOGRAPH OF JULIETTE
COURBET IN MIDDLE AGE

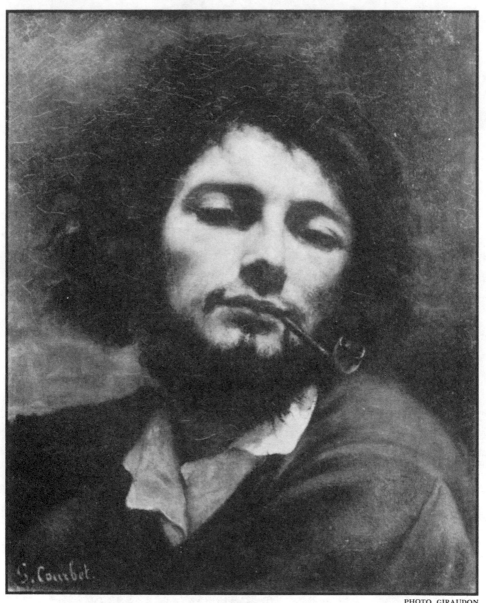

9. THE MAN WITH THE PIPE

ABOUT 1846. MUSÉE FABRE, MONTPELLIER

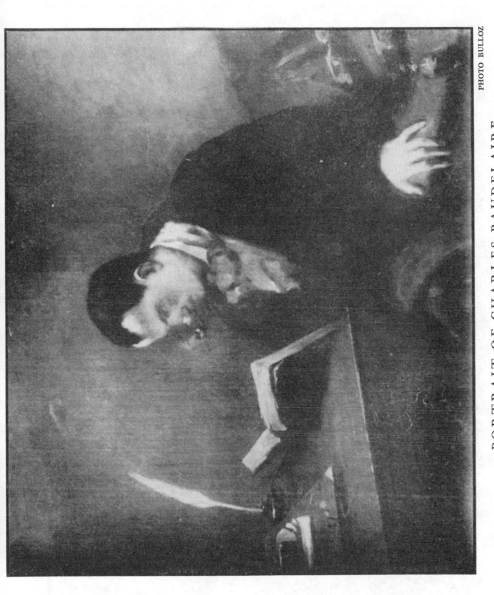

10. PORTRAIT OF CHARLES BAUDELAIRE

ABOUT 1848. MUSÉE FABRE, MONTPELLIER

11. AFTER DINNER AT ORNANS
1849. PALAIS DES BEAUX-ARTS, LILLE

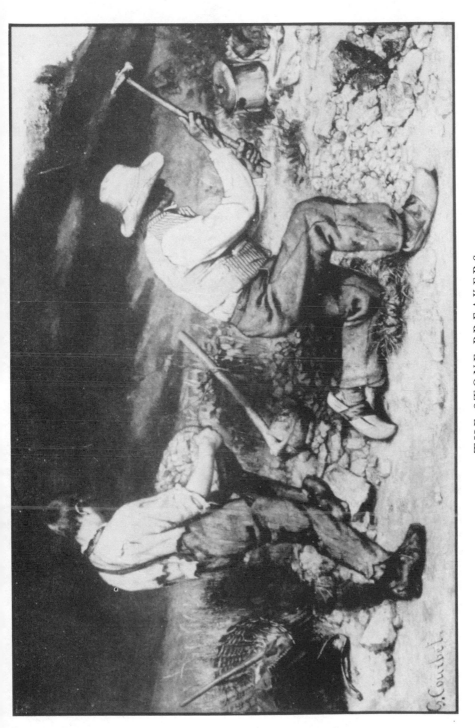

12. THE STONE BREAKERS

1850. FORMERLY IN KUNSTMUSEUM, DRESDEN.

PRESENT LOCATION UNKNOWN

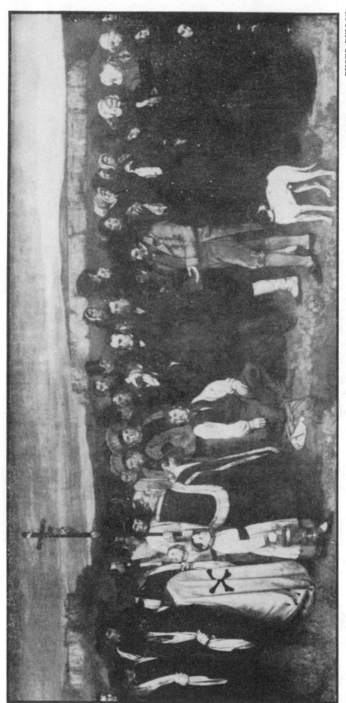

13. BURIAL AT ORNANS
1850. LOUVRE, PARIS

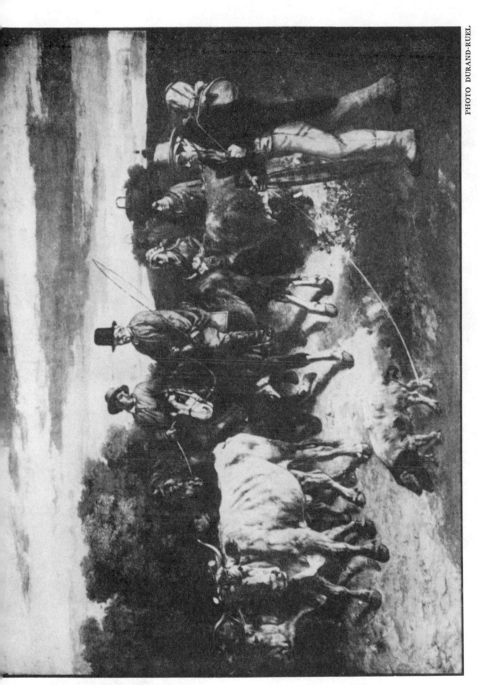

14. PEASANTS OF FLAGEY RETURNING FROM
THE FAIR
1850. PRIVATE COLLECTION

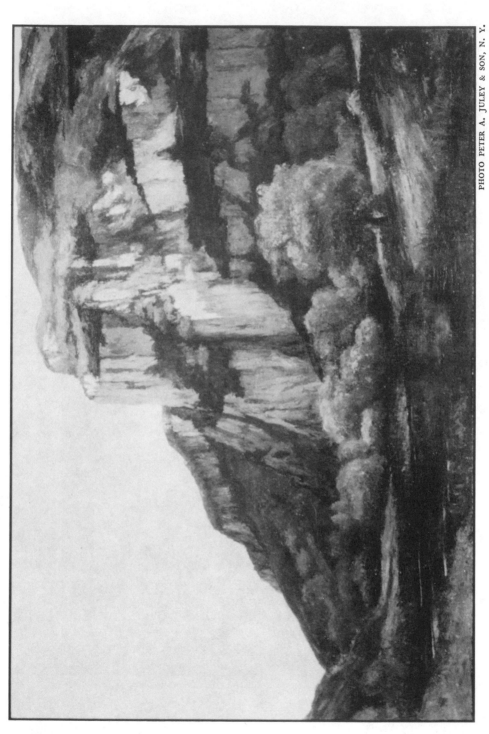

15. ROCKS AT ORNANS

ABOUT 1850. PHILLIPS COLLECTION, WASHINGTON, D. C.

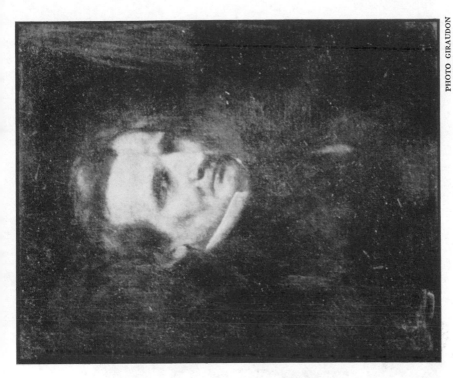

17. PORTRAIT OF HECTOR BERLIOZ

1850. LOUVRE, PARIS

16. PORTRAIT OF ALPHONSE
PROMAYET

ABOUT 1851. METROPOLITAN
MUSEUM OF ART, NEW YORK

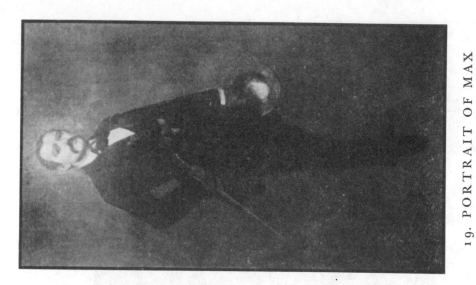

19. PORTRAIT OF MAX
BUCHON

ABOUT 1866. MUSÉE JÉNISCH,
VEVEY

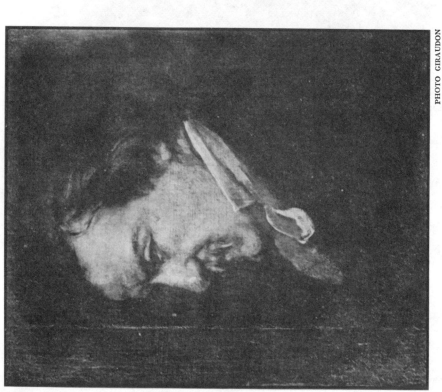

18. PORTRAIT OF CHAMPFLEURY
1853. LOUVRE, PARIS

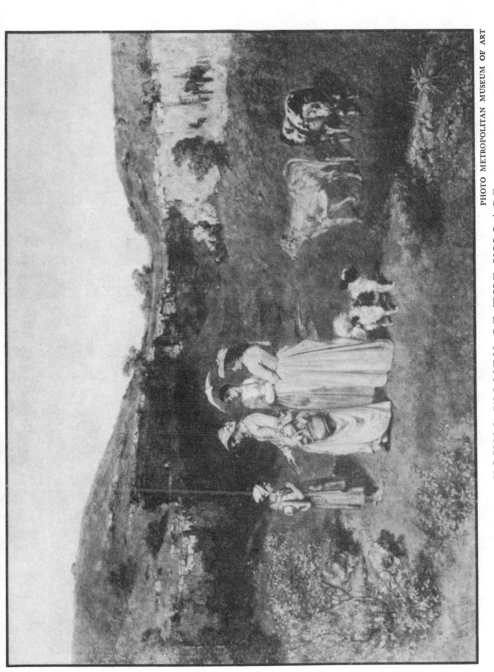

20. YOUNG WOMEN OF THE VILLAGE

1851–1852. METROPOLITAN MUSEUM OF ART, NEW YORK

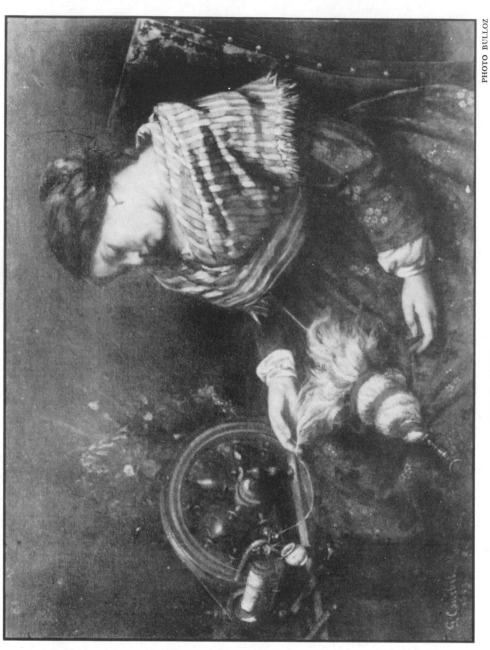

21. THE SLEEPING SPINNER

1853. MUSÉE FABRE, MONTPELLIER

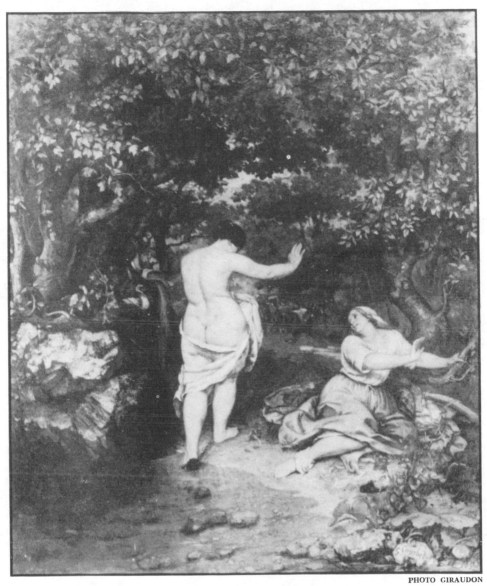

22. THE BATHERS

1853. MUSÉE FABRE, MONTPELLIER

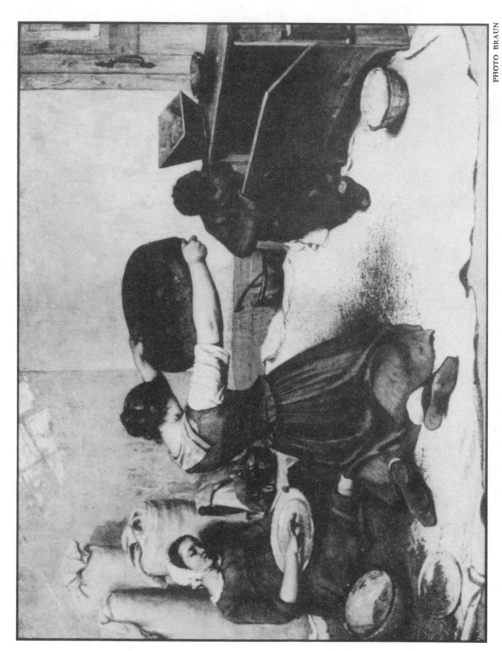

23. THE WINNOWERS

1854. MUSÉE DES BEAUX-ARTS, NANTES

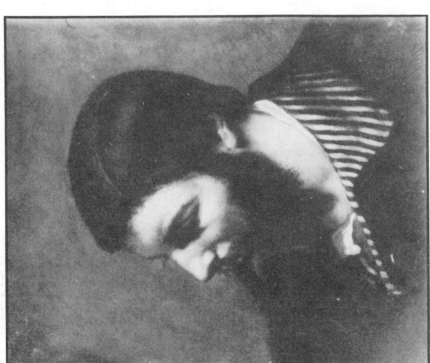

25. COURBET IN A STRIPED COLLAR

1854. MUSÉE FABRE, MONTPELLIER

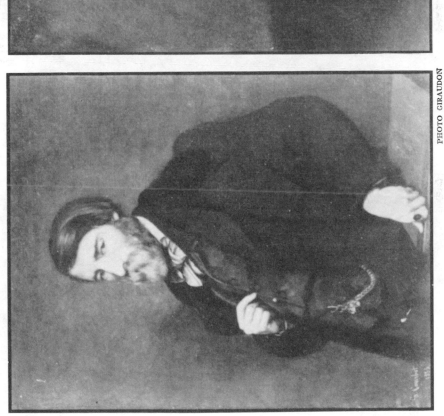

24. PORTRAIT OF ALFRED BRUYAS

1853. MUSÉE FABRE, MONTPELLIER

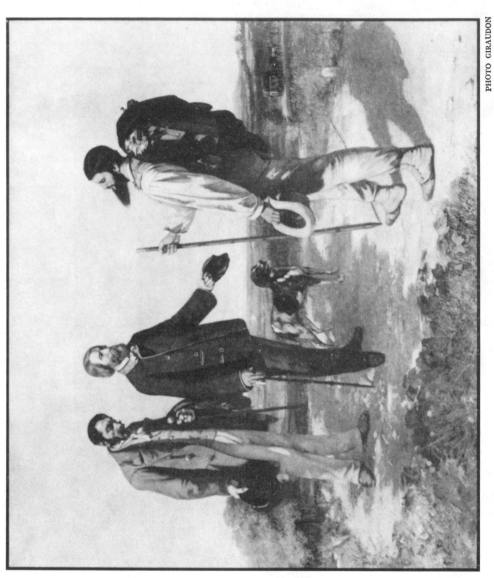

26. THE MEETING

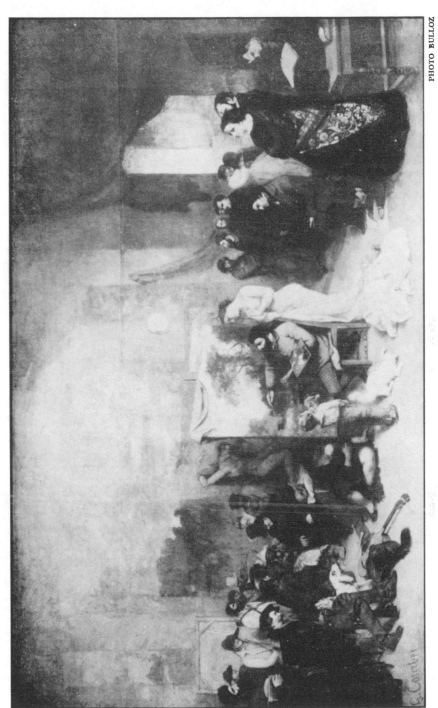

27. THE ATELIER
1855. LOUVRE, PARIS

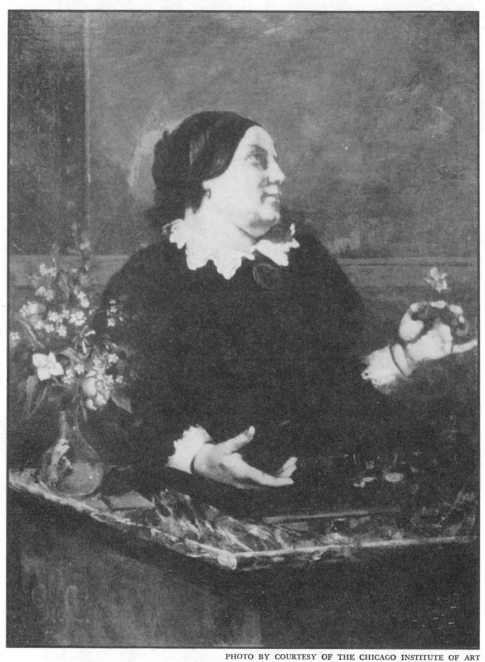

28. MERE GREGOIRE

ABOUT 1855. CHICAGO INSTITUTE OF ART, CHICAGO

29. DOE LYING EXHAUSTED IN THE SNOW

1857. PRIVATE COLLECTION

30. YOUNG WOMEN ON THE BANKS OF THE SEINE

1857. PETIT PALAIS, PARIS

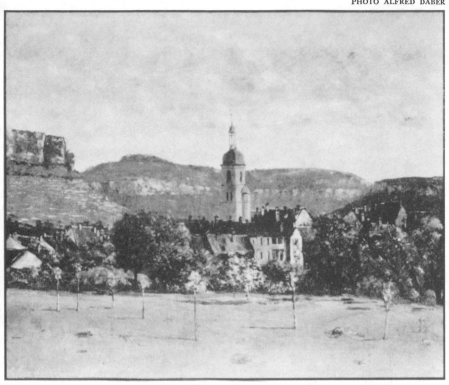

31. VIEW OF ORNANS
ABOUT 1858. PRIVATE COLLECTION

32. VIEW OF ORNANS
FROM A PHOTOGRAPH

33. FIGHTING STAGS

1859. LOUVRE, PARIS

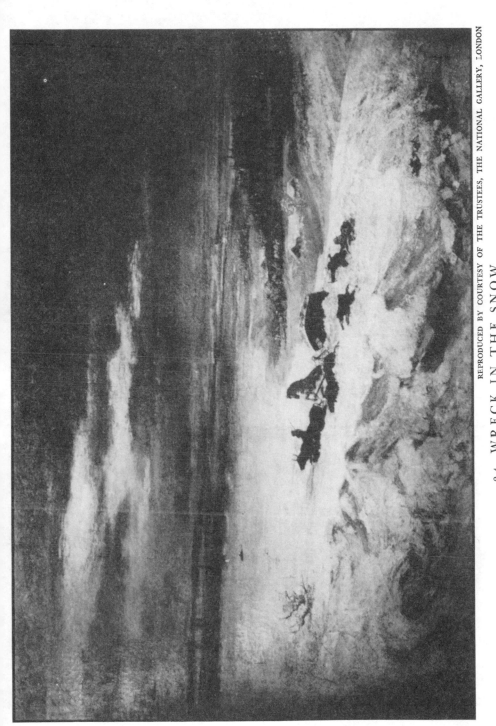

34. WRECK IN THE SNOW

1860. NATIONAL GALLERY, LONDON

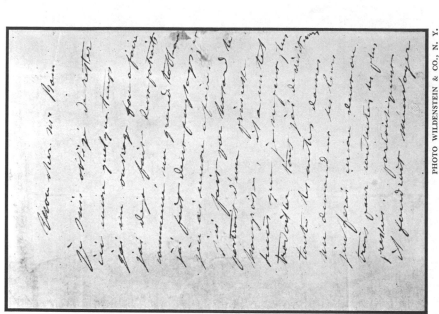

36. FIRST PAGE OF LETTER
WRITTEN BY COURBET AT
TROUVILLE, 8 SEPTEMBER 1865
FROM THE ORIGINAL LETTER OWNED
BY MR JOHN REWALD, NEW YORK

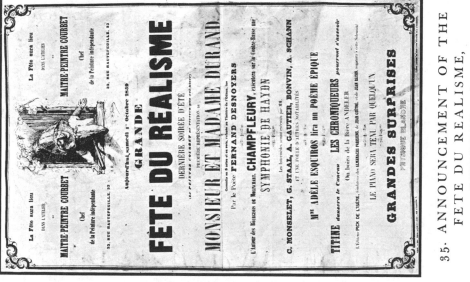

35. ANNOUNCEMENT OF THE
FÊTE DU RÉALISME,
1 OCTOBER 1859
FROM AN ORIGINAL IN THE BIBLIO-
THÈQUE NATIONALE, PARIS

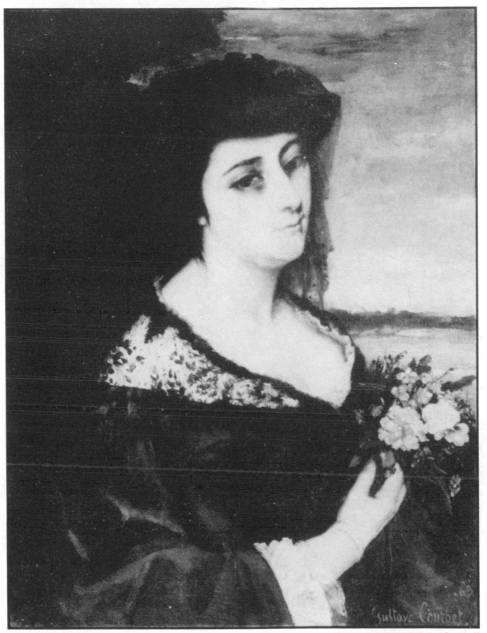

37. PORTRAIT OF MADAME BOREAU

1863. PAUL ROSENBERG AND COMPANY, NEW YORK

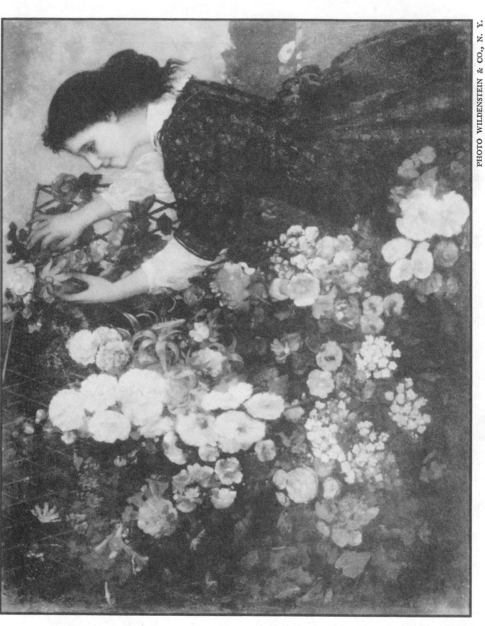

PHOTO WILDENSTEIN & CO., N. Y.

38. THE TRELLIS

1862–1863. TOLEDO MUSEUM OF ART, TOLEDO, OHIO

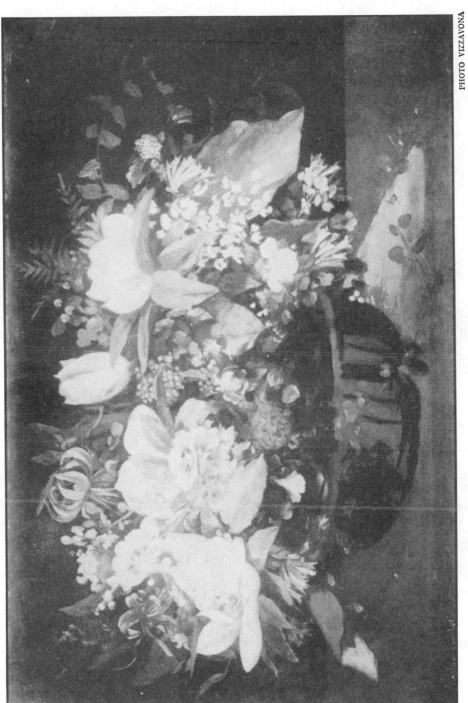

39. MAGNOLIAS AND OTHER FLOWERS
1862. PRIVATE COLLECTION

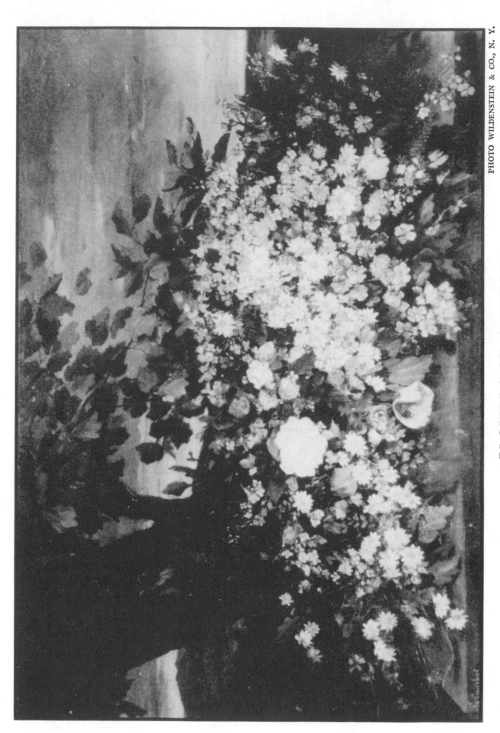

40. FLOWERS ON A BENCH

1862. PRIVATE COLLECTION

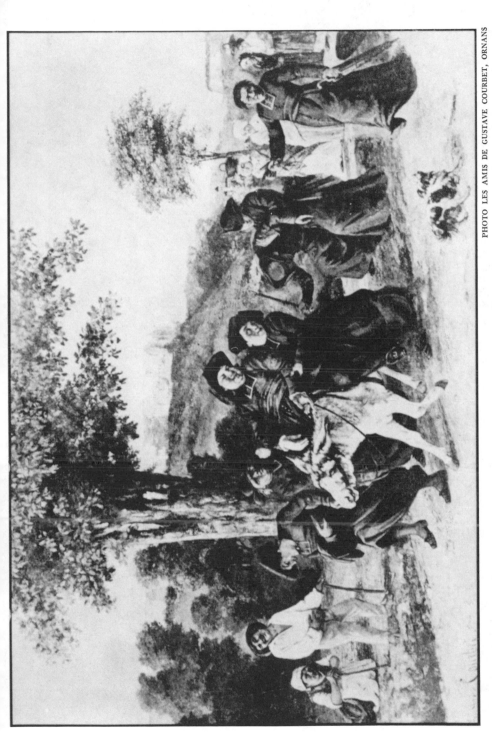

41. RETURN FROM THE CONFERENCE

1863. PAINTING DESTROYED

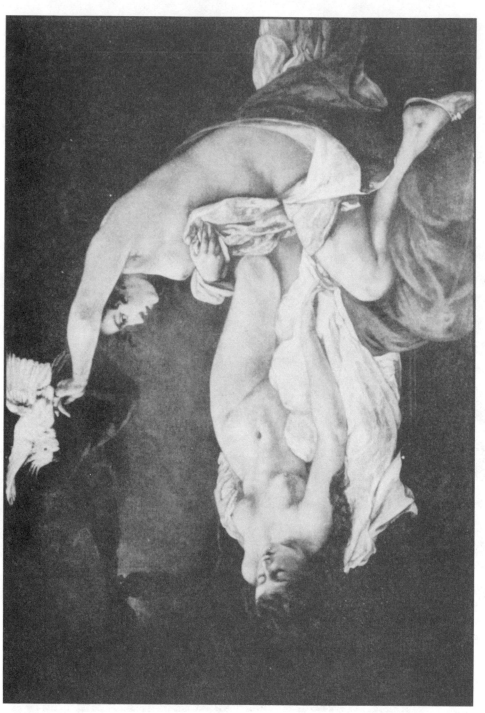

42. VENUS AND PSYCHE (THE AWAKENING)
1864. PRIVATE COLLECTION

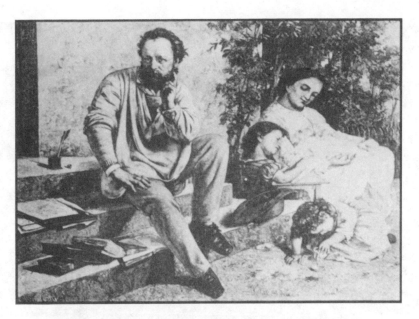

43. PROUDHON AND HIS FAMILY
1865. ORIGINAL VERSION

44. PROUDHON AND HIS FAMILY
1865–1866. EXISTING VERSION. PETIT PALAIS, PARIS

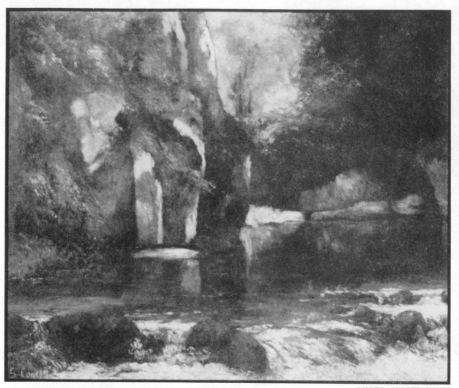

45. RIVULET OF THE PUITS NOIR
1865. ALFRED DABER COLLECTION, PARIS

46. RIVULET OF THE PUITS NOIR
FROM A PHOTOGRAPH

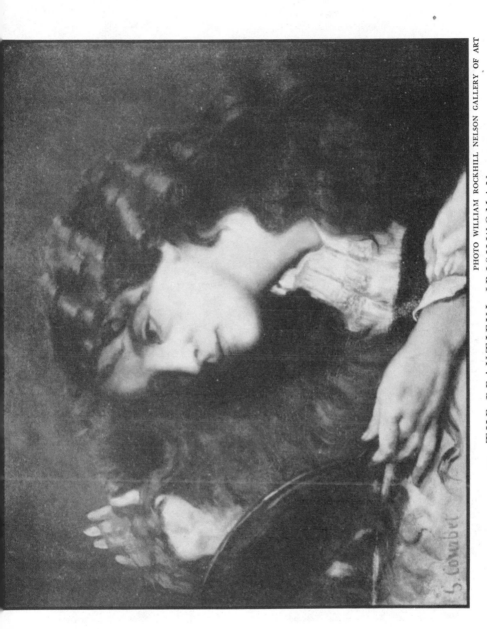

47. THE BEAUTIFUL IRISHWOMAN

1855. WILLIAM ROCKHILL NELSON GALLERY OF ART,

KANSAS CITY

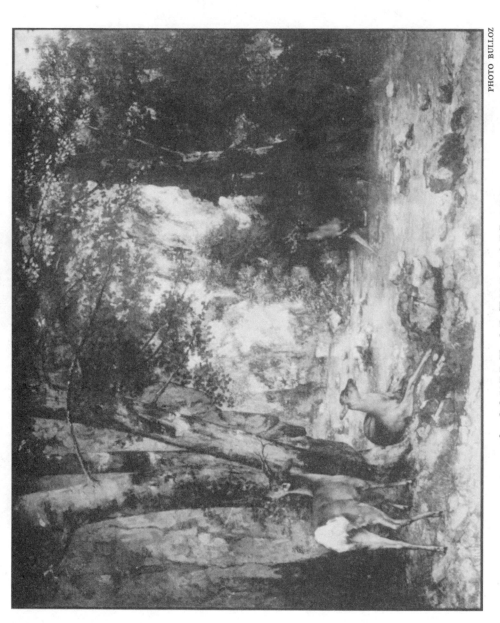

48. COVERT OF THE ROEDEER

1866. LOUVRE, PARIS

49. SIESTA

1867. PETIT PALAIS, PARIS

50. HALLALI DU CERF
1867. MUSÉE, BESANÇON

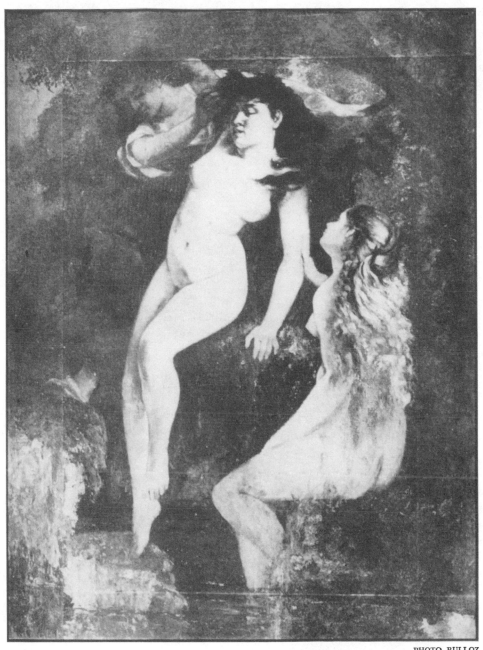

51. THE THREE BATHERS

1868. PETIT PALAIS, PARIS

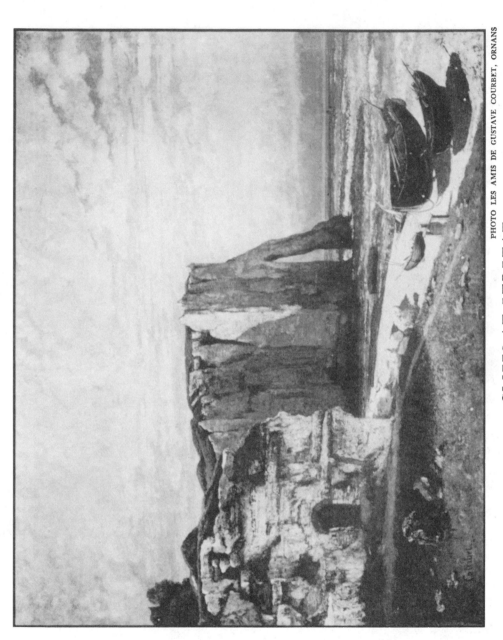

52. CLIFFS AT ETRETAT

1869. LOUVRE, PARIS

53. STORMY SEA
1869. LOUVRE, PARIS

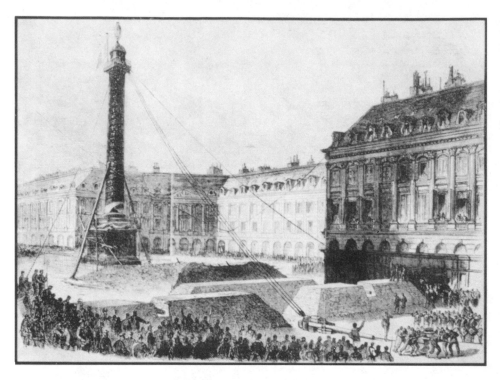

54. DEMOLITION OF THE VENDOME COLUMN,
16 MAY 1871
FROM AN ENGRAVING IN *L'Illustration,* 27 MAY 1871

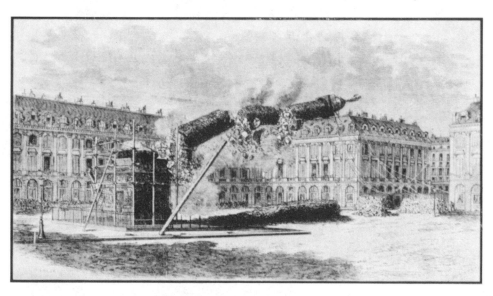

55. DEMOLITION OF THE VENDOME COLUMN,
16 MAY 1871
FROM AN ENGRAVING IN *L'Illustration,* 27 MAY 1871

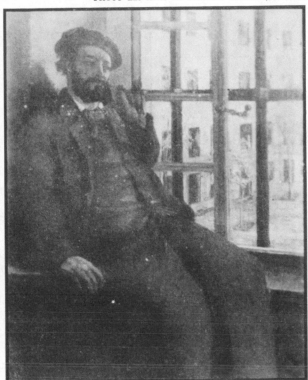

56. COURBET IN
SAINTE–PELAGIE
ABOUT 1871. MUSÉE,
ORNANS

57. [below] APPLES AND
POMEGRANATE
IN A BOWL
1871. NATIONAL GAL-
LERY, LONDON

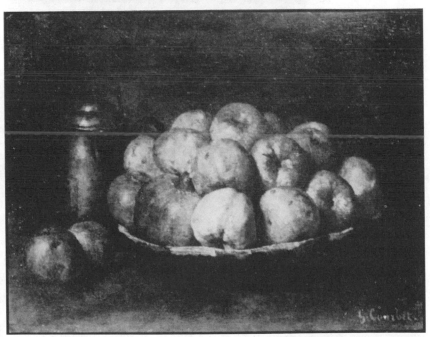

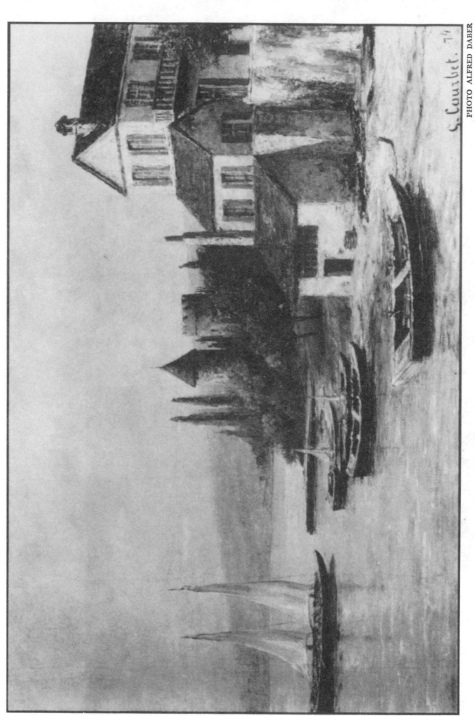

G. Courbet. 74

58. BON-PORT, LA TOUR–DE–PEILZ

1874. PRIVATE COLLECTION

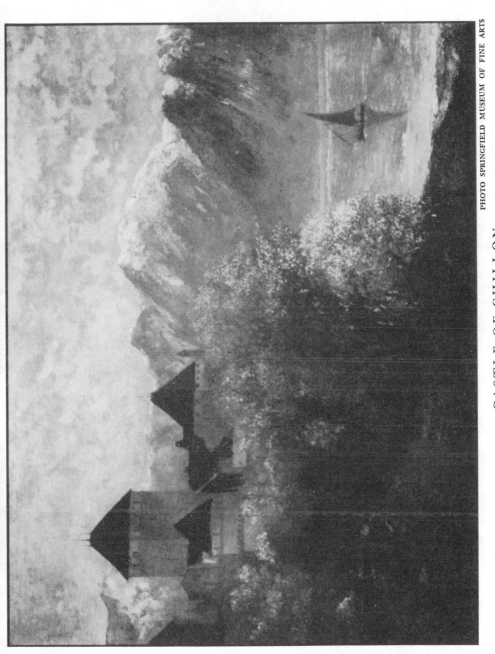

59. CASTLE OF CHILLON

1873. SPRINGFIELD MUSEUM OF FINE ARTS, SPRINGFIELD, MASSACHUSETTS

6o. A PHOTOGRAPH OF GUSTAVE COURBET
AT LA CHAUX–DE–FONDS

REFERENCE NOTES

THE most frequently used references are indicated by initials, as follows:

BOR Borel, Pierre: *Le Roman de Gustave Courbet.* E. Sansot (R. Chiberre, *succr.*), Paris; 1922. (2nd edition).

CD Courbet Documents. A collection of letters, notes, newspaper cuttings, and miscellaneous documents by or concerning Courbet, in the Salle des Estampes, Bibliothèque Nationale, Paris. These papers are kept in seven boxes numbered 1 to 7. Boxes 3, 4, and 5 contain an unfinished and unpublished biography of Courbet by Castagnary, in MS., and notes for the same.

CHA "Lettres inédites de Champfleury au poète franc-comtois Max Buchon." *La Revue Mondiale* (Paris), vol. 105 (November–December 1913), pp. 30–49, 213–30; vol. 133 (October–December 1919), pp. 531–45, 701–10.

COU Courthion, Pierre: *Courbet raconté par lui-même et par ses amis.* Vol. 1: *Sa Vie et ses œuvres;* 1948. Vol. 2: *Ses Ecrits, ses contemporains, sa postérité;* 1950. Pierre Cailler, Geneva. Reprints of some of the documents in **CD** and of documents from other sources.

OL "Lettres inédites de quelques peintres. Gustave Courbet." *L'Olivier. Revue de Nice* (Nice), *année* 2, no. 8 (September–October 1913), pp. 468–512. Reprinted, with minor textual variations, in **BOR**.

RI Riat, Georges: *Gustave Courbet, peintre.* H. Floury, Paris; 1906.

367

REFERENCE NOTES

CHAPTER I

ORNANS

1. Original in Courbet Museum, Ornans. Copy in **CD**, box 3. Printed in **COU**, vol. 1, p. 347.

2. Castagnary, Jules-Antoine: "Fragments d'un livre sur Courbet." *Gazette des Beaux-Arts* (Paris), *année 53, période 4,* vol. 5, no. 643 (January 1911), p. 8.

3. Léger, Charles: *Courbet,* p. 5. G. Crès et Cie., Paris; 1929.

4. Wey, Francis: *Extrait des mémoires inédits de feu Francis Wey. Notre maître-peintre G. Courbet,* p. 22. MS. in Salle des Estampes, Bibliothèque Nationale.

5. **CD**, box 3.

6. Champfleury: *Les Demoiselles Tourangeau,* pp. 3–4. Michel Lévy Frères, Paris; 1864.

7. *Ibid.,* p. 2.

8. *Ibid.,* pp. 4–5.

9. *Ibid.,* pp. 5–6, 9–10.

10. François-Julien Oudot to Courbet family, Paris, 7 January 1830. **RI**, pp. 3–4.

11. Mme François-Julien Oudot to Courbet family, Paris, 7 January 1830. **RI**, p. 4.

12. Buchon to Castagnary, 20 February, 1866. **CD**, box 1. Printed in **COU**, vol. 1, pp. 206–7.

13. Ordinaire to Castagnary, Vevey, 26 January 1874. **CD**, box 2.

14. **CD**, box 3.

15. Courthion, Pierre: *Courbet,* p. 63. H. Floury, Paris; 1931.

16. Gros-Kost, E.: *Gustave Courbet. Souvenirs intimes,* p. 25. Derveaux, Paris; 1880.

17. *Petit Comtois* (Besançon), 13 January 1897.

18. Ideville, H. d': *Gustave Courbet. Notes et documents sur sa vie et son œuvre,* p. 5. Paris-Gravé, Paris; 1878.

CHAPTER II

BESANÇON

1. Courbet to his family, Besançon, undated. **RI**, p. 6.
2. *Ibid.*
3. *Ibid.*
4. *Ibid.*
5. *Ibid.*
6. *Ibid.*
7. Courbet to his family, Besançon, undated. **RI**, p. 7.
8. *Ibid.*
9. *Ibid.*
10. Courbet to his family, Besançon, undated. **RI**, pp. 7–8.
11. Courbet to his family, Besançon, 4 December 1837. **RI**, p. 8.
12. Courbet to his family, Besançon, 9 December 1837. Léger, Charles: *Courbet,* pp. 21–3. G. Crès et Cie., Paris; 1929.
13. Courbet to his family, Besançon, 5 January 1838. **RI**, p. 8.
14. Courbet to his family, Besançon, undated. **RI**, p. 9.
15. Léger, Charles: *Courbet,* p. 23. G. Crès et Cie., Paris; 1929.
16. Castagnary, Jules-Antoine: "Fragments d'un livre sur Courbet." *Gazette des Beaux-Arts* (Paris), *année* 53, *période* 4, vol. 5, no. 643 (January 1911), p. 17.
17. *Ibid.*, p. 17.
18. Wey, Francis: *Extrait des mémoires inédits de feu Francis Wey. Notre maître-peintre G. Courbet,* pp. 12–13. MS. in Salle des Estampes, Bibliothèque Nationale.
19. Courbet to his family, Besançon, undated. **RI**, pp. 9–10.
20. Castagnary, Jules-Antoine: Article in *L'Opinion Nationale* (Paris), 19 May 1860.
21. Léger, Charles: *Courbet,* pp. 17, 19–20. G. Crès et Cie., Paris; 1929.
22. Castagnary, Jules-Antoine: "Fragments d'un livre sur Courbet." *Gazette des Beaux-Arts* (Paris), *année* 53, *période* 4, vol. 5, no. 643 (January 1911), pp. 18–20.

REFERENCE NOTES

CHAPTER III

PARIS

1. Courbet to his family, Paris, undated. **RI**, p. 24.
2. Courbet to his family, Paris, 24 December 1842. **RI**, p. 24.
3. *Ibid.* **RI**, p. 25.
4. **CD**, box 3. Printed in **COU**, vol. 1, pp. 142–3.
5. Panier to Régis Courbet, Paris, 20 August 1842. **RI**, p. 23.
6. François-Julien Oudot to Courbet family, Paris, 18 December 1842. **RI**, p. 24.
7. Schanne, Alexandre-Louis: *Souvenirs de Schaunard,* p. 288. Charpentier, Paris; 1886.
8. Courbet to his family, Paris, 21 February 1844. **RI**, p. 29.
9. Courbet to his family, Paris, undated. **RI**, p. 26.
10. Courbet to his family, Paris, undated. **RI**, p. 26.
11. Courbet to his family, Paris, 21 February 1844. **RI**, p. 26.
12. **RI**, p. 27.
13. Courbet to his family, Paris, undated, **RI**, p. 28.

CHAPTER IV

THE SALON

1. Courbet to his family, 1841. **COU**, vol. 2, pp. 70–1.
2. Courbet to his family, Paris, May 1842. **RI**, p. 34.
3. Courbet to his family, Paris, 21 February 1844. **RI**, pp. 28–30.
4. Courbet to his family, Paris, March 1844. **RI**, p. 33.
5. Courbet to Jean-Antoine Oudot, Paris, undated. **RI**, p. 33.
6. *Ibid.* **RI**, p. 34.
7. Courbet to his family, Paris, February 1845. **RI**, pp. 35–6.
8. Courbet to his family, Paris, March 1845. **RI**, p. 36.
9. Courbet to his family, Paris, December 1844. **RI**, p. 34.
10. Courbet to his family, Paris, March 1845. **RI**, pp. 38–9.
11. *Ibid.* **RI**, pp. 39–40.
12. Courbet to his family, Paris, January 1846. **RI**, p. 42.

13. Courbet to his family, Paris, March 1846. **RI**, p. 43.
14. Courbet to his family, Paris, 23 March 1847. **RI**, p. 45.
15. Courbet to his family, Paris, March 1847. **RI**, p. 46.
16. Courbet to his family, Amsterdam, 1847. Léger, Charles: *Courbet,* p. 37. G. Crès et Cie., Paris; 1929.
17. Courbet to Comte H. d'Ideville, La Tour-de-Peilz, 29 August 1876. Ideville, H. d': *Gustave Courbet. Notes et documents sur sa vie et son œuvre,* p. 84. Paris-Gravé, Paris; 1878.
18. Schanne, Alexandre-Louis: *Souvenirs de Schaunard,* p. 106. Charpentier, Paris; 1886.
19. Courbet to his family, Paris, January 1848. **CD**, box 1.
20. Hawke to Courbet, Dinan, 18 May 1849. **CD**, box 1.

CHAPTER V

REVOLUTION

1. Courbet to his family, Paris, undated. **RI**, p. 47.
2. Courbet to his family, Paris, 26 June 1848. **RI**, p. 50.
3. Vandérem, Fernand: *Charles Baudelaire. Le Salut Public. Reproduction en fac-similé, avec une préface de Fernand Vandérem.* Paris (no d.).
4. *Ibid.*
5. Gros-Kost, E.: *Gustave Courbet. Souvenirs intimes,* p. 31. Derveaux, Paris; 1880.
6. Champfleury: *Souvenirs et portraits de jeunesse,* p. 135. E. Dentu, Paris; 1872.
7. *Ibid.,* p. 135.
8. Courbet to his family, Paris, 17 April 1848. **RI**, p. 53.
9. Courbet to Castagnary, Salins, 16 December 1869. **CD**, box 2. Printed in **COU**, vol. 2, pp. 116–18.
10. Courbet to Wey, Ornans, January 1852. **RI**, p. 100.
11. Cuénot to Juliette Courbet, Paris, 13 February 1851. **CD**, box 3. Printed in **COU**, vol. 1, p. 98.
12. Courbet to ?, Ornans, 19 November 1851. **RI**, p. 94.
13. Duret, Théodore: *Les Peintres français en 1867,* p. 92. E. Dentu, Paris; 1867.
14. Hugo, Victor: *Choses vues,* p. 258. J. Hetzel et Cie., Paris; 1887.

15. Les Amis de Gustave Courbet: *Bulletin,* no. 2, p. 16. Paris-Ornans; 1947.
16. Thoré, Théophile: *Salons de W. Bürger, 1861 à 1868,* vol. 2, p. 277. Veuve Jules Renouard, Paris; 1870.

CHAPTER VI

BRASSERIE ANDLER

1. Schanne, Alexandre-Louis: *Souvenirs de Schaunard,* p. 295. Charpentier, Paris; 1886.
2. Champfleury: *Souvenirs et portraits de jeunesse,* p. 186. E. Dentu, Paris; 1872.
3. **CD**, box 3. Printed (in part) in **COU**, vol. 1, pp. 150–2.
4. **CD**, box 3. Printed in **COU**, vol. 1, p. 154.
5. Silvestre, Théophile: *Les Artistes français. Etudes d'après nature,* p. 68. Office de Publicité, Brussels, and August Schnee, Leipzig; 1861. Reprinted in **COU**, vol. 1, p. 58.
6. Schanne, Alexandre-Louis: *Souvenirs de Schaunard,* p. 296. Charpentier, Paris; 1886.
7. Andler to Courbet, Paris, 17 January 1865. **CD**, box 1.
8. Andler to Courbet, Courbevoie, 7 September 1865. **CD**, box 1.
9. Courbet to Chaudey, Paris, 8 July 1868. **CD**, box 1.
10. Chaudey to Courbet, Paris, 22 December 1868. **CD**, box 1.
11. Chaudey to Courbet, Paris, 16 April 1869. **CD**, box 2.

CHAPTER VII

ACHIEVEMENT

1. Wey, Francis: *Extrait des mémoires inédits de feu Francis Wey. Notre maître-peintre G. Courbet,* pp. 2–3. MS. in Salle des Estampes, Bibliothèque Nationale. Printed in **COU**, vol. 2, p. 184.
2. Huyghe, René (and others): *Courbet. L'Atelier du peintre, allégorie réelle, 1855,* p. 16. Plon, Paris; 1944.
3. Schanne, Alexandre-Louis: *Souvenirs de Schaunard,* p. 293. Charpentier, Paris; 1886.
4. **RI**, p. 63.

5. Wey, Francis: *Extrait des mémoires inédits de feu Francis Wey. Notre maître-peintre G. Courbet*, pp. 6–7. MS. in Salle des Estampes, Bibliothèque Nationale. Printed in **COU**, vol. 2, p. 189.

6. **RI**, p. 72.

7. Courbet to Wey, Ornans, 30 October 1849. **RI**, p. 73.

8. Courbet to Wey, Ornans, 26 November 1849. Wey, Francis: *Extrait des mémoires inédits de feu Francis Wey. Notre maître-peintre G. Courbet*, pp. 17–18. MS. in Salle des Estampes, Bibliothèque Nationale. Printed in **COU**, vol. 2, pp. 75–6.

9. Proudhon, Pierre-Joseph: *Du Principe de l'art et de sa destination sociale*, pp. 236–7. Garnier Frères, Paris; 1865.

10. Ideville, H. d': *Gustave Courbet. Notes et documents sur sa vie et son œuvre*, pp. 37–8. Paris-Gravé, Paris; 1878.

11. Courbet to Wey, Ornans, 10 March 1850. **RI**, p. 80.

12. Courbet to (?Wey), Ornans, undated. **RI**, p. 82.

13. Courbet to Buchon, undated. **RI**, p. 82.

14. Courbet to Bruyas, Ornans, undated. **OL**, p. 483; **BOR**, p. 42.

15. Duret, Théodore: *Courbet*, p. 136. Bernheim-Jeune et Cie., Paris; 1918.

16. Wey, Francis: *Extrait des mémoires inédits de feu Francis Wey. Notre maître-peintre G. Courbet*, pp. 9–10. MS. in Salle des Estampes, Bibliothèque Nationale. Printed in **COU**, vol. 2, p. 192.

CHAPTER VIII

BURIAL AT ORNANS

1. Duret, Théodore: *Courbet*, p. 32. Bernheim-Jeune et Cie., Paris; 1918.

2. Courbet to Champfleury, Ornans, undated. Champfleury: *Souvenirs et portraits de jeunesse*, pp. 174–5. E. Dentu, Paris; 1872.

3. Champfleury: *Grandes figures d'hier et d'aujourd'hui*, pp. 236–7, 239. Poulet-Malassis et De Broise, Paris; 1861.

4. Courbet to Champfleury, Ornans, undated. **RI**, p. 95.

5. Champfleury to Buchon, Paris, 6 September 1852. **CHA**, vol. 105 (November–December 1913), p. 42.

6. Estignard, A.: *G. Courbet. Sa Vie et ses œuvres*, p. 193. Delagrange et Magnus, Besançon; 1897.

7. Collin to Lemonnier, La Tour-de-Peilz, 31 December 1877. Le-

monnier, Camille: *G. Courbet et son œuvre,* pp. 87–8. Alphonse Lemerre, Paris; 1878.

8. Gros-Kost, E.: *Gustave Courbet. Souvenirs intimes,* pp. 68–9. Derveaux, Paris; 1880.

9. **CD,** box 3. Printed in **COU,** vol. 1, p. 110.

10. Courbet to Champfleury, Ornans, undated. **RI,** pp. 94–5.

11. Lydie Joliclec to ?, 1883. Bauzon, Louis: "Documents inédits sur Courbet." *L'Art* (Paris), vol. 40 **(1886)**, p. 238.

CHAPTER IX

REALISM

1. *Le Précurseur d'Anvers* (Antwerp), 22 August 1861.

2. Thackeray, William M.: *The Paris sketch book of Mr. M. A. Titmarsh,* p. 41. Smith, Elder and Co., London; 1868.

3. Lemonnier, Camille: *G. Courbet et son œuvre,* pp. 36–7. Alphonse Lemerre, Paris; 1878.

4. Camille Pissarro to Lucien Pissarro, Paris, 22 November 1895. Rewald, John: *Camille Pissarro. Letters to his son Lucien,* p. 276. Pantheon Books, Inc., New York; 1943.

5. **RI,** p. 146.

6. **CD,** box 3.

7. Champfleury: Article in *Le Pamphlet* (Paris), 28 September 1848. Reprinted in Champfleury: *Souvenirs et portraits de jeunesse,* p. 171. E. Dentu, Paris; 1872.

8. Amiel, J. Henri: "Un Précurseur du réalisme: Max Buchon." *Modern Language Quarterly* (Seattle), vol. 3, no. 3 (September 1942), p. 379.

9. Champfleury: "Du Réalisme. Lettre à Madame Sand." *L'Artiste* (Paris), *série* 5, vol. 16, no. 1 (2 September 1855), p. 2. Reprinted in Champfleury: *Le Réalisme,* p. 272. Michel Lévy Frères, Paris; 1857.

10. Champfleury to Buchon, undated. **CHA,** vol. 105 (November–December 1913), p. 230.

11. *Réalisme* (Paris), no. 3 (15 January 1857). Reprinted in Amiel, J. Henri: "Un Précurseur du réalisme: Max Buchon." *Modern Language Quarterly* (Seattle), vol. 3, no. 3 (September 1942), p. 380.

12. About, Edmond: *Voyage à travers l'exposition des Beaux-Arts,* p. 201. L. Hachette et Cie., Paris; 1855.

13. Champfleury to Buchon, Paris, 10 December 1855. **CHA**, vol. 133 (October–December 1919), p. 538.
14. Courbet to his pupils, Paris, 25 December 1861. **CD**, box 3. Printed in *Le Courrier du Dimanche* (Paris), 29 December 1861. Reprinted in **COU**, vol. 2, pp. 204–7.
15. Fournel, Victor: *Les Artistes français contemporains,* p. 366. Alfred Mame et Fils, Tours; 1885. (2nd edition).

CHAPTER X

ALFRED BRUYAS

1. Courbet to his family, Paris, 13 May 1853. **RI**, pp. 101–2.
2. Champfleury to Buchon, Paris, undated. **CHA**, vol. 105 (November–December 1913), p. 44.
3. Delacroix, Eugène: *Journal,* vol. 2, pp. 18–19 (entry for 15 April 1853). Plon, Paris; 1932.
4. About, Edmond: *Nos Artistes au Salon de 1857,* pp. **150–1. L.** Hachette et Cie., Paris; 1858.
5. **CHA**, vol. 105 (November–December 1913), p. 44.
6. **RI**, p. 104.
7. **BOR**, pp. 15–16.
8. Courbet to Bruyas, Paris, undated. **OL**, pp. 485–90; **BOR**, pp. 65–72.
9. Courbet to Bruyas, Ornans, undated. **OL**, pp. 482–3; **BOR**, pp. 41–3.
10. *Ibid.*
11. Courbet to Marlet, undated. **RI**, p. 115.
12. Courbet to Bruyas, Ornans, May 1854. **OL**, pp. 468–70; **BOR**, pp. 37–8.
13. *Ibid.* **OL**, pp. 470–1; **BOR**, pp. 39–40.

CHAPTER XI

MONTPELLIER

1. Fajon to Bruyas, Montpellier, undated. Borel, Pierre: "Quatre modèles de Gustave Courbet." *La Revue de France* (Paris), *année* 5, vol. 2 (March–April 1925), p. 186.
2. About, Edmond: *Voyage à travers l'exposition des Beaux-Arts*, p. 205. L. Hachette et Cie., Paris; 1855.
3. Zoé Courbet to Bruyas, Ornans, 17 June 1854. **BOR**, pp. 49–50.
4. Courbet to Buchon, Montpellier, undated. Original in Metropolitan Museum of Art, New York (presented by Samuel P. Avery). Printed in Les Amis de Gustave Courbet: *Bulletin,* no. 5, p. 23. Paris–Ornans; 1949.
5. *Ibid.,* pp. 22–3.
6. Courbet to Bruyas, Ornans, November 1854. **OL**, p. 473; **BOR**, p. 54.
7. Champfleury to Buchon, Paris, 30 May 1854. **CHA**, vol. 105 (November–December 1913), p. 213.
8. Champfleury to Buchon, Paris, undated. **CHA**, vol. 105 (November–December 1913), p. 214.
9. Champfleury to Buchon, Paris, 26 July 1854. **CHA**, vol. 105 (November–December 1913), p. 221.
10. Courbet to Buchon, undated. **RI**, pp. 144–5.
11. Courbet to Bruyas, Ornans, November 1854. **OL**, p. 473; **BOR**, pp. 54–6.

CHAPTER XII

THE ATELIER

1. Courbet to Bruyas, Ornans, November 1854. **OL**, pp. 472–4; **BOR**, pp. 54–7.
2. *Ibid.* **OL**, pp. 474–5; **BOR**, pp. 57–9.
3. Courbet to Bruyas, Ornans, November 1854. **OL**, pp. 471–2; **BOR**, pp. 60–1.
4. Courbet to Bruyas, undated. **OL**, pp. 476–7; **BOR**, pp. 61–4.

5. Courbet to Champfleury, January 1855. Huyghe, René (and others): *Courbet. L'Atelier du peintre, allégorie réelle, 1855,* p. 23. Plon, Paris; 1944.

6. Huyghe, René (and others): *Courbet. L'Atelier du peintre, allégorie réelle, 1855,* p. 3. Plon, Paris; 1944.

7. *Ibid.,* p. 3.

8. Champfleury to Buchon, Paris, 14 April 1855. **CHA,** vol. 133 (October–December 1919), p. 532.

CHAPTER XIII

EXHIBITION: 1855

1. Courbet to Bruyas, Paris, undated. **OL,** pp. 478–9; **BOR,** pp. 74–6.

2. **CD,** box 1.

3. Courbet to Bruyas, Paris, undated. **OL,** pp. 479–81; **BOR,** pp. 78–80.

4. *Exhibition et vente de 40 tableaux et 4 dessins de l'œuvre de M. Gustave Courbet, avenue Montaigne, 7, Champs-Elysées.* Paris; 1855.

5. Champfleury to Buchon, Paris, 28 June 1855. **CHA,** vol. 133 (October–December 1919), pp. 533–4.

6. Delacroix, Eugène: *Journal,* vol. 2, p. 364 (entry for 3 August 1855). Plon, Paris; 1932.

7. Gautier, Théophile: *Les Beaux-Arts en Europe, 1855 (série 2),* pp. 155–6. Michel Lévy Frères, Paris; 1856.

8. Loudun, Eugène: *Le Salon de 1855,* pp. 139–40. Ledoyen, Paris; 1855.

9. Du Camp, Maxime: *Les Beaux-Arts à l'exposition universelle de 1855,* p. 236. Librairie Nouvelle, Paris; 1855.

10. Champfleury to Buchon, Paris, 22 July 1855. **CHA,** vol. 133 (October–December 1919), p. 535.

11. Champfleury: "Du Réalisme. Lettre à Madame Sand." *L'Artiste* (Paris), *série* 5, vol. 16, no. 1 (2 September 1855), pp. 1, 4. Reprinted in Champfleury: *Le Réalisme,* pp. 270, 283. Michel Lévy Frères, Paris; 1857.

12. Champfleury to Buchon, Paris, 1 October 1855. **CHA,** vol. 133 (October–December 1919), p. 535.

13. Champfleury to Buchon, Paris, 24 October 1855. **CHA**, vol. 133 (October–December 1919), p. 536.
14. Champfleury to Buchon, Paris, 16 April 1856. **CHA**, vol. 133 (October–December 1919), p. 540.
15. Courbet to his family, Paris, August 1855. **RI**, p. 141.
16. Courbet to his family, Ghent, September 1855. **RI**, p. 142.
17. Courbet to Bruyas, Paris, 9 December 1855. **OL**, pp. 484–5; **BOR**, pp. 85–6.

CHAPTER XIV

FRANKFORT

1. Champfleury to Buchon, Paris, 25 January 1856. **CHA**, vol. 133 (October–December 1919), p. 540.
2. Gautier, Théophile: "Salon de 1857." *L'Artiste* (Paris), *nouvelle série*, vol. 2, no. 3 (20 September 1857), p. 34.
3. About, Edmond: *Nos Artistes au Salon de 1857*, pp. 141–4, 147. L. Hachette et Cie., Paris; 1858.
4. Castagnary, Jules-Antoine: *Philosophie du Salon de 1857*, pp. 39, 42–4. Poulet-Malassis et De Broise, Paris; 1858. Reprinted in Castagnary: *Salons (1857–1879)*, vol. 1, pp. 26, 28–30. Charpentier, Paris; 1892.
5. Champfleury to Buchon, Paris, 22 July 1857. **CHA**, vol. 133 (October–December 1919), p. 544.
6. Champfleury to Buchon, 25 June 1857. **CHA**, vol. 133 (October–December 1919), p. 543.
7. Champfleury: "Les Sensations de Josquin. Histoire de M. T—." *Revue des Deux Mondes* (Paris), *période* 2, vol. 10 (15 August 1857), p. 864.
8. *Ibid.*, pp. 864–6.
9. *Ibid.*, p. 869.
10. *Ibid.*, p. 870.
11. Courbet to Fajon, undated. **OL**, pp. 490–1; **BOR**, pp. 88–90.
12. Champfleury to Buchon, Paris, 20 August 1857. **CHA**, vol. 133 (October–December 1919), p. 545.
13. Courbet to Fajon, undated. **OL**, pp. 491–2; **BOR**, p. 91.
14. Courbet to his mother, Frankfort, 21 December 1858. **RI**, p. 163.

15. Courbet to Wey, Ornans, 19–20 April 1861. **COU**, vol. 2, pp. 89–90.
16. Courbet to his family, Frankfort, undated. **COU**, vol. 2, pp. 88–9.
17. Courbet to Wey, Ornans, 19–20 April 1861. **COU**, vol. 2, p. 92.

CHAPTER XV

MASTER AND PUPILS

1. Courbet to Bruyas, Ornans, November 1854. **OL**, p. 475; **BOR**, p. 59.
2. **RI**, pp. 217–18.
3. Schanne, Alexandre-Louis: *Souvenirs de Schaunard*, pp. 229–30. Charpentier, Paris; 1886.
4. Jean-Aubry, G.: *Eugène Boudin d'après des documents inédits. L'homme et l'œuvre*, p. 39. Bernheim-Jeune, Paris; 1922.
5. *Ibid.*
6. Schanne, Alexandre-Louis: *Souvenirs de Schaunard*, pp. 230–1. Charpentier, Paris; 1886.
7. Original announcement in **CD**, box 1.
8. Lydie Jolicler to ?, 1883. Bauzon, Louis: "Documents inédits sur Courbet." *L'Art* (Paris), vol. 40 (1886), p. 238.
9. Léger, Charles: *Courbet*, p. 107. G. Crès et Cie., Paris; 1929.
10. Courbet to Wey, Ornans, 20 April 1861. **RI**, p. 184.
11. Thoré, Théophile: *Salons de W. Bürger, 1861 à 1868,* vol. 1, p. 74. Veuve Jules Renouard, Paris; 1870.
12. Champfleury to Buchon, Paris, 30 May 1861. **CHA**, vol. 133 (October–December 1919), p. 704.
13. Arnaud to Castagnary, Paris, 11 June 1861. **CD**, box 1.
14. Arnaud to Castagnary, Paris, 18 June 1861. **CD**, box 1.
15. **CD**, box 3. Printed in **COU**, vol. 1, pp. 144–6.
16. **CD**, box 1.
17. Courbet to his pupils, Paris, 25 December 1861. **CD**, box 3. Printed in *Le Courrier du Dimanche* (Paris), 29 December 1861. Reprinted in **COU**, vol. 2, pp. 204–7.
18. Cibot to Castagnary, Paris, 2 February 1862. **CD**, box 1.

CHAPTER XVI

SAINTONGE

1. Sainte-Beuve to Duveyrier, 27 April 1862. Sainte-Beuve, Charles-Augustin: *Correspondance (1822–1865)*, vol. 1, pp. 289–90. Calmann Lévy, Paris; 1877.
2. Champfleury: *Grandes figures d'hier et d'aujourd'hui*, pp. 260–1. Poulet-Malassis et de Broise, Paris; 1861.
3. Champfleury to Buchon, Paris, 24 June 1864. **CHA**, vol. 133 (October–December 1919), p. 708.
4. Léger, Charles: *Courbet*, p. 150. G. Crès et Cie., Paris; 1929.
5. "Courbet à Saintes." *Revue de Saintonge et d'Aunis. Bulletin de la Société des Archives Historiques* (Saintes), vol. 38, no. 5 (August 1919), p. 295.
6. **CD**, box 3. Printed (with minor omissions) in **COU**, vol. 1, pp. 165–6.
7. **CD**, box 3.
8. Duret, Théodore: *Courbet*, p. 56. Bernheim-Jeune, Paris; 1918.
9. **CD**, box 3.
10. Duret, Théodore: *Courbet*, p. 59. Bernheim-Jeune, Paris; 1918.
11. **CD**, box 3. Printed in **COU**, vol. 1, pp. 166–7.
12. Courbet to Castagnary, Saintes, 16 August 1862. **CD**, box 1.
13. **CD**, box 3.
14. Courbet to Castagnary, Saintes, 16 August 1862. **CD**, box 1.
15. Courbet to Carjat, Saintes, March 1863. Léger, Charles: *Courbet selon les caricatures et les images*, p. 50. Paul Rosenberg, Paris; 1920.
16. Auguin to Castagnary, Saintes, 28 January 1863. **CD**, box 1. Printed in **COU**, vol. 1, pp. 172–4.

CHAPTER XVII

RETURN FROM THE CONFERENCE

1. Courbet to his family, Saintes, undated. **RI**, p. 201.
2. Léger, Charles: *Courbet*, p. 96. G. Crès et Cie., Paris; 1929.

3. Courbet to his family, Paris, 28 July 1863. Léger, Charles: *Courbet*, p. 98. G. Crès et Cie., Paris; 1929.

4. Courbet to Castagnary, Maisières, 21 April 1867. **CD**, box 1.

5. Thoré, Théophile: *Salons de W. Bürger, 1861 à 1868,* vol. 1, p. 382. Veuve Jules Renouard, Paris; 1870.

6. *Ibid.,* pp. 417–18, 420.

7. Champfleury to Buchon, Paris, 8 April 1863. **CHA**, vol. 133 (October–December 1919), p. 705.

8. Champfleury to Buchon, Paris, 14 May 1863. **CHA**, vol. 133 (October–December 1919), pp. 705–6.

9. Champfleury to Buchon, Paris, 2 June 1863. **CHA**, vol. 133 (October–December 1919), pp. 706–7.

10. Champfleury to Buchon, Paris, 30 June 1863. **CHA**, vol. 133 (October–December 1919), p. 707.

11. Castagnary, Jules-Antoine: *Salons (1857–1879),* vol. 1, pp. 150–1. Charpentier, Paris; 1892.

PIERRE-JOSEPH PROUDHON

1. Courbet to his family, Paris, undated. **RI**, p. 208.

2. Courbet to Buchon, Paris, undated. **RI**, p. 209.

3. Proudhon, Pierre-Joseph: *Du Principe de l'art et de sa destination sociale,* pp. 279–80. Garnier Frères, Paris; 1865.

4. Champier, Victor: *L'Année artistique,* pp. 493–4. A. Quantin, Paris; 1879.

5. Proudhon, Pierre-Joseph: *Du Principe de l'art et de sa destination sociale,* pp. 3–4. Garnier Frères, Paris; 1865.

6. *Ibid.,* pp. 14–15.

7. *Ibid.,* p. 43.

8. *Ibid.,* p. 186.

9. *Ibid.,* pp. 218–19.

10. *Ibid.,* pp. 224–5.

11. *Ibid.,* p. 266.

12. *Ibid.,* p. 279.

13. *Ibid.,* p. 280.

14. *Ibid.,* pp. 281–5.

15. Zola, Emile: *Mes Haines,* pp. 31–9. Charpentier, Paris; 1913 (first published 1866).
16. Courbet to Castagnary, Paris, 19 June 1865. **CD**, box 1.
17. Champfleury to Buchon, Paris, 14 November 1863. **CHA**, vol. 133 (October–December 1919), pp. 707–8.
18. Courbet to Castagnary, Ornans, 18 January 1864. **CD**, box 1.
19. Thoré, Théophile: *Salons de W. Bürger, 1861 à 1868,* vol. 2, pp. 67–8. Veuve Jules Renouard, Paris; 1870.
20. Courbet to Luquet, Ornans, undated. **RI**, p. 217.

CHAPTER XIX

SALINS

1. Claudet, Max: *Souvenirs: Gustave Courbet,* pp. 8–12. Dubuisson et Cie., Paris; 1878. Reprinted in **COU**, vol. 1, pp. 197–201.
2. **CD**, box 4.
3. Claudet, Max: *Souvenirs: Gustave Courbet,* p. 13. Dubuisson et Cie., Paris; 1878. Reprinted in **COU**, vol. 1, p. 202.
4. **CD**, box 4.
5. *Ibid.*
6. *Ibid.*
7. Champfleury to Buchon, Paris, 29 October 1864. **CHA**, vol. 133 (October–December 1919), p. 709.
8. Courbet to Hugo, Salins, 28 November 1864. Léger, Charles: *Courbet,* pp. 110–11. G. Crès et Cie., Paris; 1929.
9. Hugo to Buchon, Hauteville House, Guernsey, 17 (? November) 1864. Léger, Charles: "Courbet et Victor Hugo d'après des lettres inédites." *Gazette des Beaux-Arts* (Paris), *année* 63, *période* 5, vol. 4, no. 722 (December 1921), p. 359.
10. Hugo, Victor: *Choses vues,* vol. 2, p. 186 (entry for 18 March 1871). Ollendorff, Paris; 1913.
11. Courbet to Castagnary, Salins, 10 December 1864. **CD**, box 1.
12. Courbet to Castagnary, Salins, 14 December 1864. **CD**, box 1.
13. Courbet to Castagnary, Ornans, 20 January 1865. **CD**, box 1.
14. Courbet to Chaudey, Ornans, 24 January 1865. Droz, Edouard: "Pierre-Joseph Proudhon. Lettres inédites à Gustave Chaudey et à divers comtois, suivies de quelques fragments inédits de Proudhon et d'une lettre de Gustave Courbet sur la mort de Proudhon." *Mémoires*

de la Société d'Emulation du Doubs (Besançon), *série* 8, vol. 5 (1910), pp. 255–7.

15. Thoré, Théophile: *Salons de W. Bürger, 1861 à 1868,* vol. 2, pp. 269–70. Veuve Jules Renouard, Paris; 1870.

16. Champfleury to Buchon, Paris, 23 April 1865. **CHA,** vol. 133 (October–December 1919), pp. 709–10.

17. Courbet to Lydie Jolicler, Ornans, 15 April 1865. Bauzon, Louis: "Documents inédits sur Courbet." *L'Art* (Paris), vol. 40 (1886), pp. 238–9.

18. Courbet to Lydie Jolicler, Paris, June 1865. Bauzon, Louis: "Documents inédits sur Courbet." *L'Art* (Paris), vol. 40 (1886), p. 239.

CHAPTER XX

TROUVILLE

1. Courbet to Bain, Trouville, 8 September 1865. Original letter owned by Mr John Rewald, New York.

2. Courbet to his family, Trouville, 17 November 1865. **RI,** p. 228.

3. Whistler to Fantin-Latour, autumn 1867. Bénédite, Léonce: "Whistler." *Gazette des Beaux-Arts* (Paris), *année* 47, *période* 3, vol. 34, no. 579 (September 1905), pp. 232–3.

4. Courbet to Castagnary, Paris, 3 January 1866. **CD,** box 1.

5. Courbet to Bruyas, Paris, January 1866. **OL,** pp. 492–4; **BOR,** pp. 93–5.

6. *Ibid.*

7. Courbet to Bruyas, Paris, January 1866. **OL,** pp. 494–6; **BOR,** pp. 96–7.

8. Du Camp, Maxime: *Les Beaux-Arts à l'exposition universelle et aux salons de 1863, 1864, 1865, 1866 et 1867,* pp. 219–20. Veuve Jules Renouard, Paris; 1867.

9. Castagnary, Jules-Antoine: *Salons (1857–1879),* vol. 1, p. 238. Charpentier, Paris; 1892.

10. Nadar: Article in *Le Monde des Eaux,* 3 June 1866. Reprinted in **COU,** vol. 1, p. 223.

11. Thoré, Théophile: *Salons de W. Bürger, 1861 à 1868,* vol. 2, pp. 276, 278. Veuve Jules Renouard, Paris; 1870.

12. Courbet to Cuénot, Paris, 6 April 1866. **RI,** pp. 236–7.

13. Nieuwerkerke to Courbet, Paris, 2 July 1866. **CD,** box 1.

14. Courbet to Juliette Courbet, Deauville, 27 September 1866. **CD**, box 3.
15. Courbet to Boudin, Deauville, undated. **RI**, p. 244.
16. Khalil Bey to Chaudey, undated. **CD**, box 4.

CHAPTER XXI

EXHIBITION: 1867

1. Courbet to Bruyas, Ornans, 18 February 1867. **OL**, p. 497; **BOR**, p. 103.
2. Courbet to Chaudey, Ornans, 2 March 1867. **CD**, box 1.
3. Courbet to Castagnary, Maisières, 21 April 1867. **CD**, box 1.
4. Courbet to Bruyas, Ornans, 27 April 1867. **OL**, pp. 498–9; **BOR**, pp. 104–5.
5. Courbet to Bruyas, Paris, 28 May 1867. **OL**, pp. 499–500; **BOR**, pp. 100–1.
6. Courbet to Gill, undated. *La Lune* (Paris), *année 3*, no. 66 (9 June 1867).
7. *Exposition des œuvres de M. G. Courbet. Rond-point du pont de l'Alma (Champs-Elysées)*. Lebigre-Duquesne Frères, Paris; 1867.
8. Courbet to Castagnary, Paris, 13 July 1867. **CD**, box 1.
9. Courbet to Castagnary, Paris, 16 August 1867. **CD**, box 1.
10. Unidentified newspaper cutting, undated. **CD**, box 4. Reprinted in **COU**, vol. 1, pp. 227–8.
11. Courbet to Bruyas, Paris, 1868. **OL**, pp. 501–2; **BOR**, pp. 110–11.
12. Isabey to Courbet, Paris, 16 November 1868. **CD**, box 1.
13. Chaudey to Courbet, Paris, 22 December 1868. **CD**, box 1.

CHAPTER XXII

MUNICH

1. Courbet to his sisters, Paris, 9 January 1868. **CD**, box 1.
2. Thoré, Théophile: *Salons de W. Bürger, 1861 à 1868*, vol. 2, p. 490. Veuve Jules Renouard, Paris; 1870.
3. Chaudey to Courbet, Paris, 22 December 1868. **CD**, box 1.

4. *Les Curés en goguette. Avec six dessins de Gustave Courbet*, p. 5. Brussels; 1868.

5. Courbet to Bruyas, Paris, 10 September 1868. **OL**, p. 503; **BOR**, p. 108.

6. Geffroy, Gustave: *Claude Monet. Sa Vie, son temps, son œuvre*, p. 41. G. Crès et Cie., Paris; 1922.

7. Courbet to Castagnary, Ornans, 17 October 1868. **CD**, box 1.

8. Ordinaire to Castagnary, Maisières, 18 December 1868. **CD**, box 1. Printed in **COU**, vol. 1, pp. 235–6.

9. Courbet to Castagnary, Paris, 5 July 1869. **CD**, box 2.

10. Courbet to Castagnary, Etretat, 6 September 1869. **CD**, box 2.

11. *Ibid.*

12. Champfleury: *Souvenirs et portraits de jeunesse*, p. 180. E. Dentu, Paris; 1872.

13. Courbet to Castagnary, Interlaken, 20 November 1869. **CD**, box 2. Printed in **COU**, vol. 2, pp. 113–16.

14. Courbet to Gaudy, Salins, 8 December 1869. Les Amis de Gustave Courbet: *Bulletin*, no. 6, p. 14. Paris-Ornans; 1949.

15. Courbet to Castagnary, Salins, 16 December 1869. **CD**, box 2. Printed in **COU**, vol. 2, pp. 116–20.

CHAPTER XXIII

WAR

1. Courbet to La Rochenoire, Ornans, 4 February 1870. Léger, Charles: *Courbet*, p. 151. G. Crès et Cie., Paris; 1929.

2. Courbet to Castagnary, Ornans, 5 February 1870. **CD**, box 2.

3. Castagnary, Jules-Antoine: *Salons (1857–1879)*, vol. 1, p. 396. Charpentier, Paris; 1892.

4. Courbet to his family, Paris, 11 May 1870. **RI**, p. 277.

5. Courbet to Richard, Paris, 23 June 1870. Printed in Ideville, H. d': *Gustave Courbet. Notes et documents sur sa vie et son œuvre*, pp. 34–6. Paris-Gravé, Paris; 1878.

6. Group of friends to Courbet, Ornans, undated. **CD**, box 2.

7. Courbet to his family, Paris, 15 July 1870. **CD**, box 7.

8. Courbet to his family, Paris, 9 August 1870. **CD**, box 7. Printed in **COU**, vol. 2, p. 127.

9. Régis Courbet to Courbet, undated. From an unsigned, undated

fragment of a report headed: *Courbet et la colonne sous le 4 septembre et le 18 mars.* **CD**, box 7.

10. Courbet to his family, Paris, undated. From an unsigned, undated fragment of a report headed: *Courbet et la colonne sous le 4 septembre et le 18 mars.* **CD**, box 7.

11. Courbet to his family, Paris, 9 September 1870. Léger, Charles: *Courbet selon les caricatures et les images,* p. 123. Paul Rosenberg, Paris; 1920.

12. *Ibid.*

13. Darcel, Alfred: "Les Musées, les arts et les artistes pendant le siège de Paris." *Gazette des Beaux-Arts* (Paris), *année* 12, *période* 2, vol. 4, no. 4 (October 1871), p. 290.

14. Courbet to Simon, Paris, 1 December 1870. Draft of letter in **CD**, box 2.

15. Courbet, Gustave: *A l'Armée allemande,* pp. 5–6, 9. Paris; 1870. Reprinted in **COU**, vol. 2, pp. 129–30, 134.

16. Courbet, Gustave: *Aux Artistes allemands,* pp. 11, 14. Paris; 1870. Reprinted in **COU**, vol. 2, pp. 135, 138–9.

17. Boyer, Pierre: *Les Aventures d'un étudiant, 1870–1871,* pp. 182, 185, 190–2. L. Sauvaitre, Paris; 1888.

CHAPTER XXIV

THE COMMUNE

1. Courbet to his family, Paris, 23 February 1871. **CD**, box 7. Printed (in part) in **COU**, vol. 2, pp. 125–6.

2. *Le Soir* (Paris), 6 April 1871. Reprinted in Darcel, Alfred: "Les Musées, les arts et les artistes pendant la Commune." *Gazette des Beaux-Arts* (Paris), *année* 14, *période* 2, vol. 5, no. 1 (January 1872), pp. 44–5.

3. *Le Rappel* (Paris), 7 April 1871. Reprinted in Darcel, Alfred: "Les Musées, les arts et les artistes pendant la Commune." *Gazette des Beaux-Arts* (Paris), *année* 14, *période* 2, vol. 5, no. 1 (January 1872), p. 45.

4. *Journal Officiel de la République Française sous la Commune* (Paris), 15 April 1871.

5. *Ibid.*

6. *Ibid.,* 24 April 1871.

7. Courbet to his family, Paris, 30 April 1871. **CD**, box 7. Printed (in part) in **COU**, vol. 2, p. 140.

8. *Journal Officiel de la République Française sous la Commune* (Paris), 4 May 1871.

CHAPTER XXV

THE COLUMN

1. Courbet to Ideville, La Tour-de-Peilz, 29 August 1876. Ideville, H. d': *Gustave Courbet. Notes et documents sur sa vie et son œuvre,* pp. 81–2. Paris-Gravé, Paris; 1878.

2. Copy of original draft in **CD**, box 2. Printed in *Journal des Débats* (Paris), 29 September 1870.

3. Gill, André: *Vingt années de Paris,* p. 168. C. Marpon et E. Flammarion, Paris; 1883.

4. Courbet to Arago, Paris, 5 October 1870. **RI**, p. 289.

5. Courbet to his family, Paris, 23 February 1871. **CD**, box 7.

6. Castagnary, Jules-Antoine: *Gustave Courbet et la colonne Vendôme. Plaidoyer pour un ami mort,* pp. 21–2. E. Dentu, Paris; 1883.

7. *Journal Officiel de la République Française sous la Commune* (Paris), 13 April 1871.

8. *Ibid.,* 20 April 1871.

9. *Ibid.,* 28 April 1871.

10. **CD**, box 2.

11. Lanjalley, Paul, et Corriez, Paul: *Histoire de la révolution du 18 mars,* pp. 486–7. A. Lacroix, Verboeckhoven et Cie., Paris, Brussels, Leipzig, and Leghorn; 1871.

12. *The Times* (London), 17 May 1871.

13. *Ibid.,* 19 May 1871.

14. Castagnary, Jules-Antoine: *Gustave Courbet et la colonne Vendôme. Plaidoyer pour un ami mort,* p. 63. E. Dentu, Paris; 1883.

CHAPTER XXVI

ARREST

1. **RI**, p. 309.
2. Courbet to Castagnary, Paris, 8 June 1871. **CD**, box 2. Printed in **COU**, vol. 2, p. 141.
3. Cutting from unidentified newspaper. **CD**, box 7.
4. Cutting from unidentified newspaper. **CD**, box 7.
5. Morel, Henry: *Le Pilori des Communeux* (preface), p. ix. E. Lachaud, Paris; 1871.
6. *Le Figaro* (Paris), 12 June 1871.
7. Courbet to his family, Paris, 11 June 1871. **CD**, box 7.
8. Duriez to Castagnary, Versailles, 14 June 1871. **CD**, box 2.
9. Reverdy to Castagnary, Bréac, 13 June 1871. **CD**, box 2.
10. *Ibid.*
11. Ordinaire to Castagnary, Maisières, 18 June 1871. **CD**, box 2.
12. Ordinaire to Castagnary, Maisières, 22 June 1871. **CD**, box 2.
13. *The Times* (London), 27 June 1871.
14. Zoé Reverdy to Castagnary, Paris, 5 July 1871. **CD**, box 2.
15. Duriez to Castagnary, Versailles, 10 July 1871. **CD**, box 2.
16. **CD**, box 2.
17. Zoé Reverdy to Bruyas, Paris, 26 July 1871. **BOR**, pp. 115–17.
18. Zoé Reverdy to Bruyas, Paris, (?26 July 1871). **BOR**, p. 118.
19. Bruyas to Lachaud, Montpellier, 8 August 1871. **BOR**, p. 117.
20. Bruyas to Zoé Reverdy, Montpellier, undated. **BOR**, p. 119.

CHAPTER XXVII

PRISON

1. **RI**, p. 321.
2. Zoé Reverdy to Bruyas, Paris, undated. **BOR**, pp. 121–3.
3. Courbet to Juliette Courbet, Versailles, 27 August 1871. **CD**, box 2.
4. Courbet to his family, Versailles, 3 September 1871. **CD**, box 7.

5. Courbet to Baudry, La Tour-de-Peilz, 18 June 1875. **CD**, box 2. Printed in Léger, Charles: *Courbet selon les caricatures et les images,* p. 125. Paul Rosenberg, Paris; 1920.

6. Du Camp, Maxime: *Les Convulsions de Paris,* vol. 1, p. 204. Hachette et Cie., Paris; 1878–80.

7. Courbet to Castagnary, Paris, 23 September 1871. **CD**, box 2.

8. Courbet to Castagnary, Paris, September 1871. **CD**, box 2. Printed in **COU**, vol. 2, pp. 141–2.

9. Courbet to Juliette Courbet, Paris, 29 September 1871. **CD**, box 7.

10. Zoé Reverdy to Bruyas, Paris, 30 November 1871. **BOR**, pp. 123–6.

11. Courbet to Lydie Jolicler, Paris, undated. Bauzon, Louis: "Documents inédits sur Courbet." *L'Art* (Paris), vol. 40 (1886), p. 240.

12. Zoé Reverdy to Lydie Jolicler, Paris, 1 December 1871. Bauzon, Louis: "Documents inédits sur Courbet." *L'Art* (Paris), vol. 40 (1886), p. 239.

13. Zoé Reverdy to Lydie Jolicler, Paris, 12 December 1871. Bauzon, Louis: "Documents inédits sur Courbet." *L'Art* (Paris), vol. 40 (1886), p. 240.

CHAPTER XXVIII

HOSPITAL

1. Zoé Reverdy to Bruyas, Paris, undated. **BOR**, pp. 126–7.

2. Courbet to his family, Neuilly, 4 January 1872. **CD**, box 7.

3. Zoé Reverdy to Bruyas, Paris, 14 January 1872. **BOR**, pp. 128–9.

4. Zoé Reverdy to Bruyas, Paris, 29 January 1872. **BOR**, pp. 129–30.

5. Zoé Reverdy to Lydie Jolicler, Paris, 29 January 1872. Bauzon, Louis: "Documents inédits sur Courbet." *L'Art* (Paris), vol. 40 (1886), pp. 240–1.

6. Zoé Reverdy to Bruyas, Paris, undated. **BOR**, p. 131.

7. Hugo, Victor: *Choses vues,* vol. 2, p. 205 (entry for 25 April 1872). Ollendorff, Paris; 1913.

8. Zoé Reverdy to Bruyas, Paris, undated. Borel, Pierre: "Quatre modèles de Gustave Courbet." *Revue de France* (Paris), année 5, vol. 2 (March–April 1925), pp. 184–5.

9. Champfleury to Zoé Reverdy, undated. **BOR**, p. 133 (footnote).

10. Castagnary, Jules-Antoine: *Gustave Courbet et la colonne Vendôme. Plaidoyer pour un ami mort,* p. 77. E. Dentu, Paris; 1883.
11. Castagnary, Jules-Antoine: *Salons (1857–1879)*, vol. 2, pp. 11–13. Charpentier, Paris; 1892.
12. Hervilly, Ernest d': "Le Conseil de Guerre à l'exposition des Beaux-Arts." *L'Eclipse* (Paris), *année* 5, no. 181 (14 April 1872).
13. *Ibid.*
14. *Ibid.*

CHAPTER XXIX

RETURN TO ORNANS

1. Courbet to Castagnary, Ornans, 14 August 1872. **CD**, box 2. Printed in **COU**, vol. 2, p. 147.
2. Courbet to his sisters, Maisières, 26 July 1872. Léger, Charles: *Courbet selon les caricatures et les images,* pp. 123–4. Paul Rosenberg, Paris; 1920.
3. Courbet to Castagnary, Ornans, 14 August 1872. **CD**, box 2. Printed in **COU**, vol. 2, p. 146.
4. Courbet to Cornuel, Ornans, 6 October 1872. **CD**, box 7. Printed in **COU**, vol. 2, pp. 147–9.
5. Courbet to Cornuel, Ornans, 9 October 1872. **CD**, box 7. Printed in **COU**, vol. 2, pp. 150–1.
6. Courbet to Castagnary, Ornans, 16 January 1873. **CD**, box 2. Printed (in part) in **COU**, vol. 2, pp. 151–2.
7. Léger, Charles: *Courbet,* p. 188. G. Crès et Cie., Paris; 1929.
8. Courbet to Mathilde G—, undated. Moreau, Pierre: "Les Origines du réalisme franc-comtois." Académie des Sciences, Belles-Lettres et Arts de Besançon: *Bulletin trimestriel, trimestre* 1, 1936, p. 35. Besançon; 1936.
9. Courbet to Mathilde G—, November 1872. *Ibid.,* p. 31.
10. Courbet to Castagnary, Ornans, 24 January 1873. **CD**, box 2.
11. Courbet to Castagnary, Besançon, 28 January 1873. **CD**, box 2.
12. Courbet to Castagnary, Ornans, 9 February 1873. **CD**, box 2.
13. Courbet to Castagnary, Ornans, 19 March 1873. **CD**, box 2. Printed (in part) in **COU**, vol. 2, pp. 153–4.
14. Duval to Castagnary, Paris, 4 April 1873. **CD**, box 2.
15. Courbet to Sandrans, Ornans, 26 March 1873. **CD**, box 2. Printed

in Estignard, A.: *G. Courbet. Sa Vie et ses œuvres,* pp. 116–17. Delagrange et Magnus, Besançon; 1897.
16. Courbet to his sisters, Ornans, 26 April 1873. **CD**, box 7. Printed in **RI**, pp. 343–4.

CHAPTER XXX

FLIGHT

1. Courbet to Zoé Reverdy, Ornans, 15 June 1873. **CD**, box 2.
2. Courbet to Chopard, undated. Léger, Charles: *Courbet,* p. 181. G. Crès et Cie., Paris; 1929.
3. Courbet to Sandrans, undated. Léger, Charles: *Courbet,* pp. 183–4. G. Crès et Cie., Paris; 1929.
4. Ordinaire to Castagnary, Maisières, 23 June 1873. **CD**, box 2.
5. Ordinaire to Castagnary, Maisières, 24 June 1873. **CD**, box 2.
6. Courbet to Castagnary, 28 June 1873. **CD**, box 2.
7. Léger, Charles: *Courbet en exil,* p. 10. Les Amis de Gustave Courbet, Pontarlier; 1943.
8. Ordinaire to Castagnary, Maisières, 16 July 1873. **CD**, box 2.
9. Courbet to Castagnary, Maisières, 21 July 1873. **CD**, box 2.
10. Courbet to Lydie Jolicler, 20 July 1873. Bauzon, Louis: "Documents inédits sur Courbet." *L'Art* (Paris), vol. 40 (1886), pp. 241–2. Reprinted (in part) in **COU**, vol. 2, pp. 154–5.

CHAPTER XXXI

BON–PORT

1. Léger, Charles: *Courbet en exil,* p. 12. Les Amis de Gustave Courbet, Pontarlier; 1943.
2. Ordinaire to Castagnary, La Tour-de-Peilz, 13 October 1873. **CD**, box 2.
3. Courbet to Castagnary, La Tour-de-Peilz, December 1873. **CD**, box 2.
4. Ordinaire to Castagnary, La Tour-de-Peilz, 25 December 1873. **CD**, box 2.

5. Ordinaire to Castagnary, La Tour-de-Peilz, 26 January 1874. **CD,** box 2.

6. Ordinaire to Castagnary, Maisières, 22 March 1874. **CD,** box 2.

7. Fernier, Robert: "La Vigneronne de Montreux." Les Amis de Gustave Courbet: *Bulletin,* no. 4, p. 9. Paris-Ornans; 1948.

8. Pia to Castagnary, Geneva, 23 September 1874. **CD,** box 2.

9. Courbet to Castagnary, La Tour-de-Peilz, 4 February 1875. **CD,** box 2.

10. Courbet to (?Olga de Tallenay), La Tour-de-Peilz, 28 November 1874. **CD,** box 2.

11. Olga de Tallenay to Courbet, undated. Léger, Charles: *Courbet en exil,* p. 18 (footnote). Les Amis de Gustave Courbet, Pontarlier; 1943.

12. Olga de Tallenay to Courbet, undated. Léger, Charles: *Courbet en exil,* p. 18 (footnote). Les Amis de Gustave Courbet, Pontarlier; 1943.

13. **CD,** box 2.

14. Ordinaire to Castagnary, Maisières, 22 March 1874. **CD,** box 2.

15. Courbet to Castagnary, La Tour-de-Peilz, 26 March 1874. **CD,** box 2.

16. Courbet to Castagnary, La Tour-de-Peilz, 26 July 1875. **CD,** box 2.

17. "H. K. 113" to Castagnary, Paris, 24 February 1875. **CD,** box 2.

18. Courbet to Castagnary, La Tour-de-Peilz, 22 April 1875. **CD,** box 2.

19. Courbet to Juliette Courbet, La Tour-de-Peilz, 5 January 1875. Léger, Charles: *Courbet en exil,* p. 15. Les Amis de Gustave Courbet, Pontarlier; 1943.

20. Courbet to Juliette Courbet, La Tour-de-Peilz, 29 May 1875. **CD,** box 2. Printed (in part) in **BOR,** pp. 152–3. Reprinted (in part) in **COU,** vol. 2, pp. 157–8.

CHAPTER XXXII

PROSECUTION

1. *The Times* (London), 24 June 1874.

2. Duval to Courbet, Paris, 19 November 1875. **CD,** box 7.

3. Duval to Courbet, Paris, 9 March 1876. **CD,** box 2. Printed in **COU,** vol. 2, p. 159.

4. Courbet, Gustave: *Lettre ouverte aux députés et sénateurs des nouvelles assemblées nationales.* Vérésoff, Geneva; March 1876. Reprinted in **COU**, vol. 2, pp. 159–66.

5. Courbet to Castagnary, La Tour-de-Peilz, 28 August 1876. **CD**, box 2.

6. Duval to Castagnary, Paris, 1 December 1876. **CD**, box 2.

7. Courbet to Castagnary, La Tour-de-Peilz, 5 December 1876. **CD**, box 2. Printed (in part) in **COU**, vol. 2, p. 170.

8. Courbet to Castagnary, La Tour-de-Peilz, 8 January 1877. **CD**, box 2.

9. Courbet to Régis Courbet, La Tour-de-Peilz, 8 January 1877. **CD**, box 7.

10. Duval to Courbet, Paris, 10 February 1877. Copied in a letter from Courbet to Castagnary, La Tour-de-Peilz, 12 February 1877. **CD**, box 2.

11. Castagnary, Jules-Antoine: *Gustave Courbet et la colonne Vendôme. Plaidoyer pour un ami mort,* p. 83. E. Dentu, Paris; 1883.

CHAPTER XXXIII

ZOÉ

1. Zoé Reverdy to Bruyas, 20 August 1873. **BOR**, pp. 139–40.

2. Ordinaire to Castagnary, La Tour-de-Peilz, 13 October 1873. **CD**, box 2.

3. Courbet to Castagnary, La Tour-de-Peilz, December 1873. **CD**, box 2.

4. Zoé Reverdy to Bruyas, Ornans, 18 January 1874. **BOR**, p. 141.

5. Courbet to Castagnary, La Tour-de-Peilz, 4 February 1875. **CD**, box 2.

6. Courbet to Castagnary, La Tour-de-Peilz, 1 April 1875. **CD**, box 2.

7. Courbet to Zoé Reverdy. Copied in a letter from Courbet to Juliette and Zélie Courbet, La Tour-de-Peilz, 21 May 1875. Printed in **BOR**, pp. 150–2. Reprinted in **COU**, vol. 2, pp. 155–7.

8. Courbet to Juliette Courbet, La Tour-de-Peilz, 29 May 1875. **CD**, box 2.

9. Zoé Reverdy to Bruyas, Ornans, 14 January 1876. **BOR**, p. 144.

10. Zoé Reverdy to Bruyas, undated. **BOR**, pp. 142–4.

11. Courbet to Juliette Courbet, La Tour-de-Peilz, 9 February 1876. **BOR**, p. 153. Reprinted in **COU**, vol. 2, pp. 158–9.
12. Courbet to Castagnary, La Tour-de-Peilz, 9 April 1876. **CD**, box 2.
13. Courbet to Castagnary, La Tour-de-Peilz, 28 August 1876. **CD**, box 2.
14. Juliette Courbet to Castagnary, Ornans, 5 February 1878. **CD**, box 6.
15. Courbet to Juliette Courbet, La Tour-de-Peilz, 17 May 1877. **BOR**, p. 154. Reprinted in **COU**, vol. 2, p. 174.
16. Courbet to Juliette Courbet, La Tour-de-Peilz, 15 September 1877. **BOR**, p. 154.

CHAPTER XXXIV

DEATH

1. Courbet to Castagnary, La Tour-de-Peilz, 14 May 1877. **CD**, box 2.
2. Collin to Lemonnier, La Tour-de-Peilz, 31 December 1877. Lemonnier, Camille: *G. Courbet et son œuvre*, p. 86. Alphonse Lemerre, Paris; 1878.
3. Bill from the Maison de Santé Guerrieri, La Chaux-de-Fonds. **CD**, box 2.
4. Leloup to Castagnary, La Chaux-de-Fonds, 31 October 1877. **CD**, box 2.
5. Morel to Castagnary, La Tour-de-Peilz, 4 November 1877. **CD**, box 2. Printed (in part) in **COU**, vol. 1, pp. 315–16.
6. Eberhardt to Blondon, La Chaux-de-Fonds, 10 November 1877. Les Amis de Gustave Courbet: *Bulletin,* no. 3, pp. 41–2. Paris-Ornans; 1948.
7. Juliette Courbet to Blondon, Flagey, 13 November 1877. Les Amis de Gustave Courbet: *Bulletin,* no. 3, p. 43. Paris-Ornans; 1948.
8. Leloup to Castagnary, La Chaux-de-Fonds, 16 November 1877. **CD**, box 2. Printed (in part) in **COU**, vol. 1, p. 317.
9. Leloup to Castagnary, La Chaux-de-Fonds, 16 November 1877. **CD**, box 2. Printed (in part) in **COU**, vol. 1, p. 317. (In the printed version this and the preceding letter of the same date are combined into one. Actually they are two separate letters.)
10. Courbet to Castagnary, La Chaux-de-Fonds, 23 November 1877. **CD**, box 2.

11. Copy of inventory prepared for the auction of 26 November 1877. **CD**, box 7.

12. Courbet to Castagnary, La Tour-de-Peilz, 12 December 1877. **CD**, box 2. Printed (in part) in **COU**, vol. 2, p. 178.

13. Collin to Lemonnier, La Tour-de-Peilz, 31 December 1877. Lemonnier, Camille: *G. Courbet et son œuvre*, p. 84. Alphonse Lemerre, Paris; 1878.

14. *Ibid.*, pp. 84–7.

15. Courbet to Régis and Juliette Courbet, La Tour-de-Peilz, 23 December 1877. **CD**, box 2. Printed in **COU**, vol. 2, p. 179.

16. Collin to Lemonnier, La Tour-de-Peilz, 31 December 1877. Lemonnier, Camille: *G. Courbet et son œuvre*, p. 96. Alphonse Lemerre, Paris; 1878.

17. Juliette Courbet to Blondon, Flagey, 29 December 1877. Les Amis de Gustave Courbet: *Bulletin*, no. 3, p. 44. Paris-Ornans; 1948.

18. Collin to Lemonnier, La Tour-de-Peilz, 31 December 1877. Lemonnier, Camille: *G. Courbet et son œuvre*, p. 96. Alphonse Lemerre, Paris; 1878.

19. *Ibid.*, pp. 96–7.

CHAPTER XXXV

JULIETTE

1. Telegram, Collin to Castagnary, La Tour-de-Peilz, 31 December 1877. **CD**, box 2. Printed in **COU**, vol. 1, p. 327 (footnote).

2. Collin to Castagnary, La Tour-de-Peilz, 31 December 1877. Printed in **COU**, vol. 1, p. 327.

3. Juliette Courbet to Blondon, La Tour-de-Peilz, 31 December 1877. Les Amis de Gustave Courbet: *Bulletin*, no. 3, pp. 45–6. Paris-Ornans; 1948.

4. Pata to Castagnary, La Tour-de-Peilz, 3 January 1878. **CD**, box 6.

5. **COU**, vol. 1, p. 348.

6. "Philibert" to Duval, Lausanne, 5 October 1878. **BOR**, pp. 148–9.

7. Enclosure in above. **BOR**, p. 148.

8. *Ibid.*

9. Duval to Juliette Courbet, Paris, 17 October 1878. *Le XIXe Siècle* (Paris), 3 April 1879.

10. The dates of Zoé Reverdy's admission to the asylum and of her

death were given to the author when he visited Saint-Ylie on 20 April 1950. The rules of the institution prohibited the disclosure of any other information.

11. Léger, Charles: *Au Pays de Gustave Courbet,* pp. 18–20. Meudon; 1910.

12. Valerio, Edith: "Gustave Courbet and his country." *Art in America* (New York), vol. 10, no. 6 (October 1922), pp. 248, 251.

13. Juliette Courbet to Blondon, Flagey, 13 November 1877. Les Amis de Gustave Courbet: *Bulletin,* no. 3, p. 43. Paris-Ornans; 1948.

14. Copy of official notice, August 1880, unsigned. **CD,** box 6.

15. Most of the material in this paragraph was related to the author on 5 May 1950 by Mlle Suzanne Canoz of Saint-Sulpice-de-Favières (Seine-et-Oise), who had known Juliette Courbet during her last years in Paris.

BIBLIOGRAPHY

MANUSCRIPTS

COURBET DOCUMENTS. A collection of letters, notes, newspaper cuttings, and miscellaneous documents in seven boxes in the Salle des Estampes, Bibliothèque Nationale, Paris. Indexed and arranged in chronological order by M. Jean Adhémar, *conservateur adjoint* of the Cabinet des Estampes.

> Boxes 1 and 2: Letters and other documents collected by Castagnary.
> Boxes 3, 4, and 5: Unfinished and unpublished biography of Courbet by Castagnary, in MS., and notes for the same.
> Box 6: Letters and notes collected by Castagnary, relating to events after Courbet's death.
> Box 7: Letters, notes, and documents collected by Georges Riat, relating chiefly to the years 1870–1877.

WEY, FRANCIS: *Extrait des mémoires inédits de feu Francis Wey. Notre maître peintre G. Courbet.* MS. (35 pp.) in Salle des Estampes, Bibliothèque Nationale, Paris.

Original letter from Courbet to Max Buchon, undated, written at Montpellier during the summer of 1854. In the library of the Metropolitan Museum of Art, New York (presented by Samuel P. Avery).

Original letter from Courbet to his concierge, Bain, written at Trouville, 8 September 1865. Lent by Mr John Rewald, New York.

BIBLIOGRAPHY

Courbet's birth register. Original in Courbet Museum, Ornans.
Municipal records of Ornans and Flagey.
Records of the asylum at Saint-Ylie.

BOOKS, PAMPHLETS, CATALOGUES

ABOUT, EDMOND: *Nos Artistes au Salon de 1857.* L. Hachette et Cie., Paris; 1858.

——: *Voyage à travers l'exposition des Beaux-Arts (peinture et sculpture).* L. Hachette et Cie., Paris; 1855.

ALMERAS, HENRI D': *La Vie parisienne pendant le siège et sous la Commune.* Albin Michel, Paris; 1927.

BAILLODS, JULES: *Courbet vivant.* Delachaux et Niestlé, Neuchâtel and Paris; 1940.

BAUDELAIRE, CHARLES-PIERRE: *Curiosités esthétiques.* Michel Lévy Frères, Paris; 1868.

BAUDRY, ETIENNE: *Le Camp des bourgeois.* E. Dentu, Paris; 1868.

BERGERAT, EMILE: *Sauvons Courbet!* Alphonse Lemerre, Paris; 1871.

BOAS, GEORGE (ed.): *Courbet and the naturalistic movement. Essays read at the Baltimore Museum of Art, May 16, 17, 18, 1938.* Johns Hopkins Press, Baltimore; 1938.

BON, J.-E.: *A la Mémoire de Gustave Courbet.* Frazier-Soye, Paris (no d.).

BOREL, PIERRE: *Le Roman de Gustave Courbet.* E. Sansot (R. Chiberre, succr.), Paris; 1922. (2nd edition).

BOUVIER, EMILE: *La Bataille réaliste (1844–1857).* Fontemoing et Cie., Paris; 1913 (?).

BOYER, PIERRE: *Les Aventures d'un étudiant, 1870–1871.* L. Sauvaitre, Paris; 1888.

BRUNO, JEAN (*pseud.* of Dr Blondon): *Les Misères des gueux. Ouvrage entièrement illustré par G. Courbet.* A. Lacroix, Verboeckhoven et Cie., Paris, Brussels, Leipzig, and Leghorn; 1872.

BUCHON, MAX: *Essais poétiques, par Max B—, vignettes par Gust. C—.* Besançon; 1839.

——: *Recueil de dissertations sur le réalisme.* Neuchâtel; 1856.

Bulletin des lois, arrêtés, décrets et proclamations de la Commune de Paris. Recueil de tous les actes officiels du 26 mars au 23 mai 1871. A. Lacroix, Verboeckhoven et Cie., Paris, Brussels, Leipzig, and Leghorn; 1871.

398

BIBLIOGRAPHY

CASTAGNARY, JULES-ANTOINE: *Gustave Courbet et la colonne Vendôme. Plaidoyer pour un ami mort.* E. Dentu, Paris; 1883.

——: *Philosophie du Salon de 1857.* Poulet-Malassis et De Broise, Paris; 1858.

——: *Salons (1857–1879).* Charpentier, Paris; 1892. (2 vols.).

CHAMPFLEURY (*pseud.* of Jules-François-Félix Husson): *Les Amis de la nature.* Poulet-Malassis et De Broise, Paris; 1859.

——: *Les Demoiselles Tourangeau.* Michel Lévy Frères, Paris; 1864.

——: *Grandes figures d'hier et d'aujourd'hui.* Poulet-Malassis et De Broise, Paris; 1861.

——: *Le Réalisme.* Michel Lévy Frères, Paris; 1857.

——: *Les Sensations de Josquin.* Michel Lévy Frères, Paris; 1859.

——: *Souvenirs et portraits de jeunesse.* E. Dentu, Paris; 1872.

CHAMPIER, VICTOR: *L'Année artistique (1878).* A. Quantin, Paris; 1879.

CHIRICO, GIORGIO DI: *Gustave Courbet.* Valori Plastici, Rome; 1925.

CLAUDET, MAX: *Souvenirs. Gustave Courbet.* Dubuisson et Cie., Paris; 1878.

COURBET, GUSTAVE: *A l'Armée allemande. Aux Artistes allemands.* Paris; 1870.

——: *Lettre ouverte aux députés et sénateurs des nouvelles assemblées nationales.* Vérésoff, Geneva; March 1876.

COURTHION, PIERRE: *Courbet.* H. Floury, Paris; 1931.

——: *Courbet raconté par lui-même et par ses amis.* Vol. 1: *Sa Vie et ses œuvres* (1948). Vol. 2: *Ses Ecrits, ses contemporains, sa postérité* (1950). Pierre Cailler, Geneva.

Les Curés en goguette. Avec six dessins de Gustave Courbet. A. Lacroix, Verboeckhoven et Cie., Paris, Brussels, Leipzig, and Leghorn; 1868.

DAMÉ, FRÉDÉRIC: *La Résistance. Les Maires, les députés de Paris et le comité central du 18 au 26 mars. Avec pièces officielles et documents inédits.* Alphonse Lemerre, Paris; 1871.

DELACROIX, EUGÈNE: *Journal* (entries for 15 April 1853, 17 October 1853, 3 August 1855). Plon, Paris; 1932. (3 vols.)

DELÉCLUZE, E.-J.: *Exposition des artistes vivants, 1850.* Au Comptoir des Imprimeurs, Paris; 1851.

DELVAU, ALFRED: *Histoire anecdotique des cafés et cabarets de Paris.* E. Dentu, Paris; 1862.

DU CAMP, MAXIME: *Les Beaux-Arts à l'exposition universelle de 1855.* Librairie Nouvelle, Paris; 1855.

——: *Les Beaux-Arts à l'exposition universalle et aux Salons de*

1863, 1864, 1865, 1866 et 1867. Veuve Jules Renouard, Paris; 1867.

——: *Les Convulsions de Paris.* L. Hachette et Cie., Paris; 1878–80. (4 vols.).

DURANTY, E.: *La Nouvelle peinture. A propos du groupe d'artistes qui expose dans les galeries Durand-Ruel.* E. Dentu, Paris; 1876.

DURET, THÉODORE: *Courbet.* Bernheim-Jeune et Cie., Paris; 1918.

——: *Les Peintres français en 1867.* E. Dentu, Paris; 1867.

ESTIGNARD, A.: *G. Courbet. Sa Vie et ses œuvres.* Delagrange et Magnus, Besançon; 1897.

Exhibition et vente de 40 tableaux et 4 dessins de l'œuvre de M. Gustave Courbet, avenue Montaigne, 7, Champs-Elysées. Paris; 1855.

Explication des ouvrages de peinture et de sculpture exposés dans les salles de la Mairie au profit des pauvres. 160 tableaux signés Corot, Courbet, Auguin, Pradelles. Saintes; 1863.

Exposition des œuvres de Gustave Courbet à l'école des Beaux-Arts (mai 1882). Paris; 1882.

Exposition des œuvres de M. G. Courbet. Rond-point du pont de l'Alma (Champs-Elysées). Lebigre-Duquesne Frères, Paris; 1867.

Exposition Gustave Courbet, ville d'Ornans, 23 juillet—1 octobre, 1939. 1939.

FOCILLON, HENRI: *La Peinture aux XIXᵉ et XXᵉ siècles. Du réalisme à nos jours.* Renouard, Paris; 1928.

FONTAINAS, ANDRÉ: *Courbet.* Félix Alcan, Paris; 1921.

——: *Courbet (Albums d'art Druet, no. 8).* Librairie de France, Paris; 1927.

FOSCA, FRANÇOIS: *Courbet.* Albert Skira, Paris; 1940.

FOURNEL, VICTOR: *Les Artistes français contemporains.* Alfred Mame et Fils, Tours; 1885. (2nd edition).

GAUTIER, THÉOPHILE: *Les Beaux-Arts en Europe, 1855. (Série 2).* Michel Lévy Frères, Paris; 1856.

——: *Tableaux à la plume.* Charpentier, Paris; 1880.

GAZIER, GEORGES: *Gustave Courbet. L'homme et l'œuvre. (Conférence faite à la Société des Amis de l'Université de Franche-Comté, le 19 mars 1906.)* Besançon; 1906.

GEBAÜER, ERNEST: *Les Beaux-Arts à l'exposition universelle de 1855.* Librairie Napoléonienne des Arts et de l'Industrie, Paris; 1855.

GEFFROY, GUSTAVE: *Claude Monet. Sa Vie, son temps, son œuvre.* G. Crès et Cie., Paris; 1922.

GILL, ANDRÉ *(pseud.* of Louis-Alexandre Gosset de Guines): *Vingt années de Paris.* C. Marpon et E. Flammarion, Paris; 1883.

GONCOURT, EDMOND et JULES DE: *Etudes d'art. Le Salon de 1852; la peinture à l'exposition de 1855.* E. Flammarion, Paris; 1893.

GROS-KOST, E.: *Gustave Courbet. Souvenirs intimes.* Derveaux, Paris; 1880.

GUICHARD, M.: *Les Doctrines de M. Gustave Courbet, maître peintre.* Poulet-Malassis, Paris; 1862.

HUGO, VICTOR: *Choses vues.* J. Hetzel et Cie., Paris; 1887. Ollendorff, Paris; 1913.

HUYGHE, RENÉ; BAZIN, GERMAIN; et ADHÉMAR, HÉLÈNE JEAN: *Courbet. L'Atelier du peintre, allégorie réelle, 1855.* Plon, Paris; 1944.

IDEVILLE, COMTE H. D': *Gustave Courbet. Notes et documents sur sa vie et son œuvre.* Paris-Gravé, Paris; 1878.

JEAN-AUBRY, G.: *Eugène Boudin d'après des documents inédits. L'homme et l'œuvre.* Bernheim-Jeune, Paris; 1922.

JOUVE, PIERRE-JEAN: *Défense et illustration.* Charlot, Paris; 1946.

KÉRATRY, COMTE EMILE DE: *Le 4 septembre et le gouvernement de la Défense nationale. Déposition devant la commission d'enquête de l'Assemblée nationale. Mission diplomatique à Madrid, 1870.* A. Lacroix, Verboeckhoven et Cie., Paris, Brussels, Leipzig, and Leghorn; 1872.

LANJALLEY, PAUL, et CORRIEZ, PAUL: *Histoire de la révolution du 18 mars.* A. Lacroix, Verboeckhoven et Cie., Paris, Brussels, Leipzig, and Leghorn; 1871.

LARAN, JEAN, et GASTON-DREYFUS, PH.: *Courbet. Précédé d'une étude biographique et critique par Léonce Bénédite.* La Renaissance du Livre, Paris; 1911.

——: *Gustave Courbet. With a biographical and critical study by Léonce Bénédite.* Wm. Heinemann, London; 1912.

LÁZÁR, BÉLA: *Courbet et son influence à l'étranger.* H. Floury, Paris; 1911.

LECOQ DE BOISBAUDRAN, HORACE: *Enseignement artistique.* Veuve A. Morel et Cie., Paris; 1879.

——: *The Training of the memory in art and the education of the artist* (tr. by L. D. Luard). Macmillan and Co., Ltd., London; 1911.

LÉGER, CHARLES: *Au Pays de Gustave Courbet.* Meudon; 1910.

——: *Courbet.* G. Crès et Cie., Paris; 1929.

——: *Courbet.* Braun et Cie., Paris; 1934.

——: *Courbet en exil (d'après des documents inédits).* Les Amis de Gustave Courbet, Pontarlier; 1943.

BIBLIOGRAPHY

——: *Courbet selon les caricatures et les images.* Paul Rosenberg, Paris; 1920.

——: *Tableaux inconnus de Gustave Courbet.* (Preface, notes, and comments in catalogue, exhibition at Galerie Sèvres, Paris, 28 June–12 July 1930). Galerie Sèvres, Paris; 1930.

LEMONNIER, CAMILLE: *G. Courbet et son œuvre.* Alphonse Lemerre, Paris; 1878.

L'HERS, JEAN DE (*pseud.* of Baron Marie-Louis Desazars de Montgailhard): *Au Musée de Montpellier. Les dix-sept portraits du donateur Alfred Bruyas.* Toulouse; 1900.

LOUDUN, EUGÈNE: *Le Salon de 1855.* Ledoyen, Paris; 1855.

MEIER-GRAEFE, JULIUS: *Courbet.* R. Piper & Co. Verlag, Munich; 1921.

MOREL, HENRY: *Le Pilori des Communeux.* E. Lachaud, Paris; 1871.

Mort de Jeannot, La. Les Frais du culte. Avec quatre dessins de Gustave Courbet. A Lacroix, Verboeckhoven et Cie., Paris, Brussels, Leipzig, and Leghorn; 1868.

NAEF, HANS: *Courbet.* Alfred Scherz Verlag, Berne; 1947.

PROUDHON, PIERRE-JOSEPH: *Du Principe de l'art et de sa destination sociale.* Garnier Frères, Paris; 1865.

REWALD, JOHN: *Camille Pissarro. Letters to his son Lucien.* Pantheon Books, Inc., New York; 1943.

——: *The History of impressionism.* Museum of Modern Art, New York; 1946.

RIAT, GEORGES: *Gustave Courbet, peintre.* H. Floury, Paris; 1906.

ROCHEGUDE, MARQUIS DE, et DUMOLIN, MAURICE: *Guide pratique à travers le vieux Paris.* Edouard Champion, Paris; 1923.

SAINTE-BEUVE, CHARLES-AUGUSTIN: *Correspondance (1822–1865).* Calmann Lévy, Paris; 1877. (2 vols.).

SCHANNE, ALEXANDRE-LOUIS: *Souvenirs de Schaunard.* Charpentier, Paris; 1886.

SILVESTRE, THÉOPHILE: *Les Artistes français. Etudes d'après nature.* Office de Publicité, Brussels, and August Schnee, Leipzig; 1861.

—— (preface): *La Galerie Bruyas, musée de Montpellier.* Paris; 1876.

SOMARÉ, ENRICO: *Courbet.* Istituto Italiano d'Arti Grafiche, Bergamo; 1934.

TALMEYR, MAURICE: *Souvenirs d'avant le déluge, 1870–1914.* Perrin et Cie., Paris; 1927.

THACKERAY, WILLIAM MAKEPEACE: *The Paris sketch book of Mr. M. A. Titmarsh.* Smith, Elder and Co., London; 1868.

THORÉ, THÉOPHILE: *Salons de W. Bürger, 1861 à 1868.* Veuve Jules Renouard, Paris; 1870. (2 vols.).

BIBLIOGRAPHY

TROUBAT, JULES: *Une Amitié à la d'Arthez. Champfleury—Courbet— Max Buchon. Suivi d'une conférence sur Sainte-Beuve.* Lucien Duc, Paris; 1900.

VALLÈS, JULES-LOUIS JOSEPH: *La Rue.* Achille Faure, Paris; 1866.

VANDÉREM, FERNAND: *Charles Baudelaire.* Le Salut Public. *Reproduction en fac-similé, avec une préface de Fernand Vandérem.* Paris (no d.).

VENTURI, LIONELLO: *Modern painters.* Charles Scribner's Sons, New York and London; 1947.

VIGNON, CLAUDE: *Exposition universelle de 1855. Beaux-Arts.* Auguste Fontaine, Paris; 1855.

ZAHAR, MARCEL: *Gustave Courbet.* Flammarion, Paris; 1950.

——: *Gustave Courbet* (tr. by D. I. Wilton). Harper & Bros., New York; 1950.

ZOLA, EMILE: *Mes Haines.* Charpentier, Paris; 1913. (First published 1866).

PERIODICALS

AMIEL, J. HENRI: "Un Précurseur du réalisme: Max Buchon." *Modern Language Quarterly* (Seattle), vol. 3, no. 3 (September 1942), pp. 379–90.

AMIS DE GUSTAVE COURBET, LES: *Bulletin,* nos. 1–2 (1947); 3–4 (1948); 5–6 (1949); 7–8 (1950). Paris-Ornans.

BAUD-BOVY, DANIEL: "Un Portrait de Max Buchon par Courbet." *Gazette des Beaux-Arts* (Paris), *année* 64, *période* 5, vol. 5, no. 727 (May 1922), pp. 318–20.

BAUZON, LOUIS: "Documents inédits sur Courbet." *L'Art* (Paris), vol. 40 (1886), pp. 237–42.

BÉNÉDITE, LÉONCE: "Whistler." *Gazette des Beaux-Arts* (Paris), *année* 47, *période* 3, vol. 33, no. 575 (May 1905), pp. 403–10; no. 576 (June 1905), pp. 496–511; vol. 34, no. 578 (August 1905), pp. 142–58; no. 579 (September 1905), pp. 231–46.

BOREL, PIERRE: "Gustave Courbet en Suisse." *Le Mois Suisse* (Montreux), *année* 4, no. 35 (February 1942), pp. 93–110.

——: "Quatre modèles de Gustave Courbet." *Revue de France* (Paris), *année* 5, vol. 2 (March–April 1925), pp. 180–6.

CASTAGNARY, JULES-ANTOINE: Article on Courbet. *L'Opinion Nationale* (Paris), 19 May 1860.

——: "Fragments d'un livre sur Courbet." *Gazette des Beaux-Arts* (Paris), *année* 53, *période* 4, vol. 5, no. 643 (January 1911), pp. 5–20; vol. 6, no. 654 (December 1911), pp. 488–97; *année* 54, *période* 4, vol. 7, no. 655 (January 1912), pp. 19–30.

CHAMPFLEURY (*pseud.* of Jules-François-Félix Husson): Article on the Salon of 1848. *Le Pamphlet* (Paris), 28 September 1848.

——: "Du Réalisme. Lettre à Madame Sand." *L'Artiste* (Paris), *série* 5, vol. 16, no. 1 (2 September 1855), pp. 1–5.

——: "Les Sensations de Josquin. Histoire de M. T—." *Revue des Deux Mondes* (Paris), *période* 2, vol. 10 (15 August 1857), pp. 863–85.

COURBET, GUSTAVE: Letter from Courbet to his pupils. *Courrier du Dimanche* (Paris), 29 December 1861.

——: "Proposition aux membres du gouvernement de la défense nationale." *Journal des Débats* (Paris), 29 September 1870.

"Courbet à Saintes." *Revue de Saintonge et d'Aunis. Bulletin de la Société des Archives Historiques* (Saintes), vol. 38, no. 5 (August 1919), pp. 294–302.

DARCEL, ALFRED: "Les Musées, les arts et les artistes pendant la Commune." *Gazette des Beaux-Arts* (Paris), *année* 14, *période* 2, vol. 5, no. 1 (January 1872), pp. 41–65; no. 2 (February 1872), pp. 140–50; no. 3 (March 1872), pp. 210–29; no. 5 (May 1872), pp. 398–418; no. 6 (June 1872), pp. 479–90.

——: "Les Musées, les arts et les artistes pendant le siège de Paris." *Gazette des Beaux-Arts* (Paris), *année* 12, *période* 2, vol. 4, no. 4 (October 1871), pp. 285–306; no. 5 (November 1871), pp. 414–29.

XIXᵉ Siècle, Le (Paris), 3 April 1879. (Article on forged will).

DROZ, EDOUARD: "Pierre-Joseph Proudhon. Lettres inédites à Gustave Chaudey et à divers comtois, suivies de quelques fragments inédits de Proudhon et d'une lettre de Gustave Courbet sur la mort de Proudhon." *Mémoires de la Société d'Emulation du Doubs* (Besançon), *série* 8, vol. 5 (1910), pp. 159–257.

DUMAS, ALEXANDRE (*fils*): Article on Courbet. *Le Figaro* (Paris), 12 June 1871.

FERNIER, ROBERT: "Courbet avait un fils." *Arts* (Paris), *nouvelle série*, no. 310 (11 May 1951), pp. 1, 3.

FROND, VICTOR: Article on Courbet. *Panthéon des illustrations françaises au XIXᵉ siècle. Publié sous le patronage de sa majesté l'empereur par Victor Frond et Lemercier* (Paris), vol. 6. (No d.; probably 1866).

GANTOIS, CHARLES: "Quelques souvenirs sur l'abbé Cordier, curé de Notre-Dame de Pontoise et ses hôtes le peintre Gustave Courbet

et le dessinateur Saint-Marcel." *Mémoires de la Société Historique et Archéologique de l'Arrondissement de Pontoise et du Vexin* (Pontoise), vol. 49 (1941), pp. 129–45.

GAUTIER, THÉOPHILE: "Beaux-Arts. Collection Khalil-Bey." *Moniteur Universel* (Paris), 14 December 1867.

——: "Revue dramatique." *Moniteur Universel* (Paris), 10 December 1855.

——: "Salon de 1857." *L'Artiste* (Paris), *nouvelle série,* vol. 2, no. 3 (20 September 1857), pp. 33–6.

GILL, ANDRÉ (*pseud.* of Louis-Alexandre Gosset de Guines): Caricature of Courbet. *La Lune* (Paris), *année* 3, no. 66 (9 June 1867).

HERVILLY, ERNEST D': "Le Conseil de Guerre de l'exposition des Beaux-Arts." *L'Eclipse* (Paris), *année* 5, no. 181 (14 April 1872), p. 3.

Journal Officiel de la République Française sous la Commune (Paris), 19 March–24 May 1871.

LARKIN, OLIVER: "Courbet and his contemporaries, 1848–1867." *Science and Society* (New York), vol. 3, no. 1 (winter 1939), pp. 42–63.

LÉGER, CHARLES: "Courbet et Victor Hugo d'après des lettres inédites." *Gazette des Beaux-Arts* (Paris), *année* 63, *période* 5, vol. 4, no. 722 (December 1921), pp. 353–63.

"Lettres inédites de Champfleury au poète franc-comtois Max Buchon." *La Revue Mondiale* (Paris), vol. 105 (November–December 1913), pp. 30–49, 213–30; vol. 133 (October–December 1919), pp. 531–45, 701–10.

"Lettres inédites de quelques peintres. Gustave Courbet." *L'Olivier. Revue de Nice* (Nice), *année* 2, no. 8 (September–October 1913), pp. 468–512.

MANTZ, PAUL: "Gustave Courbet." *Gazette des Beaux-Arts* (Paris), *année* 20, *période* 2, vol. 17, no. 6 (June 1878), pp. 514–27; vol. 18, no. 1 (July 1878), pp. 17–30; no. 6 (December 1878), pp. 371–84.

MOREAU, PIERRE: "Les Origines du réalisme franc-comtois. Discours de réception." Academie des Sciences, Belles-Lettres et Arts de Besançon, *Bulletin trimestriel* (Besançon), *trimestre* 1, 1936, pp. 22–43.

NADAR: Article on Courbet. *Le Monde des Eaux* (?Paris), 3 June 1866.

Petit Comtois (Besançon), 13 January, 22 January, 10 February 1897.

Précurseur d'Anvers, Le (Antwerp), 22 August 1861.

Rappel, Le (Paris), 7 April 1871.

Réalisme (Paris), no. 1 (10 July 1856); no. 2 (15 December 1856); no. 3 (15 January 1857); no. 4 (15 February 1857); no. 5 (15 March 1857); no. 6 (April–May 1857).

BIBLIOGRAPHY

Rochefort, Henri: "Dumas jugé par Rochefort." *Le Reveil* (Paris),
19 February 1882.

Siècle, Le (Paris), 1 March 1872.

Soir, Le (Paris), 6 April 1871.

Thiesson, Gaston: "Le Peintre Gustave Courbet en 1870–1871." *Demain. Pages et Documents* (Geneva), *année* 1, no. 3 (15 March 1916), pp. 152–7.

Timbal, Charles: "Le Cabinet de M. Thiers." *La Chronique des Arts et de la Curiosité* (Paris), no. 32 (20 October 1877), pp. 307–8.

Times, The (London), 17 and 19 May 1871 (demolition of Vendôme Column); 27 June 1871 (letter to editor from Robert Reid); 24 June 1874 (letter to editor from Félix Pyat).

Valerio, Edith: "Gustave Courbet and his country." *Art in America* (New York), vol. 10, no. 6 (October 1922), pp. 246–54.

INDEX

i

INDEX

ii

INDEX

viii

INDEX

Other DACAPO titles of interest

AMERICANS IN PARIS
George Wickes
New foreword by Virgil Thomson
302 pp., 16 pp. of photos
80127-2 $6.95

APOLLINAIRE ON ART
Essays and Reviews 1902-1918
Edited by LeRoy C. Breunig
592 pp., 16 illus.
80312-7 $13.95

THE ART CRITICISM OF
JOHN RUSKIN
Edited by Robert Herbert
430 pp.
80310-0 $12.95

THE *BLAUE REITER*
ALMANAC
Edited by Wassily Kandinsky
and Franz Marc
296 pp., 113 illus.
80346-1 $13.95

ITALIAN VILLAS AND
THEIR GARDENS
Edith Wharton
With pictures and illus. by
Maxfield Parrish
270 pp., 37 b&w illus.,
15 color plates, 7 × 10
80048-9 $15.95

THE PAINTER OF MODERN
LIFE AND OTHER ESSAYS
Charles Baudelaire
Edited by Jonathan Mayne
298 pp., 53 illus.
80279-1 $11.95

PICASSO ON ART
A Selection of Views
Edited by Dore Ashton
200 pp., 43 illus.
80330-5 $11.95

THE STONES OF VENICE
John Ruskin
Edited by J. G. Links
256 pp.
80344-9 $9.95

Available at your bookstore

OR ORDER DIRECTLY FROM

DA CAPO PRESS, INC.

233 Spring Street, New York, New York 10013